The 20th-Century Art Book

Phaidon Press Limited
Regent's Wharf
All Saints Street
London N1 9PA

Phaidon Press Inc.
180 Varick Street
New York, NY 10014

www.phaidon.com

First published 1996
Reprinted in paperback
© 1996 Phaidon Press Limited

ISBN 0 7148 3850 0

A CIP catalogue record for
this book is available from
the British Library.

Printed in Hong Kong

Note

abbreviations:

c = circa
b = born
d = died
h = height
w = width
l = length
diam = diameter

The publishers have made every
effort to include dimensions
wherever possible. As some
installations illustrated fill
entire rooms, the correct
measurements have been
impossible to acquire.

ARG	=	Argentina
ARM	=	Armenia
ASL	=	Australia
AUS	=	Austria
BAH	=	Bahamas
BAR	=	Barbados
BEL	=	Belgium
BR	=	Brazil
BUL	=	Bulgaria
CAN	=	Canada
CH	=	Chile
CHN	=	China
CI	=	Canary Islands
COL	=	Columbia
CU	=	Cuba
CZ	=	Czechoslovakia
DK	=	Denmark
FIN	=	Finland
FR	=	France
GB	=	Great Britain
GER	=	Germany
GR	=	Greece
HUN	=	Hungary
IN	=	India
IRE	=	Ireland
IS	=	Israel
IT	=	Italy
JAP	=	Japan
KOR	=	Korea
LAO	=	Laos
LEB	=	Lebanon
LIT	=	Lithuania
MAL	=	Malta
MEX	=	Mexico
MI	=	Marquesas Islands
MON	=	Principality of Monaco
MOR	=	Morocco
NL	=	Netherlands
NOR	=	Norway
NZ	=	New Zealand
POL	=	Poland
POR	=	Portugal
PRU	=	Prussia
ROM	=	Romania
RUS	=	Russia
SA	=	South Africa
SP	=	Spain
SW	=	Switzerland
SWE	=	Sweden
TAH	=	Tahiti
UG	=	Uganda
UKR	=	Ukraine
URU	=	Uruguay
USA	=	United States of America
YUG	=	Yugoslavia
ZAI	=	Zaire

More than any other era, the twentieth century offered us an unrivalled galaxy of styles and approaches to art. The century proved to be a fast-moving epoch of inventions, discoveries and political upheavals. As a result, the art scene also changed radically: it became more international, artists experimented with new media, including oil paint, collage, sculpture, ready-made objects, installation and video, and the status of women artists grew immeasurably. **The 20th-Century Art Book** offers an A to Z guide to the art of an extraordinary age. From old favourites such as Monet, Picasso, Dalí and Hockney to the most innovative contemporary artists, 500 full-page colour plates present celebrated works alongside future classics. Each image is accompanied by an incisive text, shedding light on the work and its creator. The alphabetical arrangement presents thought-provoking juxtapositions, while cross-references lead you through the century by subject matter, style or medium. Full glossaries of terms, artistic movements, and museums and galleries are included, creating a self-contained volume which presents a whole new way of looking at twentieth-century art.

Acconci Vito

Seedbed

At the back of the gallery, concealed beneath a ramp, lurks Acconci who masturbates to fantasies about the viewer above. His thoughts are relayed via a speaker in the corner. Simultaneously addressing and alienating the gallery visitor, the work speaks of pleasure, contact and desire, and conversely of invisibility and failure, perhaps as a metaphor for artistic creation. *Seedbed* is one of the most infamous performance pieces of the 1970s. As a reaction against the mathematical precision of Minimalist art of the 1960s, Acconci sought to fill his

art with intensity and passion. He later devised methods of reaching a wider audience, such as his car roofracks which inflated to reveal huge penises. He assumed that an art which could be brought directly to the public, and could not be sold, would cause the collapse of the gallery system. Ironically, his brand of Body Art, where he used himself as the subject of his work, was superseded by the 1980's gallery boom.

☛ Andre, Burden, McCarthy, Nitsch, Pane, Rainer, Schneemann

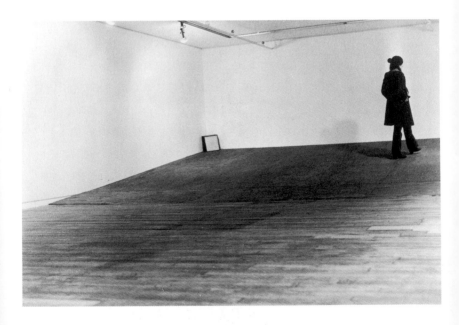

Vito Acconci. b New York (USA), 1940.

Seedbed. 1972. Photograph of a performance at the Sonnabend Gallery, New York

Ader Bas Jan

I'm too Sad to Tell You

Raw emotion is dislocated from its source in this powerful black and white image. The work exists in three forms: as a film, a photograph and as a postcard sent to the artist's friends. The recipients were assured that this was a genuine expression of grief but were not given the cause. The sadness is thus more disturbing. Confronted by the tear-stained face of the artist, and the caption, 'I'm too sad to tell you', which painfully expresses the loneliness of grief, the viewer recalls similarly distressing moments of his or her own life. In his modest output of low-budget Installation and Performance works, and his photographic pieces, Ader explored emotive subjects such as desperation, loss and departure. With a quiet yet eloquent voice, he reminds us of the immeasurable divide between us all. In 1975, as part of his project *In Search of the Miraculous*, Ader set out from Cape Cod in a tiny yacht for a two-month voyage across the Atlantic. His boat capsized and he was never seen again.

☞ Burden, González, Longo, Rainer, Soutine

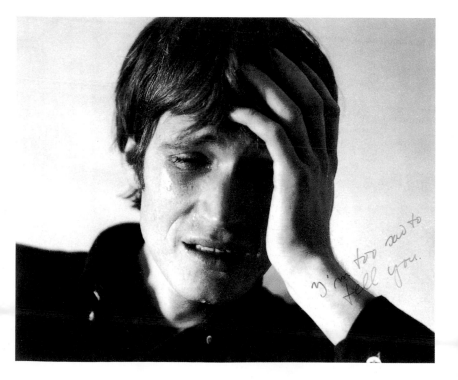

Bas Jan Ader. b Winschoten (NL), 1942. d Cape Cod, MA (USA), 1975.

I'm too Sad to Tell You. 1970. Photograph. h45 x w59 cm. h17¾ x w23¼ in. Museum Boymans-van Beuningen, Rotterdam

Agar Eileen

The Angel of Mercy

Gazing out at the viewer through half-closed eyes, this sculpture was modelled on Agar's husband. The stylized hair, which resembles Greek or Roman statuary, may reflect his keen interest in Classicism and mythology. As well as conjuring up the impression of a real person, this work is also partly abstract. The decorative swirl of orange round the eye and mouth, the spiral lines incised into the chin and neck, and the stars above the lip and on the chin recall occult, mystic symbols. Born in Buenos Aires, but living for most of her life in London,

Agar was a painter as well as a sculptor. Associated with the Surrealist movement, with whom she exhibited, she often exploited the unexpected conjunction of forms and objects in her work. However, like other British Surrealists, she took little interest in the literary, political and psychological connections of that movement.

☞ Birch, Dalí, Laurens, A Piper

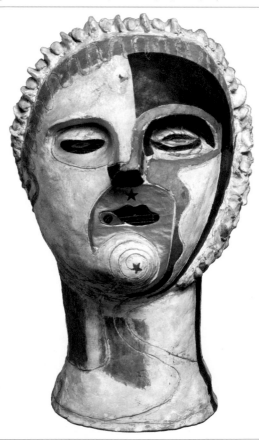

Eileen Agar. b Buenos Aires (ARG), 1904. d London (GB), 1991.
The Angel of Mercy. 1934. Collage and watercolour on plaster. h44 cm. h17⅓ in. Private collection

Aitchison Craigie

Portrait of Naaotwa Swayne

Naaotwa Swayne sits with her arms folded, gazing pensively into the mid-distance. Aitchison has simplified his subject into a subtle, decorative play of contrasting form and colour. There is little traditional modelling, and instead, clearly delineated flat shapes interact to give form to the composition. The warm colours of the sitter's flesh and dress are balanced against the dark background and the white of her headdress and sleeves, giving the painting an exotic air. Aitchison's work is characterized by a gentle innocence which displays none of the self-conscious irony of much contemporary art. What is also increasingly rare in current practice is the artist's commitment to figure-painting from life, and to portraiture in particular. Aitchison belongs to a generation of British artists, known as the School of London, who have distanced themselves from the more radical tendencies of contemporary art in order to develop the potential of figurative painting. He is also known for his large-scale paintings of Crucifixions.

☛ Hartley, John, Laurens, Schjerfbeck

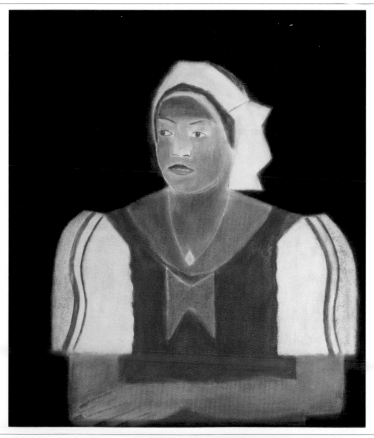

Craigie Aitchison. **b** Edinburgh (GB), 1926.
Portrait of Naaotwa Swayne. 1988. Oil on canvas. **h**61 x **w**50.8 cm. **h**24 x **w**20 in. Private collection

Albers Josef

Study for Homage to the Square: Beaming

Three concentric squares are laid on top of each other in diminishing scale. The marine blue fills the outer rim while the smallest green square sits below the centre. The interaction of the colours is disorientating after long viewing, giving the illusion that the squares are moving in and out of the picture plane. In this sense the work prefigures Op Art, which experiments with visual perception. Although Albers's geometric abstraction may have passing links with the Minimalist aesthetics of Stella and Judd, Albers's 'Squares' were part of an enormous series that was more concerned with the meditative potential offered by the interplay of colours, than with colour theory. Albers used colour as a metaphor for human relationships, wanting his work to be seen on an informal, intuitive level, not as rigid visual geometry. A one-time member of the German Bauhaus school, he later emigrated to America to teach at the influential Black Mountain College. He also designed furniture and glass, and produced photographs.

☛ Judd, Klein, Malevich, Riley, Rothko, F Stella, Turrell

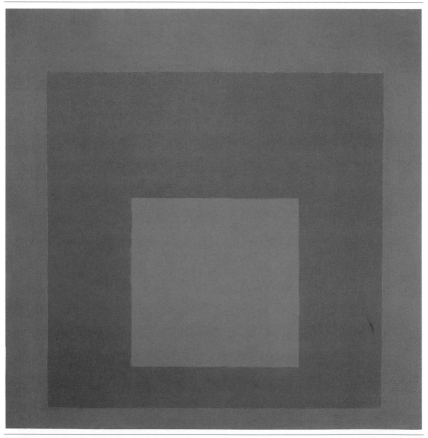

Josef Albers. b Bottrop (GER), 1888. d New Haven, CT (USA), 1976.
Study for Homage to the Square: Beaming. 1963. Oil on masonite panel. **h**76.2 x **w**76.2 cm. **h**30 x **w**30 in. Tate Gallery, London

Alechinsky Pierre

The Large Transparent Things

A whirling ground of interlocking blue and white curves of colour fills the canvas to create a rhythmic, visual narrative. The title suggests that the work may represent people or objects, and some of the shapes could be interpreted as human forms. Alechinsky often used different shades of blue, giving a vibrant, painterly depth to his works. The spontaneous and dynamic composition links his work to the Cobra movement, a group of artists who wanted to free themselves from the constraints of reason, producing compositions directly inspired by their subconscious. The name Cobra comes from the three cities where the artists were based – Copenhagen, Brussels and Amsterdam. Alechinsky was a founder member of the group, along with Appel and Jorn. He was also influenced by Japan, which he visited in the mid-1950s. Japanese calligraphy and the aesthetics of the performance-based Gutai group give his work its sense of balance.

☞ **Appel, Dubuffet, Jorn, Pollock, Yoshihara**

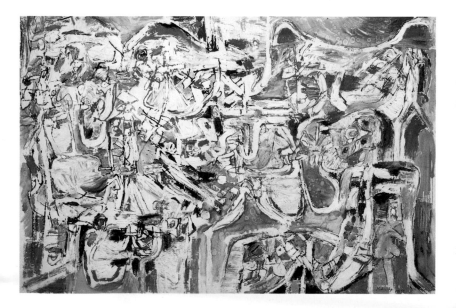

Pierre Alechinsky. b Brussels (BEL), 1927.
The Large Transparent Things. 1958. Oil on canvas. **h**199.4 x **w**299.7 cm. **h**78½ x **w**118 in. Private collection

Andre Carl

Tree Bones

Thirteen rows of identical blocks of creosoted wood lie in low relief on the floor. Each unit can be dismantled and reassembled: Andre never uses adhesives or joints, relying instead on the inherent gravity of his medium for cohesion. Outside the gallery these materials would be almost indistinguishable from those used by a builder. Andre's use of industrial materials may owe something to his experiences working on the Pennsylvania Railway. His austere sculptures display the Minimalist aesthetic which attempts to blur the boundaries of art and non-art, denying the importance of the role of the artist. The simplicity and geometric arrangement of the elements in this work harks back to Russian Constructivism and to the works of Brancusi. Andre's work has not always been well received. His *Equivalent VIII* – a structure of house bricks – is perhaps the most controversial purchase ever made by the Tate Gallery in London. It was greeted by the public with unparalleled scorn.

☛ **Brancusi, Duchamp, Judd, LeWitt, Morris, F Stella**

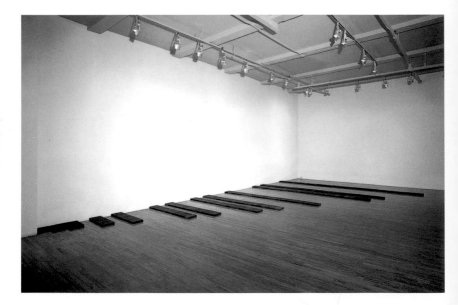

Carl Andre. b Quincy, MA (USA), 1935.
Tree Bones. 1974. Creosoted wood. **h**4.1 x **w**894.1 x **l**540.4 cm. **h**1⅝ x **w**352 x **l**212¾ in (overall). As installed at the Ace Gallery, Vancouver

Appel Karel

Hip Hip Hooray

Painted with thick brushstrokes and a childlike naïveté, a group of strange figures dance across the canvas. These masked men and fantasy animals seem to hover between anguish and jubilation. The vibrant colours, deformed figures and sheer love of excess are key features of the Cobra movement. Named after the three cities (Copenhagen, Brussels and Amsterdam) where its key members were based, the Cobra group was founded in 1948 by a band of painters who wanted to be free from debates about the relative merits of abstraction and figuration, believing in instinct over reason. Rather than trying to reproduce the world around them, they aimed to exploit the free expression of their unconscious. They painted images that were both abstract and figurative, demonstrating that energy and spontaneity were more important than rationality and design. The English art historian Herbert Read wrote that looking at Appel's paintings gives one the impression 'of a spiritual tornado that has left these images of its passage'.

☞ Baselitz, Jorn, De Kooning, Tamayo

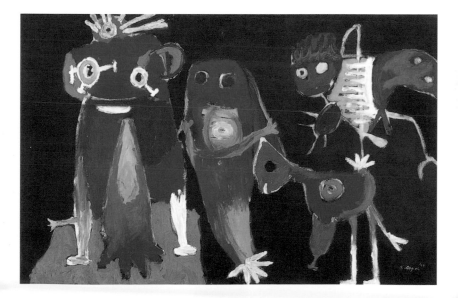

Karel Appel. b Amsterdam (NL), 1921.
Hip Hip Hooray. 1949. Oil on canvas. h82 x w129 cm. h32⅓ x w50⅞ in. Tate Gallery, London

Archipenko Alexander

Standing Nude

The stylized form of a woman emerges from a block of warm, reddish wood. This work combines elements of both figuration and abstraction. The woman's face, breasts and thighs are concave, instead of convex, exhibiting Archipenko's revolutionary approach to sculpture. Abandoning Classical forms, Archipenko has tried to suggest curves by means of hollows, reconstructing the woman's body in terms of geometrical volumes, and juxtaposing curved and straight lines to suggest movement. The woman's hips and lower body face one way, while her shoulders are twisted in the opposite direction. This combination of different viewpoints owes much to Cubism, a movement which rejected traditional forms of representation and modelling. Archipenko was born in the Ukraine, but later moved to Paris where he came across Picasso and the Cubists. He subsequently went to Berlin, where he opened an art school, finally settling in New York.

☛ González, Lipchitz, Moore, Popova

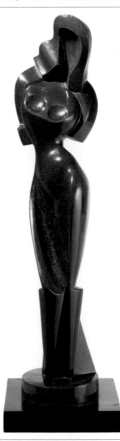

Alexander Archipenko. b Kiev (UKR), 1887. d New York (USA), 1964.
Standing Nude. c1921. Wood. h44.5 cm. h17½ in. Private collection

Avery Milton

Walkers by the Sea

Two women walk mournfully along an empty beach. Behind them, the sea and small strip of sky create a blank and impenetrable wall. The figures are dwarfed by the scale of nature, engulfed by the wash of blue sea. This is a work from Avery's middle period and though he often painted seascapes, this picture is unusual in its melancholy colouring and mood. A self-taught painter, Avery started out as a Fauvist, painting figurative works using flat areas of bright colour. He later developed a style which hovers pleasingly between figuration and abstraction, in which recognisable imagery is reduced to simple shapes and set off against decorative washes of colour. His paring down of form to its bare essentials and his organization of the canvas into flat bands of colour was to have a significant influence on the next generation of American artists, such as Gottlieb and Rothko, whom Avery befriended in the 1930s.

☛ Gottlieb, Lowry, Rothko, Wallis

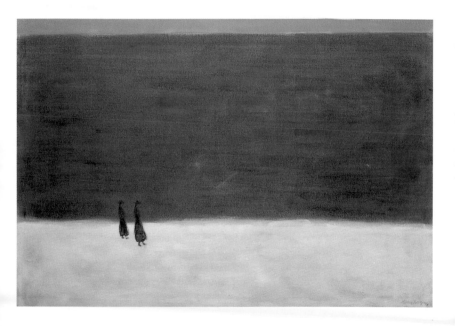

Milton Avery. b Altmar, NY (USA), 1893. d New York (USA), 1964.
Walkers by the Sea. 1954. Oil on canvas. h106.7 x w152.4 cm. h42 x w60 in. Private collection

Auerbach Frank

Head of EOW: Profile

The features of a face emerge from a mass of oil paint, scraped and daubed on the picture surface. Every slash of brush or palette knife searches for a painterly equivalent to flesh and light. The built-up paint surface is so caked with varied approaches that the final, impatient result appears molten. Auerbach has attempted to capture the very essence of Estelle West – his lover and regular model at the time. The apparent speed with which the paint has been applied is indicative of the artist's restless search for new images from familiar subjects.

Auerbach was sent to England as a child to escape the Nazis in Germany. He was taught by Bomberg and is associated with the School of London – a close circle of figurative painters, who chose to work mainly on domestic or local subjects. Throughout his career, Auerbach has maintained an attachment to London's National Gallery, regularly transcribing from its greatest masterpieces.

☛ Bacon, Bomberg, Freud, De Kooning, Kossoff, Soutine

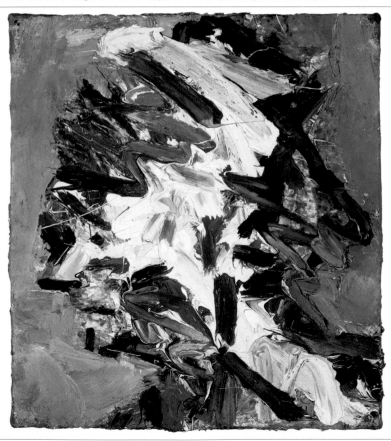

Frank Auerbach. b Berlin (GER), 1931.
Head of EOW: Profile. 1972. Oil on board. **h**50.8 x **w**44.5 cm. **h**20 x **w**17½ in. Private collection

Artschwager Richard

House

Despite its emotional potency, this representation of home, based on imagery from the real estate section of the *New York Post*, seems resolutely anonymous. The monochrome colour scheme, which gives the picture a rough, grainy texture, and the use of celotex, a fibrous, paper-like material, sets up a relationship between the surface and the image, as our attention fluctuates between two and three dimensions, between actual and constructed space. During the 1950s, Artschwager was a commercial furniture maker, commissioned by the Catholic Church to make altars for ships. It was during this time that he began to graft two-dimensional effects such as wood-grain Formica onto three-dimensional, furniture-like objects. Informed both by the aesthetics of Pop Art, which incorporated everyday objects, and the cool, economy of Minimalist art, these works had no functional use. Attacking the boundaries between real and illusory, the sculptures are an important parallel to his paintings.

☛ **Graham, Hockney, Matta-Clark, Oldenburg, Whiteread**

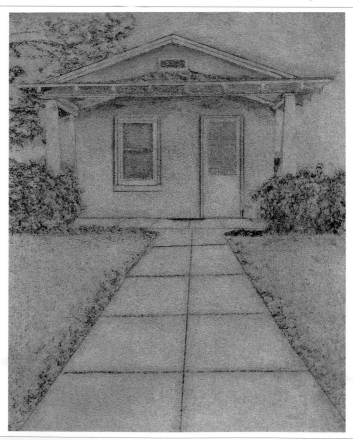

Richard Artschwager. b Washington, DC (USA), 1923.
House. 1966. Acrylic on celotex. **h**144.8 x **w**109.2 cm. **h**57 x **w**43 in. Private collection

Artaud Antonin

The Totem

A strange figure appears to hang from a rope, its arms outstretched, clutching at objects suspended in mid-air. The left leg is amputated, dripping blood, and the face has been reduced to simplistic lines. Artaud's primary interest was drawing. Suffering from mental instability throughout his life, he approached art as a kind of therapy, often producing his works while in mental institutions. Skulls, coffins and dismembered limbs are recurring themes, reflecting the imagery he absorbed on a visit to Mexico, as well as the debilitating effects of electric shock treatment. Fear of the unknown and death are central to his work. This preoccupation links him to the Existentialists, who believed that society itself was alien, isolating and insane. Artaud was also an important theatrical innovator, actor, designer and director, who aimed to move theatre away from the intellectual towards the sensual. His dramatic productions, with their strange imagery, bore many similarities to the work of the Surrealists, such as Dalí.

☛ Dali, Nitsch, Pane, Sarmento, Wölfli

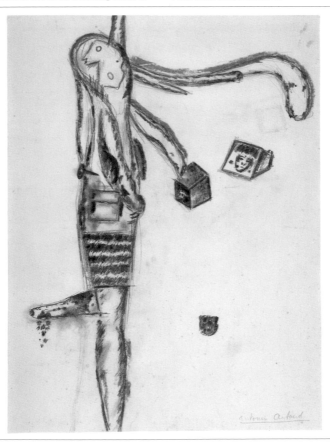

Antonin Artaud. b Marseille (FR), 1896. **d** Ivry-sur-Seine (FR), 1948.
The Totem. 1945. Pencil and coloured chalk on paper. **h**63 x **w**48 cm. **h**24⅞ x **w**18⅞ in. Musée Cantini, Marseille

Art & Language
Joseph Stalin Gazing ... in the Style of Jackson Pollock

A spirit of scepticism and irony looms in this painting which looks, superficially, like the work of the American Abstract Expressionist Pollock. The full title – *Joseph Stalin Gazing Enigmatically at the Body of VI Lenin as it Lies in State in Moscow in the Style of Jackson Pollock* – suggests that the bright splashes of enamel paint may represent the Russian leaders Stalin and Lenin. Art & Language have sometimes placed next to this abstract work a 'map', or grid superimposed over a drawing of Stalin looking down at Lenin. The combination of the two images questions the appearance of paintings and what they stand for. The title and 'map' impose a meaning on the image which prevents the viewer from having total control over its interpretation. This work typifies the theoretical and Conceptual approach of Art & Language – a collaboration between two artists, Michael Baldwin and Mel Ramsden, whose dual status questions individual genius.

☞ **Komar and Melamid, Mukhina, Pollock, Vautier**

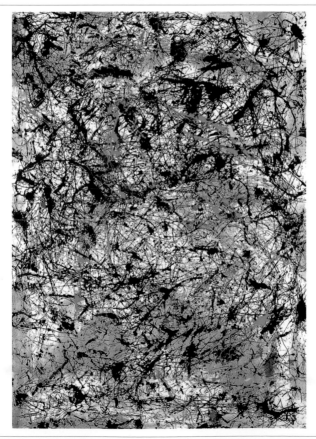

Art & Language. Michael Baldwin. **b** Chipping Norton (GB), 1945. Mel Ramsden. **b** Ilkeston (GB), 1944.
Joseph Stalin Gazing ... 1979. Oil and enamel on board. **h**177 x **w**126 cm. **h**69¾ x **w**49⅔ in. Private collection

Arp Jean

The polished surface and supple curves of this sensuous bronze evoke organic forms. The title suggests that the sculpture may be metamorphosing into a real object. By juxtaposing smooth curves with an angular protuberance, Arp gives this work sexual connotations. He once wrote that 'Art is a fruit which grows in man', and this sculpture seems to illustrate that phrase. Arp was one of the founder members of Dada, present at their first meeting at the Cabaret Voltaire in Zurich in 1916. This was a group of radical artists, who attempted to upset the art establishment by participating in experimental activities such as nonsense poetry and spontaneous drawing, known as automatism. Arp was perhaps the most abstract of these artists, experimenting early on with reliefs and collages. From 1930 he began to make sculptures based on nature, adapting the technique of automatism to the investigations of organic growth, for which he is best known.

☞ **Brancusi, Hepworth, Mondrian, O'Keeffe**

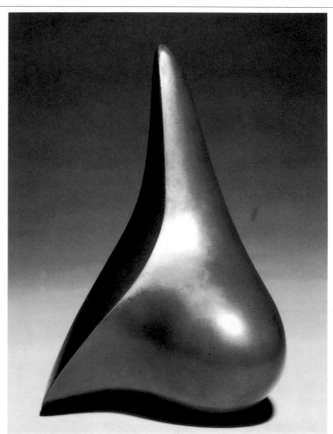

Jean (Hans) Arp. b Strasbourg (FR), 1886. **d** Basle (SW), 1966.

Metamorphosis (Shell–Swan–Balance–You). 1935. Bronze. **h**22.5 cm. **h**9⅞ in. Private collection

Arman

Crusaders

Stacks of paint brushes are attached to the canvas in almost military formation, their silver-coloured handles and black bristles forming an abstract design. The title of the work – *Crusaders* – personifies the brushes, all pointing in the same direction, as daring adventurers with a holy mission. In his work, Arman explores the beauty in gathering together a number of similar objects. Taking the Dadaist idea of the elevation of banal objects to works of art, he explores the diversity of man-made things by collecting them together in large quantities or by fragmenting and

reassembling them. Arman's assemblages of accumulated objects reflect our throwaway society, offering a fetishistic portrait of how we live and document our lives. He uses a variety of materials, including bottle tops, crank shafts, glass eyes, hypodermic needles, bullets and cigarette butts. His focus on everyday life, rather than more abstract themes, links him to the Nouveaux Réalistes.

☛ Beuys, Cragg, Duchamp, Manzoni, Rauschenberg, Spoerri

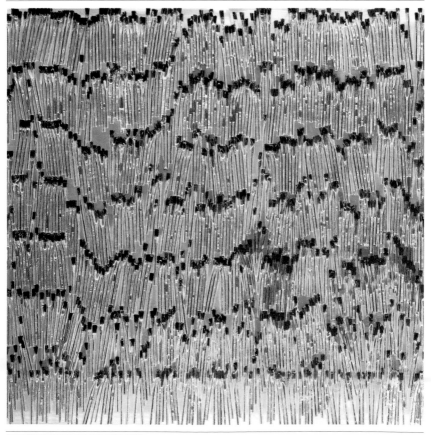

Arman (Armand Fernandez). b Nice (FR), 1928.

Crusaders. 1968. Silver glue brushes in polyester and Plexiglas. **h**122 x **w**122 cm. **h**48 x **w**48 in. Private collection

Arikha Avigdor

Sam's Spoon

The name 'Sam' is just visible, engraved on the handle of a small silver spoon. Placed on a creased white napkin, it is the focus of this intensely studied and carefully constructed painting. *Sam's Spoon* is a tribute to Arikha's friend, the celebrated writer Samuel Beckett, and was painted on the first anniversary of his death. The christening spoon is Beckett's own, which he had given to Arikha's daughter on her birth. Born in Romania, Arikha was imprisoned in a Nazi concentration camp as a child during the Second World War. He subsequently

moved to Israel, and then to Paris, where he established himself as an abstract painter. He abandoned abstract art after seeing an exhibition by the sixteenth-century Italian painter Caravaggio in 1965. He is now best known for his intimate still lifes of fruit and vegetables and everyday objects, and for his striking portraits of public figures, including the Queen Mother and the former British Prime Minister Lord Home.

☛ Caulfield, Hockney, Hopper, Morandi, Spoerri, Wyeth

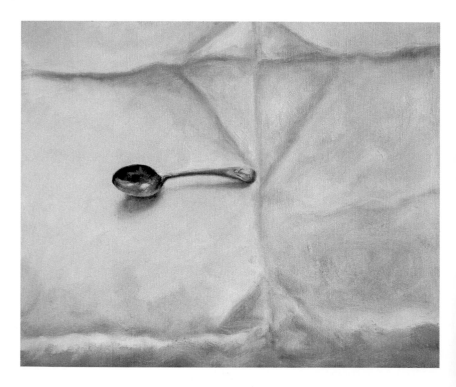

Avigdor Arikha. b Radauti (ROM), 1929.
Sam's Spoon. 1990. Oil on canvas. h38 x w46 cm. h15 x w18⅛ in. Private collection

Ayres Gillian

Hinba

A huge canvas is encrusted with paint, with accents of blue, green, white and yellow set against a warm orange ground. The massive expanse of rich colour overwhelms the viewer. The spontaneous and gestural brushstrokes owe much to Abstract Expressionism, and to the techniques of Pollock. After seeing photographs of Pollock working on his paintings on the floor, Ayres adopted a freer approach to her own working methods. Using large, unstretched canvases, she began to concentrate on the actual process of painting. Her works are often devoid of specific subject matter, but the balance of colours reflects the artist's emotions, or the feelings evoked by a particular time or place. This interest in the emotive value of colour and abstract gestures links Ayres to the Tachiste movement. Born in England, Ayres has recently travelled to India, inspired by the vivid colours of the region.

☛ Art & Language, Michaux, Pollock, Riopelle

Gillian Ayres. b London (GB), 1930.
Hinba. 1977–8. Oil on canvas. **h**213.4 x **w**304.8 cm. **h**84 x **w**120 in. Southampton City Art Gallery

Bacon Francis

Triptych – August 1972

Three male figures are each isolated in a room, their twisted, visceral forms brutally emphasized by the black doorway in the background. Violently distorted and isolated, they speak of horror, revulsion and loneliness, themes which Bacon grappled with throughout his career. In this work, Bacon carries forward the traditional format of portraiture to produce simultaneously brutal and beautiful images. His paintings of cages and empty rooms, and deformed images of dogs and men are often based on real images – either Old Master paintings, film stills or photographs from newspapers – which littered the floor and walls of his studio. A self-taught painter, Bacon defies categorization, although his nightmarish fantasies share some similarities with the works of the Surrealists. He is regarded as one of the most important post-war British artists, with a shocking and unique vision of the human form.

☛ Basquiat, Freud, Hirst, Lehmbruck, Nitsch

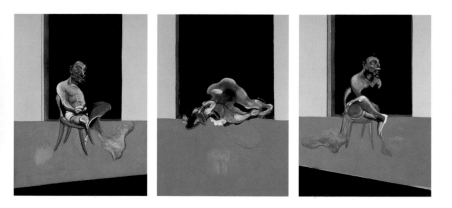

Francis Bacon. **b** Dublin (IRE), 1909. **d** Madrid (SP), 1992.

Triptych – August 1972. 1972. Oil on canvas. **h**198.1 x **w**147.3 cm. **h**78 x **w**58 in. Tate Gallery, London

Bakst Léon

A bejewelled, exotic-looking dancer stands complete with turban, breast-plate, sword and shoes with pointed toes. The tear-shaped patterns on his trousers recall the sinuous lines of the turn-of-the-century design movement, Art Nouveau, as well as evoking the fantastical element in Chagall's art around this time. (Chagall had studied for a short time at Bakst's art school in St Petersburg.) Born in St Petersburg, Bakst trained in Moscow, before returning to his home town in 1900, where he met the dancer Diaghilev. Through Diaghilev, Bakst was introduced to the world of theatre, and he began to make valuable contributions to both stage-set and costume design. He subsequently moved to Paris, and it was here, in 1909, that he began to design his most extraordinary inventions for the Russian Ballet. Some of his costumes became legendary in his own lifetime, combining, as they did, the bold colours of Russian folk art and the sophistication and splendour of Oriental art.

☛ Beckmann, Chagall, Gontcharova, Klimt

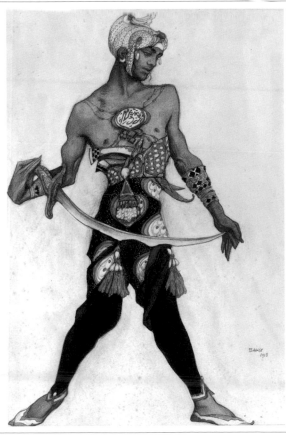

Léon Bakst. b St Petersburg (RUS), 1866. **d** Paris (FR), 1924.
Costume Design for 'Oriental Fantasy'. 1915. Gouache and pencil on paper. **h**48.3 x **w**32.4 cm. **h**19 x **w**12¾ in. Private collection

Baldessari John

Four Men (With Guns Pointed at their Heads)

Four men are tortured at gunpoint. Their faces have been blotted out by white discs, as though to protect or obliterate their identities. Above and below, banal café scenes anaesthetize the violent imagery, the plates echoing the circular disguises. This late work is typical of Baldessari's varied output: he often juxtaposed found photographs in order to analyse our understanding of film and television imagery. A playful and inquisitive thinker, Baldessari used the language of popular culture to question the whole notion of art. 'I was trying to figure out just what I thought art was', he said. This questioning often provoked witty responses. One canvas from 1966 is blank but for the message: 'EVERYTHING IS PURGED FROM THIS PAINTING BUT ART, NO IDEAS HAVE ENTERED THIS WORK.' Eventually, he turned his back on painting entirely, staging a ceremony in which all the canvases he had produced between 1953 and 1966 were burned.

☛ Burgin, Dittborn, E Kelly, Spoerri

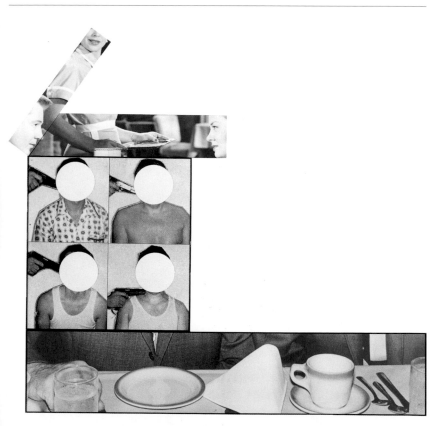

John Baldessari. **b** National City, CA (USA), 1931.
Four Men (With Guns Pointed at their Heads). 1988. Black and white and colour photographs. **h**213.5 x **w**213.5 cm. **h**84⅛ x **w**84⅛ in.
Lisson Gallery, London

Balka Miroslaw

190 x 30 x 7, 190 x 30 x 7, 50 x 42 x 1

This work is based on an abstract representation of Balka's own body in space. The dimensions in the title are taken from his own measurements – his height, weight and foot size. The carpet gives the idea of a domestic location, while the strong-smelling soap smeared on the tall steel plates suggests a ritual process of washing and cleansing. Drawing on common activities and life's daily routines, Balka brings out the quiet sense of the sacred which can be found in even the most humble existence. The work is also partly abstract, and shows Balka's debt to Minimalism, with its emphasis on pared-down forms. Much of Balka's work uses familiar everyday materials, which are transformed by the artist to produce powerful and evocative works. Often, his sculptures and installations have strong autobiographical elements, reflecting on his rejection of the Catholic faith and on his difficult childhood, growing up in Poland during the Communist regime.

☞ Andre, Bustamante, Newman, Whiteread

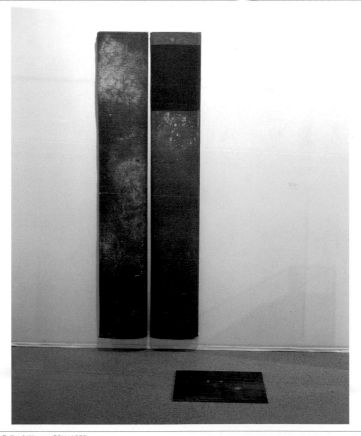

Miroslaw Balka. b Warsaw (POL), 1958.
190 x 30 x 7, 190 x 30 x 7, 50 x 42 x 1. 1993. Steel, carpet and soap. Main panels: **h**190 x **w**30 x **l**7 cm. **h**74⅞ x **w**11⅞ x **l**2¾ in.
London Projects, London

Balla Giacomo

Abstract Speed – the Car Has Passed

Huge, sweeping curves which cut across the surface of the canvas suggest the passage of a car at high speed. The white strip on the left-hand side represents the road, the green the landscape and the blue the sky. The distorted forms evoke the feeling of sitting in a vehicle and watching the world rush past the windows. Part of a triptych – a group of three paintings originally intended to hang together – this work is typical of Futurism, a movement which aimed to convey a sense of speed through art, seeing it as typifying the spirit of the modern age. Balla was one of the leaders of the Futurist movement, along with Boccioni, Carrà and Severini, signing the first Futurist manifesto in 1910. From 1931, however, he moved away from Futurism and reverted to a figurative style. Born in Turin, Balla was the son of a photographer. He started out as a lithographer before turning to painting. He also made sculptures and designed furniture and interiors.

☛ **Boccioni, Carrà, Metzinger, Severini**

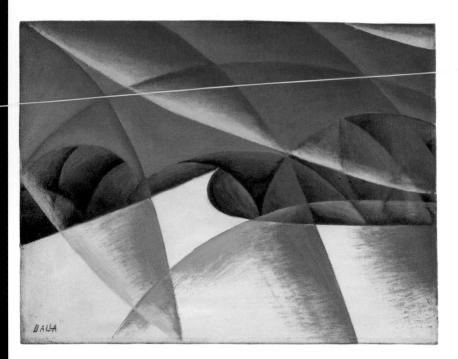

BALLA

Giacomo Balla. b Turin (IT), 1871. d Rome (IT), 1958.
Abstract Speed – the Car Has Passed. 1913. Oil on canvas. **h**50 x **w**65.5 cm. **h**19¾ x **w**25¾ in. Tate Gallery, London

Balthus

Sleeping Girl

A young girl lies suggestively before our gaze, her blouse open to the waist, revealing her chest. Her eyes are closed and her mouth is slightly open as she sleeps; she is unaware that she is the object of our attention. The dark colours and heavy shadows add to the sense of brooding eroticism. Balthus chose to work in a figurative manner at a time when avant-garde artists considered figuration to be either reactionary or a style suited to the service of politics. But the subject and mood of this work has much in common with more radical art, challenging the viewer to confront what is a forbidden or repressed area of consciousness. While the style looks back to the Old Masters, the subject is daring in its modernity and could almost be an illustration for the studies in infant sexuality of Sigmund Freud, whose ideas had an enormous impact on twentieth-century art. Born in Paris of Jewish ancestry, Balthus and his family were forced to abandon their home during both world wars. He retired in 1977 and spent the last years of his life in Switzerland.

☛ **Bonnard, Fischl, Schiele, Sickert**

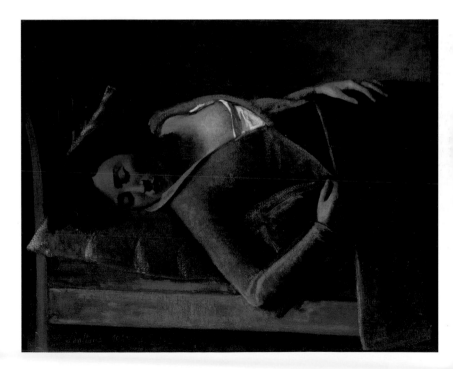

Balthus (Balthasar Klossowski de Rola). **b** Paris (FR), 1908. **d** Rossinière (SW), 2001.

Sleeping Girl. 1943. Oil on canvas. **h**79.7 x **w**98.4 cm. **h**31⅜ x **w**38¾ in. Tate Gallery, London

Barlach Ernst

The Singing Man

This monumental sculpture depicts a man singing, his head thrown back and his eyes closed in concentration. He clutches his right knee in both hands, in an attempt to balance, and seems almost to be rocking backwards and forwards in time to the music. The emotive power of this work links Barlach to the Expressionist movement, a group of artists who sought to describe their feelings, rather than represent actual objects, in their work. Their subjects often tended towards universally tragic themes and, more specifically, the horrors of the Nazi regime, under which Barlach lived. The Nazis launched a campaign of defamation against Barlach, branding him a 'degenerate artist'. Like many of the Expressionists, he was also a gifted writer, producing plays and an especially powerful series of poems in the 1920s. He was arguably at his best as a wood carver, inspired by the tradition of medieval craftsmen. He also produced a huge body of graphic work.

☞ Bourdelle, González, Kollwitz, Lehmbruck

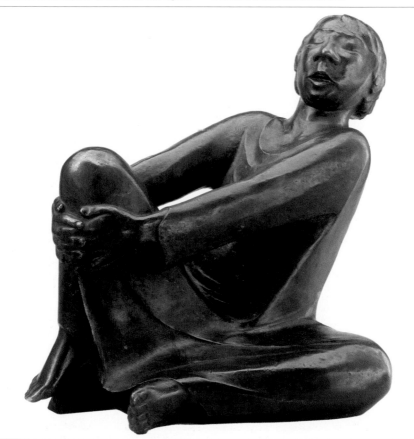

Ernst Barlach. b Wedel (GER), 1870. d Rostock (GER), 1938.
The Singing Man. 1930. Bronze. h50 cm. h19¾ in. Private collection

Barney Matthew

TRANSEXUALIS (decline)

This work is contained within the chilled space of a walk-in fridge. The central piece, resembling body-building apparatus, is fabricated from frozen petroleum jelly. On the ceiling are mountain-climbing hooks, and on the floor a pink medical body implant. To what perverse use this equipment can be put is not clear, though the hooks do suggest the idea of bondage and restraint, while the implant illustrates the possibility of bodily transformation. Superimposing elements of medical science, sport, performance art, mythology and sex, Barney creates semi-futuristic sets suggestive of mutant behaviour or bizarre sexual acts. He often climbs around his sets, attempting to make drawings in difficult positions. He records his actions on video, playing the tape back during the exhibition of props (which he calls 'docufragments'). Barney has made several films featuring satyrs, fairies, surgical instruments and a stylized form of motorcycle sidecar racing.

☛ Acconci, Benglis, Dix, C Noland, Oppenheim

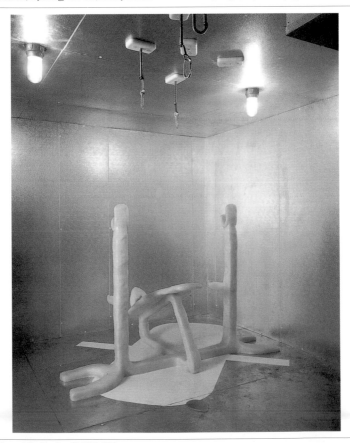

Matthew Barney. b San Francisco, CA (USA), 1967.
TRANSEXUALIS (decline). 1991. Walk-in cooler, petroleum jelly, incline bench and silicon. h2.6 x w4.2 x l3.6 m. h12 x w14 x l8'6 ft.
Private collection

Barry Judith

First and Third

The disembodied head of a woman is projected directly onto the wall of a stairwell. Although filmed in a familiar, documentary style, the figure has a haunting presence which draws the viewer in to the work. *First and Third* was made for an exhibition at the Whitney Museum of American Art in New York and was a response to Barry's perception of the museum as an exclusive institution. A kind of alternative archive project, it tells the story of those who have been excluded from official American history. After interviewing and collecting personal testimonies from a variety of people, Barry used actors to relate their different narratives. By installing her video in a non-gallery, transitional space, Barry underlines the figures' disenfranchised status. In her other video, film and slide projections, Barry looks at mass culture and explores the nature of self-identity in a media-dominated society. Each project is created specifically for the particular cultural context in which it is realized.

☞ Calle, Hatoum, Hiller, Viola

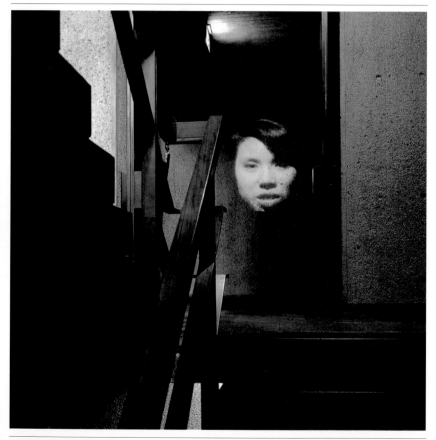

Judith Barry. b New York (USA), 1949.

First and Third. 1987. Video projection: Dimensions variable. As installed at the Whitney Museum of American Art, New York

Bartlett Jennifer

Yellow and Black Boats

Two real boats are set in front of a painting of boats moored on a beach. By placing the same objects depicted in the painting in the real space of the gallery, Bartlett expands the two-dimensional limits of the painted canvas in this installation. The manner and process by which objects are represented holds a central importance in Bartlett's work. The imagery itself is simply a means of exploring and discovering new ways of depicting a given scene through the medium of art. Born in California, Bartlett studied at Yale School of Art and Architecture with Dine and Rosenquist. She employs an unusually large range of materials to create her elaborate, representational works. Pencil, pen and ink, oil, pastel, gouache, mirrors, collage and silk-screens may all be used in a single installation. Bartlett applied this approach to full effect in *The Garden*, her study of a French villa garden, for which she produced over 200 works on paper.

☞ **Brossa, Bustamante, Dine, Heckel, Rosenquist, Wallis**

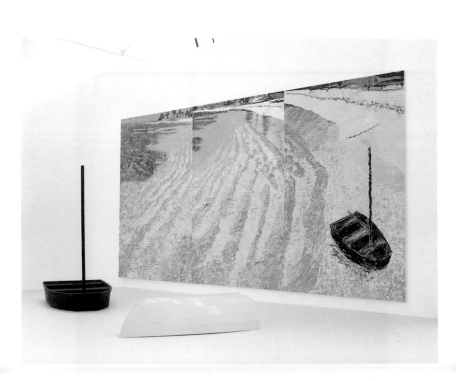

Jennifer Bartlett. b Long Beach, CA (USA), 1941.
Yellow and Black Boats. 1985. Oil on canvas and painted wooden boats. Canvas: **h**3 x **w**5.9 m. **h**10 x **w**19'6 ft.
Naoshima Museum, Naoshima

Baselitz Georg

The Gleaner

The contrived violence of the brushstrokes threatens to overwhelm the image of a figure bent double, gleaning corn. In a dramatic gesture, Baselitz has turned the canvas upside-down, attempting to distort or fragment the figurative element in his work. By devaluing the subject in such a way, the question of abstract versus figurative becomes irrelevant. Since 1965, when the Public Prosecutor confiscated two paintings from his first exhibition in Berlin, Baselitz has courted controversy. His famed refusal to discuss or explain his prolific output of paintings, drawings, and sculptures hacked by a chain saw from tree-trunks, has won as many adversaries as admirers. The anti-intellectualism of his ferocious brushwork, and his Neo-Expressionist style, has been viewed as a reaction to the elegance of American Minimalism. Baselitz's 1985 manifesto, *Painters' Equipment* sheds little light on his motives. With typical aplomb, he states, 'There is nothing I can say about my pictures. I paint, which is far from easy, and that's all I can do.'

☛ **Basquiat, Guston, Kiefer, Penck**

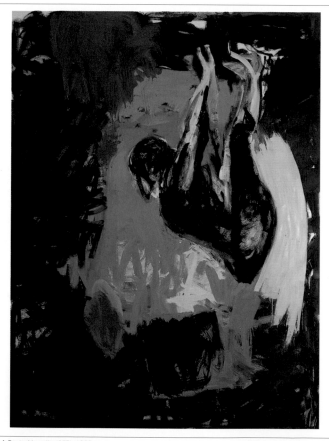

Georg Baselitz. **b** Deutschbaselitz (GER), 1938.
The Gleaner. 1978. Oil and tempera on canvas. **h**330 x **w**250 cm. **h**130 x **w**98½ in. Solomon R Guggenheim Museum, New York

Basquiat Jean-Michel

Zydeco

A man with an accordion stands in the middle of this triptych. The microphone and the word 'Zydeco', repeated three times in the central panel, reinforce the musical theme – Zydeco is the name given to a form of Cajun music. The work has an immediate and vital energy. The outlines of objects and silhouettes of figures are speedily drawn with a wax crayon, and then partially filled with bright yellow and red. Paint is allowed to drip down, and areas are quickly worked over and rubbed out. Drawing on his background as a graffiti artist in New York,

Basquiat plays ironically on notions of 'primitive' art in order to question stereotypes of black artists. He often painted directly onto walls, doors, furniture and other objects as well as canvases, building up a complex lexicon of words, signs and images that tell of a fragmented and chaotic world. He reached fame and fortune almost overnight, and collaborated with major artists such as Warhol and Clemente before his untimely death at the age of 28.

☞ Bacon, Clemente, Hammons, Lawrence, Warhol

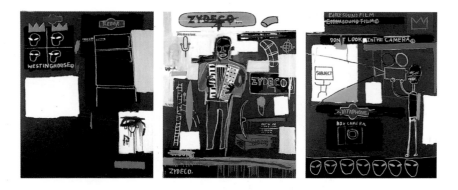

Jean-Michel Basquiat. b New York (USA), 1960. **d** New York (USA), 1988.

Zydeco. 1984. Wax crayon, acrylic and oil on canvas. **h**219 x **w**518 cm. **h**86 x **w**204 in. Private collection

Baumeister Willi

Eidos

Soft, nebulous forms in pinks and mauves occupy a landscape-like territory. The work exudes a spiritual calm. Hovering between abstraction and a kind of hieroglyphic notation this painting suggests an inner state without being dependent on a rigid interpretation. 'Eidos' means, in Greek, a visual image of a mental state, and in this work, Baumeister aims to depict in paint an undefined mood. He believed that the untrammelled imagination could produce forms reflecting the deep, primitive roots of the human psyche. Baumeister helped found and was involved with several groups of artists; the most significant was the Paris-based Abstraction-Création movement, a group of abstract artists. Baumeister's style continually evolved and developed in his search for an abstract visual language that would depict psychological reality. At the time he made this work he was being persecuted by the Nazis, although, unlike many other so-called 'degenerate' artists, Baumeister remained in Germany.

☛ Ayres, Gottlieb, Kandinsky, Miró

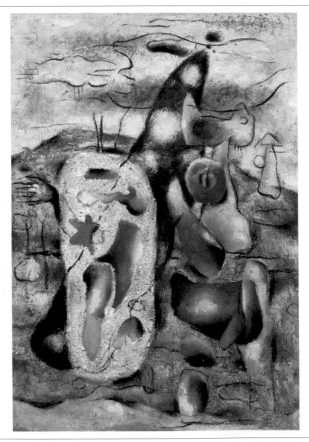

Willi Baumeister. **b** Stuttgart (GER), 1889. **d** Stuttgart (GER), 1955.
Eidos. 1940. Oil on canvas. **h**64.7 x **w**46.7 cm. **h**25½ x **w**18⅜ in. Museum Folkwang, Essen

Baumgarten Lothar

Culture-Nature

As if by accident, a delicate feather has been found hidden under the floorboards of the artist's studio; it shines out like a red light from the darkness. The feather, a symbol of nature, is juxtaposed with the man-made floorboards, a symbol of culture, but which were once wild and growing in a rainforest. This image was first shown as one of eighty-one slides projected by Baumgarten in a work called *A Voyage with Ms Remscheid on the Amazon: the account of a voyage under the stars of the refrigerator.* This title suggests exploration: the slides were images from anthropological books or mysterious objects, found out of context, like this one. The act of uncovering the feather is a poetic evocation of the very act of geographical discovery. Conceived at a time when the idea or concept behind a work of art was as important as the work itself, the physical act of placing the feather in the floorboards could be considered as the actual artwork.

☞ Goldsworthy, Horn, Long, G Orozco

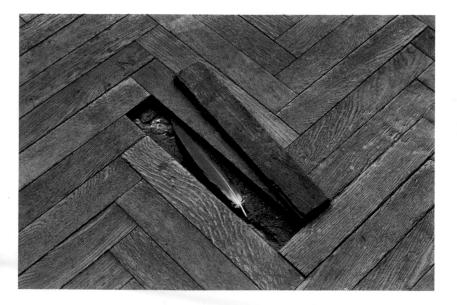

Lothar Baumgarten. **b** Rheinsberg (GER), 1944.

Culture-Nature. 1971. Colour print of arara feather and hardwood floor. **h**47 x **w**60 cm. **h**18½ x **w**23⅔ in. Private collection

35

Becher Bernd and Hilla

Industrial Façades

The standardized format of these black and white photographs allows for concentrated comparison. Each of the six industrial buildings has been photographed from the same position, and each façade is based on a similar design. But, despite the fact that this architecture has no grand civic or religious function, each elevation has its own unique character. These exquisite photographs are both elegies to a changing industrial landscape and a cool critique of the design history which has altered it. The Bechers are a husband and wife team who use photography to make art which is chillingly anonymous. Their subjects – water towers, pitheads and warehouses – are as much landmarks as public buildings, the kind of architecture rarely committed to memory. In the Bechers's hands, the role of artist becomes that of documentor. Travelling the world they collate, sometimes over decades, the visual information needed for a work. Their cerebral approach has led to their somewhat awkward categorization as Conceptualists.

☛ Haacke, Graham, Matta-Clark, Mucha, Struth

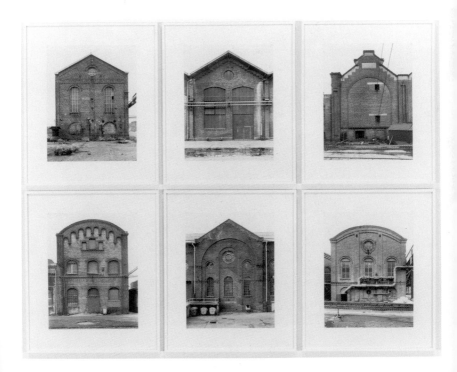

Bernd and Hilla Becher. Bernd Becher. **b** Siegen (GER), 1931. Hilla Becher. **b** Berlin (GER), 1934.
Industrial Façades. 1975–95. Six photographs. **h**114.3 x **w**142.9 cm. **h**45 x **w**56¼ in. Sonnabend Gallery, New York

Beckmann Max

Performers

Two members of a circus troupe gaze out of the canvas. The goddess-like snake-charmer, stately and exotic, emanates a hypnotic calm, while the stoic, suffering face of the clown contrasts poignantly with his comically small homburg hat. The brutal black outlines and stark colours are typical of Beckmann's style. Circus performers were a popular subject among late-nineteenth and early twentieth-century artists: they were used to represent the idea of sadness behind a mask – outward appearance versus inner reality. Early on in his career, Beckmann was associated with the German Expressionist movement, a group of artists whose work evokes emotion, rather than simply representing a particular subject. Beckmann's work continued to focus on dramatic imagery which often expressed a deep sense of anxiety. His subjects were sometimes taken from Classical mythology and his style was derived partly from Medieval art.

☛ Kirchner, Léger, Macke, Pechstein, Picasso, Rouault

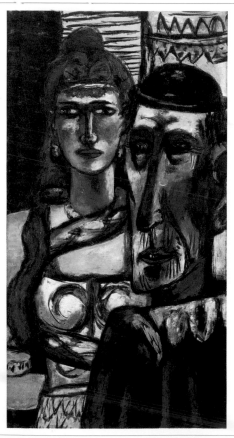

Max Beckmann. b Leipzig (GER), 1884. **d** New York (USA), 1950.
Performers. 1948. Oil on canvas. **h**165 x **w**88.5 cm. **h**65 x **w**34⅞ in. Private collection

Bellmer Hans

A Thousand Girls

The shape of a woman emerges from a mass of limbs and organic forms resembling fruit and vegetables. Her hair is piled up on top of her head, and seems to be composed of pears and pumpkins. The whole arrangement appears to be in danger of toppling over, but it is pinned in place by the scaffolding-like structure in the background. The original French title is *Mille Filles*, which translates literally as *A Thousand Girls*, but it may also be a pun on the famous French cake, *mille-feuille*, which is made up of many layers of pastry. The work makes a clear allusion to the bizarre paintings of the sixteenth-century Italian artist Giuseppe Arcimboldo, who composed paintings of human anatomy out of organic matter such as vegetables and fruit. Fascinated by the work of the Surrealists, Bellmer moved from his native Poland to Paris in 1938 where he became a leading figure in the group. He is best known for his disturbing, erotically charged constructions made out of the disembodied parts of children's dolls.

☞ **Balthus, Bonnard, Dalí, Delvaux, Morimura**

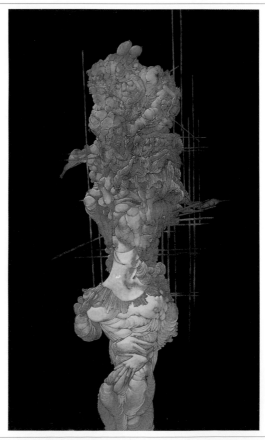

Hans Bellmer. **b** Katowice (POL), 1902. **d** Paris (FR), 1975.
A Thousand Girls. 1939. Oil on board. **h**48.5 x **w**30 cm. **h**19⅛ x **w**11¾ in. Private collection

Bellows George Wesley

Club Night

A boxer reels back after receiving a crippling blow from his opponent. The crowd of onlookers presses forward round the ring to get a better look. The bold, broad strokes of monochromatic paint, and the dramatic lighting, conjure up the excitement and tension of the boxing ring. A couple of years after painting this work, Bellows went on to depict illegal boxing matches in yet more sinister paintings. He studied art in New York, and became closely associated with The Eight, a group of painters who joined together to argue for the importance of representing contemporary urban life, a genre rejected by the National Academy of Design in New York. He was found to be gifted at sport while attending Ohio State University and might have become a professional baseball player had he not chosen to become a painter. He is also known for his compassionate portraits which provide a strong contrast to his scenes of American sport and street life.

☛ Benton, Hopper, Komar and Melamid, Wallinger

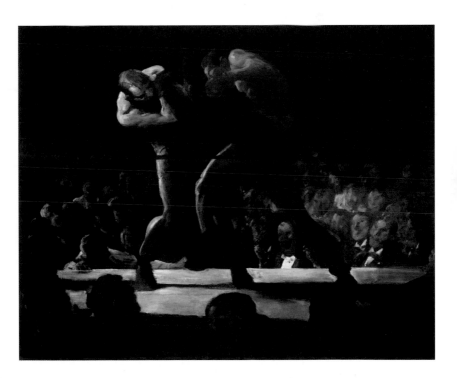

George Wesley Bellows. b Columbus, OH (USA), 1882. d New York (USA), 1925.
Club Night. 1907. Oil on canvas. **h**109 x **w**135 cm. **h**43 x **w**53⅛ in. National Gallery of Art, Washington, DC

Benglis Lynda

For Darkness: Situation and Circumstance

There is an element of kitsch drama in these colossal, poured polyurethane forms that protrude from the wall. After dark, theatricality is amplified, when phosphorescent pigment in the surfaces reacts with the artificial lights in the gallery, providing an eerie ambience. Like glowing minerals from the set of a B-movie horror film, the biomorphic shapes cast haunting, yet slightly comic shadows. The quest to capture the overwhelming sense of grandeur in the natural world has fuelled artists for centuries. By pleating, folding and pouring materials,

Benglis celebrates the flow of nature and the pull of gravity, presenting forms that appear to be in a state of flux. Her rigorous approach to the various processes of making sculpture is indicative of Post-Minimalist tendencies of the time. In the mid-1970s, Benglis was linked to the feminist movement, making provocative videos on the theme of female sexuality.

☛ Bourgeois, Christo, Hesse, Iglesias

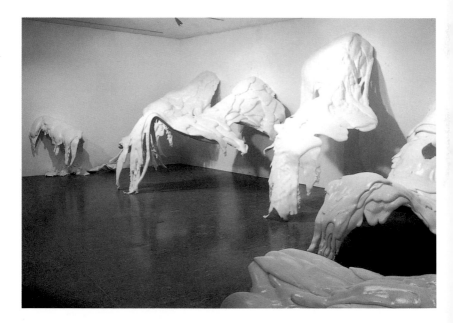

Lynda Benglis. b Lake Charles, LA (USA), 1941.
For Darkness: Situation and Circumstance. 1971. Phosphorescent polyurethane. h3.1 x w10.4 x l7.6 m. h10'2 x w34 x l25 ft.
As installed at Milwaukee Art Center, WI

Benton Thomas Hart

City Activities with Subway

Dancing girls, performers, boxers, subway travellers and a kissing couple are painted in rich colours in this realist wall-painting. These separate scenes are pieced together to form a broad picture of the chaotic experience of city life. Benton was one of America's most prolific muralists. This one was part of a series entitled 'America Today' and was made for the New School for Social Research in New York. Benton was born in Missouri and began his career as a cartoonist. Like other left-wing artists in the 1930s, he rejected abstraction, preferring instead to

work in a figurative style, conveying clearer meaning to ordinary people. Eventually tiring of life in New York, Benton returned to Missouri in 1935 and became the leader of a group of artists known as the Regionalists. They addressed the particular concerns of the people of rural, mid-western America – their pastimes, entertainments and daily lives.

☛ **Bellows, Grosz, Hopper, Immendorff**

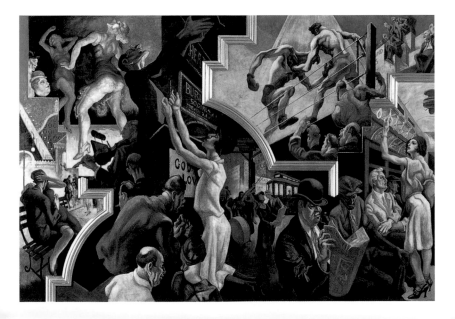

Thomas Hart Benton. b 1889 and **d** 1975, Missouri, MI (USA).
City Activities with Subway. 1930. Tempera on linen. **h**2.3 x **w**3.4 m. **h**92 x **w**134½ in. Equitable Life Assurance Society of the United States, New York

Beuys Joseph

Barraque d'Dull Odde

Fenced off from the viewer, this work resembles a restricted zone or workshop. Characteristically, Beuys incorporates in this installation non-art items – a desk, a chair and shelves stacked with bottles and scientific equipment – all of which have had previous lives and uses. Among them are the fat-covered vessels and layers of felt for which he is best known. According to the artist, in 1943, when his Luftwaffe aeroplane crashed on the Russian front, Tartar tribesmen saved his life, covering him with fat and felt to keep him warm. These materials

became constant emblems of healing and nurture in his work. Beuys is remembered as a priest-like figure, his performances (for which he always wore his trademark fedora hat) taking on the character of ritual and his work imbued with spiritual meaning. Occupying a key role in post-war art, Beuys was one of the great personalities of twentieth-century art, whose work had a significant influence on subsequent artists.

☛ Bhimji, Broodthaers, Green, Steinbach

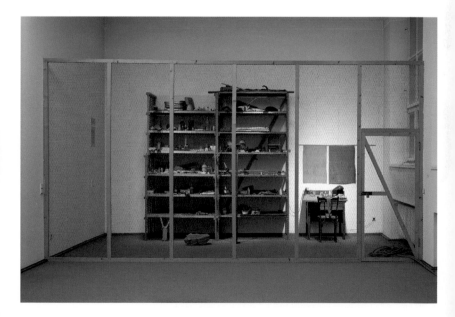

Joseph Beuys. b Krefeld (GER), 1921. d Düsseldorf (GER), 1986.
Barraque d'Dull Odde. 1961–7. Mixed media. h290 x w400 x l90 cm. h114¼ x w157⅔ x l35½ in. Kaiser Wilhelm Museum, Krefeld

Bhimji Zarina

1822 – Now

In this installation, inexpensive metal shelving is stacked at random with black and white photographic portraits on the left, and colour ones on the right, suggesting the insensitivity with which institutions archive their members. Like a graveyard of lost identities and shattered lives, this work illustrates the trauma and humiliation of everyday dealings with bureaucracy. The title is significant: 1822 was the birthdate of Francis Galton, founder of the now disreputable 'science' of eugenics, which was loosely connected to Darwin's theory of evolution and which saw the physical differences of non-white peoples as signs of racial inferiority. For this piece the artist photographed over 200 people, working like a scientist to dispel any assumptions about stereo-types of physical appearance. Non-Western cultures have been increasingly prominent in art since the 1980s, and Bhimji has avoided traditional materials and techniques, such as painting and sculpture, to create this very moving 'wall of faces'.

☛ Beuys, Boltanski, Darboven, Dittborn, Kiefer

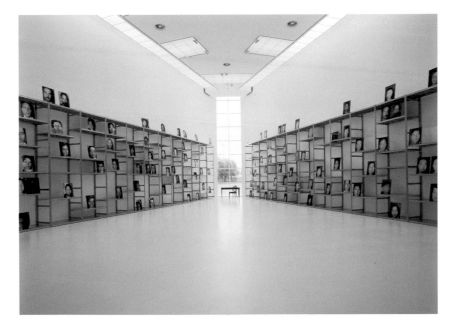

Zarina Bhimji. b Mbarara (UG), 1963.
1822 – Now. 1993. Colour and black and white photographs on library shelving. Photographs: **h**50 x **w**40 cm. **h**19¾ x **w**15¾ in.
Collection of the artist

Bickerton Ashley

Le Art (Composition with Logos 2)

Though this work has been hand-crafted, it has the appearance of an industrially designed object. Each of the different materials used to make the work is represented by the logo of its manufacturing company, as though Bickerton were crediting commercial sponsors. The artist's own signature is also made to look like a trademark, thus taking on the same value as a brand name. This ironic statement on the use of art as a commodity is reflected in Bickerton's wording of the painting's date: 'Season 86–87', which emphasizes

the status of the artwork as a fashionable piece of merchandise, produced for the stylistic demands of that year's art market. But the artist is also paying homage to the sophisticated aesthetics of commercial design, indicating through the work's title that he sees this area of culture as art in its own right. Bickerton was part of a group of artists working in New York in the 1980s who were concerned with the visual language of advertising, the media and consumer society.

☛ Kruger, McCollum, Mullican, Steinbach

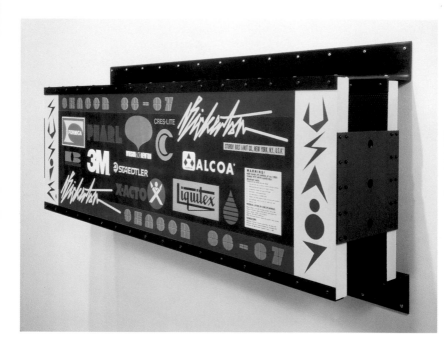

Ashley Bickerton. b Bridgetown (BAR), 1959.
Le Art (Composition with Logos 2). 1987. Silkscreen and acrylic with lacquer on plywood with aluminium.
h87.6 x **w**183 x l38 cm. **h**34½ x **w**72 x l15 in. Private collection

Bill Max

A grid of interlocking rectangles and squares, both vertical and horizontal in format, exudes a sense of rhythmic equilibrium. The artist uses a range of colours and sizes to set up a subtle, spatial dynamism between the shapes, with some colours and forms appearing to be closer to the viewer while others recede. Inspired by the work of Kandinsky, Mondrian and the De Stijl group of artists, who limited their palette to the primary colours and their forms to lines and right-angles, Bill referred to his work as 'concrete' rather than 'abstract'. In other words, he was not concerned with representing some element from nature in abstract form, but rather with creating works which have a life of their own. For Bill, this 'concrete art' was an art of geometric shapes and flat colours. He was particularly influenced by the rigorous logic of mathematics. The desire to emphasize the concrete nature of art led Bill to produce both wall-based and freestanding three-dimensional works.

☛ Van Doesburg, Kandinsky, Lissitzky, Mondrian, Nicholson

Birch Willie

Sister

A traditional, Western form of sculpture – a bust on a pedestal – has been adopted for this non-Western figure. Using inexpensive, ordinary materials and festive colours, the artist pays homage to black womanhood with this proud, goddess-like effigy. She may actually be the artist's sister, but above all she embodies sisterhood within a close-knit community, combining a modern-day aesthetic with her ethnic heritage. The surface of this altar-like object is covered with found materials, harking back to African tradition. The nails protruding from the base, for example, relate to an African custom which believes that they imbue the object with spiritual power. Much of Birch's sculpture relates to his ancestors, the members of his family and his local community, at times narrating his own involvement in the American civil rights movement. His work examines the relationship between personal history and the historical and cultural context from which it develops.

☞ Agar, Durham, Nhlengethwa, A Piper

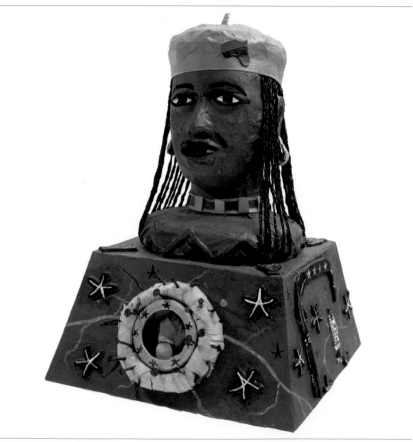

Willie Birch. **b** New Orleans, LA (USA), 1942.
Sister. 1991. Acrylic on papier mâché with found objects. **h**61 cm. **h**24 in. Private collection

Blake Peter

Girlie Door

A fake door, painted bright red, is covered with pin-ups of girls, taken from the pages of magazines, giving the impression that this is a fragment from a personal collection. It seems to be a tribute to the cult of the star, and the British obsession with collecting ephemera and souvenirs. The inclusion of elements from everyday life, such as magazines, links Blake to the Pop Art movement, which revolutionized art in the late 1950s by celebrating popular culture. Although his graphic style, and his references to consumer goods such as toys, postcards and records are typical of Pop, Blake's nostalgia is at odds with the movement's celebration of new technology. Blake started his artistic career at a young age, going to art college when he was only 14. His most notable early work was a series of naturalistic portraits of boys and girls wearing badges or reading comics. His later collages included photographs of famous actors and other elements borrowed from popular culture.

☛ **Duchamp, Hamilton, Paolozzi, Rosenquist, Rotella**

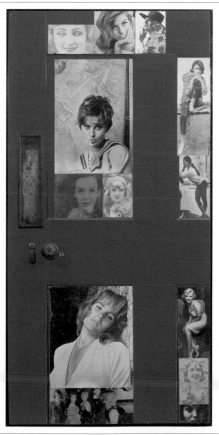

Peter Blake. **b** Dartford (GB), 1932.
Girlie Door. 1959. Collage and objects on hardboard. **h**121.9 x **w**59.1 cm. **h**48 x **w**23¾ in. Private collection

Bleckner Ross

Cage

This work is made up of a series of visually disorientating stripes – pulsating bands of light, emerging from the darkness of deep space. The title of the work and the small birds – symbols of beauty and freedom – which flit and perch among them, imply that they are the bars of a cage. The dazzling stripes hark back to the Op Art movement of the mid-1960s, which experimented with optical illusion. Bleckner's paintings have an intense, atmospheric quality, transcending the ordinary to achieve a spiritual, often romantic state of charged reverie.

In much of his work there is a continuing conflict between light and dark, and life and death. Funereal imagery, such as wreaths, flowers and urns are used to symbolize earthly mortality and remembrance. Bleckner has been profoundly affected by the impact of AIDS on his New York milieu, and has made a series of commemorative paintings, some of which are inscribed with the official death count from AIDS on the day the painting was finished.

☛ Dion, Espaliú, Martin, Riley, Vasarely

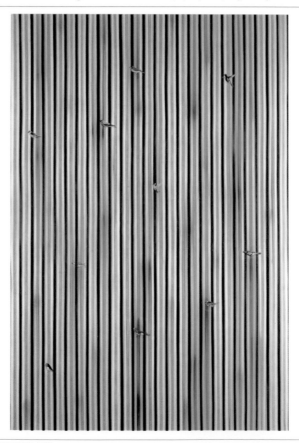

Ross Bleckner. b New York (USA), 1949.
Cage. 1986. Oil on canvas. h274.3 x w182.9 cm. h108 x w72 in. Private collection

Boccioni **Umberto**

Straddling two plinths, this extraordinary bronze sculpture looks like a figure striding forward. The rounded and angular elements which make up this work resemble growing plant and animal forms, but at the same time they also evoke the shapes and movement of machinery. The dynamic sense of power and movement embodies the concepts of Futurism, which had hitherto only been expressed in paint. Boccioni signed the Futurist Manifesto in 1910, along with Balla, Carrà and Severini. He had only taken up sculpture the year before, in an attempt to develop Futurist ideas in three-dimensional art. He wrote of his work: 'What we want to do is to show the living object in its dynamic growth...all subjects previously used must be swept aside in order to express our whirling life of steel, of pride, of fever and of speed.' His brilliantly inventive career was cut short at the age of 34 when he was killed in the First World War.

☞ **Balla, Borofsky, Carrà, Metzinger, Severini**

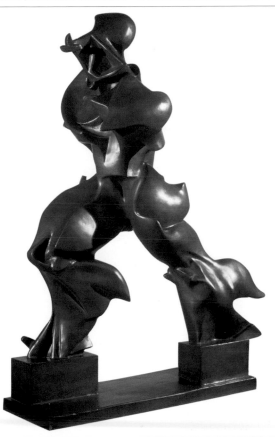

Umberto Boccioni. **b** Reggio Calabria (IT), 1882. **d** Sorte (IT), 1916.
Unique Forms of Continuity in Space. 1913. Bronze. **h**114 cm. **h**44⅞ in. Tate Gallery, London

Boetti Alighiero E

The Map of the World

'One of the most outstanding errors of our culture is the division of the uniqueness and globality of the world into rigid classifications,' stated Boetti. In this decorative embroidery, every nation of the world has been represented in both its geographical form and by the design of its flag. While illustrating the richness of culture through the complex combination of colours and patterns, the artist also comments on the absurdity of the demarcation of territory. Boetti's diverse *œuvre* spans painting and sculpture and incorporates kilim rugs,

Body Art (where the artist's own body is the medium) and Mail Art, disseminated via the postal system. Boetti hoarded information contained in charts and maps of all kinds and often presented data in an anonymous form, leaving interpretation to the viewer. One of the protagonists of Arte Povera – a movement which experimented with everyday materials not normally associated with art – Boetti has been profoundly influential on subsequent generations of artists.

☞ Brossa, Fabro, Green, Trockel

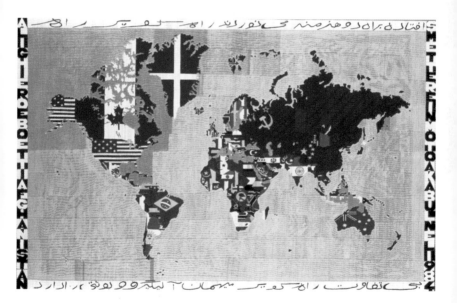

Alighiero E Boetti. b Turin (IT), 1940. **d** Rome (IT), 1994.
The Map of the World. 1971. Embroidery. **h**150 x **w**200 cm. **h**59⅛ x **w**78⅞ in. Galleria Franz Paludetto, Turin

Boltanski Christian

Reliquary

The grainy, blurred, black and white photographs of *Reliquary* are blow-ups taken from a 1939 group portrait of Jewish children posing in costume for Purim, the festival celebrating the narrow escape of Jews from mass execution. Innocent children's faces have become like corpses with empty black sockets for eyes. Installed in semi-darkness, the piece is illuminated only by small incandescent bulbs that cast soft haloes of light. Framed in coffin-like metal drawers and supported on rusty old biscuit tins, the photographs become a poignant archive, indirectly memorializing the dead. Boltanski's photographic sculptures are powerful evocations of haunting memory, loss and death. He has also created archives of obituaries and news clippings of murders and accidents. His series of installations in which the gallery walls and floors are covered with thousands of second-hand items of clothing are elegiac allusions to the mountains of garments left behind by the Holocaust victims of Nazi death camps.

☛ Andre, Bhimji, Collins, Kiefer, Kounellis

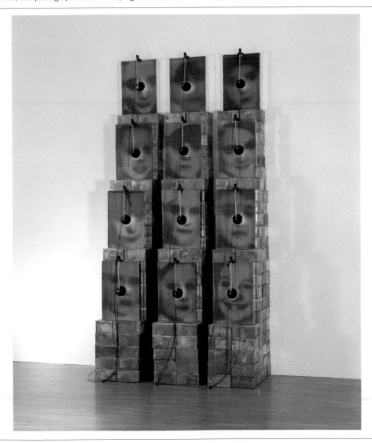

Christian Boltanski. b Paris (FR), 1944.

Reliquary. 1990. Photographs, metal drawers, boxes, wires and lamps. **h**276 x **w**158 x **l**92 cm. **h**108¾ x **w**62¼ x **l**36¼ in.

IFEMA Collection, Madrid

Bomberg David

Vision of Ezekiel

The interlocking figures in this Bible scene have been rendered geometrically, their bodies and heads squared off into flat planes. Ezekiel prophesied that Jerusalem would fall and that the temple would be overrun, and here Bomberg shows the Jews locked in combat with the forces of Nebuchadnezzar. The simplification of form to its geometric essentials, and the lack of realistic modelling reveal the influence of Cubism. But the lilacs and pinks and the sense of movement also have close affiliations with Matisse's paintings. Like all of Bomberg's work of the period, this painting is a response to the modern urban environment, with its emphasis on movement and chaos. For this reason, Bomberg is often associated with Vorticism, a revolutionary British movement which shared Cubism's tendency towards abstraction, and Futurism's interest in movement. The critic, Roger Fry, said that 'he is evidently trying with immense energy to realize a new kind of plasticity in art.'

☛ **Boccioni, Immendorff, Lewis, Matisse, Picasso**

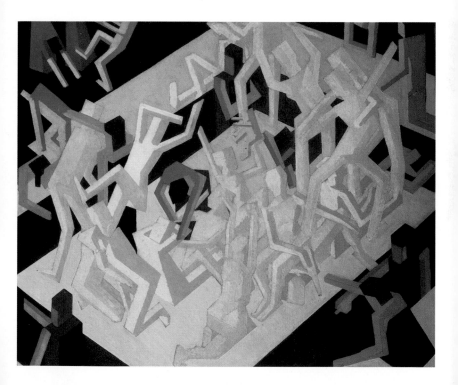

David Bomberg. **b** Birmingham (GB), 1890. **d** London (GB), 1957.
Vision of Ezekiel. 1912. Oil on canvas. **h**114.3 x **w**137.2 cm. **h**45 x **w**54 in. Tate Gallery, London

Bonnard Pierre

Nude against Daylight

The artist's wife, Marthe, sprays herself with perfume after her bath. The light flooding through the window picks up the pattern on the sofa and the rug, and highlights the form of her body. Slightly neurotic, Marthe had an obsession with washing, and Bonnard often painted her in the bath. The viewer is placed in the position of voyeur, watching this intimate, domestic scene. The mosaic-like patchwork of colour, and the expressive handling of paint are typical of Bonnard, while the interest in capturing the effect of light links him to the

Impressionists. Also evident here is Bonnard's interest in unexpected angles and aerial perspective, influenced by Japanese prints. The emphasis on textiles and furnishings links Bonnard to Vuillard and the Nabis, a group of artists who deliberately distorted colour and composition for decorative effect. In the last decades of his life, Bonnard retired to Le Bosquet in the South of France where he developed his radiant visions of the Midi

☞ López García, Maillol, Popova, Sickert, Vuillard

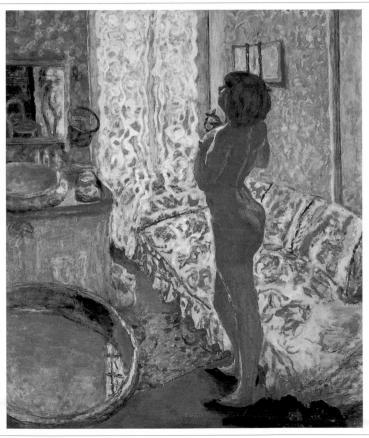

Pierre Bonnard. b Fontenay-aux-Roses (FR), 1867. **d** Le Cannet (FR), 1947.

Nude against Daylight. 1908. Oil on canvas. **h**124.5 x **w**108 cm. **h**49 x **w**42½ in. Musées Royaux des Beaux-Arts de Belgique, Brussels

Borofsky Jonathan

Hammering Men

The giant, black silhouetted figures reach high up to the gallery ceiling, filling the space with a majestic aura. Each one has a motorized arm which rhythmically strikes a hammer down onto a shoe, acting out the idea of the artist working with his hands. This work refers both to the nobility of labour and to the hardship of exploited, underpaid workers, while the monotonous repetition of the moving arm suggests the fate of a mechanized world. The papers strewn around the floor are photocopies of an original notice against littering. The artist used the leaflets to create a windswept appearance, bringing part of the city into the gallery. Borofsky always numbers his works, and here the digits appear on the foot of the figure in the foreground. These numbers symbolize the rational side of Borofsky's work, counteracting the other, more lyrical, elements in his installations. Borofsky's powerful and expressive form of art directly engages with the viewer by commenting on important social issues.

☞ Boccioni, Caro, Tinguely, Woodrow

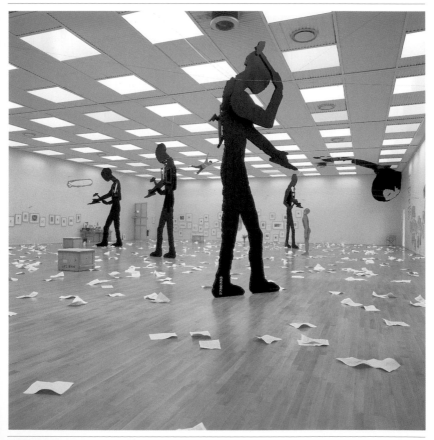

Jonathan Borofsky. b Boston, MA (USA), 1942.
Hammering Men. 1984. Acrylic on wood, aluminium, steel with motor. Each figure: **h**4.3 m. **h**14 ft.
As installed at the Moderna Museet, Stockholm

Botero Fernando

Sunday Afternoon

A family with inflated heads and rotund bodies enjoys a traditional Sunday afternoon picnic. The father reclines with a cigarette, the decadently coiffed mother tends two bulbous children, while the son, decked out in his sailor suit, stands guard behind. The cramped composition, with the trees cut off by the edge of the frame, accentuates the size of the figures. Botero's use of grotesquely swollen figures may also be an attempt to criticize the rituals of the colonial bourgeoisie. Here the family is made to look degenerate in their bland setting. Botero successfully draws from Western artistic traditions, using works by Old Masters such as Francisco Goya, Diego Velázquez and Piero della Francesca, and fusing them with contemporary Colombian culture. His self-consciously naïve style heightens the uneasy balance between humour and social criticism, art and politics. He has also made sculptures, including a series of monumental female nudes.

☛ Moore, Rivera, Rousseau, De Saint Phalle

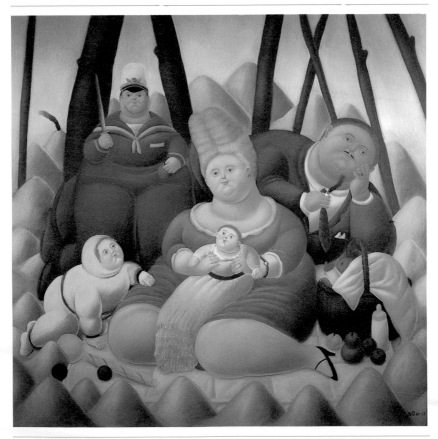

Fernando Botero. b Medellín (COL), 1932.
Sunday Afternoon. 1967. Oil on canvas. h175 x w175 cm. h69 x w69 in. Private collection

Bourdelle Antoine

Crouching Bather

A naked woman crouches on a rock, trying to cover herself up with a swathe of drapery. The undulating curves of her body, her elaborately patterned hair and the naturalistic appearance of the rock are reminiscent of sculpture from a much earlier age. Given that this work was produced at the same time that Cézanne was taking the first steps towards abstraction, it is evident that Bourdelle remained relatively unimpressed by the avant-garde movements at the turn of the century. His style remained rooted in the figurative tradition, and his sensibility in romantic subjects. This was reflected by his many representations of Beethoven, whose powerful, passionate works he admired. Bourdelle was especially influenced by the work of Rodin, whose methods he had the opportunity to observe at first hand when he moved into his Paris studio as his assistant. Bourdelle was also a painter, ceramicist and teacher. One of his more famous pupils was Giacometti.

☛ **Barlach, Cézanne, Giacometti, Lehmbruck, Rodin**

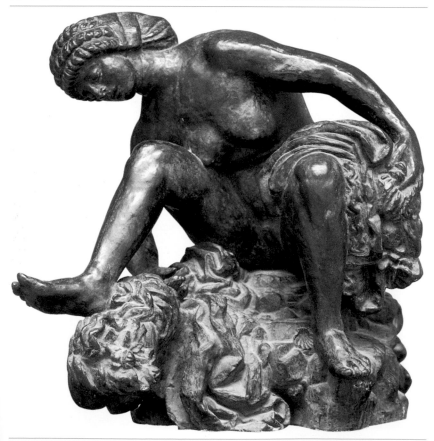

Antoine Bourdelle. **b** Montauban (FR), 1861. **d** Le Vésinet (FR), 1929.
Crouching Bather. 1906–7. Bronze. **h**52 cm. **h**20½ in. Musée Bourdelle, Paris

Bourgeois Louise Cell III

Taps fixed to a door, a poised guillotine, a slab of marble sprouting a leg and a foot clenched in pain make up this installation, which seems to reflect fragments from a dream. Reflected in the mirror, the viewer also becomes trapped in this nightmare of incarceration. This installation is one of the artist's many, highly personal dream-chambers. Bourgeois' work defies categorization, ranging from small-scale, fetish-like sculptures to prints and drawings, and room-sized installations. Filled with menace, tenderness, humour and despair, her works evoke terrifying psycho-sexual dramas pervaded by fear and insecurity. The irrational juxtaposition of objects is rooted in the Surrealist movement of Paris, where Bourgeois studied before moving to America. Her powerful and original vision has evolved over five decades, though she has only been fully recognized late in life. With her pioneering use of materials such as latex and plaster, she has had a great influence on subsequent generations of artists.

☞ Bacon, Benglis, Hesse, Oppenheim

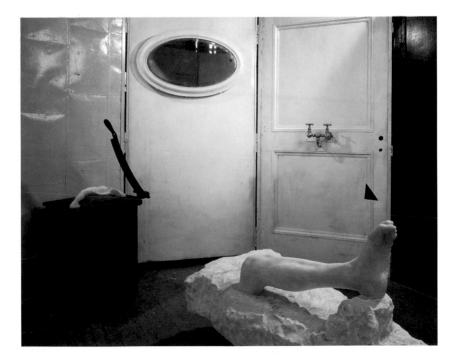

Louise Bourgeois. b Paris (FR), 1911.
Cell III. 1991. Mixed media. h281.9 x w331.4 x l419.4 cm. h111 x w130½ x l165⅛ in. Ydessa Hendeles Art Foundation, Toronto

Boyce Sonia

Untitled (Kiss)

In this photograph, black womanhood is asserted alongside white malehood in a perfectly ordinary kiss between an attractive young man and woman. Why should it be shocking or surprising merely because they belong to different races? A native Londoner of Caribbean descent, Boyce contrasts the experiences of a black woman with that of a white male, asking why it is that a black woman reflects a specific identity, whereas a white male automatically represents the universal. 'Being a black woman is a perpetual struggle to be heard and appreciated as a human being', Boyce has said. All of her work since the mid-1980s – from large chalk and pastel drawings to collage and photo-based art such as this – examines the common experiences of black people, from South Africa to Surrey, questioning why society and the media consistently view black men and women as belonging to a separate, if neighbouring, world.

☛ Chagall, Clark, Gill, Goldin

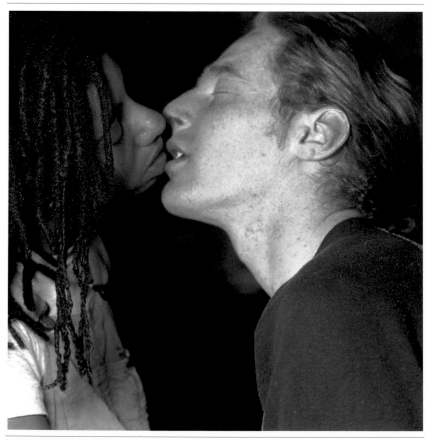

Sonia Boyce. **b** London (GB), 1962.
Untitled (Kiss). 1995. Ink-jet print on heavy duty vinyl. **h**5.49 x **w**4.88 m. **h**18 x **w**16 ft. Collection of the artist

Boyd Arthur

Half-caste Child

A frightened looking girl, barefoot, and wearing bridal flowers in her hair, embraces her husband. The arms of the dark-skinned Aborigine hang limply by his sides. The girl's half-caste status is signified by her white face and black arms and legs. In the background sits a crouched figure, head in hands, in the entrance to a hut. The bird of prey on the roof signals the fears and problems of this interracial marriage. This work forms part of Boyd's classic series of 'Bride' paintings, and is a poignant example of social documentation – a visual ballad of two worlds. The figures in Boyd's paintings often show emotion, but he avoided sentimentality through a brutal, almost Expressionist, style, using bright blocks of colour. The large, bulging eyes, the slightly naïve style, and the bright, earthy colours reveal the influence of Picasso and Chagall, among others. Living and working in self-imposed exile in England for many years, Boyd also painted from memory a series of intense Australian landscapes.

☞ **Chagall, Nolan, Picasso, A Piper, Tjapaltjarri**

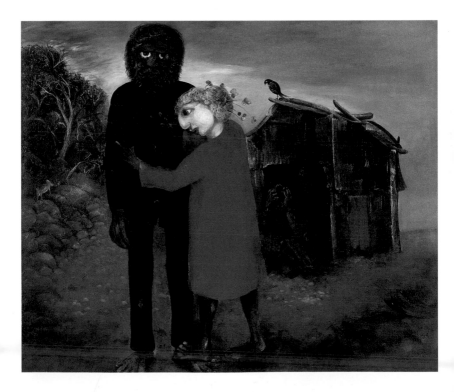

Arthur Boyd. b Murrumbeena (ASL), 1920. **d** Sydney (ASL), 1999.

Half-caste Child. 1957. Oil and tempera on canvas. **h**150 x **w**177.5 cm. **h**59⅛ x **w**69⅞ in. JCL Investments, Melbourne

Boyle Family

Tiled Path Study with Broken Masonry

The corner of a tiled path is juxtaposed with bits of rubble and set against a tarmac background. It looks so realistic, it is hard to believe that it is in fact made of fibreglass. Out of context and displayed for contemplation on the gallery wall, the work questions the point at which real life ends and art begins. Exactly how the Boyle Family cast their works remains a secret, but each piece is technically almost perfect. The Boyle family consists of Mark Boyle, his wife Joan Hills and their children, Sebastian and Georgia, who have been involved in their parents' projects from infancy. Their work investigates the surfaces of different terrains, from deserts and demolition sites to snow and mud. In the early 1960s, they concentrated on Happenings – live events involving music and theatrical performance. They also designed the psychedelic light shows for the concert tour of the rock singer Jimi Hendrix.

☛ **Brisley, Long, De Maria, Smithson**

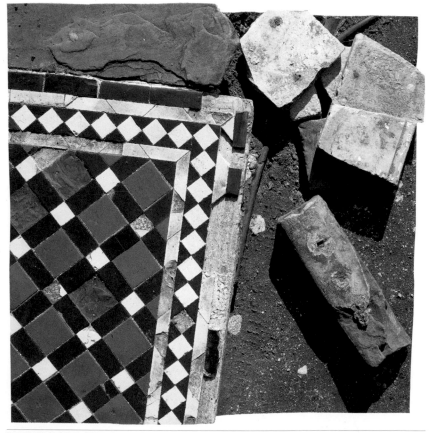

Boyle Family. Mark Boyle. **b** Glasgow (GB), 1934. Joan Hills. **b** Edinburgh (GB), 1937.
Tiled Path Study with Broken Masonry. 1989. Painted fibreglass. **h**122 x **w**122 cm. **h**48 x **w**48 in. Private collection

Brancusi Constantin

Bird in Space

Every element in this sculpture has been pared down to its bare essentials. Only the graceful curves and soaring form of this golden bronze remain, powerfully evoking the upward movement of a bird in flight. The surface of the bronze has been polished to its natural yellow colour, contrasting with the texture and colour of the stone base. In all, Brancusi made 28 versions of the *Bird in Space*, now often cited as the pinnacle of his achievement. In 1904, Brancusi left his native Romania and walked to Paris, where he made his home. He worked for Rodin for a short time before establishing his own studio. Not afraid of controversy, Brancusi took the United States customs to court when they impounded one of his sculptures, claiming that it was not a work of art, but just a piece of metal which was liable for tax. Brancusi's radical vision and his simplification of form has had a huge impact not only on twentieth-century sculpture, but also on abstract art.

☛ **Arp, Gaudier-Brzeska, Judd, Rodin**

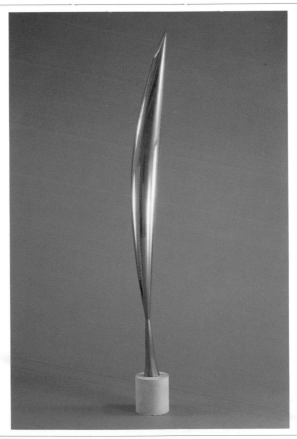

Constantin Brancusi. **b** Hobitza (ROM), 1876. **d** Paris (FR), 1957.

Bird in Space. 1927. Bronze. **h**118 cm. **h**72½ in. National Gallery of Art, Washington, DC

Braque Georges

Composition with the Ace of Clubs

A bunch of grapes, playing cards and parts of musical instruments look as if they have been placed on the canvas at random, but in fact the composition is carefully constructed. Braque shows a round table, viewed from above. The drawer of the table, however, appears to be painted face on, as do the ace of clubs and hearts above it. The bunch of grapes seems to float on the surface, and lettering is scattered across the composition. Rather than recreating the illusion of real space on the flat canvas with the use of perspective, light and shade,

Braque has suggested three-dimensionality and depth by showing the top and side view of the table at once. He has also included elements painted to look like wood, again suggesting real form beyond the picture plane. Along with Picasso, Braque invented Cubism in 1907 – a revolutionary movement which challenged the traditional approach to representing space on a two-dimensional surface, paving the way for abstraction.

☛ Cézanne, Fautrier, Gris, Nicholson, Picasso

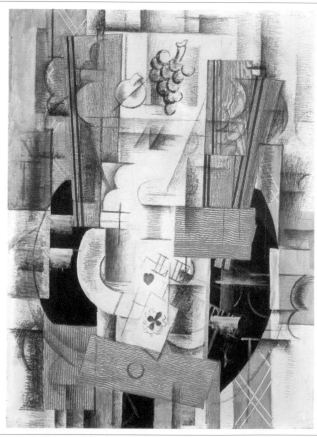

Georges Braque. b Argenteuil-sur-Seine (FR), 1882. d Paris (FR), 1963.
Composition with the Ace of Clubs. 1913. Oil on canvas. h80 x w59 cm. h31½ x w23¼ in. Musée Nationale d'Art Moderne, Paris

Brauner Victor

Frica as Fear

A man and a woman face each other, sideways on to the viewer. The man, who represents Fear, is shown penetrating the woman with a dog-shaped phallus. The woman's head is draped with a cat, traditionally a symbol of female sexuality. In this work, Brauner relates human sexuality and psychology to animal types. The violence of the imagery is reinforced by the red background, but is counteracted by the patterning on the figures' clothing, which owes much to North American Indian art. Brauner was deeply influenced by the so-called Primitive art of non-

Western civilizations – the art of South America and Mexico, and Native America. He worked in several different styles, always striving to produce a powerful, iconic image, symbolic of human desires and actions. Brauner was closely involved with the Surrealists from the late 1930s, when he painted one of his most famous series, a sequence of small panel pictures depicting various mutilations of the eye. Ironically, after painting those pictures, Brauner lost his own eye in a brawl.

☞ **Boyce, Gill, Klee, Lam, Matta**

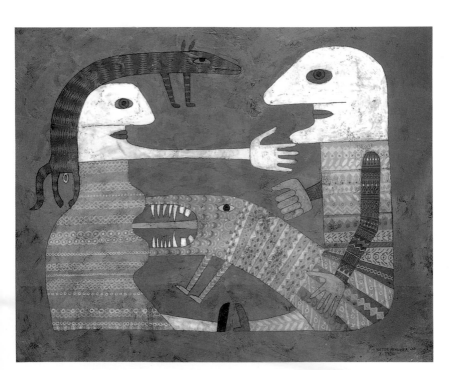

Victor Brauner. b Piatra Neamt (ROM), 1903. **d** Paris (FR), 1966.
Frica as Fear. 1950. Oil on board. **h**64.8 x **w**81 cm. **h**25½ x **w**31⅞ in. Private collection

Brisley Stuart

Leaching out from the Intersection

This installation gradually changed over the month that it was exhibited at London's Institute of Contemporary Arts. Each day Brisley worked there like an urban anthropologist, sorting out the layers of rubbish he collected from a London wasteland frequented by the homeless. Items of clothing and tables were gradually hung from the ceiling, while all the other worthless objects were spread on the floor, as if beneath human dignity, creating a surreal environment which combined the debris of humanity with a magical, floating atmosphere. Brisley

has also been involved with Performance Art. He once spent two hours a day sitting in a bath filled with rotting meat and cold water, representing the foul and humiliating side of life, and offering an image of the human body that extended beyond painting and sculpture. His extreme, disturbing work draws the rejected, unattractive elements of life into the museum or gallery, forcing the viewer to witness the lives of those marginalized by society.

☞ **Fischli & Weiss, Hesse, Pistoletto, Stockholder**

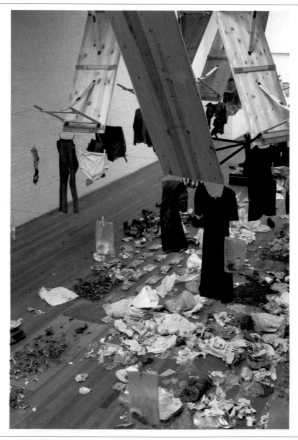

Stuart Brisley. **b** Hazlemere (GB), 1933.

Leaching out from the Intersection. 1981. Wood, clothes, cans, newspapers and bones. Dimensions variable.

As installed at the Institute of Contemporary Arts, London

Broodthaers Marcel — Table and Cupboard with Egg-shells, Painted Ivory

A table and the cupboard above are crammed with egg-shells. Painted white, and set incongruously like ornaments in a display cabinet and on a table, the egg-shells take on a life of their own. By removing them from their normal context, Broodthaers questions the nature of the everyday. This interest in the idea behind the work is typical of Conceptual Art. Broodthaers's work often focuses on humble or domestic activities and objects. A poet, film-maker, painter, sculptor and photographer, Broodthaers brought to each discipline a poetic sensibility influenced by the bizarre imagery of Surrealism. Between 1968 and 1972, he made a number of installations called 'Museums' which questioned the workings and value judgements of museums. In these works, the first of which appeared in his own house, no paintings or sculptures were on view. Instead, Broodthaers displayed packing cases and postcards of works by nineteenth-century artists – the methods of organization and documentation taking the place of the art itself.

☞ Beuys, Cornell, Judd, Magritte

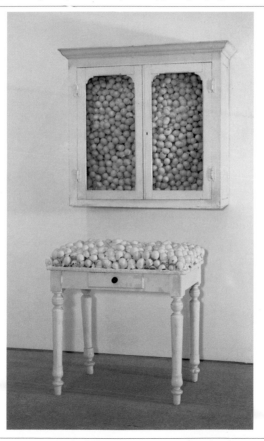

Marcel Broodthaers. b Brussels (BEL), 1924. d Cologne (GER), 1976.
Table and Cupboard ... 1965. Wood, oil and egg shells. Table: h104 x w100 x l40 cm. h41 x w39⅜ x l15¾ in. Private collection

Brossa Joan

Labour

Still attached to its needles, the knitted letter 'A' is easily identifiable yet enigmatic to the viewer. As the beginning of the alphabet, or part of the word 'Labour', the character represents a single stage in the greater creative task ahead. The original Spanish title, *Labor*, means not only work or labour but also knitting or embroidery. In this work form is divorced from function – the red woollen shape has no use other than as art – and the familiar is made strange. By denying the usual purpose of objects and everyday activities, Brossa calls into question their role in society. The practice of raising the conventional to the status of art object has been widely used since the early part of the twentieth century in the form of the ready-made, as pioneered by Duchamp who took a bicycle wheel or a urinal and called it a sculpture. Brossa adds a poetic sensibility to the genre. A theatre critic and poet, as well as the maker of object poems, of which *Labour* is an example, Brossa is one of the most versatile of Catalan artists.

☛ **Boetti, Davila, Duchamp, Trockel**

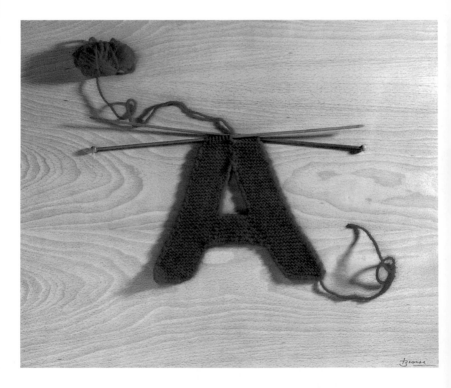

Joan Brossa. b Barcelona (SP), 1919.
Labour. 1978. Wool and needles. **h**24 x **w**37 x **l**6 cm. **h**9½ x **w**14½ x **l**2⅓ in. Collection of the artist

Burden Chris

Kunst Kick

These frozen images of the artist being kicked down a flight of stairs prompt conflicting responses. Laden with individual and collective fears of injury, yet familiar as a stunt from television and film, the scenario contrasts the reality of pain with its translation into art and theatre: the title means, literally, 'Art Kick'. In similar, highly charged performance pieces, Burden subjected himself to a number of violent acts. But these were not mere gimmicks to court moral outrage. By adopting extreme positions, he hoped to cross the threshold of the taboo in society and to question artistic responsibility. Being shot, burned or electrocuted was a means of testing not only human endurance but the social systems that prohibited these experiences. The stark, photographic results make us excruciatingly conscious of our own bodies and deepest fears. In other works Burden has begged for money over the radio, and produced a television commercial in which he included himself in a list of the most famous artists in history.

☛ Acconci, Ader, Pane, Ulay & Abramovic

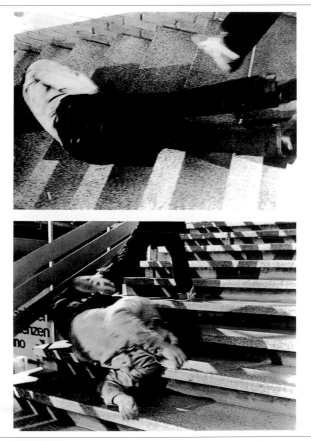

Chris Burden. b Boston, MA (USA), 1946.
Kunst Kick. 1974. Photographs of a performance at the Basel Art Fair, Switzerland

Buren Daniel

Within and Beyond the Frame

Striped banners, hanging like washing from a gallery window, flutter in the breeze. The black and white stripes have become Buren's trademark. This is ironic, since he uses the anonymity of stripes to register his contempt for individual style, announcing in 1967, that 'all art is reactionary'. His striped billboards, exhibited in Paris in 1968, constituted an eloquent voice of dissent against traditional art and traditional forms of patronage and presentation. In 1971, as a comment on the narcissism of gallery architecture, he hung a twenty-metre striped cloth in the famous atrium of the Guggenheim Museum in New York, to distract attention from the central spiral. It was soon removed. By 1985, however, Buren was officially recognized and invited to produce a work for the Palais-Royal in Paris. Though he was now working for the kind of institution he had previously derided, he continued to retain a political tension between art and context in his work, which is rarely available to collectors.

☛ Bleckner, Broodthaers, Martin, West

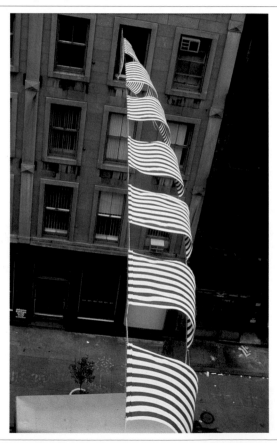

Daniel Buren. b Boulogne-Billancourt (FR), 1938.
Within and Beyond the Frame. 1973. Black and white canvas. Dimensions variable. As installed at the John Weber Gallery, New York

Burgin Victor

Today is the Tomorrow You Were Promised Yesterday

Above a typically British street scene, a poetic verse speaks of an exotic idyll. Conflicting with the drudgery of the image, it amplifies the dashed hopes, forgotten dreams and social and political injustices of a beleaguered nation. The bitter title, directly addressing the viewer, underscores the message. This work forms part of the series 'UK 76'. Burgin is a seminal figure in Conceptual Art and he has both made and written about art; his many texts have frequently appeared in periodicals and journals. In the 1970s, his largely political work focused on the nature of representation. More recently, the language of advertising has formed the basis for much of his work. In 1976, on the streets of Newcastle, he fly-posted 500 copies of a work bearing the image of an embracing couple with the text: 'What does possession mean to you? 7% of our population own 84% of our wealth.'

☛ Becher, Graham, Holzer, Kruger

The early morning mist
dissolves. And the sun shines
on the Pacific. You stand like
Balboa the Conquistadore.
On the cliff top. Among the last of
the Monterey Cypress trees.
 The old whaler's hut is abandoned now.
But whales still swim through the wild waves.
 Sea otters float on the calmer waters.
Cracking abalone shells on their chests.
 Humming birds take nectar from the red hibiscus.
Pelicans splash lazily in the surf.
 Wander down a winding path. Onto gentle sands.
Ocean crystal clear. Sea anemones. Turquoise waters.
Total immersion. Ecstasy.

TODAY IS THE TOMORROW YOU WERE PROMISED YESTERDAY

Victor Burgin. **b** Sheffield (GB), 1941. 69
Today is the Tomorrow You Were Promised Yesterday. 1976. Gelatin silver print mounted on aluminium.
h101.6 x **w**152.4 cm. **h**40 x **w**60 in. Edition of 3

Burra Edward

Storm in the Jungle

Drawn to the exotic and forbidden, Burra conjures up a scene of a fantasy tropical world. The sensual exuberance of the women, the vegetation and the animals are juxtaposed with premonitions of death – the skull in the window and the lightning flashes in the distance. In the bottom right-hand corner, common objects such as a knife and a teapot have magically taken on human characteristics. One of the first British artists to show the influence of Surrealism, a movement that was concerned with the dreamland of the subconscious, Burra created

an unsettling world peopled with extravagantly dressed women, labourers, sailors and soldiers, set mostly in imaginary locations. Due to ill health, which had rendered him physically weak from childhood, his medium was predominantly watercolour, which was easier to handle than oil. Burra celebrated the dynamism of life at the margins, and over a long career, produced a peculiarly English collection of works which ultimately defy categorization.

☛ Benton, Grosz, Rousseau, Weight

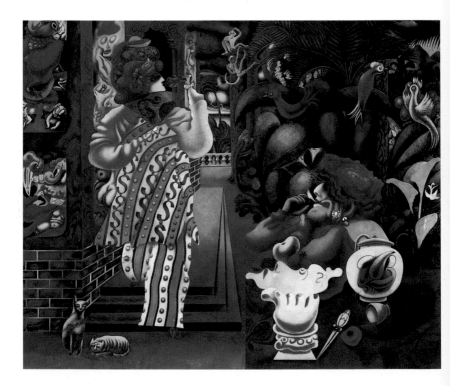

Edward Burra. b London (GB), 1905. d Playden (GB), 1976.
Storm in the Jungle. 1931. Watercolour on paper. **h**56 x **w**66.5 cm. **h**22 x **w**26¼ in. City Art Gallery, Nottingham Castle

Burri Alberto

Sacking and Red

Bringing together a collection of unpromising, humble materials – sacking, glue, and the industrial medium of vinyl paint – Burri has made a work of arresting beauty. The juxtaposition of different textures and colours, and the balanced composition, gives the work a sensual feel. However, it may also have a symbolic or psychological dimension. The sacking suggests bandages, and the red colour, blood, recalling Burri's experiences as a doctor in an Italian prisoner of war camp. His rough materials give the work a brute physicality which critics have associated with the general post-war experience of austerity and with the lingering of painful memories of suffering and destruction. Burri's unconventional arrangement of unusual materials, which have included charred wood and plastic sheets, links him with the Art Informel movement, a group of artists who used non-art materials in their work, rejecting traditional forms and methods of composition.

☞ **Dubuffet, Pistoletto, Rotella, Tàpies**

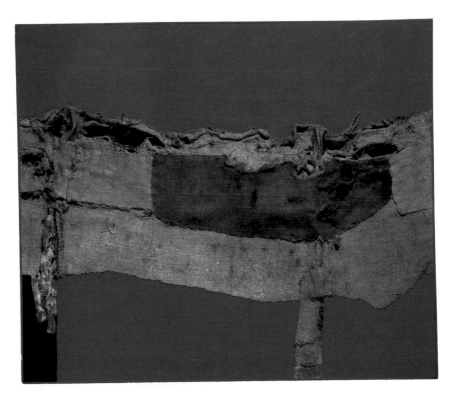

Alberto Burri. b Città di Castello (IT), 1915. **d** Nice (FR), 1995.
Sacking and Red. 1954. Sacking, glue and vinyl paint on canvas. **h**86 x **w**100 cm. **h**34 x **w**39 ½ in. Tate Gallery, London

Bury Pol

Sphere on a Cylinder

A chrome globe rotates on top of a cylinder so slowly that the movement is almost imperceptible. Reflected in the sphere is the photographer taking a picture of the work. This gently humorous sculpture represents an important stage in Bury's varied career, when he started to incorporate small motors into his sculptures. In the mid-1950s, Bury explored the aesthetic potential of moving sculptures, along with a number of European artists including Tinguely and Vasarely, showing his work in the influential international exhibition *Mouvements* of 1955. Included in this show were Bury's movable compositions which could be rotated at will by the spectator. This interest in science and technology was reflected in much of the art of the time. However, Bury's work subsequently became quieter and more reflective. Before making these moving sculptures, Bury was a prominent painter and a key member of the Cobra movement, which explored primitive urges through highly expressive, spontaneous abstract painting.

☞ **Appel, Brancusi, Tinguely, Vasarely**

Pol Bury. b Haine St Pierre (BEL), 1922.
Sphere on a Cylinder. 1969. Chromium-plated brass with motor. **h**50 x **w**19 x **l**19 cm. **h**19¾ x **w**7½ x **l**7½ in.
Louisiana Museum of Modern Art, Humlebaek

Bustamante Jean-Marc

Stationary I

Sixteen small, L-shaped forms, and six colour photographs of cypress trees are arranged in the gallery, creating a calm installation through which the viewer can pass, contemplating the relationship between the different elements. The realism of the nearly identical photographs contrasts with the abstraction and simplicity of the Minimalist floor pieces; the vertical alignment of the trees is matched by the upright axes of the sculptures; and the harmonious view of nature is countered by the man-made constructions. This work is based on Bustamante's experiences of the indistinct landscapes found on the edge of town – transitory places which exist next to an undefined, urban architecture and are neither city nor countryside. Given that the cypress tree has long symbolized death, the cement structures could be seen as stylized headstones. A sculptor and self-taught photographer, Bustamante works in a number of different media.

☞ Andre, Balka, Bartlett, Muñoz

Jean-Marc Bustamante. b Toulouse (FR), 1952.
Stationary I (detail). 1990. Cement, brass, cibachrome prints. Sculptures: **h**81 cm. **h**31⅞ in.
Caisse des Dépôts, Musée de Saint-Étienne, Saint-Étienne

Cahun Claude

Self-portrait, 1927

Wearing opaque goggles through which she cannot see, or be seen, the artist faces the camera. With her cravat, her collar turned up and her hair slicked back, she looks more like a male pilot than a woman of the 1920s. This perverse self-portrait is characteristic of Cahun's startling work. Depicting herself in a number of erotically-charged roles, she metamorphoses from the ironically feminine – as doll, fairy or sex-kitten – to the boldly masculine. Sometimes she appears exotically androgynous, at other times as a shaven-headed mutant. Cahun was deeply involved with the Surrealists, her idiosyncratic stagings anticipating many of their concerns. Born Lucy Schwob, she was a leading intellectual, poet and artist at a time when it was virtually impossible for a woman to be accepted as such. Her work was discovered posthumously, and it is only now that her pioneering talent is being recognized.

☛ Ader, Man Ray, Modigliani, Schjerfbeck, Sherman

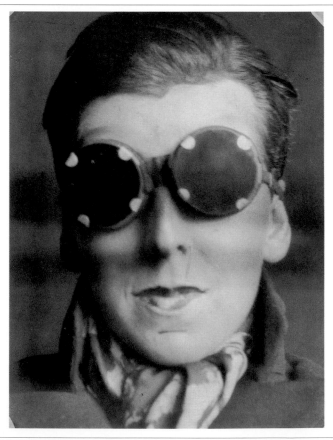

Claude Cahun. **b** Nantes (FR), 1894. **d** Jersey (GB), 1954.
Self-portrait, 1927. 1927. Black and white photograph. **h**23.5 x **w**18 cm. **h**9¼ x **w**7⅛ in. Musée des Beaux-Arts, Nantes

Calder Alexander

Obus

Arcs of red and black plunge downwards, while a black arrow pushes up towards the sky. The black and blue shapes appear to recede from view, while the red advances. Although this work is abstract, its biomorphic forms allude to nature. The drama of the work is enhanced as the viewer moves in and out of the arms of the structure. Calder was the first American artist of his generation to gain worldwide fame. His playful sculptures are composed of simple, physical elements in striking colours. His great innovation in the 1930s was to introduce movement into sculpture by hanging coloured objects, attached to thin wires, from the ceiling. Named 'Mobiles' by Duchamp, they were inspired by the abstract paintings of Mondrian, whose isolated blocks of colour seem to be suspended in space. He also made works, such as this one, which are fixed to the ground. These 'stabiles' also project a strong sense of dynamism through the juxtaposition of form and colour.

☛ Caro, Miró, Mondrian, Noguchi, Serra, D Smith

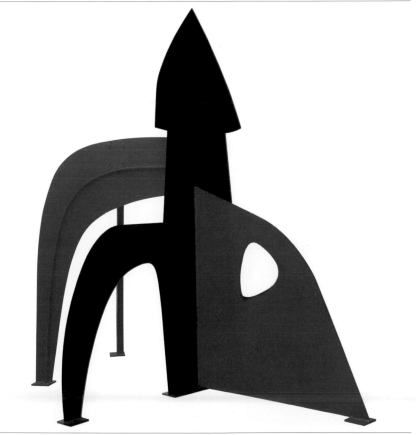

Alexander Calder. b Lawnton, PA (USA), 1898. **d** New York (USA), 1976.
Obus. 1972. Painted steel. **h**362 x **w**386 x **l**228 cm. **h**142½ x **w**152 x **l**89⅝ in. National Gallery of Art, Washington, DC

Calle Sophie

The Blind

'I met people who were born blind. Who had never seen. I asked them what their image of beauty was,' said Calle of this work, which forms part of a series on the same theme. Each consists of the person's portrait, their definition of beauty, printed and framed, and on a small shelf below, a photographic interpretation of their vision. This particular image documents one man's view of the beauty of an expanse of sea. *The Blind* discovers the inner life of its subjects, unexpectedly rich and alive. The answers are beautiful and tragic, full of imaginative

possibilities and poetic desires. Calle is a kind of art detective – an observer, voyeur and interlocutor who investigates people's lives with a mixture of compassion, humour and cold indifference. In other projects, she has followed a stranger for two weeks, keeping a diary of her experiences, and has taken a job as a hotel chambermaid so she could search among the guests' rooms for intimate information and clues about their lives.

☛ Burgin, McCollum, Marin, Wearing

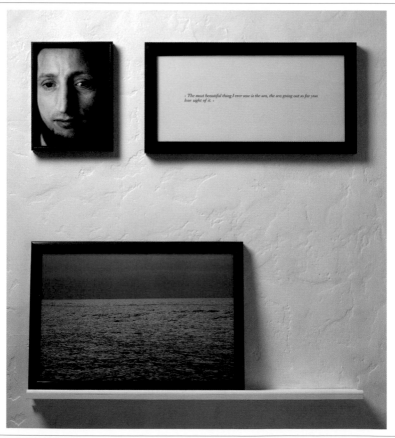

Sophie Calle. **b** Paris (FR), 1953.
The Blind. 1986. Photographs and text. Dimensions variable. Private collection

Campbell Steven Spider on the Window, Monster in the Land – Edgar Allan Poe

This remarkably detailed, large-scale painting is based on a horror story by the nineteenth-century writer Edgar Allen Poe in which a man mistakes a spider on a window for a monster far away on a hill. This confusion of perspective is represented by Campbell's distorted use of space. The window behind the blue-suited man who reads out the story resembles a flat canvas depicting an expansive landscape. The flat rendition of the chairs and the Surrealistic nude women in the foreground play with the idea of the illusion of distance, while the use

of mirrors further develops the theme of false visual impressions. The foreboding colours, dark shadows and the haunting faces lit from below reflect the scary nature of the tale. Rejecting his background as a Conceptual and Performance artist, Campbell turned to the more traditional medium of painting, and is now an important member of the Neo-Expressionist group of Scottish painters known as the Glasgow School.

☛ Carrington, Delvaux, Rego, Tanning

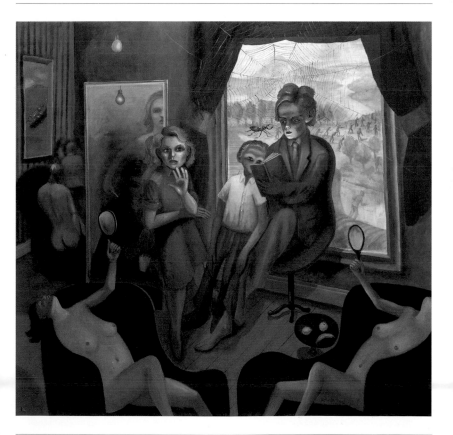

Steven Campbell. b Glasgow (GB), 1953.

Spider on the Window, Monster in the Land – Edgar Allan Poe. 1992–3. Oil on canvas. h220.4 x w232.7 cm. h86¾ x w91⅝ in.
Private collection

Campigli Massimo

The Café

This painting is divided down the middle into two almost symmetrical halves. The artist has shown the same scene twice, with two figures sitting close together at a table. The only difference is that the figures on the left are shown in muted tones, while those on the right are set against a brightly coloured background, perhaps representing the inside and outside of a continental café. Campigli aimed to create an art which would have the timeless quality of the great works of the past. This was related to a general feeling in the inter-war years that an affirmative art of everlasting order was needed to counterbalance the chaotic experience of modern life. In an attempt to find a deeper, more universal basis for art, Campigli looked to so-called Primitive art forms. In particular, he was influenced by Egyptian and Etruscan art and in this work he aims to simulate the effect of an Ancient fresco, giving a modern scene an Antique quality.

☛ **Goldin, Hopper, Immendorff, Liebermann, Morandi**

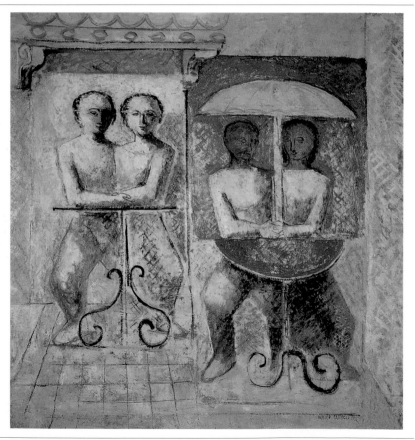

Massimo Campigli. **b** Florence (IT), 1895. **d** St Tropez (FR), 1971.
The Café. 1931. Oil on canvas. **h**100 x **w**78 cm. **h**39⅜ x **w**30¾ in. Private collection

Caro Anthony

Midday

Heavy sections of yellow painted steel beams are bolted together to form an abstract construction. The rough appearance of the sculpture, in which nuts and rivets are visible, accentuates the process by which it was made and the materials used. Abandoning the traditional mode of clay modelling, Caro preferred to 'draw in space' with man-made and industrial materials. Trained as an engineer, and assistant to Moore in the early 1950s, Caro was instrumental in changing sculptural practice in Britain. His early table sculptures – small, hand-held objects – were of particular importance. More crucially, he revolutionized sculpture by removing the base or pedestal to create works that sat directly on the ground, making the works physically more accessible. A prolific artist, Caro is influenced by the work of Smith, Picasso and González. Balancing the playful with keen observation, he maintains a powerful, aesthetic physicality.

☞ Calder, González, Moore, Picasso, D Smith

Anthony Caro. b London (GB), 1924.

Midday. 1960. Painted steel. **h**240 cm. **h**94½ in. Museum of Modern Art, New York

Carrà Carlo

Funeral of the Anarchist Galli

The luminous, riotous colours give this work a feeling of chaos and restless energy, fitting for the subject – the funeral of an anarchist. But the wild, dynamic sense of speed and movement, which conjures up the impression of the mourners carrying the coffin, belies a tight and well-structured composition. The dynamic and explosive nature of this work links it to the Futurist movement, which aimed to reflect modern life by representing machines or figures in motion. The movement also had a political dimension, aiming to break with the establishment and bring Italy back to the forefront of European culture. Carrà had signed the Futurist Manifesto in 1910, the year before this was painted, along with fellow painters Boccioni, Balla and Severini. Three years later he published his own manifesto advocating 'a painting of tones, noises and smells'. Carrà's brand of Futurism has more sense of structure and precision than that of other painters in the movement.

☞ Balla, Boccioni, Grosz, Immendorff, Severini

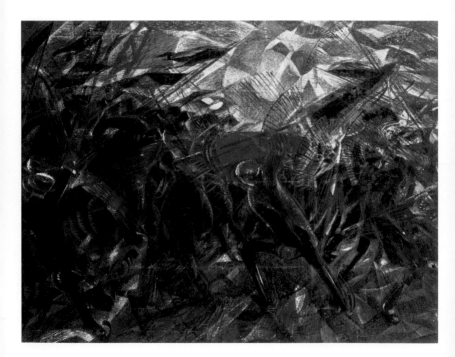

Carlo Carrà. b Quargnento (IT), 1881. d Milan (IT), 1966.
Funeral of the Anarchist Galli. 1911. Oil on canvas. h185 x w260 cm. h72⅞ x w102½ in. Museum of Modern Art, New York

Carrington Leonora

The Inn of the Dawn Horse (Self-portrait)

The woman depicted in this work is the artist herself. She sits awkwardly before a docile, lactating hyena which seems to have just materialized from a patch of ectoplasm to its right. Behind her, a rocking horse hangs on the wall, and meanwhile, framed in the ornately draped doorway, a real horse gallops free in a bucolic landscape. There is something hypnotic about the composition: it suggests the strange, distorted lucidity of a dream. Our eyes are met equally by the hyena and by Carrington herself, as though there were some affinity between

them. Perhaps the animals are meant to be projections of aspects of the artist's personality. Carrington has produced an extensive body of work, both as a painter and a novelist. Influenced by Surrealism, she evokes a rich, bizarre world populated by creatures, imagined and real, often mingling with figures of young women. Her work is informed by a combination of personal history, fantasy and mythology, particularly Celtic legends.

☞ Brauner, Campbell, De Chirico, Magritte, Rego, Varo

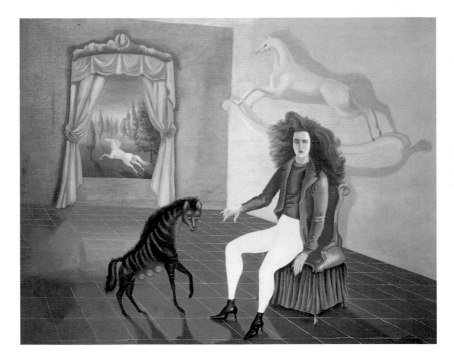

Leonora Carrington. b London (GB), 1917.
The Inn of the Dawn Horse (Self-portrait). 1936. Oil on canvas. h65 x w81 cm. h25⅔ x w31⅞ in. Private collection

Caulfield Patrick

Still Life with Jug and Bottle

An orange jug and a green bottle are set in front of a series of abstract shapes. Part figurative, part abstract, this brightly coloured, glossy image looks more like an advertisement than a work of art. This use of the language of mass culture links Caulfield to the Pop Art movement, although he tends to use less contemporary imagery than his colleagues. Caulfield is a master of the mundane, championing the unheroic side of life characterized by banal objects such as lamps, glasses, tables and chairs. His deceptively simple, emblematic style is influenced by the work of Léger, Gris and Magritte. Caulfield deliberately steers clear of the pretensions of high art, creating witty and accessible images which question the notion of taste in art. Underlying the surface wit, however, is a more contemplative and melancholy side. His work has a sense of detachment which is emphasized by the fact that his paintings of apparently trivial subject matter are largely unpopulated.

☛ Gris, Léger, Magritte, Morandi, Spoerri

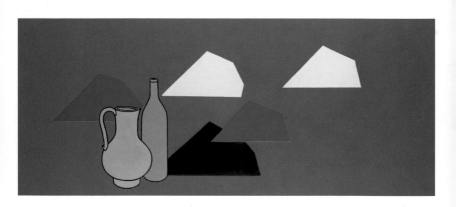

Patrick Caulfield. **b** London (GB), 1936.

Still Life with Jug and Bottle. 1965. Oil on hardboard. **h**91.4 x **w**213.3 cm. **h**36 x **w**84 in. Private collection

César

César

Compression

The components of a bicycle have been squashed into a square block. Still recognizable, the various elements such as the saddle, handlebars and pedal, combine to create a powerful work. These compressions represent some of César's best known sculptures, which range from crushed cars to wearable jewellery, figurative assemblages and plastic moulds. Economic necessity initially dictated César's use of cheap materials such as scrap metal. Despite the disposable nature of the components, however, César's work bears little relation to Pop Art. His use of pulverized vehicles is more in line with the Nouveau Réaliste aesthetic, which favoured the use of everyday and discarded materials for poetic ends. Spoerri and Arman were key members of this group, making works from crockery and paint brushes, among other objects. César's use of incongruous objects to make sculptures also owes much to the rich legacy of Dada and Surrealism.

☞ Arman, Chamberlain, Dalí, Duchamp, Metzinger, Spoerri

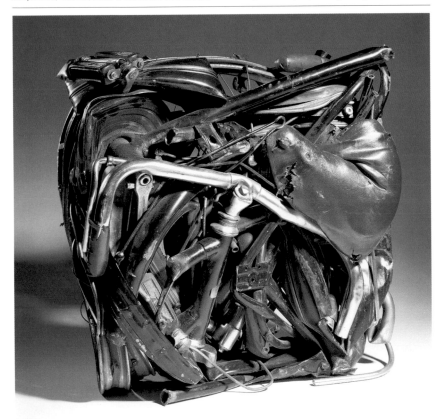

César Baldaccini. b Marseilles (FR), 1921.
Compression. 1970. Compressed bicycle. **h**51 x **w**51 x **l**22 cm. **h**20 x **w**20 x **l**8⅔ in. Private collection

Cézanne Paul

Bathing Women

A group of nude women relax in a wooded enclosure by the side of a lake. The two women on the far right are drying themselves after bathing, while the three women in the centre of the composition seem to be talking among themselves. Their skin catches the light, reflecting the blue of the water and sky. Their bodies appear strangely truncated and distorted. Rather than using models, Cézanne painted from memory. He was perhaps less interested in a faithful reproduction of the scene than in the classical theme of bathers in harmony with the landscape – a fascination that persisted for 30 years. Cézanne was the son of a banker in Aix-en-Provence, and was, by all accounts, a shy and difficult man. Although success came late to Cézanne, his works were eventually extremely influential, with many artists making pilgrimages to see him. Widely acknowledged as the 'father' of modern art because of his simplification of form, Cézanne paved the way for Cubism and abstraction.

☛ **Bourdelle, Gauguin, Maillol, Matisse, Picasso**

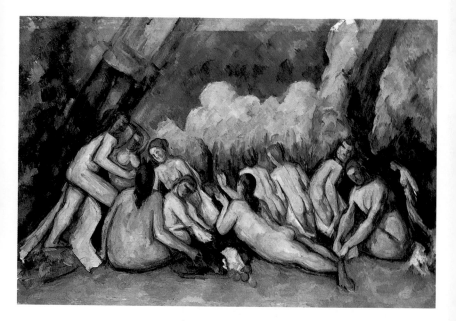

Paul Cézanne. b Aix-en-Provence (FR), 1839. **d** Aix-en-Provence (FR), 1906.
Bathing Women. 1900–5. Oil on canvas. **h**130 x **w**195 cm. **h**51¼ x **w**76¾ in. National Gallery, London

Chadwick Helen

Loop My Loop

A long lock of golden hair is looped around a sow's intestine in an act of simultaneous love and repulsion. The blonde hair symbolizes female purity and innocence, while the pig's viscera reveal the internal, animalistic side of human nature. The juxtaposition of the wet, fleshy guts and the dry hair creates a queasy, stomach-churning tension of emotions. However, the viewer is distanced from a direct encounter with the sculpture: it is presented in the form of a cool, cibachrome, photographic reproduction. However, it still remains an uncomfortable expression of disquieting sexuality, articulating an inner landscape of ritual-like transgression, and undermining conventional representations of the body. Chadwick made several works exploring the tactile, sensual qualities of meat and intestines. Her irreverent approach to the body and its functions was brought to the fore with *Piss Flowers* – a series of organic forms produced from casts of cavities which she created by urinating in the snow.

☛ **Brossa, Oppenheim, Pane, K Smith**

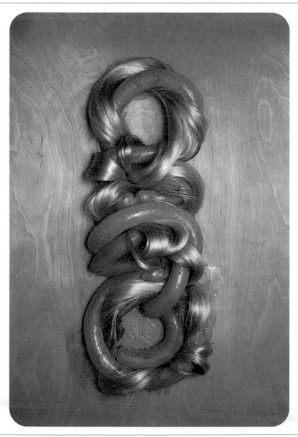

Helen Chadwick. **b** Croydon (GB), 1953. **d** London (GB), 1996.
Loop My Loop. 1991. Cibachrome transparency, glass, steel and electrical apparatus. **h**127 x **w**76 cm. **h**50 x **w**30 in. Private collection

Chagall Marc

Bouquet with Flying Lovers

Two lovers embrace while soaring above a beautiful and mysterious bouquet of lilies and poppies. The moon glows behind the two figures, who represent Chagall and his wife Bella Rosenfeld, floating above their home town of Vitebsk in Russia. The slightly menacing head of a cock, announcing the dawn, appears beneath. The subject matter and the romantic, allegorical style is typical of Chagall, who often painted pictures of lovers. This mystical, dream-like vision is full of symbols and references to Chagall's traditional Jewish upbringing in Russia. There is an elusive, enigmatic quality about this painting, suggestive of the world of dreams and the subconscious. Living in Paris from 1910 to 1914, Chagall was initially influenced by Cubism, but he remains a unique figure who defies neat categorization into any one movement. He was an incredibly prolific and talented artist, producing stained glass, mosaics, tapestries and stage sets, as well as paintings.

☛ **R Delaunay, Gontcharova, Gris, Redon, Varo**

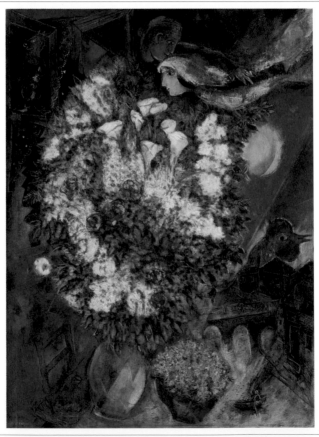

Marc Chagall. **b** Vitebsk (RUS), 1887. **d** Saint-Paul-de-Vence (FR), 1985.
Bouquet with Flying Lovers. c1934–7. Oil on canvas. **h**130.5 x **w**97.5 cm. **h**51½ x **w**38½ in. Tate Gallery, London

Chamberlain John

Etruscan Romance

Made from crushed car panels, Chamberlain's sculpture seems worlds away from the nostalgic reverie suggested by the title. But the reference to Ancient civilization and archaeology is fitting. Chamberlain, like his compatriot, Nevelson, transforms the debris of city life into highly prized art objects. Unlike Nevelson, however, who painted her assemblages in uniform colours to draw attention to the forms of objects, Chamberlain exploits the violence of jarring colours, creating an aggressive and distinctly urban effect. The transformation of the unwanted into art is a tradition which was begun in the 1920s by Dadaists such as Schwitters, whose collages made use of discarded bus tickets and labels. The tradition was continued by Chamberlain's French counterparts, the Nouveaux Réalistes, including Arman. Chamberlain has made many sculptures from crumpled cars, later working with fibreglass, foam and plastic, compressed in a similar fashion.

☞ **Arman, César, Cragg, Nevelson, Schwitters, D Smith**

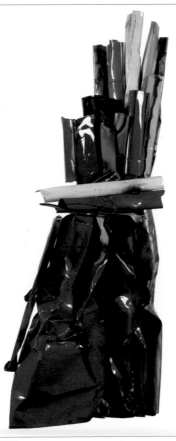

John Chamberlain. b Rochester, IN (USA), 1927.
Etruscan Romance. 1984. Painted and chromium plated steel. **h**281.9 x **w**124.5 x **l**78.7 cm. **h**111 x **w**49 x **l**31 in.
Margo Leavin Gallery, Los Angeles

Chicago Judy

The Dinner Party

On a triangular, ceramic table, place-settings anticipate the arrival of distinguished guests. To each is assigned the name of a famous woman. Most striking are the plates themselves, which resemble labial folds. This pivotal piece celebrates femininity and explores the symbolic meanings of the form of the vagina. Born Judy Cohen in Chicago, the artist adopted the name of her birthplace, aiming to establish an independent identity. Her work owes much to the feminist art theories of the early 1970s, in which traditional forms of women's labour, such as sewing and quilting, were elevated to the status of art. Later, a new generation of women artists and critics, whose economic independence took them beyond the sphere of the home and family, rejected this approach. Nonetheless, the profusion of tapestries, ceramics and quilts which emerged in this period signalled a shift in emphasis from the closed world of art to a wider debate about gender and sexuality.

☛ Brossa, M Kelly, O'Keeffe, Oldenburg

Judy Chicago. **b** Chicago, IL (USA), 1939.
The Dinner Party. 1979. Mixed media. **h**14.6 x **w**14.6 x **l**14.6 m. **h**48 x **w**48 x **l**48 ft. Collection of the artist

Chillida Eduardo

Combs of the Wind

As weathered as the battered coastline from which they spring, these massive steel forms resemble gnarled hands in the throes of a desperate tussle with the elements. Placing this work at the boundaries of land, sea and air, where one thing becomes another and the chemical properties of opposites meet, Chillida explores the fluidity and essential differences between matter. To comb the wind is literally to seek the impossible. From the huge rusting digits clutching at breezes from the open sea, we gain a mental image of the invisible.

Chillida trained as an architect, and is as famed for his drawings as for his austere sculptures. Influenced by the Spanish artists González and Tàpies as well as by the experimental sculpture of Smith and Caro, his metal sculptures are evocative of the rugged coastline of his native San Sebastián, and have inspired a subsequent generation of Basque artists.

☞ **Caro, González, D Smith, Tàpies**

Eduardo Chillida. **b** San Sebastián (SP), 1924.
Combs of the Wind. 1977. Steel. Each piece: **h**215 x **w**177 x **l**185 cm. **h**84¾ x **w**69¾ x **l**72⅞ in. Donostia Bay, San Sebastian

De Chirico Giorgio

Song of Love

A Classical head, a kid glove and a green sphere are juxtaposed against the façade of a building, back-lit by a vivid blue sky. The dramatic lighting evokes the artificial beauty of a stage-set, while the Classical head recalls the artist's background in Athens where he was born of Italian parents. The romantic mystery and dream-like combination of bizarre, seemingly disconnected objects link this work to Surrealism, although it was painted ten years before the foundation of the movement. De Chirico is best known for his series of atmospheric townscapes depicting empty squares and ghostly, monumental buildings. In 1917 he and fellow Italian painter Carrà founded the group Pittura Metafisica – 'metaphysical painting' – which sought to depict the magical, inner aspect of objects by isolating them from their normal context and imbuing them with an enigmatic aura. De Chirico's work often includes elements from Greek and Roman Antiquity, expressive of his Italian heritage.

☞ **Carrà, Delvaux, Magritte, Pistoletto, Tanguy**

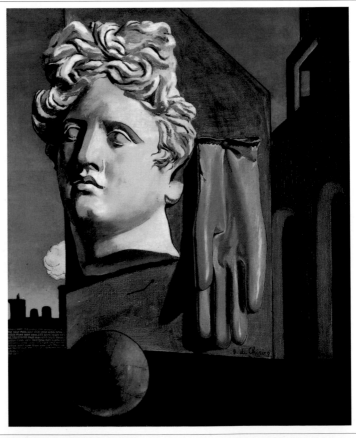

Giorgio de Chirico. **b** Vólos (GR), 1888. **d** Rome (IT), 1978.
Song of Love. 1914. Oil on canvas. **h**73 x **w**59.1 cm. **h**28¾ x **w**23¼ in. Museum of Modern Art, New York

Christo and Jeanne-Claude

Wrapped Coast

This coastal strip of Australia, swathed in rope and fabric, was one of the most startling spectacles of the 1960s. In a feat requiring great technical skill, Christo and Jeanne-Claude wrapped a one-mile stretch of rocky coast, transforming and breathing life into the landscape, which seemed to move beneath the fluttering shroud. Their use of the natural environment is comparable to Land artists of the period, but their work in urban environments distinguishes them from this group and makes them unique. By wrapping objects, Christo and Jeanne-Claude play on natural curiosity, encouraging the viewer to look at things differently, and drawing attention to particular buildings in order to make a political statement. Throughout their careers, they have executed many ambitious, large-scale, projects in public spaces, such as the wrapping of the Pont Neuf in Paris and the Reichstag in Berlin.

☛ **Benglis, Long, De Maria, Smithson**

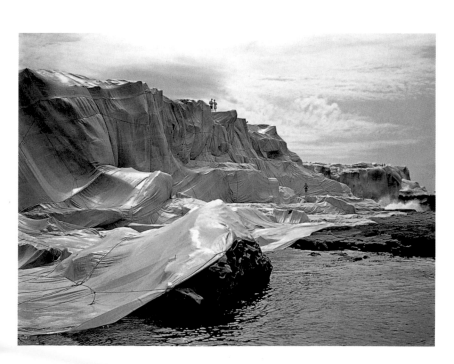

Christo and Jeanne-Claude. Christo Javacheff. **b** Gabrovo (BUL), 1935. Jeanne-Claude de Guillebon. **b** Casablanca (MOR), 1935.
Wrapped Coast. 1969. Little Bay, Australia, wrapped in fabric and 36 miles of rope

Clark Larry

Untitled (Kids)

In this disturbing photograph taken from Clark's controversial debut feature film *Kids*, a heavy-lidded girl in a lift gazes up vacantly, embodying the drug-culture of America's youth. The film graphically depicts adolescent sexuality and drug abuse, detailing a day in the lives of New York's street kids. 'I always wanted to make the teenage movie that America never made', said Clark. Crossing genres, *Kids* blurs the boundaries between documentary and fiction. Since the late 1960s, Clark's photography has similarly focused on the drug scene and the sexuality of teenagers. His books, including *Tulsa*, and *The Perfect Childhood*, which was immediately banned on release in America in 1991, have consistently provoked scandal. Clark's influence has been profound, not only on younger artists but also on fashion photographers and film-makers. His voyeuristic portrayal of youth is a powerful antidote to the soft-core advertising of Calvin Klein and the fashion spreads of lifestyle magazines.

☛ Ader, Balthus, Boyce, Goldin, Mapplethorpe

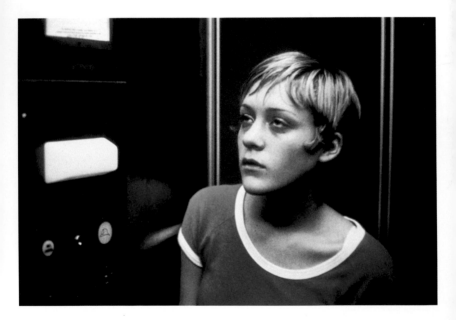

Larry Clark. b Tulsa, OK (USA), 1943.
Untitled (Kids). 1995. Colour print. **h**40 x **w**47 cm. **h**15¾ x **w**18½ in. Edition of 15

Clemente Francesco

Res Ipsa

A green circle, which represents the wheel of life, connects human body parts through the organic, radial structure of tree branches and flower stems. Clemente often uses signs and symbols, such as wheels and the body, to explore the nature of human existence. The soft washes of colour are typical of fresco painting, where pigments are applied directly to wet plaster, becoming fixed in the plaster as it dries. For many years, Clemente has been an itinerant artist, travelling between Italy, India and New York. Influenced by the particular historical, geographical and social characteristics of each place, he has produced a varied body of art using a wide range of media and drawing on popular culture, mythology, religion and legends. This nomadic, eclectic, approach links him to the Italian Transavantgarde, a group of artists whose work is traditional in format, and draws on a wide range of sources. The personal nature of his art and his figurative, sometimes dream-like style, is also close to the Neo-Expressionist movement.

☛ Haring, Indiana, Nauman, Tchelitchew

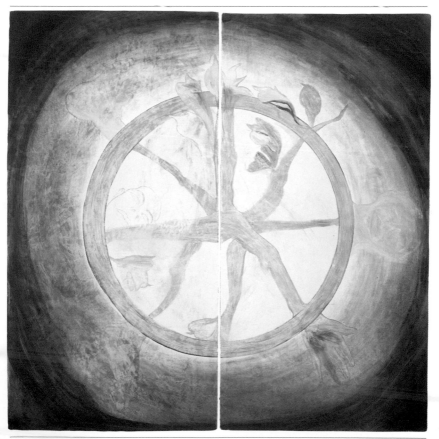

Francesco Clemente. b Naples (IT), 1952.
Res Ipsa. 1983. Fresco. Each panel: **h**2.4 x **w**1.2 m. **h**8 x **w**4 ft. Collection of the artist

Close Chuck

John

Despite its unexceptional subject matter, this large-scale painting is deeply disquieting. Though appearing straightforward at first, on closer scrutiny it confuses us with shifts of focus and scale. The blurring around the ears and shoulders makes the face loom towards us. With great technical virtuosity, Close has transcribed and enlarged a photographic print and in the process the defects of the camera's vision are exactly replicated. In turn commonplace and uncanny, the image exists somewhere between *trompe l'œil* – an illusionistic painting technique in which the subject seems tangible and three-dimensional – and photographic reproduction, which although true to life, is always limited by the depth of the camera lens. A leading Hyper-realist artist, Close has continued to paint colossal portraits. In his more recent work the image is made up of minute multicoloured dots, so that the viewer's attention fluctuates between the surface pattern and the overall picture, which can only be read from a distance.

☛ **Cahun, Estes, Hanson, Jawlensky**

Chuck Close. b Monroe, WA (USA), 1940.
John. 1971–2. Acrylic on canvas. **h**254 x **w**228.6 cm. **h**100 x **w**90 in. Pace Wildenstein Gallery, New York

Collins Hannah

In the Course of Time II

This large photograph combines the historical feel of a documentary record with the drama of a film still. Its impressive, life-size scale has a visual power and immediacy which pulls the viewer deep into its melancholic depths. The gravestones – monuments to life – are decaying and falling into ruin, suggesting a loss even more profound than death. The simple path which runs through the graveyard, however, is evidence of the human witnesses who pass through this apparently forgotten place. Mounted directly onto cotton, the photograph's vulnerable and fragile skin seems hardly capable of carrying the gloomy weight of the imagery. Collins draws on the descriptive precision of black and white photography to portray her chosen subjects, often blown up to huge proportions. Though her themes are familiar – landscapes, interiors, still lifes, the human figure – she imbues them with a haunting sense of estrangement and marginality.

☛ Ader, Bustamante, Rainer, Struth

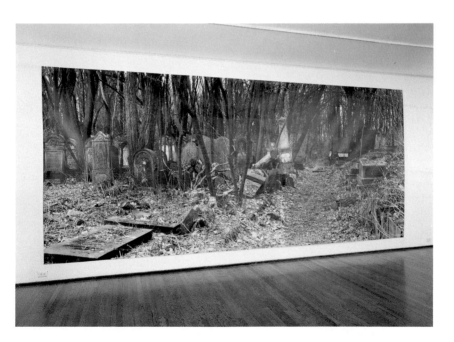

Hannah Collins. **b** London (GB), 1956.
In the Course of Time II. 1994. Silver gelatin print mounted on cotton. **h**261.6 x **w**584.2 cm. **h**103 x **w**230 in.
Leo Castelli Gallery, New York

Corinth Lovis

Ariadne of Naxos

Ariadne, naked and swooning in the foreground, was the daughter of the King of Crete. She has just arrived on the island of Naxos, only to be cruelly abandoned by her lover, Theseus, who had vowed eternal love after she had helped him slay the minotaur on Crete. Bacchus, the god of wine, meanwhile arrives from India in his chariot and instantly falls in love with her. This fiery, disturbing rendition of the famous Greek legend was painted after the German Impressionist painter Corinth suffered a severe stroke from which he would never recover.

Forcing himself to paint again with his left hand (the right one was paralysed), he abandoned his Impressionistic style, close in character to that of Liebermann, and his concentration on landscapes, in favour of a more expressive technique and much darker, increasingly pessimistic subjects. His handling of paint became rougher and more crude, conveying a sense of brooding violence akin to German Expressionism.

☛ **De Lempicka, Liebermann, Monet, Spencer**

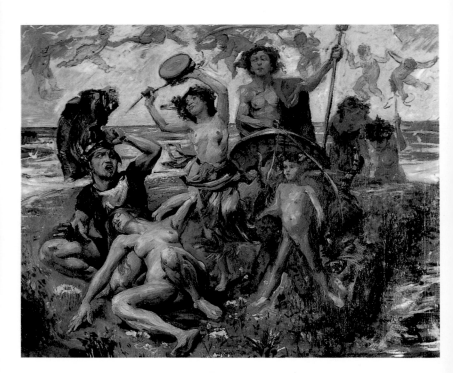

Lovis Corinth. **b** Tapiau (PRU), 1858. **d** Zandvoort (NL), 1925.
Ariadne of Naxos. 1913. Oil on canvas. **h**116 x **w**147 cm. **h**45⅝ x **w**57⅞ in. Private collection

Cornell Joseph

Untitled (Ostend)

A box contains a broken wineglass, a glass ball, a metal ring, nails and a broken piece of white piping, placed within crumbling white walls. The title suggests a connection with the Belgian seaport, Ostend, but there are no other obvious references to the town, symbolic or otherwise. Instead, through a skilful juxtaposition of banal objects, the artist has succeeded in creating a pervasive sense of mystery and nostalgia, a kind of poetic theatre of memory. Indeed, the work brings to mind a theatre or film set – a scenario for some bizarre Surrealist drama. Cornell's most celebrated works are enclosed constructions or assemblages which bring together strangely evocative groups of objects, often involving mirrors and moving parts. From the mid-1930s, Cornell exhibited with the Surrealists, but unlike fellow Americans linked with the group, such as Man Ray, who moved to Paris, he remained in the United States.

☞ **Broodthaers, De Chirico, Man Ray, Morandi, Spoerri**

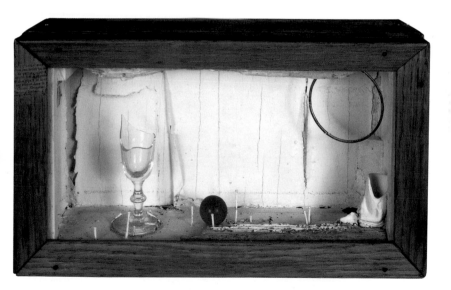

Joseph Cornell. b Nyack, NY (USA), 1903. **d** Flushing, NY (USA), 1972.
Untitled (Ostend). c1954. Mixed media. **h**19.5 x **w**33 x l10.5 cm. **h**7¾ x **w**13 x l4⅛ in. Galerie Karsten Greve, Paris

Cragg Tony

Minster

This work has been made from the debris of society, with its ever-expanding scrap-heaps of discarded objects. Collecting old car parts, tyres and wheels, Cragg has built them into a cluster of rusty spires which, in their new incarnation, ironically celebrate and stand as icons of the religion of decadence and waste. By using discarded material, Cragg raises issues about the environment and recycling. In forming the raw material for a work of art, these jettisoned car parts have taken on a whole new life. A central figure of the New British Sculpture group –

a group of avant-garde sculptors – Cragg has produced a range of extremely varied works, using a vast spectrum of materials. His works are based on observation and attention to the real world, an approach derived from his early training as a scientist. He has described his sculptures as 'thinking models to help you get through the world'.

☛ Caro, César, Chamberlain, Deacon, Woodrow

Tony Cragg. b Liverpool (GB), 1949.
Minster. 1987. Rubber, stone, wood and metal. **h**195 to 305 cm. **h**76⅞ to 120⅛ in. As installed at the Hayward Gallery, London

Dalí Salvador

The Persistence of Memory

Three melting watches, all stopped at different times, are set in the eerie landscape of Port Lligat in north-east Spain, where Dalí spent his childhood. He claimed that the melting watches were inspired by an over-ripe camembert cheese which he was looking at one evening while working on this painting. Their softness may also have a sexual significance, particularly the one in the centre of the composition, draped over the rock, which has metamorphosed into the artist's face. The work may reflect Dalí's interest in modern science, especially Einstein's theory of relativity which had destroyed fixed notions of time and space. His style perfectly expresses the unsettling experience of dreams, and his work, which ranged from paintings to sculpture and films, initially found favour with the Surrealists. Always provocative, Dalí filled his work with references to sex and violence – obsessed with what was forbidden by conventional society.

☞ De Chirico, Ernst, Nash, Tanguy, Wadsworth

Salvador Dalí. b Figueras (SP), 1904. **d** Figueras (SP), 1989.
The Persistence of Memory. 1931. Oil on canvas. **h**24.1 x **w**33 cm. **h**9½ x **w**13 in. Museum of Modern Art, New York

Darboven Hanne

Requiem for M Oppenheimer

A watercolour self-portrait by the Viennese painter, Max Oppenheimer, who died in 1965, is set on a stand among grimy musical instruments. Chronological pages from Darboven's 1985 diary line the walls, accompanied at monthly intervals by reproductions of the same painting. These diary entries present her address and telephone number beside notes and mathematical calculations, the pages taking on the appearance of musical notation. The installation is accompanied by a soundtrack which is piped from the corner opposite the battered instruments, giving the work a melancholy and disconnected air. Darboven regards herself primarily as a writer and historiographer, her art taking a secondary role. She has published several books which present series of numbers arranged in a random flow. Despite the references to funerals and requiems in her work, the sense of continuity implied by her records, diaries, and sequences of digits is oddly life-affirming.

☛ Bhimji, Boltanski, Buren, Woodrow

Hanne Darboven. b Munich (GER), 1941.

Requiem for M Oppenheimer. 1985. 192 framed works on paper. Each: **h**71.1 x **w**53.3 cm. **h**28 x **w**21 in. Private collection

Davila Juan

Utopia

A mountainous landscape fills the top of each of the multi-panelled letters which spell out the title of the work. But the sunsets, fluffy white clouds and snow scenes become progressively distressed, messy and chaotic, with blood-red and flesh-pink daubs of paint smeared by hand across the lower panels. These fragmented, figurative elements make up a troubled narrative of repression, fear, laughter and perversity. Folk stories, military dictators, pornographic comic books and strange cartoon figures are all juxtaposed in a vision of disorder and excess. It is a portrayal of a failed Utopia. Davila quotes from a wide range of historical, cultural and artistic sources, referring in particular to his own experiences as an immigrant gay artist from Chile living in Australia. He has described his art as a kind of 'bad cooking', as if his collage-like concoction of images left a sour taste in the mouth.

☛ Brossa, Schnabel, Tillers, Varo, Zorio

Juan Davila. b Santiago (CH), 1946.
Utopia. 1988. Oil and collage on canvas. **h**180 x **w**1050 cm. **h**70⅞ x **w**413¾ in. Private collection

Davis Stuart

New York under Gaslight

The noise and excitement of modern urban life in New York – skyscrapers, neon lights, and gaudy billboards – is the subject of this painting. Everything appears overstated, larger than life, suggesting the tension and speed of the city. The vivid colours and complex patterning of the different elements in the picture convey the confusion and bustle of life in the metropolis, and also evoke the beat of jazz. Reinforcing this connection with music is the sign in the right-hand corner reading 'Dig this Fine, Art-Jive'. Although Davis's subjects concentrated on urban life in the United States, he was very much influenced by French avant-garde movements such as Cubism. This movement, in particular, fascinated him, and he took on board its rejection of traditional modelling and perspective, often using lettering, as here, to emphasize the flatness of the picture plane. From the 1940s onwards, Davis became more and more withdrawn from society, producing introverted abstract and geometrical paintings.

☛ Braque, Estes, Mullican, Struth

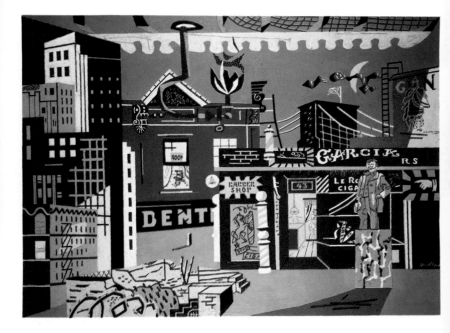

Stuart Davis. b Philadelphia, PA (USA), 1892. d New York (USA), 1964.
New York under Gaslight. 1941. Oil on canvas. h81.3 x w114.3 cm. h32 x w45 in. Israel Museum, Jerusalem

Deacon Richard

Two Can Play

This large, skeletal structure has a strong, linear rhythm, defining itself as much by the space contained in and around it, as by the solidity of the riveted steel framework. The sculpture is abstract in form, but the shapes may allude to bodily organs, or to some apparatus of entrapment. Deacon describes himself as a 'fabricator', for he neither carves nor models, but constructs using manufacturing or building techniques, frequently working in combinations of wood and metal. The physical act of making is always an integral part of the final artworks, with their ostentatious rivets, seams of glue, screws and bolts. Though they are often large, Deacon's enigmatically titled sculptures never dominate the viewer, possessing their space with grace, restraint and modesty. Deacon is a central figure of the New British Sculpture movement, and has made several large-scale works which have been installed as public, outdoor sculptures.

☞ Caro, Cragg, Espaliú, D Smith, Woodrow

Richard Deacon. b Bangor (GB), 1949.
Two Can Play. 1983. Galvanized steel with rivets. h183 cm. h72 in. Saatchi Collection, London

Delaunay Robert

Political Drama

A woman with a plumed hat and a man in morning suit seem to be spinning round on a disk of luminous, scintillating coloured bands. The title suggests that they are involved in some kind of dramatic scenario, as they slip and slide round the rings. Part figurative, part abstract, this work reveals Delaunay's tireless experimentation with colour. One of a series begun in 1912 entitled *Circular and Cosmic Disks and Forms*, this painting was among the earliest to reject natural forms, exploring instead the emotional effects of pure colour.

Believing that harmonious colours suggest slow movement while discordant ones evoke speed, Delaunay achieved the effect of activity through the juxtaposition of different hues. Together with his Russian wife, Sonia, Delaunay developed his theories on the rhythmic possibilities of colour into the movement which became known as Orphism. His interest in the effect of different colours on the canvas was to have a significant impact on the development of abstract art.

☛ **S Delaunay, Kandinsky, Marc, Nadelman**

Robert Delaunay. **b** Paris (FR), 1885. **d** Montpellier (FR), 1941.
Political Drama. 1914. Oil and collage on cardboard. **h**88.7 x **w**67.3 cm. **h**35 x **w**26 in. National Gallery of Art, Washington, DC

Delaunay Sonia

Girls in Swimming Costumes

Three girls, dressed in swimming costumes with contrasting geometric designs, are set against a background of radiant colours suffused with light. This work typifies Sonia Delaunay's fashion-based approach to the lyrical brand of Cubism developed by herself and her husband, the painter Robert Delaunay. Orphic Cubism, as it was termed by the poet Guillaume Apollinaire, was founded on a belief that light and colour were identical, and aimed for a purity of expression akin to music. Earlier, Gauguin and the Fauves had instilled in Delaunay a love of expressive colour. She drew on these influences to create fashion, book and costume designs which were to have considerable international importance. She called her hand-printed fabrics 'simultaneous contrasts', a term which reflected her interest in the relationship between colours. Earlier she had made costumes for the ballet *Cleopatra*, produced by the Russian dancer and choreographer Sergei Diaghilev.

☛ Bourdelle, Cézanne, R Delaunay, Gauguin

Sonia Delaunay. **b** Gradizhsk (UKR), 1885. **d** Paris (FR), 1979.
Girls in Swimming Costumes. 1928. Watercolour on paper. **h**20.3 x **w**27 cm. **h**8 x **w**10⅝ in. Private collection

Delvaux Paul

The Sleeping Town

The artist himself looks out at this strange scene from the doorway on the left. He seems to be participating in an erotically charged dream sequence, in which female nudes pose enigmatically. The two women on the left, one covered in ivy leaves, the other shrouded in drapery, may symbolize birth and death. In the background, in front of a fantastic Classical townscape, figures rush about or fight. Delvaux's works are typically ambiguous, and tend to combine the Classical with the contemporary. Indeed, in this work the artist is shown wearing a modern suit and tie against a Classical background – a device used to create a sense of timelessness. Delvaux experimented first with Impressionism and Expressionism, but was closely associated with the Surrealists from the late 1930s, aiming, like his fellow countryman Magritte, to recreate through paint the visual and narrative mood of dreams.

☛ Bonnard, De Chirico, Dali, Magritte, Sage, Tanguy

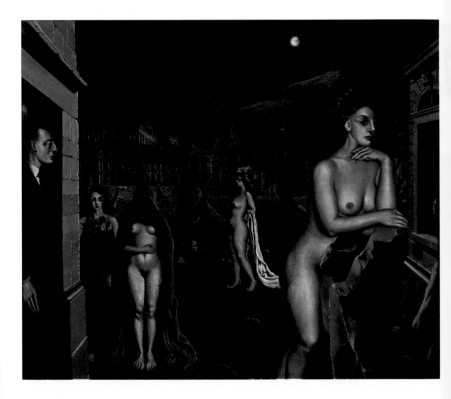

Paul Delvaux. b Antheit (BEL), 1897. d Knokke-Heist (BEL), 1994.
The Sleeping Town. 1938. Oil on canvas. h159 x w176 cm. h62⅝ x w69¼ in. Private collection

Demuth Charles

My Egypt

The industrial landscape of the East Coast of America has been reduced to clear geometric forms. Superimposed over a white factory building, complete with smoking chimney, is a web of abstract shapes, radiating like beams from the sun in the top left-hand corner of the painting. By calling the scene 'My Egypt', the artist alludes to the monumental architecture of the pyramids, giving his contemporary environment the grandeur of the Ancient World. This work reveals the influence of Precisionism, an American movement with which Demuth

was associated in the 1920s and early 1930s. Characteristic of the movement is the depiction of industrial subjects by means of the Cubist techniques of abstraction, simplifying objects to their geometric essentials. Born in Pennsylvania, Demuth travelled to London, Berlin and Paris in 1907, where he was influenced by the art of the European avant-garde.

☛ Becher, Davis, Lowry, Severini, Sheeler

Charles Demuth. b Lancaster, PA (USA), 1883. d Lancaster, PA (USA), 1935.

My Egypt. 1927. Oil on composition board. h90.8 x w76.2 cm. h35¾ x w30 in. Whitney Museum of American Art, New York

Denis Maurice

Homage to Cézanne

A group of artists gathers round to admire a still life by Cézanne. Among those represented are Redon, Vuillard, Bonnard, on the right, with glasses and a pipe and Denis himself, with his wife on the far right, sharing in a mutual adulation of Cézanne. They were all members of the Nabis group, whose name comes from the Hebrew word for 'prophet'. These artists focused on the use of colour and patterning in their work. 'Remember that a picture before being a horse, a nude or some kind of anecdote is essentially a flat surface covered with colours assembled in a certain order'. This famous definition by Denis emphasizes his fundamentally decorative approach to art. Paradoxically, the style of this painting is not especially influenced by Cézanne. The subtle palette of pinkish hues and the subdued nuances of tone are characteristic of Denis in this period. A devout Roman Catholic, Denis often painted works of an intensely spiritual nature, which combine dream-like sensations with concrete reality.

☛ **Bonnard, Cézanne, Kirchner, Magritte, Redon, Vuillard**

Maurice Denis. b Granville (FR), 1870. **d** Paris (FR), 1943.
Homage to Cézanne. 1900. Oil on canvas. **h**180 x **w**240 cm. **h**70⅞ x **w**94½ in. Musée d'Orsay, Paris

Derain André

London: The Bridge at Southwark

Two barges and a small tug, with a lone figure at the helm, glide under Southwark Bridge on the River Thames. The river is painted yellow and green, the bridge is a vivid purple and the sky is pink. The vibrant, unrealistic colours and the expressive brushstrokes, visible particularly on the roof in the lower right-hand side of the painting are typical of Fauvism. The accents of colour used to depict the water reveal the last stages of Derain's interest in pointillism, a technique whereby different shades of paint were dotted onto the canvas to re-create the effects of light. In 1906, Ambroise Vollard, one of the most influential dealers of the time, encouraged Derain to leave Paris, where he was then working, and travel to England to make a group of paintings 'inspired by the London atmosphere'. *London: The Bridge at Southwark* was one of this series, which was later considered to be among Derain's most influential work.

☞ Heckel, Kokoschka, Marin, Signac, Vlaminck

André Derain. **b** Chatou (FR), 1880. **d** Chatou (FR), 1954.
London: The Bridge at Southwark. 1905–6. Oil on canvas. **h**81 x **w**100 cm. **h**31⅛ x **w**39⅜ in. Private collection

Dibbets Jan

Universe/World's Platform

Like freeze-frames from a film, a sequence of photographs depicts the inverted curvature of the earth. Though the human eye sees the horizon as flat, the artist has presented it in its true form; upside-down, the image is an accurate reflection of what is perceived by the retina. Often dealing with the landscape, yet using it as an illustration of a thought process, Dibbets operates at the border between Earth Art and Conceptual Art. At the core of his investigation is the trick that perspective plays on the eye. In his series *Perspective Corrections* he cut trapeziums into the grass, photographing them from a particular angle to give the impression that they were squares. These simple interventions force huge perceptual leaps, and are often humorous, as in his manipulation of photographs of Holland's flat landscape to create 'Dutch Mountains'. Dibbets began his career as a painter, and his interest in colour and light and his dispassionate view of nature is aligned to the tradition of seventeenth-century Dutch painting.

☞ Long, De Maria, Schapiro, Smithson

Jan (Gerardus Johannes Marie) Dibbets. b Weert (BEL), 1941.
Universe/World's Platform. 1972. Colour photographs and pencil on paper. **h**65 x **w**65 cm. **h**25⅔ x **w**25⅔ in.
Stedelijk Museum of Modern Art, Amsterdam

Diebenkorn Richard

Berkeley No. 52

Swathes of bright, contrasting colours divide up the canvas into irregular sections. The vivid accents of orange and blue, and the lively and vigorous brushstrokes evoke the light and colour of Berkeley in California. Spending much of his working life on the West Coast, Diebenkorn absorbed and reproduced the area's particular quality of light. He always had an intimate struggle with paint, more concerned with the actual process of painting than with subject matter. He was influenced by many abstract painters, from the reductive analysis of Mondrian, to De Kooning's expressive style, Matisse's colour and Hofmann's exploration of shifting picture planes. In the mid-1950s he switched to figurative painting before returning to abstraction with his famous *Ocean Park* series. Although primarily an abstract painter, Diebenkorn displayed little of the personal angst associated with the New York Abstract Expressionists and remains difficult to categorize.

☛ **Hofmann, De Kooning, Matisse, Mondrian, De Staël**

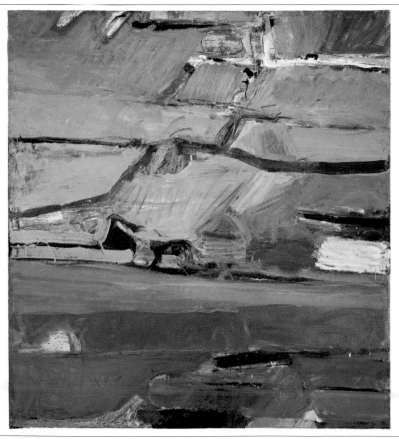

Richard Diebenkorn. b Portland, OR (USA), 1922. **d** Berkeley, CA (USA), 1993.

Berkeley No. 52. 1955. Oil on canvas. **h**149 x **w**137 cm. **h**58¾ x **w**54 in. National Gallery of Art, Washington, DC

Dine Jim

Wiring the Unfinished Bathroom

Two small metal lamps are fixed to the surface of the canvas, their wires trailing across its abstract plane. Four toothbrushes are placed on the top right-hand corner. Although the title alludes to the familiar practice of procrastinating over the DIY, Dine, like Johns and Rauschenberg, is more interested in stretching the boundaries of painting than with subject matter. In the 1960s, he frequently made these assemblages, attaching everyday objects such as bathrobes, hair and household appliances to the surface of the painting. Despite being strongly associated with the Pop artists, who drew from consumer culture, Dine was concerned with linking his work to past art movements, which he often respectfully parodied. His work is influenced by Dada, the anti-art movement, the strange juxtapositions of Surrealism and the gestural characteristics of Abstract Expressionism. Dine also initiated and participated in Happenings – live performances, which he considered to be an extension of his life.

☞ **Boltanski, Johns, Kounellis, Oldenburg, Rauschenberg**

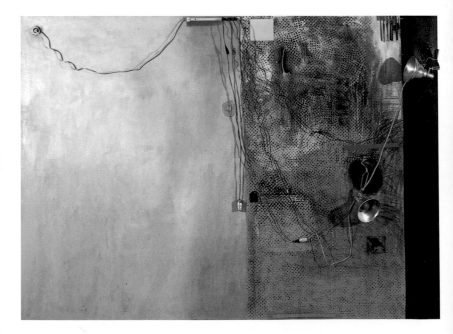

Jim Dine. **b** Cincinnati, OH (USA), 1935.
Wiring the Unfinished Bathroom. 1962. Mixed media and oil on canvas. **h**175 x **w**240 cm. **h**69 x **w**94½ in.
Louisiana Museum of Modern Art, Humlebaek

Dion Mark

Library for the Birds of Antwerp

Using props from the natural and man-made world, Dion has constructed an installation that explores contemporary attitudes to science and the environment. He has created a fictional and hybridized situation in which the trappings associated with knowledge, learning and classification – such as books and photographs – are juxtaposed with natural elements including birds and wood. The representation of nature is a fundamental subject in Dion's art, and here he takes on the role of sociologist/anthropologist and blurring the boundaries between authentic and fake, representation and parody. By adopting the persona of a scientist and by satirizing man's obsession with categorization, Dion questions the values of the Western world. His subject matter is heavily influenced by popular culture: in Dion's world we might witness Mickey Mouse as an explorer, or Clark Kent interviewing Dr Frankenstein.

☞ Bleckner, Broodthaers, Green, C Noland

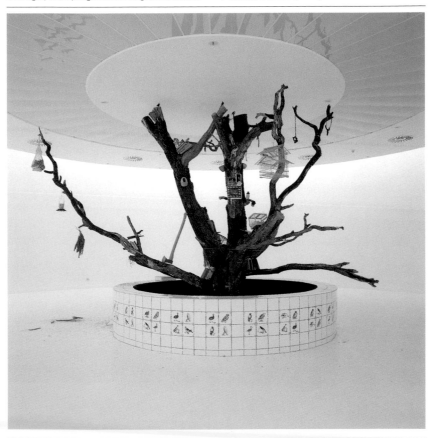

Mark Dion. b New Bedford, MA (USA), 1961.
Library for the Birds of Antwerp. 1993. Live birds, tree, ceramic tiles, books and photographs. **h**6.1 m. **h**20 ft.
As installed at the Museum van Hedendaagse Kunst, Antwerp

Dittborn Eugenio The 7th History of the Human Face ... Airmail Painting No. 78

Photographs of criminals, thieves and prostitutes are juxtaposed with portraits from a 1920s anthropological study of Tierra del Fuego Aborigines. These rows of identification pictures are reproductions of images found by Dittborn in police files, cheap detective story magazines, and text books. For Dittborn, the classification and scrutiny implied by these documentary images is symbolic of the Chilean military dictatorship, with its harsh apparatus of surveillance and control. The rudimentary drawings are made by the artist's seven year-old daughter and introduce her own innocent interpretation of the faces. The full title of this work is *The 7th History of the Human Face (The Scenery of the Sky): Airmail Painting No. 78*. Dittborn has made a large number of these airmail paintings over the last ten years, folding them down to the size of an envelope and posting them to their exhibition destination. In this way his work circulates with the freedom of a letter, travelling with ease and economy from the margins of the art world to its centre.

☛ **Baldessari, Boltanski, Golub, Gottlieb, Tillers**

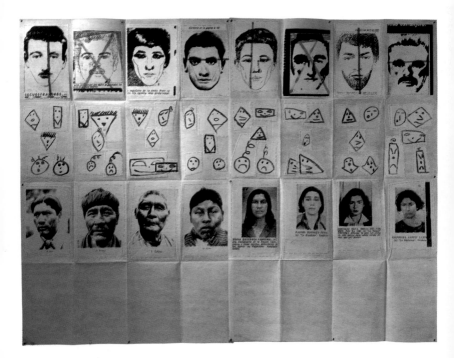

Eugenio Dittborn. **b** Santiago (CH), 1943.

The 7th History of the Human Face ... Airmail Painting No. 78. 1990. Paint, stitching, charcoal and photosilkscreen on fabric.
h215 x **w**218 cm. **h**84¾ x **w**85⅞ in. Collection of the artist

Dix Otto

Dedicated to Sado-masochists

Two women, one of them considerably younger than the other, stand in a torture chamber, surrounded by the instruments of their pleasure: whips, pistols – even a blood-stained table. The skull and the cross give the image added menace. This is one of the watercolours made by Dix in 1922 on the subject of lesbian sado-masochism. Dix's paintings set out to shock and have not lost their power over the years. After the First World War he made a series of brutal pictures depicting life in the trenches and mutilated ex-servicemen. Later, Dix's main subjects were the underdogs of the Weimar Republic: beggars, prostitutes and alcoholics. The grim and pitiless realism with which he depicted them increased their effectiveness as social criticism. During the Second World War, Dix was arrested by the Gestapo for his 'degenerate' art. Later, he turned to religious subjects, painted in an Expressionistic style.

☛ **Barney, Ensor, Grosz, Nitsch, Pane, Schad**

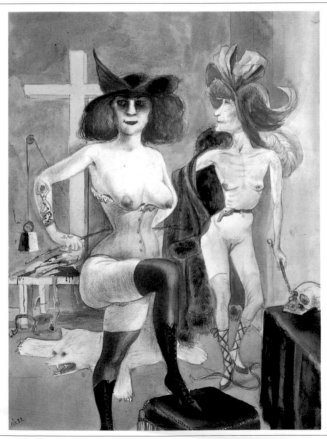

Otto Dix. b Untermhausen (GER), 1891. **d** Lake Constance (GER), 1969.
Dedicated to Sado-masochists. 1922. Watercolour, pencil, pen and black ink on paper. **h**49.8 x **w**37.5 cm. **h**19⅝ x **w**14¾ in.
Private collection

Van Doesburg Theo

Contra–Composition

The primary colours of blue, red and yellow are arranged within the strict confines of a diamond-shaped frame. The colours are kept apart by thick black lines, and by an expanse of white in the centre of the composition. This reduction of subject matter to lines and primary colours is typical of the De Stijl movement, of which Van Doesburg was a leading member, along with Mondrian. These artists rejected representation, believing that art should not depict any aspect of the world around them, but that it should stand on its own as a balanced combination of lines, shapes and primary colours. Van Doesburg's writings made a significant contribution to the movement. Born in Holland, Van Doesburg started out by making brightly coloured figurative works, under the influence of Fauvism and Post-Impressionism. He later made the move towards abstraction, and his art had a huge impact on subsequent generations of artists.

☛ **Bill, Malevich, Mondrian, K Noland**

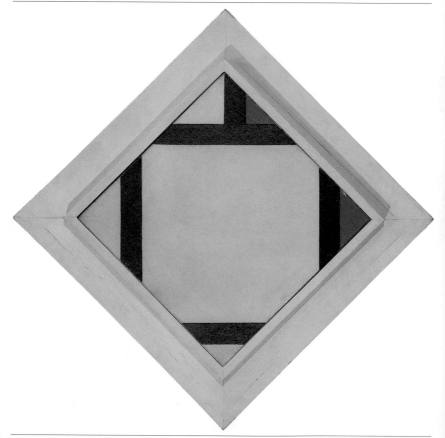

Theo van Doesburg. **b** Utrecht (NL), 1883. **d** Davos (SW), 1931.
Contra–Composition. 1924. Oil on canvas. **h**63.5 x **w**63.8 cm. **h**25 x **w**25⅛ in.
Private collection on loan to the National Gallery of Art, Washington, DC

Doherty Willie

The Only Good One is a Dead One

This installation consists of two grainy videos projected onto the walls of a large, dark, windowless space. One shows a night-time car journey along country roads, filmed with a hand-held video camera. The other is a view of a street, shot from inside a stationary car. The Irish-accented voice on the soundtrack presents a disconnected monologue of short sentences and phrases which set up two opposing points of view: the assassin waiting for his victim, and the target being pursued. The imagery and the soundtrack are based on both fictitious and documentary representations of terrorism from newspapers and television. In this highly charged space, where anxiety, fear and fantasies of murder and death are intertwined, Doherty undermines simplistic judgements about innocence and guilt. The artist's own experience of growing up in Ireland has been crucial to his videos and still photographs, all of which attempt to provide the viewer with alternative, non-partisan interpretations of the Irish conflict.

☞ Barry, Burgin, Gordon, Hill, Viola

Willie Doherty. b Londonderry (IRE), 1959.
The Only Good One is a Dead One. 1993. Double screen video projection with sound. Dimensions variable.
As installed at Matt's Gallery, London

Domela César

Relief No. 12A

This work is made from a number of different materials including copper and Plexiglas. The artist sets up a series of contrasts: pointed triangular forms are set against semicircles, smooth surfaces next to rough ones, red against blue, black against grey and opaque against transparent. The elimination of vertical or horizontal forms gives the relief a powerful sense of movement. In this way a dynamic equilibrium is set up which is entirely independent of any reference to recognizable objects. Instead the work's intrinsic interest derives from the juxtaposition of different geometric elements and media. This interest in contrasting different colours and textures is typical of the De Stijl movement, with which Domela was closely involved. In 1922 he moved to Paris where he met Van Doesburg and Mondrian, key members of the group. This relief-construction dates from that period and reflects his characteristic use of modern and unorthodox materials.

☛ **Bill, Van Doesburg, Gabo, Mondrian, Tatlin**

César Domela. b Amsterdam (NL), 1900. **d** Paris (FR), 1992.
Relief No. 12A. 1936. Copper, brass, Plexiglas and wood. **h**75 x **w**62.5 x **l**6 cm. **h**29½ x **w**24⅔ x **l**2⅓ in. Private collection

Dominguez Oscar

Homage to Manolette

A bull with a massive body and tiny head confronts the slender but unflinching figure of the toreador, Manolette. The bull has been simplified into a series of dynamic curves which extend aggressively across almost the whole surface of the canvas, while the bullfighter with his red cloak creates a vertical barrier on the right-hand side. In this work, the artist explores his Spanish roots in a style indebted to his fellow countryman, Picasso. Like Picasso, Dominguez used the contest of man and bull as a symbol for the struggle between reason and passion. Associated with the Surrrealists in the 1930s and early 1940s, Dominguez depicted a rich, fantasy world of strange beasts and eerie landscapes using the combination of a realistic style and automatic painting. This was a popular Surrealist device in which the artist worked directly from the subconscious, without pre-conceived ideas. The technique is said to have been invented by Dominguez.

☛ **Marini, Picasso, Rothenberg, Wallinger**

Oscar Dominguez. b Tenerife (CI), 1906. **d** Paris (FR), 1958.
Homage to Manolette. 1954. Oil on canvas. **h**129.5 x **w**155 cm. **h**51 x **w**61 in. Private collection

Van Dongen Kees

Portrait of Lily Damita, the Actress

Adorned in fur and wearing a short, low-cut dress, the actress Lily Damita smiles seductively at the viewer – the epitome of the elegant, 1920s starlet. Punning on the sitter's name, the artist incorporates a bunch of extravagant white lilies into the painting. The style of this painting owes much to Expressionism, but Van Dongen does not allow any over-expressive brushstrokes or dramatic colours to obscure the glamour of the sitter. Linked to the Fauvists and the Expressionists, Van Dongen's early works are characterized by luminous colours and dramatic, linear brushstrokes. But by the 1920s, this painter, sculptor, potter and graphic artist had abandoned this style and had become a much sought-after portraitist of fashionable high society and chronicler of the beau-monde. Van Dongen started out as a decorator, before turning to painting full time. He was precociously talented and led a glamorous life, funded by his artistic success.

☛ **Derain, John, De Lempicka, Vlaminck**

Kees van Dongen. **b** Delfshaven (NL), 1877. **d** Monte Carlo (MON), 1968.
Portrait of Lily Damita, the Actress. c1925–6. Oil on canvas. **h**195 x **w**130 cm. **h**76¾ x **w**51¼ in. Private collection

Dove Arthur

Lake Afternoon

The bulbous brown and yellow forms in this strange, fantasy landscape simultaneously resemble animals and abstract shapes. Separated by a sea of orange, these organic forms are painted in an almost cartoon-like style. The brilliant palette verges on the lurid, the vivid yellow and orange clashing with the blue background. Dove often represented nature in his work, usually in an abstract way. He wrote of his work: 'I should like to take the wind and water and sand and work with them, but it has to be simplified in most cases to color and force

lines just as music has done with sound.' This New York painter supported himself for years by working as a commercial illustrator for magazines. His introduction to the photographer and gallery owner Alfred Stieglitz was a turning point: Stieglitz greatly admired Dove's work and gave him his first one-man show in 1912, the earliest public exhibition of American abstract art.

☛ Heron, Kandinsky, O'Keeffe, Seligmann, Tanguy

Arthur Dove. **b** Canandaigua, NY (USA), 1880. **d** Centerport, NY (USA), 1946.

Lake Afternoon. 1935. Wax emulsion on canvas. **h**63.5 x **w**88.9 cm. **h**25 x **w**35 in. Phillips Collection, Washington, DC

Dubuffet Jean

Dimpled Cheeks

A childlike, smiling figure gazes straight out at the viewer. Butterfly wings cover the rough surface forming the eyes, nose, mouth and clothes. The collaged caricature is typical of Dubuffet's naïve style. His frequent use of unconventional materials including glass, textile fragments, buttons and sand to give his images a crude directness, loosely associates him with the movement Art Informel. Interested in reaching the subconscious roots of mental activity, and in celebrating the 'primitive' as opposed to the 'civilized', Dubuffet often focused on radical alternatives to portraiture, using the body as a kind of landscape. He made a significant contribution to the breakdown of traditional interpretations of Western art, collecting the work of psychotics, and coining the term 'Art Brut': raw work, untouched by culture, produced by those outside the established art scene, particularly children and the insane.

☛ **Giacometti, Schwitters, Wölfli, Wols**

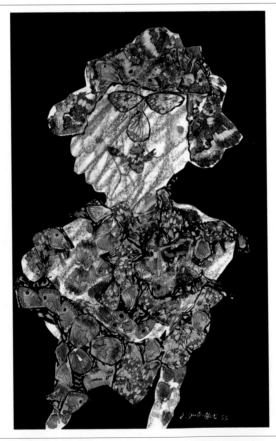

Jean Dubuffet. **b** Le Havre (FR), 1901. **d** Paris (FR), 1985.
Dimpled Cheeks. 1955. Mixed media and butterfly wing collage. **h**32.3 x **w**20 cm. **h**12¾ x **w**7⅞ in. Private collection

Duchamp Marcel

Bicycle Wheel

This real bicycle wheel attached to a stool was signed by Duchamp and exhibited as art. These everyday objects, known as ready-mades, which Duchamp transformed into art by placing them in the gallery space, overturned the concept of what constitutes artistic value. When *Bicycle Wheel* was exhibited in 1913, visitors were invited to spin it round. A ground-breaking precursor to many forms of contemporary art, it disrupted the idea of the artwork as an untouchable, precious commodity 'created' by an artist. Duchamp's rejection of traditional artistic practice is typical of the Dada movement, of which he was a leading member. Painter, intellectual and theorist, Duchamp provoked outrage throughout his career. When he added a moustache and an obscene caption to a copy of Leonardo da Vinci's *Mona Lisa* he made the archetypal, irreverent, Dada statement. A huge force in avant-garde art, Duchamp's influence on Conceptual Art has been enormous.

☛ Beuys, César, Metzinger, Wallinger

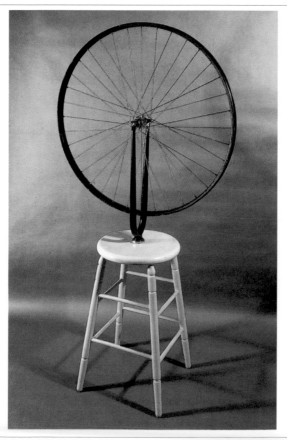

Marcel Duchamp. b Blainville (FR), 1887. **d** Neuilly (FR), 1968.
Bicycle Wheel. 1964 replica of 1913 original. Bicycle wheel and stool. **h**126.5 cm. **h**49¾ in. Private collection

Duchamp-Villon Raymond The Large Horse

This gleaming bronze sculpture is a cross between an animal and a piece of machinery. The curves and the hoof-like shape resting on the base resemble the forms of a horse, while the angular elements look like industrial equipment. This sculpture is intended to express the speed of the machine age, and it is close in spirit to the work of the Futurists whom Duchamp-Villon admired. The rejection of naturalism and the fragmentation of forms to their geometric essentials has links with Cubism, a group with which Duchamp-Villon was also closely associated.

Although it is partly abstract, it is known that the two earliest studies for this sculpture were traditional drawings of a leaping horse and rider, based on the artist's knowledge of horses, gained as an officer in the cavalry during the First World War. According to his brother, the artist Duchamp, he had intended to make a bigger version of this work. After his death from typhoid in 1918, Duchamp supervised the construction of two larger versions.

☞ **Boccioni, Duchamp, Epstein, Marini, Wallinger**

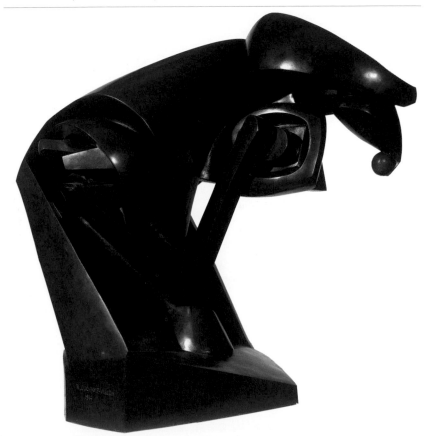

Raymond Duchamp-Villon. b Rouen (FR), 1876. **d** Cannes (FR), 1918.
The Large Horse. 1914. Bronze. **h**100 cm. **h**39⅜ in. Tate Gallery, London

Dufy Raoul

Sailing Boats in the Port at Deauville

A cluster of sailing boats is moored in the harbour at Deauville, a port just along the coast from Le Havre, where Dufy was born. The expressionistic outlines, typical of Dufy's style, suggest the movement of the boats, bobbing up and down in the water. The bright yellow sails of the vessels in the centre and on the right of the composition, contrast with the blue of the sky and imbue the work with a *joie de vivre*. In a period when many artists were depicting angst-ridden subjects, Dufy was working on these decorative seascapes and landscapes. The bright colouring and expressionistic handling of the paint are a sign of Dufy's Fauvism: he participated in the group's first exhibition in 1905 and worked closely with Derain. Dufy was profoundly influenced by Matisse's use of pure, flat areas of colour, boldly juxtaposed. By the 1930s, he was painting the race-courses, regattas and casinos of the South of France.

☛ **Derain, Heckel, Marin, Matisse, Vlaminck, Wallis**

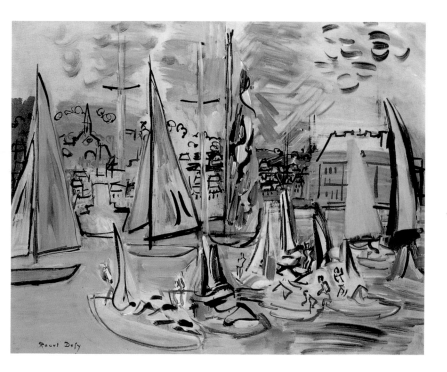

Raoul Dufy

Raoul Dufy. b Le Havre (FR), 1877. **d** Forcalquier (FR), 1953.
Sailing Boats in the Port at Deauville. 1935. Oil on canvas. **h**64.7 x **w**80.6 cm. **h**25½ x **w**31¾ in. Private collection

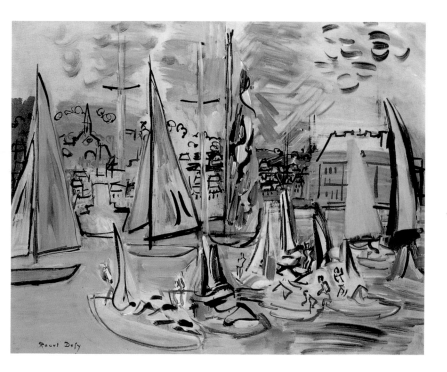

Dumas Marlene

The First People (I–IV) (The Four Seasons)

Four newborn babies have been caught in awkward poses of uncoordinated helplessness, and blown up to the height of fully-grown adults. By depicting them in this way Dumas demonstrates both their vulnerability and the alien nature of their bulbous bodies and uncontrolled expressions. Their flesh is rendered in the garish, putrid colours of decay as though the artist already sees the spectre of death in their faces. Though made after the birth of the artist's first child, this work is far from sentimental. Dumas produces disquieting paintings which search for an understanding of the human condition, confronting her emotions with a harsh honesty. Taking her own experience as a starting point, she keeps a distance from her immediate reality through photography, using a Polaroid camera to fix an image of her models. She also works from photographs found in newspapers, books, magazines and postcards, and has made interpretations of texts and the paintings of other artists.

☛ **Bacon, Kollwitz, Tuymans, Viola**

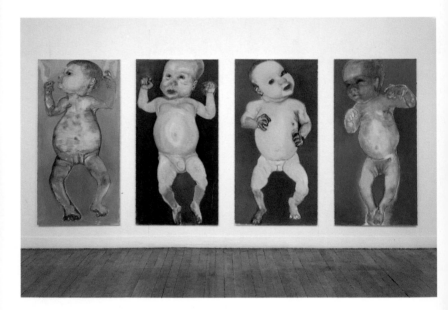

Marlene Dumas. **b** Capetown (SA), 1953.
The First People (I–IV) (The Four Seasons). 1990. Oil on canvas. Each panel: **h**180 x **w**90 cm. **h**70⅞ x **w**35½ in. De Pont Foundation, Tilburg

Durham Jimmie

La Malinche

This sculpture appears at first to be a traditional Native American carving. The melancholy face decorated with beads, snakeskin and feathers speaks of a stolen inheritance. But a work by Durham – Cherokee Indian artist, essayist and political activist – is never what it seems. This is no 'authentic' artefact. The figure is wearing plastic, hippy jewellery and a chain-store bra, the body an assemblage of recycled objects. La Malinche was an Indian princess who was the mistress of a white man, and, as such, this work can be interpreted as a symbol of sexual oppression and colonial domination. Playful and poignant, this sculpture comments on hybrid culture, and also questions the prejudices of the Western viewer – our desire to treat non-Western art as exotic ethnography and our readiness to accept stereotypical representations of indigenous peoples. Referring to himself as a 'post-modern primitive', Durham pinpoints his complex intellectual position as a Native American artist in a Eurocentric world.

☛ Baumgarten, Birch, Hammons, Man Ray, Rauschenberg

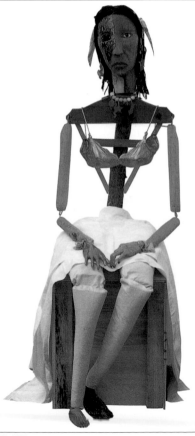

Jimmie Durham. b Washington, AR (USA), 1940.
La Malinche. 1988–91. Wood, cotton, snakeskin, watercolour, polyester and metal. **h**168 cm. **h**66⅛ in.
Museum van Hedendaagse Kunst, Ghent

Eisenman Nicole

Matisse Installation

Matisse's famous painting, *The Dance*, has been reinterpreted and incorporated into this installation. In Matisse's original, women are portrayed as innocent emblems of a natural, primitive spirit, while Eisenman's painting also includes a naked man tied to a tree. The artist has transformed the painting from one in which women are the passive subject of the male gaze, to one in which they are powerful and strong, capable of overturning a male-dominated world. The strange dolls' heads and the mechanical monkey passively look on,

perhaps watching this ritualistic scene to see if they could learn something about their own situation. Next to the painting, a large phallus faces the wall. Mounted on castors, with a rope attached to its end, it is reduced to a child's plaything. Eisenman's work is based on an eclectic range of sources from the great male artistic giants to the Flintstones. While her position is informed by the serious political issues of feminism, her work remains witty and irreverent.

☛ **Bartlett, Kelley, Matisse, Nitsch**

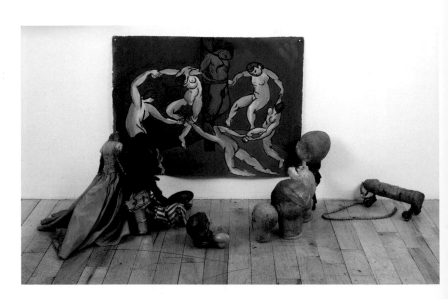

Nicole Eisenman. **b** Verdun (FR), 1965.

Matisse Installation. 1994. Watercolour on paper and doll parts. **h**42.5 x **w**56.5 cm. **h**16¾ x **w**22¼ in. Private collection

Ensor James

Death and the Masks

The grotesque figure of Death grasps a baby with his bony fingers, deaf to the pleas of the surrounding masked figures. The macabre pessimism of this work sums up Ensor's dark vision. The theme of masks, through which he frequently expressed his gloomy view of the world, relates to the carnival costumes sold by his parents in their souvenir shop in Ostend. Reacting against Impressionism's focus on landscapes and everyday scenes, Ensor developed his own highly personal vision which was full of cryptic and symbolic references. His idiosyncratic and slightly disturbing work was initially rejected by the establishment, but he finally exhibited with the avant-garde group Les Vingt. However, even they refused to show his masterpiece *Entry of Christ into Brussels*, in which he identified himself with Jesus. It was not until the end of his life that his highly original work, which had a huge impact on later Expressionist artists, was finally acknowledged with a barony.

☞ **Dix, Kubin, Nolde, Rouault, Soutine, Weight**

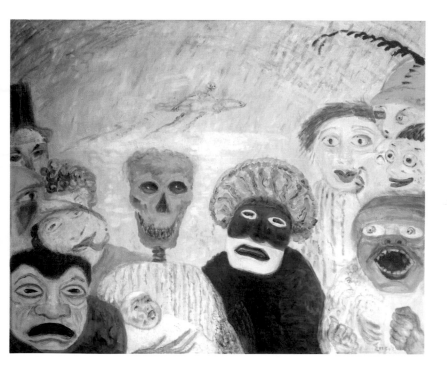

James Ensor. b Ostend (BEL), 1860. **d** Ostend (BEL), 1949.
Death and the Masks. 1927. Oil on canvas. **h**80 x **w**100 cm. **h**31½ x **w**39¼ in. Private collection

Epstein Jacob

Torso in Metal from The Rock Drill

Half-human, half-machine, this hybrid creature presages the science-fiction fantasies of later decades. Representing Epstein at his most experimental, the hard, dynamic edges of this bronze sculpture reflect the wide-spread interest of artists of this period in the progressive forms of the new mechanical age. This piece originally formed part of a larger, robotic construction which was greeted with almost universal scorn when it was shown in 1915. Epstein himself lost faith in it and removed all appendages to the torso when he showed the work again in 1916. In 1912 he met Picasso, Brancusi and Modigliani; it was this encounter – along with his discovery of Antique and Primitive sculpture in the Louvre – that was to provide inspiration throughout his career. In 1913, Epstein formed the short-lived avant-garde movement The Vortex with Gaudier-Brzeska. Born in New York of Russian-Jewish parents, Epstein is also known for his penetrating, psychological sculptural portraits.

☛ Boccioni, Brancusi, Gaudier-Brzeska, Modigliani, Picasso

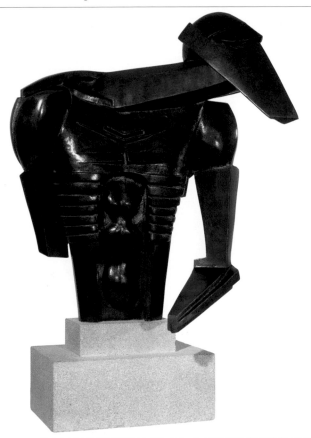

Jacob Epstein. **b** New York (USA), 1880. **d** London (GB), 1959.
Torso in Metal from The Rock Drill. 1913–14. Bronze. **h**70.5 cm. **h**27¾ in. Tate Gallery, London

Ernst Max

Elephant of Celebes

Dominating the composition is the image of a monster which looks like a mechanical elephant, but was based on a photograph of a Sudanese corn-storage bin which Ernst saw in an anthropological journal. The title comes from a German nursery rhyme, which begins with the words: 'The elephant from Celebes…' The creature is standing on what looks like an airfield, and combined with the trail of smoke in the sky, the image may evoke Ernst's unhappy memories of his time in the army during the First World War. The dream-like atmosphere of this painting and the strange juxtaposition of objects is typical of Surrealism. Ernst was a founding member of the group, and this work is one of the most famous Surrealist images. His bizarre account of his birth provides insight into his fantasy world: 'On 2 April at 9.45, Max Ernst hatched from the egg which his Mother had laid in an eagle's nest and which the bird had brooded over for 7 years.'

☞ **De Chirico, Dali, Delvaux, Tanguy**

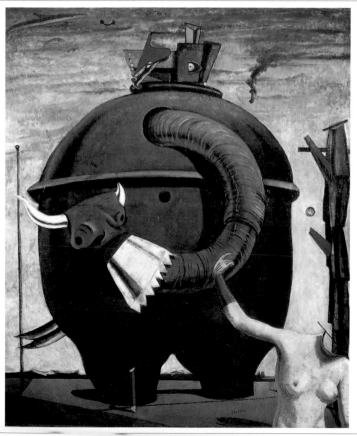

Max Ernst. **b** Brühl (GER), 1891. **d** Paris (FR), 1976.
Elephant of Celebes. 1921. Oil on canvas. **h**126 x **w**108 cm. **h**49⅔ x **w**42½ in. Tate Gallery, London

Espaliú Pepe

The Gospel According to Saint Matthew

Two birdcage-like forms suggest the entrapment of the soul within the framework of the body. Though the cages are open, possibly allowing an escape to freedom, they are joined together by the heavy, swooping metal wires, as if any outward passage must return inwards again. Perhaps the two elements represent a couple who have found in their love a release from the prison of loneliness and are now inextricably linked as one being. This highly poetic sculpture has a graceful lyricism, reflecting metaphorically on the fragility of the human condition. Espaliú died young from AIDS, and much of his later work was informed by his illness. Themes of mortality, sickness and salvation imbue his art with a palpable, melancholy poignancy. His sedan chair sculptures, suspended from the walls of the gallery, and his poetry and performances often explore the notion of 'carrying', a word that expresses both the transmission of the virus and the care and support which can be offered to those suffering from the disease.

☞ **Dion, Hesse, Phaophanit, Sterbak**

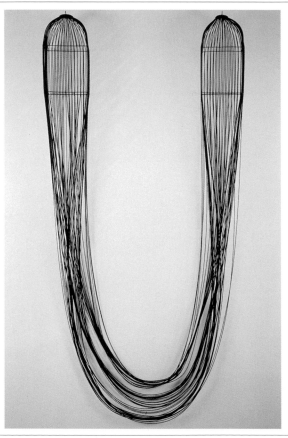

Pepe Espaliú. b Cordoba (SP), 1955. d Cordoba (SP), 1993.
The Gospel According to Saint Matthew. 1992. Iron. **h**245 x **w**115 x **l**28 cm. **h**96½ x **w**45⅓ x **l**11 in. Location unknown

Estes Richard

Times Square at 3.53 pm, Winter

New York on a raw winter's afternoon. The once melted snow has frozen again on the pavement, and the pale sunlight shines softly on the building and van on the right-hand side of the street. This detailed scene is silent and deserted. If someone were to walk down the street the sound of their footsteps would reverberate against the buildings. This work looks so lifelike that it is hard to believe it is a painting. By working from photographs, Hyper-realist artists, such as Estes, were able to recreate the world around them with painstaking attention to detail. However, their work is sometimes deliberately inaccurate: the window on the left of the composition looms at an unusual angle, forcing our attention to the centre and right-hand side of the composition, making us look past the Coca Cola and Sony advertisements, deep down the street. Estes started out as an illustrator, before taking up painting full time. His work is often executed on a vast scale, making its precision even more impressive.

☛ Close, Davis, Morley, Struth, Wall

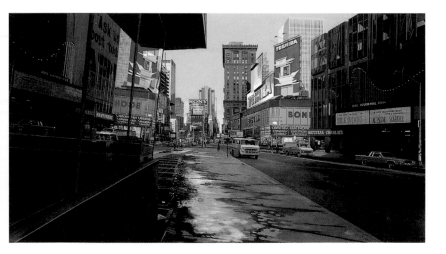

Richard Estes. **b** Keewane, IL (USA), 1932.
Times Square at 3.53 pm, Winter. 1985. Oil on canvas. **h**68.6 x **w**124.5 cm. **h**27 x **w**49 in. Private collection

Evergood Philip

Dance Marathon (Thousand Dollar Stakes)

Exhausted couples competing for the $1,000 prize in a dance marathon – a craze which swept America in the 1930s – prop each other up, determined to stay on their feet longer than their competitors. A sign in the background indicates that the competition is in its 49th day. In the period of the Great Depression many of the unemployed were driven to try their luck in these contests, often ending up in hospital through sheer exhaustion. By distorting the features and costumes of the competitors, Evergood makes no secret of his contempt for the subject, nor his pity for those involved. Evergood was committed to an art which addressed the experiences of ordinary people. Like several other Americans in the 1930s, he rejected abstraction in favour of paintings informed by Socialist ideals, seeing art as a means of protest. His work mixes fantastical and bizarre imagery with realistic and everyday subject matter, giving a unique picture of America in the 1930s.

☞ Hopper, Lawrence, Matisse, Nadelman

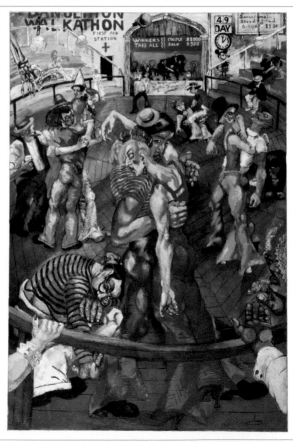

Philip Evergood. b New York (USA), 1901. d Bridgewater, CT (USA), 1973.

Dance Marathon ... 1934. Oil on canvas. h152.4 x w101.6 cm. h60 x w40 in. Archer M Huntington Art Gallery, University of Texas at Austin

Fabro Luciano

Italy

Suspended upside-down from a noose, the image depicted in the iron relief defies immediate recognition. Inversion has the effect of abstracting the form of Italy, thereby challenging the viewer's knowledge of the familiar. *Italy* is one of a series of sculptures in which Fabro has used the shape of his homeland as a pretext for the manipulation of diverse materials such as iron, copper, plywood and bronze. Each version is distinguished by the specific challenge of the material used. Fabro was part of a group of artists working in Italy whose style of

sculpture was labelled Arte Povera, literally 'Poor Art'. These artists often chose to emphasize the concept of transformation by using mundane and ephemeral materials for their sculptures. Willingness to experiment with materials in this way represents a move away from the static or fixed meaning of the artwork towards an openness that embraces the complexity of modern culture.

☛ Boetti, Merz, Penone, Pistoletto

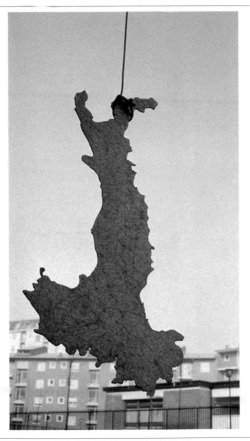

Luciano Fabro. b Turin (IT), 1936.
Italy. 1968. Road map moulded in anodized iron. **h**120 cm. **h**47¼ in. Collection of the artist

Fahlström Öyvind

Phase Four of Sitting, Five Panels

Five panels shaped into a 'V', resembling a board game, contain a number of unusual and indecipherable images. Part-cartoon, part-illustration, the symbols suggest endless narratives which are left up to the spectator to piece together. Fahlström is a poet, writer and journalist, as well as an artist, and all the elements of his work are encompassed in his eclectic, humorous compositions. Incorporating a range of images from Krazy Kat to Monopoly he uses the board-game format in order to comment on social and political issues, and to satirize the world of politics through references to chance and games. He has also created large interactive works in which spectators were invited to move painted enamel shapes on a metal background. Fahlström's use of images from popular culture has links with Pop Art, but his work crosses too many disciplines to be neatly defined. He has had a large influence on younger artists including Rauschenberg and Kelley.

☞ Baldessari, Chicago, Kelley, Lichtenstein, Rauschenberg

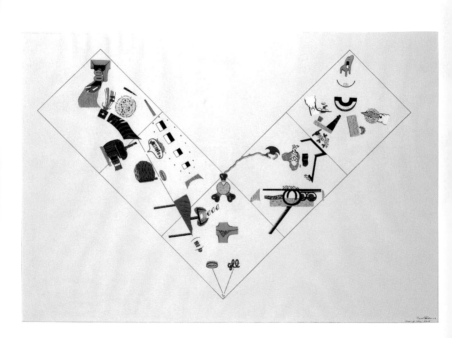

Öyvind Fahlström. b São Paulo (BR), 1928. d New York (USA), 1976.
Phase Four of Sitting, Five Panels. 1968. Tempera on paper. **h**60.3 x **w**85.5 cm. **h**23¾ x **w**33⅝ in.
Louisiana Museum of Modern Art, Humlebaek

Fautrier Jean

The Jack of Clubs

The title of this painting and the shape of the rectangle of thick white paint in the centre of the composition suggest a playing card, but essentially this work is without specific subject matter. Its meaning is indivisible from the materials which went into its making and which give it a physical, almost sculptural quality. Instead of using conventional oils, Fautrier has pasted thick paper onto the canvas. Using brushes and other implements, he then worked oil paint into the surface. The effect produced is like the encrusted, battered surface of a

wall. Working on a small scale, Fautrier invested his paintings with an intimate, private quality. His expressive, abstract style and his focus on the actual process of painting is typical of the Art Informel movement of the 1950s. Fautrier came to prominence late in life in Paris with a series of highly abstracted heads called 'Hostages'. Catching the bleak mood of post-war Paris, these works are close in style and technique to this one.

☛ **Braque, Hofmann, Soulages, Wols, Yoshihara**

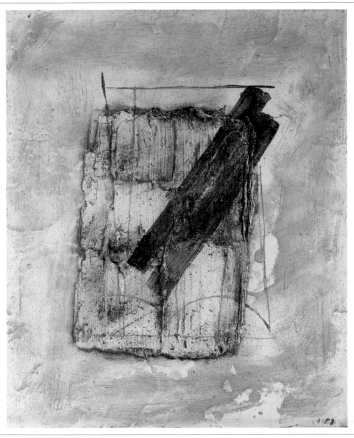

Jean Fautrier. b Paris (FR), 1898. **d** Châtenay (FR), 1964.

The Jack of Clubs. 1957. Oil and pigment on paper mounted on canvas. **h**46 x **w**38 cm. **h**18 x **w**15 in. Private collection

Feininger Lyonel

Village Church

The glowing colours of the church in the German village of Gelmeroda and the sweeping hills behind have a romantic, dream-like quality. Feininger began this series of views of the church and town at Gelmeroda in 1912. The writer Hans Hesse wrote: 'The church at Gelmeroda was to Feininger what Mont Sainte-Victoire was to Cézanne, the subject of a lifelong search for new discoveries of hidden meanings, waiting for formal expression.' The geometric structure of the architectural forms is essentially Cubist, combining several different views of the church, while the mood owes something to the great nineteenth-century Romantic landscapists. The dynamic impact of the German Expressionists also looms large. Born in America to a German family, Feininger studied in Germany, exhibiting with the Expressionist group Der Blaue Reiter and teaching at the Bauhaus school. He painted several series of works depicting seascapes, sailing ships, bridges and viaducts.

☛ Cézanne, R Delaunay, Picasso, Utrillo

Lyonel Feininger. b New York (USA), 1871. d New York (USA), 1956.
Village Church. 1915. Oil on canvas. h86 x w100 cm. h33 ¾ x w39½ in. Private collection

Fischl Eric

Bad Boy

A young boy steals a glance at a sprawled naked woman, perhaps his mother, while filching from her purse – an emblem for her vagina. The sensual atmosphere evoked by the striped light from the blinds adds a further sexual dimension. It is a picture full of complexity, ambiguity and erotic symbolism, evoking Oedipal conflicts, secrets and taboos. An unavoidable, complicit voyeurism and embroilment in the drama on the part of the viewer is implied by the interchangeability of the young boy's perspective with ours. Fischl came to prominence in the early 1980s in New York as part of the revival of painting and the emerging Neo-Figurative movement. The illustrative, relaxed brushstrokes and casual style of his large, figurative paintings belie their highly charged, psycho-sexual content. Depicting the suburban lifestyles of the leisured class, Fischl peels back the comfortable surface to expose a world of anxieties, insecurities and repressed desires.

☞ Balthus, De Lempicka, Salle, Sickert

Eric Fischl. **b** New York (USA), 1948.
Bad Boy. 1981. Oil on canvas. **h**168 x **w**244 cm. **h**66 x **w**96 in. Saatchi Collection, London

Fischli & Weiss

Untitled

This installation is a recreation of the setting-up of a museum exhibition. All the materials, including the worker's jacket and shoes, leftover refreshments – a carton of ice tea and a banana – and painting and cleaning materials have been faithfully reproduced in hand-carved, painted polyurethane. The bright colours and the distortion of scale between the objects in the foreground and those in the background create a paradox between the real and the artificial. With witty irony Fischli & Weiss create simulated models of everyday objects using simple sculptural techniques and materials such as clay and rubber. They began collaborating in the late 1970s, playing on clichés of Swiss identity and culture. They have produced a number of bizarre short films including *The Least Resistance*, in which the artists dress up as a giant rat and a panda bear and travel the world in search of knowledge and enlightenment.

☛ Acconci, Bartlett, Brisley, Gober, Oldenburg

Fischli & Weiss. Peter Fischli. **b** Zurich (SW), 1952. David Weiss. **b** Zurich (SW), 1946.
Untitled. 1991. Painted polyurethane objects. **h**3.2 x **w**2.2 x **l**5 m. **h**10'6 x **w**7'3 x **l**16'5 ft. Collection of the artists

Flanagan Barry

Six Foot Leaping Hare on Steel Pyramid

A bronze hare effortlessly hurdles a pyramid made from layers of steel. Caught in mid-flight, it embodies a sense of exhilaration and hope – the hare was traditionally seen as a symbol of life by the Ancient Egyptians and the Chinese. It is one of a series of hares leaping and prancing over obstacles, which was produced by Flanagan from 1979. He used a wide range of materials in his work of the 1960s and 1970s, reflecting the influence of Post-Minimalism, a movement which arose as a reaction to the rigidity and austerity of Minimalism. Using sand,

sacking, polystyrene, rope and light, he produced abstract sculptures which defy rigid principles of geometry and evoke organic forms. In the 1980s, following two decades of radical invention, he returned to traditional materials such as marble, stone and bronze, which he exploited to the full through his animal sculptures and his playful, witty approach. In 1982 Flanagan represented Britain at the Venice Biennale.

☛ Fritsch, Marc, Marini, Wallinger

Barry Flanagan. b Prestatyn (GB), 1941.
Six Foot Leaping Hare on Steel Pyramid. 1990. Bronze and steel. h239 x w188 x l50.8 cm. h94 x w74 x l20 in. Edition of 8

Flavin Dan

Untitled (For Ellen)

Coloured fluorescent tubes punctuate the corner of an otherwise empty gallery, transforming it into a softly glowing niche. Enticing, yet prohibitive, the structure welcomes the eye while simultaneously excluding the body. This forces a two-fold response – the viewer fluctuates between regarding the strips as objects, and contemplating the effect of the light they emit. The title, which suggests that this piece is a homage to a friend or lover whose aura has lingered after her departure, adds an emotional dimension. Flavin's use of the light-fitting as sculpture is a new take on the ready-made, altering the entire focus of the gallery space. Our attention is drawn to what is usually inconspicuous, in a fragile relationship that hinges upon the flick of a switch. A self-taught artist, Flavin is linked to Minimalism because of his concern with architectural space and subtle intervention. His embrace of light as medium, however, is timeless.

☛ Judd, LeWitt, Merz, Morris, Nauman, Opie, Turrell

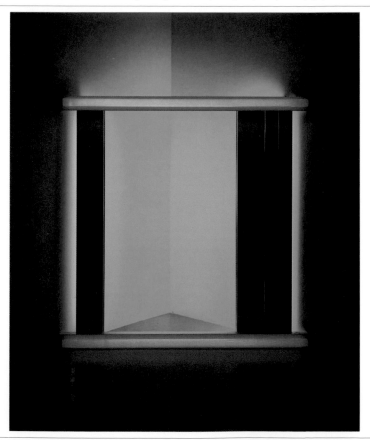

Dan Flavin. **b** New York (USA), 1933. **d** Long Island (USA), 1996.
Untitled (For Ellen). 1975. Pink, blue and green fluorescent light. **h**224 cm. **h**88¼ in.
As installed at the Donald Young Gallery, Seattle, WA, 1994

Fontana Lucio

The End of God

A pink, egg-shaped canvas is peppered with numerous clusters of puncture marks, revealing the blank space behind. This is one of a series of works in which Fontana made single cuts or holes in the canvas, and represents the artist's ultimate gestural act. The puncture marks and gashes were made to draw attention to the infinite space behind the canvas, making the void beyond the flat surface as much a part of the work as the canvas itself. Unlike figurative painters, who create the illusion of space, Fontana attacks his canvas, bringing actual space into his work. This rejection of the traditional space of the canvas, and the movement of the work into the real space of the gallery is typical of Spazialismo, an avant-garde group of which Fontana was a founder member. Fontana's cerebral approach to painting and his move away from the emotive abstraction of many European artists paved the way for Conceptual Art.

☛ Huang, Klein, Pollock, Rothko, Schnabel, Turnbull

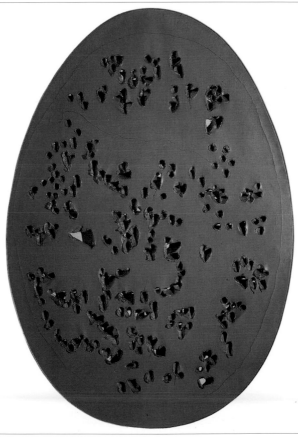

Lucio Fontana. **b** Rosario di Santa Fé (ARG), 1899. **d** Varese (IT), 1968.
The End of God. 1963. Oil on canvas. **h**178.1 x **w**123.2 cm. **h**70⅛ x **w**48½ in. Private collection

Förg Günter

Rivoli

The contrasting areas of orange and green are juxtaposed on the canvas, painted with easy, light brushstrokes, clearly visible in broad vertical and horizontal trails. The instinctive touch and subtle handling reflect Förg's rapid, fluent method of working within the constraints of the geometrical design. The finished surface is soft and serene, and has a simple beauty which evokes a wistful and spiritual longing. The plain bands of colour owe much to the Abstract Expressionism of Newman and Rothko, but Förg's work is much fresher and less contemplative.

Förg has also produced bas-reliefs in bronze, paintings on lead and occasionally, photographs. He often creates his paintings in closely related series or suites which are then exhibited together as a single installation. For Förg, these sequences have a sense of place which relates both to the internal architecture of the gallery, and to the space beyond.

☞ Avery, Newman, K Noland, Rothko

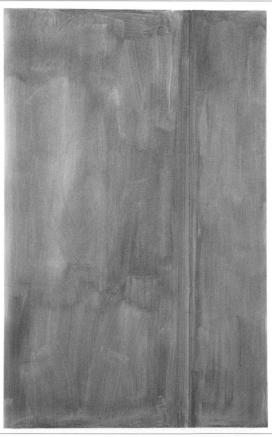

Günther Förg. **b** Füssen (GER), 1952.

Rivoli. 1989. Acrylic on canvas. **h**220 x **w**140 cm. **h**86⅔ x **w**55⅛ in. Galerie Barbel Grässlin, Frankfurt

Foujita Tsugouharu

My Studio: View of Paris

This inviting image shows a view from the artist's studio looking towards Montmartre and the Sacré Cœur in Paris, home to so many of the great early twentieth century artists. A powerful and uplifting spatial effect is created through the convergence of the clouds at the top of the picture. The window is open for us to pass through onto the veranda, where a solitary potted plant – symbol of the artist – awaits us. Foujita was the first Asian to belong to the School of Paris. He brought with him from Japan a graphic tradition of linear design and fused this with a measured application of the innovations of such artists as Matisse and Dufy. He spent most of his life in Paris where he converted from Buddhism to Roman Catholicism. Many of his works include animals, especially cats, which are often depicted sensuously nestling up to their attractive mistresses. He also produced nudes, landscapes, book illustrations and a series of tender, Christian devotional paintings.

☛ **Dufy, Magritte, Matisse, Utrillo**

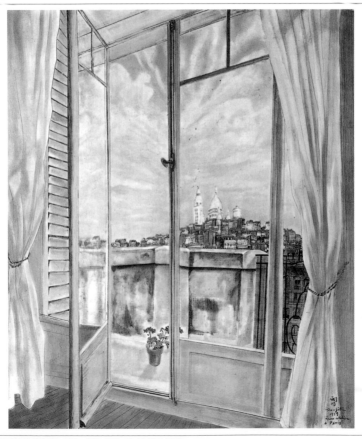

Tsugouharu (Léonard) Foujita. **b** Tokyo (JAP), 1886. **d** Zurich (SW), 1968.

My Studio: View of Paris. 1939. Oil on canvas. **h**55 x **w**46 cm. **h**21¾ x **w**18⅛ in. Private collection

Francis Sam

Untitled

The canvas is filled with a loose, fluid mass of abstract colour. The flatness of the image is accentuated by the shifting forms that drip and merge into one another. This subtle image encourages contemplation, like the Abstract Expressionist work of Rothko, one of Francis's contemporaries. His saturated fields of colour also reveal the influence of the contemplative quality of Japanese abstract art. Primarily interested in transforming different sensations of light onto canvas, Francis was influenced by the light of California, where he lived and worked, and by Monet's *Waterlilies* series. Having absorbed the early work of Gorky and Rothko in the United States, he moved to Paris to study at Léger's influential school. Despite the apparent spontaneity of his compositions, Francis was highly methodical and rigorous. In his later work he pushed out the abstract forms to the edges of the composition, leaving large empty spaces in accordance with the Oriental notion of negative space.

☛ Frankenthaler, Gorky, Léger, Monet, Rothko, Tobey

Sam Francis. **b** San Mateo, CA (USA), 1923. **d** Santa Monica, CA (USA), 1994.

Untitled. 1956. Oil on canvas. **h**370 x **w**240 cm. **h**145¾ x **w**94½ in. Louisiana Museum of Modern Art, Humlebaek

Frankenthaler Helen

The Other Side of the Moon

A red circle, possibly a symbol for the moon, is surrounded by a web of lines, tracing their way across the paper. The vivid purple, blue and green colour scheme gives this work a brooding feel. Although the painting is abstract in form, the title suggests that it represents the natural world. Frankenthaler was married to the Abstract Expressionist Motherwell, but despite her close association with the movement, her technique was quite different from theirs: she poured pigment onto the canvas or paper, avoiding painterly brushstrokes. Her method of staining the unprimed canvas with paint to achieve immediacy and transparency inspired Noland and Louis, after their visit to her studio. A fluid use of colour runs throughout her work and her large paintings of the 1960s take this idea to the extreme by pushing small, select strips of colour to the edges of the canvas, leaving the centre blank. Frankenthaler was a pupil of Tamayo, and her varied work is more serene and diaphanous than that of her contemporaries.

☛ Gorky, Louis, Motherwell, K Noland, Pollock, Tamayo

Helen Frankenthaler. b New York (USA), 1928.
The Other Side of the Moon. 1995. Acrylic on paper. **h**179.4 x **w**162.6 cm. **h**70⅝ x **w**64 in. Knoedler Gallery, New York

Freud Lucian

Leigh under the Skylight

The Performance artist Leigh Bowery stands on top of a table, his head nearly touching the skylight in this claustrophobic composition. Every element has been mercilessly scrutinized to produce a startling painting. The light from the windows catching the heavy frame of the model, the tablecloth, the distorted perspective of the room – each is painted with expressive brushstrokes in densely worked oils. A massive figure in every sense, Bowery is the subject of a series of portraits by Freud. Best known for his outlandish costumes, Bowery naked

is the perfect embodiment of Freud's ability to strip bare his subject psychologically. In the 1950s, the meticulous detail of Freud's early paintings was replaced by a more visceral approach. Changing fine sable brushes for hog hair, Freud began to sculpt with paint, taking to new levels his pitiless observation of flesh. The grandson of the psychoanalyst Sigmund Freud, the artist has been the subject of major retrospectives throughout the world.

☞ **Auerbach, Corinth, Kossoff, Schad, Spencer**

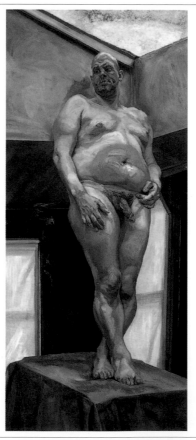

Lucian Freud. b Berlin (GER), 1922.
Leigh under the Skylight. 1994. Oil on canvas. **h**297.2 x **w**120.6 cm. **h**117 x **w**47½ in. Acquavella Contemporary Art, Inc., New York

Freundlich Otto

Composition

Interlocking rectangles and wedges of colour are combined like a mosaic to produce a solid, architectural structure, enhanced by the textured surface of the paint. Subtle changes in hue from sombre to bright suggest the effect of natural light on the surface, and give the work the rich atmosphere of evening. The reduction of subject matter to abstract, geometric shapes of different colours is reminiscent of the work of the Constructivists, an international group of artists who pared down art to its abstract essentials. Although of German origin, Freundlich settled in Paris in the early 1920s, where he initially exhibited with the Cubists, renting a studio near Picasso in the Bateau-Lavoir. Freundlich was condemned by the Nazis at the 'degenerate' art exhibition of 1937, and after war broke out he was eventually arrested in the Pyrenees where he was living. He later died in Majdanek, a concentration camp near Lublin in Poland.

☞ Bill, Domela, Hélion, Klee, Picasso

Otto Freundlich. b Stolp (GER), 1878. d Lublin (POL), 1943.
Composition. 1930. Oil on wood panel. h147 x w113 cm. h57⅞ x w44½ in. Musée de Pontoise, Cergy-Pontoise

Frink Elisabeth

Soldier's Head IV

The heavy-jawed face with its stern, downturned mouth, cauliflower ear, broken nose and deep-set eyes is characteristic of many of Frink's bronze heads. Pared down to its essentials, the sculpture is made up of powerful and strong lines and forms, expressive of character. Frink's soldiers' heads attack male aggression, aiming to reveal the stupidity, feeble machismo and futility of war. Refusing to acknowledge the Classical concept of heroism, Frink preferred to show her subjects as frightened and dazed. This theme attracted great sympathy from the feminist movement. Frink was a younger member of a new generation of sculptors – including Paolozzi – who used animal and human forms to express the anguish of the post-war period. Gaining recognition in the early 1950s, Frink sculpted many bronzes of horses, birds, dogs and pigs, as well as society portraits and some memorable church commissions.

☛ Close, Epstein, Giacometti, González, Paolozzi

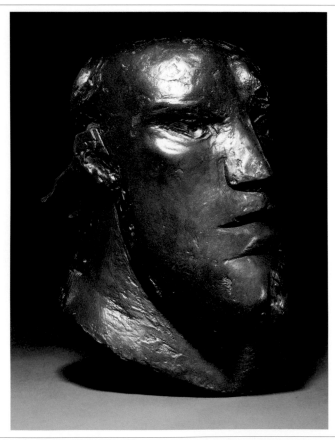

Elisabeth Frink. b Thurlow (GB), 1930. d Woolland (GB), 1993.
Soldier's Head IV. 1965. Bronze. h35.6 cm. h14 in. Beaux Arts, London

Fritsch Katharina

Rat King

This imposing sculpture consists of a ring of identical, giant-sized, rats made of polyester resin. Arranged with their noses pointing outwards and their tails entwined in the centre, they form the shape of a crown. Fritsch has meticulously crafted *Rat King* using sophisticated modern manufacturing techniques and materials, working from an initial image to produce objects resembling mass-produced goods found in shops. But this sense of familiarity and the humorous quality of the work is accompanied by equal feelings of ambiguity and unease, generated by the huge scale of the work, which is nearly three metres high, and the sinister connotations of the rats, traditionally a symbol of evil. Fritsch's sculptures have included a yellow Madonna, a life-sized elephant and a room-sized table around which sit eerily identical men. Their scale, monochromatic colour scheme and stark expressions evoke a similarly compelling yet unsettling response.

☞ Flanagan, Koons, Marc, Rothenberg

Katharina **Fritsch**. b Essen (GER), 1956.
Rat King. 1993. Polyester resin. **h**2.8 x **diam.** 13 m. **h**9 x **diam.** 42'8 ft. Dia Center for the Arts, New York

Funakoshi Katsura

Distant Rain

This carved wooden figure, cut off at the waist, stands bolt-upright, staring into the distance with his cold, blue, marble eyes. The body seems wrapped in a thin veil of mist, or perhaps submerged below water. The title and the powerful sense of tranquility emanating from the figure suggest that it is meditating in a silent, rainy landscape. This sculpture is not just a portrait but also a representation of universal humanity, an everyman derived from drawings and photographs of real people. Funakoshi carves his figures from blocks of fragrant camphor wood, painting them in a highly realistic manner, though the illusionistic effect is deliberately undermined by the fact that the wood grain always remains visible. His sculpting technique owes much to traditional Japanese carving, inspired by ancient Buddhist temples, but it also acknowledges the European tradition of figurative stone-carving found in Gothic cathedrals.

☞ Epstein, Frink, Giacometti, Hanson, Nadelman

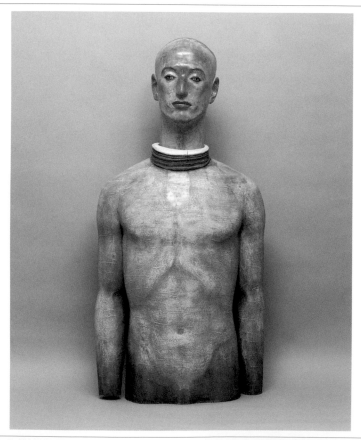

Katsura Funakoshi. b Morioka City (JAP), 1951.

Distant Rain. 1995. Polychromed camphor wood and marble. h102 cm. h40⅛ in. Collection of the artist

Gabo Naum

Construction in Space: Crystal

This sculpture, made out of perspex – a new material at the time – has a luminous brilliance and lightness. The curves and spokes interact to create a gentle rhythm, and the solid elements are delicately balanced by the empty spaces. The reduction of form to its abstract, geometric essentials links this work to Constructivism, of which Gabo was a leading exponent. He believed that sculptures should interact with the space around them, rejecting the idea that they should just be static entities. To achieve this he created kinetic, or moving sculptures

and works made from transparent or highly polished materials which would give the impression of weightlessness. Born in Russia, Gabo was forced into exile after the Revolution, along with many other Russian artists. After a period in Paris, he eventually settled in Britain where he had an enormous influence on British artists such as Hepworth and Nicholson.

☛ **Domela, Hepworth, Lissitsky, Nicholson, Tatlin**

Naum Gabo. b Briansk (RUS), 1890. **d** Waterbury, CT (USA), 1977.
Construction in Space: Crystal. 1937. Perspex. **h**22.9 cm. **h**9 in. Private collection

Gargallo Pablo

Dancer

A ballerina performs a pirouette, her skirt billowing out behind her as she moves. Made of welded copper, the figure has a lightness, freedom and dynamic sense of movement. The artist excludes all peripheral detail, concentrating on capturing the essence of the dancer's movement. Gargallo was astonishingly adept technically, making the difficult materials with which he chose to work appear plastic and malleable. His first trip to Paris from Barcelona in 1903 proved to be seminal, and he continued to gain inspiration from the different movements and artists living there for the rest of his career. Starting out with traditional materials such as bronze and stone, Gargallo juxtaposed concave and convex forms. In 1907 he made a major breakthrough when he began to develop experimental projects in copper and sheet-metal, cutting the materials into thin strips to represent hair, as here. He is also known for his series of iron, lead and copper masks.

☞ **Matisse, Nadelman, Richier, Segal**

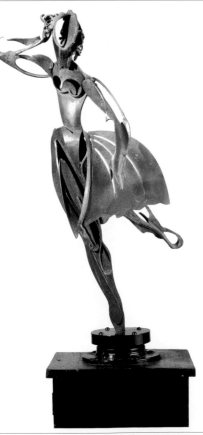

Pablo Gargallo. **b** Maella (SP), 1881. **d** Reus (SP), 1934.
Dancer. 1934. Welded copper. **h**78 cm. **h**31 in. Private collection

Gaudier-Brzeska Henri Bird Swallowing Fish

In this tactile, dramatically balanced sculpture, a bird struggles to swallow a whole fish. The bird's bulging eyes and awkward leg, and the glum fish, convey a naïve, anthropomorphic comedy. The inventive genius of this bronze illustrates the tremendous potential of the French sculptor whose death at the age of 24 cut short a promising career. By concentrating on the patina of dark green bronze, Gaudier-Brzeska allies himself with other early twentieth-century, avant-garde sculptors who aimed to maximize the potential of their materials, using the colour and texture of their preferred medium to evoke the subject of the work. Abandoning his initial alliance to Rodin's realism, Gaudier-Brzeska became more influenced by sculptors such as Epstein and Brancusi. While in the army he continued to make small sculptures. Despite his tragic early death in the trenches, the body of work he left behind reveals a rich and imaginative mind.

☛ **Brancusi, Epstein, Flanagan, Rodin**

Henri Gaudier-Brzeska. b St-Jean-de-Braye (FR), 1891. d Neuville-Saint-Vaast (FR), 1915.
Bird Swallowing Fish. c1913–14. Bronze. **h**31.8 cm. **h**12½ in. Private collection

Gauguin Paul

The Invocation

A naked woman raises her arms in prayer, while two others look on. Set in the paradisiacal landscape of Tahiti, where Gauguin lived, these exotic and dignified figures demonstrate his celebration of the 'noble savage' and his passion for so-called Primitive cultures. The rich and atmospheric colour scheme of deep green, blue and purple adds to the lyrical mystery of the work. Since his early childhood in Peru, Gauguin had developed a taste for faraway places and a voracious appetite for non-Western cultures. Giving up his career as a stockbroker at the age of 40 Gauguin became a full-time painter. Although he initially exhibited with the Impressionists, he soon developed his own unique style of flatly coloured shapes and heavy contours. Though he died in poverty and obscurity in the Marquesas Islands, his rejection of naturalism and his enthusiasm for Primitive art had a huge impact on the development of modern art.

☞ Boyd, Cézanne, Matisse, Pechstein, Picasso

Paul Gauguin. b Paris (FR), 1848. d Atuona (MI), 1903.

The Invocation. 1903. Oil on canvas. h65.5 x w75.6 cm. h25¾ x w29¾ in. National Gallery of Art, Washington, DC

Geva Avital

A Greenhouse: Sun, Water, Plants, Fish, People

This work is a fully functioning, experimental greenhouse. A creative laboratory, it is a union of nature, culture, science and technology, all brought together to present a real solution to the concrete problem of food production. The Hebrew sign on the left refers to the intensive breeding of fish. Blurring the line between art and life and the distinction between the work of the 'sophisticated' artist and the farm labourer, this work unites human endeavours with a communal ideology. Concepts of recycling, renewal and the regeneration of waste materials are also central to the ecological system set up in this piece. Much of Geva's work has been made outside an art context, and for several years he boycotted exhibitions and museums. His Conceptual and political approach to art owes much to his experiences of life on a kibbutz, which he joined to the Israel Museum in Jerusalem through an extension of road markings. He has also organized political demonstrations and made public artworks from manure.

☛ Fischli & Weiss, Grippo, Haacke, Tiravanija

Avital Geva. b Kibbutz Ein Shemer (IS), 1941.
A Greenhouse: Sun, Water, Plants, Fish, People. 1977–96. Metal, plastic, plants, fish, water, sun, people and soil. Dimensions variable.
As installed at the Venice Biennale, 1993

Giacometti Alberto

Diego

The artist's brother, Diego, stares straight ahead with unflinching intensity. The elongated head and the restless manipulation of the surface are typical of Giacometti, who spent his life obsessively trying to reproduce the appearance of the human form, both in painting and sculpture. The rough, pitted texture of his sculptures reflects his method of relentlessly building up and destroying the work until he felt unable to continue. Seeing space as an endless abyss in which his lonely figures were situated, Giacometti would often dramatically shrink them to emaciated proportions. These attenuated figures, sometimes alone, sometimes standing or walking in silent groups, express a painful vulnerability. This sense of isolated individualism led the writer Jean-Paul Sartre to identify Giacometti as the pre-eminent existentialist artist. Though involved with Impressionism, Cubism and Surrealism early in life, Giacometti cannot be classified by any artistic movement.

☞ Close, Frink, Richier, Rodin

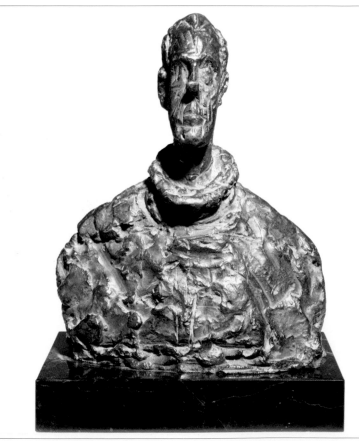

Alberto Giacometti. b Stampa (SW), 1901. d Chur (SW), 1966.
Diego. c1950. Bronze with dark brown patina. h27.5 cm. h10¾ in. Private collection

Gilbert & George

Flying Shit

The artists themselves perch on up-ended turds and fly naked across the sky on comets of shit. This work is composed of a formal grid of panels, within which the artists broach life, death and sexuality head on. Their aim is not to shock but to make art as accessible as possible to the public, to 'de-shock', as they put it. Gilbert and George often produce groups of works on the same theme, and this piece forms part of the 'Naked Shit' series. The artists have worked together ever since leaving college, making themselves the subject of their work. Between 1969 and 1972, they became 'living sculptures', acting out their lives in public and identifying all everyday actions as 'sculptural', thus pushing the term to its limits. As well as producing photo-works such as this one, Gilbert and George have also made videos, books, drawings and Performance pieces, one of which involved them miming for several hours to a song played over and over again.

☛ Modigliani, Mullican, K Smith, Ulay & Abramovic

Gill Eric

Ecstasy

A man and a woman are locked in a passionate embrace, their arms and legs entwined. The woman's eyes are closed in ecstasy as she holds her lover close to her. The heavy and simplified forms are typical of Gill and reveal his interest in Primitive art. This work has been carved directly into the stone, a method Gill adopted instead of the more usual technique of making a preparatory model for a sculpture, as practised by artists such as Rodin. The primal sense of eroticism reflects the overt sensuality which characterizes much of Gill's work, and was,

unsurprisingly, deeply shocking in pre-war Britain. This particular piece was relatively recently discovered in a boathouse by the artist's nephew. Gill's conversion to Roman Catholicism in 1913 did little to stem the flow of his sexual themes. He is also famed for his *Stations of the Cross*, a series of relief carvings made for London's Westminster Cathedral, and for his typographical innovations which made an important contribution to the revival of book design.

☛ Boyce, Chagall, Laurens, Lipchitz

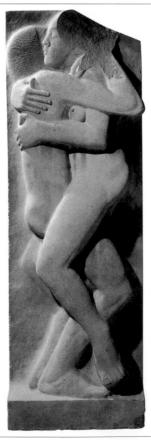

Eric Gill. **b** Brighton (GB), 1882. **d** Uxbridge (GB), 1940.
Ecstasy. 1910–11. Stone. **h**137.2 cm. **h**54 in. Tate Gallery, London

Gironella Alberto

Queen Riqui

The image of a queen is reduced to a network of coloured, impastoed lines, the gaudy frame recalling Mexican folk art. Based on *Queen Mariana* by the seventeenth-century Spanish painter Diego Velázquez – an image which Gironella copied many times – this work is a metaphor for Mexico's colonial past and present. The title refers to the artist's ex wife, Carmen Parra: 'Riqui' was her nickname. Throughout his career, Gironella tried to tackle a problem central to twentieth-century Latin American art: how to develop an original and autonomous artistic identity out of a hybrid heritage linked to the great European tradition of painting. The unavoidable legacy of conquest and colonization was central to his concerns, and his ironic reworkings of paintings by European Old Masters is evidence of his ambivalence towards his artistic heritage. Hailed as Surrealist by André Breton, Gironella's work has been difficult to classify and this is undoubtedly its strength.

☛ Hodgkin, Kirkeby, Kline, Mitchell

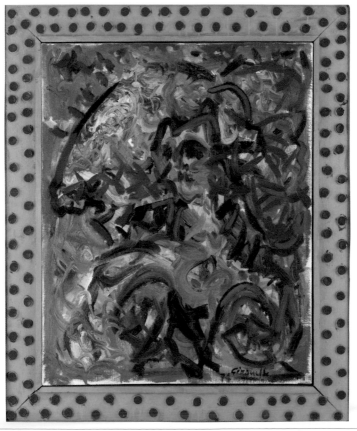

Alberto Gironella. **b** Mexico City (MEX), 1929. **d** Mexico City (MEX), 1999.

Queen Riqui. 1974. Oil on canvas. **h**122 x **w**102 cm. **h**48 x **w**40⅛ in. Museo de Arte Moderno, Mexico City

Gleizes Albert

The Hunt

Visible through a complex patchwork of colours and shapes are the figures of four red-coated huntsmen. The one in the foreground with his back to the viewer has a hunting horn slung under his arm. In the background, looking on, stand a shepherd and his family. A village is just visible on the horizon. The dislocated and hard-edged forms link this work to Cubism. However, the dramatic subject is at odds with Cubism's focus on still life and portraits. Gleizes worked as a designer before taking up painting full time. He was a founder member of the Section d'Or, a group of young artists including Duchamp, Metzinger and Léger, who broke away from the original Cubists to concentrate on theories of ideal proportions and the beauty of geometric forms. They rejected Cubism's exclusion of perspective and all but still-life themes, wishing to portray life in all its richness. Together with Metzinger, he wrote the influential book *On Cubism* in 1912.

☞ **Duchamp, Léger, Marc, Metzinger, Weber**

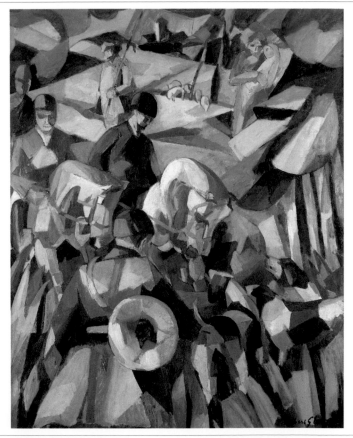

Albert Gleizes. **b** Paris (FR), 1881. **d** St Remy (FR), 1953.
The Hunt. 1911. Oil on canvas. **h**124 x **w**99 cm. **h**48¾ x **w**39 in. Private collection

Gober Robert

Wedding Gown

Gober designed and made *Wedding Gown* himself, using bridal magazines as source material. Shown here as part of an installation, *Wedding Gown* is set against the background of Gober's controversial wallpaper, depicting a black man hanging while a white man sleeps. The juxtaposition of the two elements strikes a discordant note and conveys a deep sense of unease. The white bridal gown symbolizes moral and bodily purity, yet its benign ritual status belies an oppressive sexual stereotyping that encourages prejudice and exclusion.

The wallpaper underlines the complacency of white, male privilege. Gober's art is influenced by his experiences as a gay man attempting to define his identity in a predominantly heterosexual world. In this respect, his work parallels that of feminist artists who challenge masculine assumptions and the values of contemporary American society.

☞ Fischli & Weiss, Horn, K Smith, Sterbak, Trockel, Wilke

Robert Gober. b Wallingford, CT (USA), 1954.
Wedding Gown. 1989. Silk satin, muslin, linen, tulle and welded steel. h137.8 cm. h54¼ in. Private collection

Goldin Nan

Misty and Jimmy Paulette in a Taxi, NYC

In this photograph of two of the artist's transsexual friends taken on the day of the Gay Pride parade in New York, Goldin is neither voyeuristic nor sentimental. Through her intimacy and affection for her subjects she reveals their vulnerability as well as her own admiration for their overt sexuality and glamour. Goldin takes her photographs directly from life. She concentrates on her extended family of friends and lovers – the people who surround her, sharing the same pleasures and pains. It is a life on the edge: a *demi-monde* of hard-living,

drug-abuse, love, sex, survival, violence, and the ever-present shadow of death. There is an absence of deliberation in Goldin's photographs, as though they are snapshots from a family album, and it is this realism and unpretentious style which makes her photographic diary a truthful, compelling record of her life. Goldin is best known for her slide show, *The Ballad of Sexual Dependency*, which has been shown in theatres, film festivals, museums and galleries.

☞ **Birch, Dali, Laurens, A Piper**

Nan Goldin. b Washington, DC (USA), 1953.
Misty and Jimmy Paulette in a Taxi, NYC. 1991. Cibachrome print. **h**76.2 x **w**101.6 cm. **h**30 x **w**40 in. Multiple edition

Goldstein Zvi

Future

In this relief, a silver coloured, tapering octagon is held in place by a pair of semicircular discs each bearing the word 'Future'. Above, in red, is the slogan 'Eschatology', a branch of theology concerned with the end of the world. Combining elements of Russian Constructivism with the use of text, Goldstein's work takes on an ideological stance, as if part of a manifesto. This is typical of his approach: much of his work aims to explore and expose the imbalances between First and Third World cultures reflecting the need for Western countries to address the problems of other societies. His paintings and related sculptures depict ambiguous, functionless objects, resembling mechanical tools. Goldstein's work owes much to the Conceptual Art movement of the mid-1960s, in which the idea behind a work was believed to be more important than the work itself. Originally from Romania, Goldstein lives in Israel where his interest in cultural plurality has a particular relevance.

☛ Brancusi, Severini, Vasarely, Zorio

Zvi **Goldstein**. b Cluj (ROM), 1947.

Future. 1985. Painted aluminium relief and silkscreen. **h**55 x **w**48 x **l**8 cm. **h**21¾ x **w**18⅞ x **l**3⅛ in. Collection of the artist

Goldsworthy Andy

Maple Leaf Lines

A line of vivid, red maple leaves floats in a mountain stream. Delicate and rhythmic, this work has been produced with minimal intervention in the landscape. Like the Land artists of the late 1960s, Goldsworthy has an intimate involvement with the earth's own resources. Balancing spiralling structures of rocks, sticks and leaves, he explores the natural bonds and tensions that exist in nature. His most ambitious works have been dictated by changes in climate. He once made a series of large snowballs, which were put together during the night, and fell apart in the morning sun to reveal an inner structure of twigs or pebbles. Because of the transience of much of Goldsworthy's work, it generally remains solely in the form of a photographic record. Far less intrusive than the work of his predecessors, Goldsworthy's art reflects a change in attitude to the environment. The vogue for this New Age brand of Earth Art reached its peak during the mid-1980s when Goldsworthy was the subject of a number of major exhibitions.

☛ Baumgarten, Long, Monet, G Orozco, Smithson

Andy Goldsworthy. b Sale (GB), 1956.
Maple Leaf Lines. 1987. Maple leaves. Dimensions variable. As installed at Ouchiyama-Mura, Japan

Golub Leon

Mercenaries IV

The hard-hitting realism of this painting graphically reflects the aggressive nature of the mercenary, and the associated world of sanctioned killing, terror and atrocity. The painting has a raw, porous surface, achieved by dissolving areas of paint, scraping them down – often with a meat-cleaver – then building them back up again. There is great tension in the composition. Against the charged space of the abstract background, mercenaries of the same outfit are shown turning on each other in a moment of habitual hostility. Golub refers to media images to ensure authenticity in dress, weaponry and gesture. The location, perhaps Africa or Latin America, is unspecified, implying a critique of violence as a universal social phenomenon. Violence is Golub's central theme and for many years he was seen as peripheral, working against the fashions in the art world. However, in the late 1970s, as interest grew both in a more political art and in figurative painting, Golub became recognized as a pivotal artist of his time.

☛ **Baldessari, Dittborn, Howson, Severini**

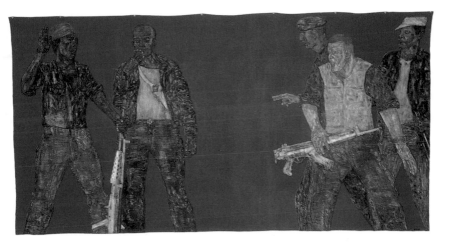

Leon Golub. b Chicago, IL (USA), 1922.
Mercenaries IV. 1980. Acrylic on canvas. **h**305 x **w**584 cm. **h**120 x **w**230 in. Saatchi Collection, London

Gontcharova Natalia

The Ice Cutters

Two hunched figures cut blocks of ice which a third carries to a waiting pony and trap. The fairy-tale atmosphere of this Russian snowscape conveys the naïveté and charm characteristic of Gontcharova's early work. The figures have a childlike quality, while the reduction of form to simplified geometric shapes owes much to the work of the Parisian avant-garde of the time. Gontcharova often produced flat and brilliantly coloured compositions using Russian folklore as subject matter. She and her husband, the painter Larionov, were key figures in the Russian avant-garde in the first decade of the century. She is perhaps best known for her contribution to Larionov's Rayonnist movement, the essence of which he described as 'spatial forms arising from the intersection of reflected rays of various objects, forms, chosen by the will of the artist'. In 1916 the couple left Russia and settled in Paris where Gontcharova began designing sets for Sergei Diaghilev's Russian Ballet.

☛ Feininger, Larionov, Macke, Marc

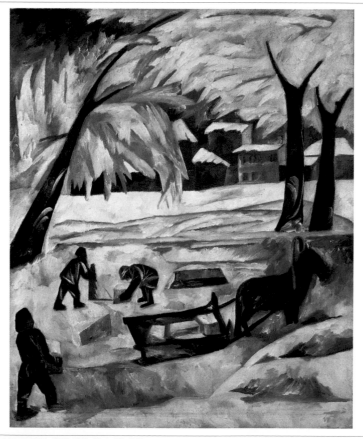

Natalia Gontcharova. b Tula (RUS), 1881. d Paris (FR), 1962.
The Ice Cutters. 1911. Oil on canvas. **h**118.7 x **w**97.8 cm. **h**46¾ x **w**38½ in. Leonard Hutton Galleries, New York

González Julio

Head of Screaming Montserrat

A peasant woman, wearing a headscarf, tips back her head and cries out in pain. By calling her 'Montserrat', after the mountain outside Barcelona, González relates the suffering of the common people during the Spanish Civil War to the rough, enduring nature of the Spanish landscape itself. This particular work, made during the Second World War, expresses the distress and anguish endured in wartime. González trained as a metalworker in his father's workshop, but took evening classes in painting. The family moved to Paris in 1900 and

González became friendly with fellow Spaniard Picasso, whom he taught to weld. González in turn learned from Picasso, his increasingly abstract style owing much to Cubism. He started out by making metal masks, influenced by African art, and subsequently went on to construct figures from sheet metal. Towards the end of his life, in the late 1930s and early 1940s, he produced some works of a more realistic nature, including this bust.

☞ Ader, Barlach, Frink, Picasso

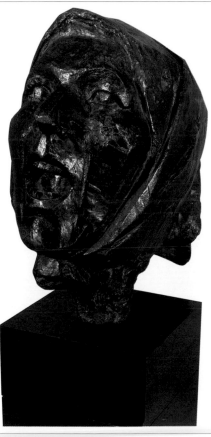

Julio González. b Barcelona (SP), 1876. **d** Arcueil (FR), 1942.
Head of Screaming Montserrat. c1942. Bronze. **h**31 cm. **h**12¼ in. Peter Stuyvesant Foundation Limited, Aylesbury

Gonzalez-Torres Felix

Untitled (USA Today)

The works of Gonzalez-Torres are often discreet and ephemeral, and are invested with an understated yet persuasive humanism. *Untitled (USA Today)* is a great mound of sweets, spilling out from its corner position across the gallery floor. Viewers are invited to take one of the sweets, and in doing so to participate in an act of social communion, receiving a small gift which completely reverses the normal process of gallery commerce, where usually nothing is given away for free. The heap is replenished every day, making the artist's act of giving unlimited and infinite. Gonzalez-Torres has also made similar works with bubble gum, fortune cookies and free souvenir posters. His desire to break down the formal relationship between art and the viewer was further developed in his public billboard projects in which he dealt with more direct political issues like the history of the gay liberation movement. His is a political art of quiet optimism which gently insists on a better, more understanding society.

☞ Brisley, Meireles, Tiravanija, West

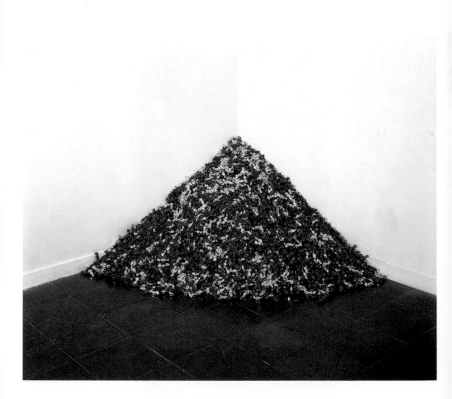

Felix Gonzalez-Torres. b Guáimaro (CU), 1957. d Miami, FL (USA), 1996.
Untitled (USA Today). 1990. Red, silver and blue wrapped sweets. Dimensions variable. Dannheisser Foundation, New York

Gordon Douglas

Hysterical

Hysterical is a grainy, black and white medical documentary found by the artist and shown on two adjacent screens. One projection runs in slow motion, which creates a bizarre, disturbing effect, bordering on slapstick comedy. The masked woman is having a fit and is attended by two doctors. They engage in a highly dubious treatment which involves rubbing her stomach and then literally bouncing her on the ground. Her fit seems to have been arrested and the two men look into the camera and smile. What at first appears to be a hospital is actually a crude film set, and the three characters are actors working from a script; the film is possibly an early training vehicle. The viewer is left to question the relationship between madness, science and art. Gordon's earlier work was closer to the Conceptual pieces of Kawara and Weiner, in terms of its focus on the idea rather than the means of expression. Using lists of names and isolated sentences he examined memory, language and cultural history.

☞ Barry, Hill, Hiller, Kawara, Viola, Weiner

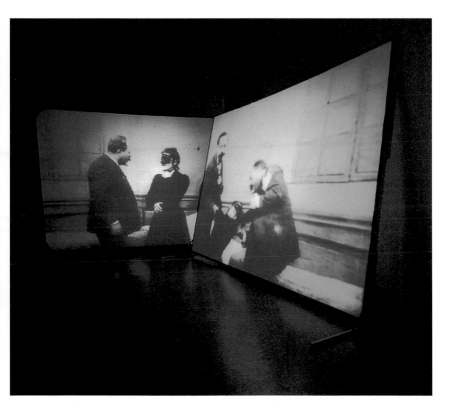

Douglas Gordon. **b** Glasgow (GB), 1966. 171

Hysterical. 1995. Video installation. Dimensions variable. As installed at the Venice Biennale

Gorky Arshile

One Year the Milkweed

In this powerful and emotional work, the paint seems to take on a life of its own, flowing and spreading across the canvas in washes of purple, grey and brown. It produces a veil through which the abstract forms derived from organic shapes such as flowers, milkweed and cocoons can be vaguely discerned. The images extend across the whole surface of the canvas, drawing the viewer into the picture. The use of abstract, organic forms in this composition owes much to Surrealism and the abstract language of Miró and Kandinsky, while the

gestural method of painting was to lay the foundations for American Abstract Expressionism. Forced to flee his native Armenia, Gorky arrived in the United States in 1920. The myths and folk art of Armenia were to have a lasting influence on his work. His later life was marked by tragedy: a fire in his studio destroyed most of his work; he was involved in a car crash in which his neck was broken, and as a result he committed suicide in 1948.

☛ **Francis, Frankenthaler, Kandinsky, Matta, Miró**

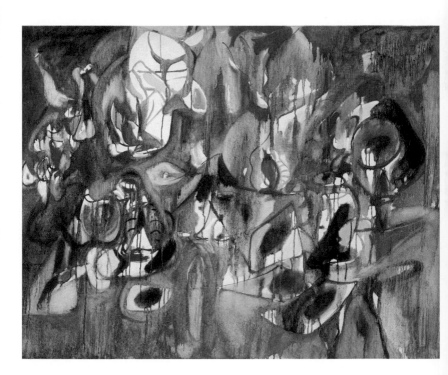

Arshile Gorky. **b** Khorkom Vari (ARM), 1904. **d** Sherman, CT (USA), 1948.
One Year the Milkweed. 1944. Oil on canvas. **h**94.2 x **w**119 cm. **h**37 x **w**46⅞ in. National Gallery of Art, Washington, DC

Gormley Antony

A Case for an Angel II

The mighty, outstretched wings of this powerful, graceful figure express the idea of soaring freedom. Yet they are also a perpetual handicap, trapping the figure in the gallery space. An exercise in perfect but seemingly impossible balance, the sculpture is poised and meditative, possessing an air of introspection and containment. This is one of many figures which Gormley makes by casting his body in plaster and encasing the mould in lead. By means of this gruelling and dangerous process, he attempts to understand different states of being and his relationship with his own body, ultimately reaching out to find universal and spiritual bonds with his audience. His works are often situated in public spaces, such as town squares, or out in the natural landscape. Recently, Gormley received widespread attention and acclaim for *Field*, a great expanse of 40,000 miniature terracotta figures, produced in collaboration with the local inhabitants of each place in which he exhibited the work.

☛ Brancusi, Rodin, Segal, D Smith

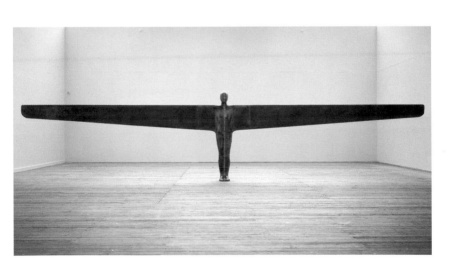

Antony Gormley. **b** London (GB), 1950.
A Case for an Angel II. 1990. Plaster, fibreglass, lead, steel and air. **h**197 x **w**858 x **l**46 cm. **h**77 x **w**344½ x **l**18 in.
Contemporary Sculpture Centre, Tokyo

Gottlieb Adolph

The Enchanted Ones

In this work Gottlieb uses what he called his 'pictographic' style – panels divided into chequerboard compartments – in order to evoke a mysterious and mythic narrative. Fear and death were his major themes at this time, and here he depicts the victims of the Second World War (the 'Enchanted' of the title) rising up as bird-like spirits. Gottlieb collected Primitive and American Indian art, and in this work his imagery is influenced in particular by the art of the Eskimo peoples of Alaska: the head in the top left-hand corner is similar to their designs. The colours evoke a spiritual, ethereal mood, which adds to the sacramental air of the painting. Gottlieb was later associated with the bold, spontaneous Abstract Expressionist movement, but some of his most interesting work dates from the period before it emerged. His automatic paintings based on unconscious mental activity established him as one of the first Americans successfully to absorb Surrealist ideas.

☛ Dittborn, Gorky, Klee, Nevelson, Rothko

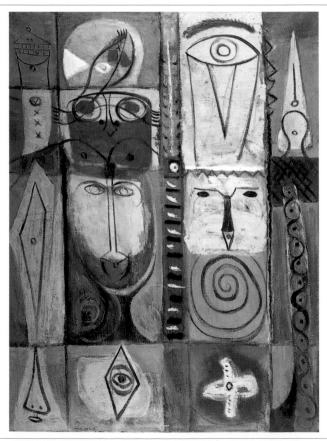

Adolph Gottlieb. b New York (USA), 1903. d Easthampton, NY (USA), 1974.
The Enchanted Ones. 1945. Oil on linen. h121.9 x w91.4 cm. h48 x w36 in. Adolph and Esther Gottlieb Foundation, Inc., New York

Graham Dan

New Housing Project, Staten Island

Two photographs of a housing development are juxtaposed in this work. The top one shows a backyard, complete with garden table and chairs and sun umbrella, and the bottom one is of the entrance courtyard – the two images reflecting public and private space. This work is one of a series of photographs which Graham made of mass-produced housing estates that had been built to create a new suburban landscape in post-war America. He examines their use of space and materials, their relation to the environment and their effect on people's

lives. In the 1960s Graham organized exhibitions of works by Judd, Flavin and LeWitt. He went on to develop his own brand of Conceptual Art, using magazines and newspapers as his forum in order to reflect his disillusionment with the gallery system. Graham is also a prolific writer who peppers his essays with as many references to pop music and drug culture as to art and architecture.

☛ **Artschwager, Becher, Flavin, Judd, LeWitt, Matta-Clark**

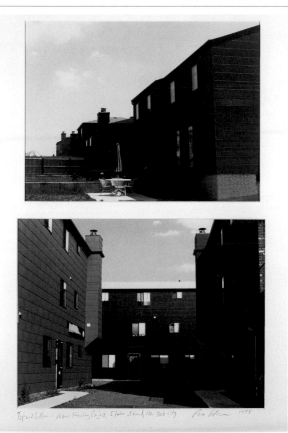

Dan Graham. **b** Urbana, IL (USA), 1942. 175
New Housing Project, Staten Island. 1978. Colour prints. **h**102 x **w**51 cm. **h**40⅛ x **w**20 in. Private collection

Green Renée

Peak

Photographs of mountain peaks are displayed on a wooden stand. Binoculars, a telescope, a ladder, ropes and a small flag all operate as elements of a conventional narrative about exploration. Opposite are three framed quotations by fictional and real explorers, presented as mock prizes with coloured rosettes. The texts reveal how nature has been seen as female – something to be conquered and possessed by males, and that many so-called undiscovered places were already known to the indigenous populations who in fact guided the colonial explorers. Exploration and geographical conquest are here used as a vehicle to examine the forces of imperialism and exploitation. Using art as a way of communicating a political message, Green comments on the way in which our understanding of geography and history is based on our Western preconceptions, exemplified by our use of the terms 'First' and 'Third' World, which imply the superiority of Western society.

☛ Barry, C Noland, Tiravanija, Wodiczko

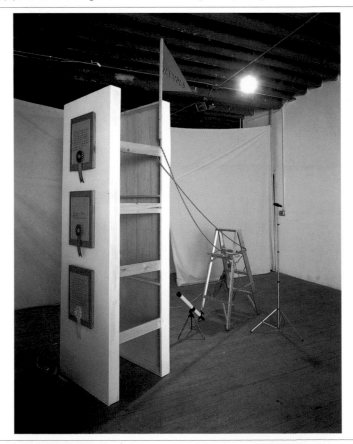

Renée Green. b Cleveland, OH (USA), 1959.

Peak. 1991. Wood, ladder, nylon ropes, binoculars, telescope, magnifying glass, Plexiglas, ribbon, framed silver gelatin print. Dimensions variable. Pat Hearn Gallery, New York

Grippo Victor

The Potato Gilds the Potato ...

The mystery of a scientist's laboratory is conveyed through this installation. Energy generated by a group of potatoes is passed along wires to a perspex sphere containing a gold, electrolytic solution. Inside this, a solitary potato is gilded by the electrical current. Blending art and science, the work transforms the humble potato, illustrating the alchemical potential of everyday objects. Reflecting Grippo's training as a chemist and his compassion for the struggles in his native Argentina, the glimmering result is a synthesis of Conceptual and humanist concerns. Though contained within perspex vitrines, this act of creation alludes to a life-force that transcends physical constraints. It is a metaphor for political resistance, an act of beauty evading the censorship of brutal regimes. Transforming staple foodstuffs such as potatoes and bread in his installation-based work, Grippo comments not only on society's basic needs, but also on its unstable core.

☛ Beuys, Geva, Hirst, Pistoletto

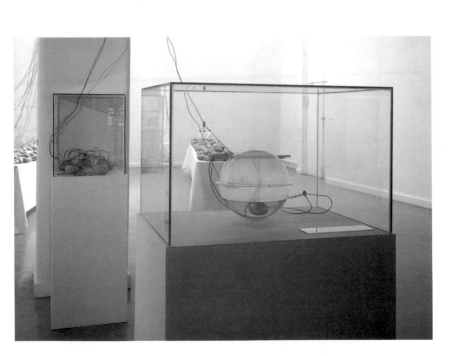

Victor Grippo. **b** Buenos Aires (ARG), 1936.
The Potato Gilds the Potato, Consciousness Enlightens Consciousness. 1978. Potatoes, voltmeter and electrical wires.
Dimensions variable. As installed at the Ikon Gallery, Birmingham, 1995

Gris Juan

Still Life before an Open Window: The Place Ravignon

A melancholy, blue urban landscape of trees and shuttered windows is visible through the window of a dark room. In the foreground is a table on which stands a bottle of wine, labelled 'MEDOC', and a newspaper, called 'LE JOURNAL'. The forms of the objects are dislocated and fragmented in a manner typical of Cubism. However, this work is unusual in its attempt to combine indoor and outdoor space within a Cubist framework. Although Gris did not invent Cubism, he was one of its most capable exponents. He combined elements he had learned from Picasso and Braque, such as the representation of objects from different angles, with his own bright palette. Gris moved to Paris from his native Madrid in 1906, and rented a studio close to Picasso in Montmartre. A highly intelligent and influential artist, he enjoyed close relationships with some of the greatest figures of this century, including Braque, Matisse and Picasso. An asthma sufferer, he died at the age of 40.

☛ **Braque, Gontcharova, Le Corbusier, Matisse, Picasso**

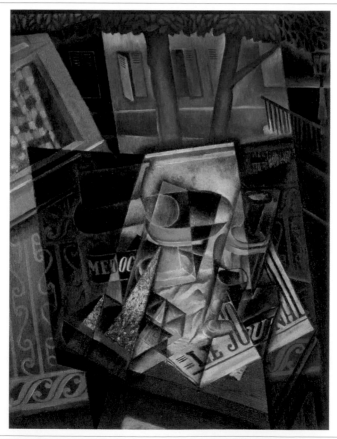

Juan Gris. b Madrid (SP), 1887. **d** Boulogne-sur-Seine (FR), 1927.
Still Life before an Open Window: The Place Ravignon. 1915. Oil on canvas. **h**116.5 x **w**89.2 cm. **h**45⅛ x **w**35⅛ in.
Philadelphia Museum of Art, PA

Grosz George

Dedication to Oskar Panizza

A herd of chaotic bodies with tortured faces jostle in the night-time city streets. A sinister Expressionist colour scheme of dark reds and greens and the Futurist-inspired, distorted space add to the feeling of sinful decadence and impending doom. Oskar Panizza was a psychiatrist and writer who was prosecuted for blasphemy in the 1890s. He and Grosz shared a pessimistic view of urban life: the figures in the bottom left-hand corner represent Alcoholism, Syphilis and Plague. The figure of Death – the skeleton in the middle of the composition – is the only victor; even the priest, representing the Church, throws up his arms in surrender. Grosz is best known for his savagely satirical drawings. Before and during the Second World War he directed his biting irony at the corruption of the German government. He too was frequently prosecuted for blasphemy and for insulting public morals, and was eventually court marshalled and nearly shot. He subsequently moved to America and turned his satirical genius against bourgeois materialism.

☛ Carrà, Dix, Ensor, Immendorff, Severini

George Grosz. b Berlin (GER), 1893. d Berlin (GER), 1959.
Dedication to Oskar Panizza. 1917–18. Oil on canvas. h140 x w110 cm. h55⅛ x w43⅓ in. Staatsgalerie Stuttgart

Guston Philip

Head

The mouthless head with its massive eye provides the disquieting focus of this startling image. This persona, painted in a raw, comic-book style, crops up again and again in Guston's paintings from the final decade of his life. In many of these works, scenes littered with paint-pots and brushes – the debris of the artist's solitary activity – are populated by dismembered limbs. Representing aspects of the artist's psyche, these body-parts smoke, drink and wage war on one another. Simple spatial relationships belie a complexity of meaning infused with bitterness, irony and moments of rare tenderness. Having established a reputation as an Abstract Expressionist, Guston confounded critics and contemporaries when in the late 1960s these stark cartoons were first exhibited. A maverick amid a tide of derision, he profoundly influenced subsequent generations. His friend and fellow painter, De Kooning, offered valuable insight when he suggested to Guston that ultimately his work was 'about freedom'.

☛ **Frink, De Kooning, Rothko, Shahn**

Philip Guston. **b** Montreal (CAN), 1913. **d** Woodstock, NY (USA), 1980.
Head. 1975. Oil on canvas. **h**175.9 x **w**189.2 cm. **h**69¼ x **w**74½ in. Private collection

Guttuso Renato

The Crucifixion

The figure of Christ in this Crucifixion scene is partly concealed by one of the thieves and by Mary Magdalene at the foot of the cross, forcing us to concentrate instead on the sinister still life of vinegar bottles, hammer and nails in the foreground. This shift of focus away from Christ was considered radical at the time, provoking a strong reaction from the Church. The work was also seen as an implicit criticism of the Italian regime under Mussolini. This painting is typical of the Socialist Realists, a group of artists who aimed to create a political art that would be both modern and readily understandable by ordinary people. Guttuso was a leading exponent of the movement, and in this work he fuses elements from Cubism, such as the non-naturalistic colour scheme and the distortion of anatomy, with a descriptive realism. In the late 1930s and early 1940s he was a member of the clandestine Communist Party in Fascist Italy.

☞ Gleizes, Howson, Nitsch, Picasso, Rego

Renato Guttuso. b Bagheria (IT), 1912. **d** Rome (IT), 1987.
The Crucifixion. 1941. Oil on canvas. **h**200 x **w**200 cm. **h**78¾ x **w**78¾ in. Galleria Nazionale d'Arte Moderna e Contemporanea, Rome

Haacke Hans

GERMANIA

Visitors to Haacke's *Germania* at the Venice Biennale were greeted by a scene of devastation. The floor was broken up into jagged fragments, and as the pieces moved underfoot, the amplified sound reverberated mournfully round the space. Exhibited in 1993, this piece is Haacke's response to the history of the German pavilion. Constructed in 1909, the building is indelibly marked by Germany's turbulent past, especially by the structural changes made by the Third Reich. Its role as a showcase for prevailing artistic and political trends is made especially poignant by the reunification. Loaded with these associations, the building is perfect for this form of site-specific art. Haacke is best known for photographic and text pieces exposing the questionable ethics of companies who invest in corrupt regimes. His posters of the 1970s, which contrast images of luxurious goods with the conditions of the workers who made them, voice public concerns with rare eloquence.

☛ Broodthaers, Geva, Kiefer, LeWitt, Radziwill

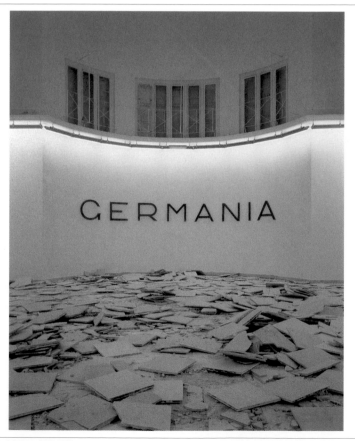

Hans Haacke. **b** Cologne (GER), 1936.
GERMANIA (detail). 1993. Marble floor tiles. Dimensions unknown. As installed at the Venice Biennale

Halley Peter

CUSeeMe

Two rectangles of yellow and blue are set on top of a grid of interlocking, multicoloured lines. Though this painting at first appears to be an abstract, geometrical work, it has a strongly figurative content. The yellow and blue rectangles are intended to represent prison cells, and the right-angled lines suggest secret communicating passageways. The title reinforces the theme of clandestine meetings and surveillance. The bright, Day-Glo colours evoke a high-tech, artificial world – a place where the pervasive forces of capitalism control and confine individuals within a solitary and alien space. Halley has used Roll-a-Tex, a brand of artificial stucco, for the prison cells, to give the painting an architectural texture and sense of solidity. The cell and the secret passageway are the foundations of Halley's pictorial vocabulary, and feature in all his paintings from the last 15 years. Halley's thought-provoking works, with their political slant, draw heavily on the writings of post-modern philosophers and social theorists.

☛ **Bickerton, Van Doesburg, Mondrian, Mullican**

Peter Halley. b New York (USA), 1953.

CUSeeMe. 1995. Acrylic, metallic and Day-Glo acrylic and Roll-a-Tex on canvas. **h**274.3 x **w**279.7 cm. **h**108 x **w**110⅛ in.
Goetz Collection, Munich

Hamilton Richard

I'm Dreaming of a White Christmas

In this picture of Bing Crosby in a hotel lobby, Hamilton plays with our knowledge of visual imagery: we may think this is a photographic negative but it is in fact a watercolour. The mass appeal of the Hollywood film star and actor, Crosby, whose hit song gives the work its title, was an important element in the artist's careful balance between Fine Art and mass culture. A member of the Independent Group, a collection of artists who established Pop Art in Britain, Hamilton became one of Pop's leading exponents. Although lacking the scale and colour of American Pop, his work typifies the dedication of that movement to contemporary influences, from pop music and advertising slogans to technology and film. Pop, he declared, should be glamorous, expendable, mass-produced and popular. This particular work combines many of these elements. Hamilton's *œuvre* is impressively varied. His recent work has mainly concentrated on highly political subject matter.

☞ Blake, Van Dongen, Organ, Paolozzi, Warhol

Richard Hamilton. b London (GB), 1922.
I'm Dreaming of a White Christmas. 1967. Black ink, watercolour and graphite on paper and two plastic films. **h**58.5 x **w**91.5 cm. **h**23 x **w**36 in. Private collection

Hamilton-Finlay Ian A Woodland Flute

Like an epitaph, the Latin names of ancient trees have been carved into marble. The letter 'U', common to them all, forms a central band. This links them both visually and aurally, in the manner of the concrete poetry for which Hamilton-Finlay first made his name – poetry in which the visual form of the words expresses their meaning. Beginning by publishing short stories, poetry and plays in 1958, Hamilton-Finlay's first freestanding poems were shown in 1963. His eclectic taste provides a provocative blend of classical and modern, civilized and savage. Working from within a classical tradition, he has made a series of *Homages* to other artists, styles and periods, imbuing familiar and timeless forms with wit and visual metaphor: bird tables in the form of aircraft carriers, the folded shape of a paper boat, made from marble and apparently floating on a pond. He has made permanent landscape installations throughout Europe and America and 'Little Sparta', the garden of his home in Scotland is internationally renowned.

☛ **Burgin, Goldsworthy, Long, Turnbull**

Ian Hamilton-Finlay. b Nassau (BAH), 1925.
A Woodland Flute. 1990. Marble. **h**53 cm. **h**20⅞ in. Private collection

Hammons David

In the Hood

A discarded and dismembered piece of clothing found in the street is displayed like a sad trophy of the poor and homeless. The title puns on the colloquial black expression for 'neighbourhood', injecting humour and playfulness into an otherwise serious socio-political issue. Like the world he inhabits, Hammons's art is resourceful, transforming the unwanted and the handed-down into a means of personal expression. The central focus of Hammons's art is the culture and history of African-American people. Working within the vernacular of his own environment in Harlem, New York's historic black ghetto, Hammons documents a rich and complex social reality. He uses found objects and the improvised language of the streets, and is more influenced by jazz, basketball and black poetry than the history of art. Hammons has also sold snowballs on street corners, devised an African-American flag, placed designer shopping bags on a classical Italian sculpture (*Bag Lady*), and made artworks from circus elephant dung.

☛ Basquiat, Durham, Kounellis, Oppenheim, A Piper

David Hammons. **b** Springfield, IL (USA), 1943.
In the Hood. 1993. Sweatshirt hood. Dimensions variable. Jack Tilton Gallery, New York

Hanson Duane

Queenie

Queenie, an impassive cleaning woman, stands frozen, her expression glazed. Like many of Hanson's characters, she is a downtrodden member of the American working class, overburdened, fatigued and trapped by circumstance. Starting in the late 1960s, Hanson made uncannily lifelike sculptures. This super-realism was achieved through a lengthy process which involved casting the model in a fast-setting silicon rubber. He then placed his sculpture alongside judiciously selected ready-made elements, such as Queenie's duster and tools. In the gallery space, this combination subverts a sense of reality by blurring what is genuine and what is counterfeit. Hanson's early works depict murder and riot scenes, but he is best known for his deadly accurate, satirical studies of bored and idle America. Through his tourists, shoppers and housewives, he explored the inescapable tedium of ordinary life.

☛ Close, Estes, Koons, Wegman

Duane Hanson. b Alexandria, MN (USA), 1925. d Boca Raton, FL (USA), 1996.
Queenie. 1995. Polychromed bronze and mixed media. h166 cm. h65⅜ in. Private collection

Haring Keith

Monkey Puzzle

These teeming, monkey-like figures, with their bright, bold colours resemble the kind of images found in Primitive wall-paintings. Full of boundless energy and gaiety, they are engaged in a ritual dance of communal pleasure. Working in New York, Haring was inspired by the bustle and confusion of life in the big city. Though he trained as an artist, he shunned traditional techniques and turned instead to the increasingly sophisticated medium of graffiti art which spoke directly to the public in the language of the street. Starting out by filling the empty black advertising hoardings in subway stations with his own unique set of interacting animal and human figures, he eventually attracted the attention of commercial art galleries and museums. However, Haring continued to produce art for public spaces and works which were not intended for the gallery such as illustrations for children's story books, T-shirts and badges. He also experimented with the body as a site for art in his body paintings.

☛ **Basquiat, Mapplethorpe, Nauman, Vasarely**

Keith Haring. b Kutztown, PA (USA), 1958. d New York (USA), 1990.
Monkey Puzzle. 1988. Acrylic on canvas. **diam.** 25.4 cm. **diam.** 10 in. Estate of Keith Haring, New York

Hartley Marsden

Madawaska – Arcadian Light – Heavy

Dominating the canvas, this thickset figure has a powerful presence. He sits resolutely with his hands on his legs, his form thrown into relief by light coming in from the left, indicated by the strong yellow highlights on his shoulder, hand and chest. The bold colour scheme owes much to the Expressionists, who were interested in the emotive value of colour, while the simplification of form is close to Cubism. Hartley belonged to the circle of American avant-garde painters who exhibited regularly at the famous 291 gallery belonging to the photographer Alfred Stieglitz. Stieglitz encouraged Hartley to seek out influences from Europe, resulting in the artist's trip to Paris in 1912. There he absorbed Cubism, and went on to find inspiration in Berlin through the work of Kandinsky and Jawlensky, exhibiting with Der Blaue Reiter, a group of Expressionist painters, in 1913. Hartley's last years were spent restlessly wandering between France, Italy, Germany and New Mexico.

☛ Aitchison, Jawlensky, Kandinsky, Schlemmer

Marsden Hartley. b Lewiston, ME (USA), 1877. **d** Ellworth, ME (USA), 1943.
Madawaska – Arcadian Light – Heavy. 1940. Oil on masonite. **h**101.6 x **w**76.2 cm. **h**40 x **w**30 in. Private collection

Hartung Hans

Untitled

Two patches of aquamarine blue, separated by a black, vertical line, contain two groups of sharp, white, vertical striation marks. 'A single line, violent, passionate, broken or beautifully calm, regular, uniform, conveys what we are feeling. It corresponds to what we are living through.' The violence and aggression of the marks on this canvas may reflect the artist's own anxious state of mind. Like Wols, Fautrier and Riopelle, he helped initiate the new methods which came to be known as Art Informel – formless works, inspired by calligraphy, which he called 'psychic

improvisations'. Though dynamic and spontaneous in appearance, they were actually highly considered. Hartung was born in Germany and studied philosophy and art history at university. He fled the country before the outbreak of the Second World War and settled in Paris, where he became one of France's foremost abstract painters.

☞ Fautrier, Klein, Michaux, Riopelle, Wols

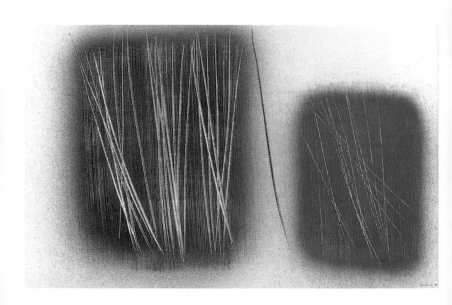

Hans **Hartung**. **b** Leipzig (GER), 1904. **d** Paris (FR), 1992.
Untitled. 1961. Oil on canvas. **h**80 x **w**130 cm. **h**31½ x **w**51¼ in. Private collection

Hatoum Mona

Foreign Body

This unsettling video of the interior of Hatoum's body is created with the modern medical technique of endoscopy, in which a microscopic camera is inserted into the body's various orifices and passed along internal tubes and passageways. The video is installed inside a vertical circular wall, which the viewer may enter, and is accompanied by the sound of the artist's heartbeat and breath. It is a powerful and original self-portrait, which can be read either as illustrative of some kind of painful, unwanted invasion, or as an embodiment of the narcissistic desire to see and know oneself literally inside-out. Born in Lebanon, Hatoum was exiled to London by the outbreak of civil war in 1975. Though not directly concerned with politics, her work is implicitly informed by her experiences as a forced stranger, isolated from her homeland. Hatoum uses many different media in her work, originally focusing on Performance Art, but later employing installation, sculpture, video and photography.

☛ Chadwick, M Kelly, Laib, Mendieta, K Smith, Viola

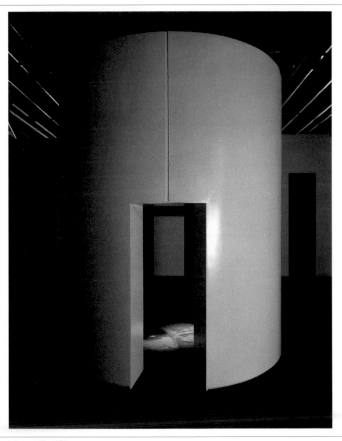

Mona Hatoum. b Beirut (LEB), 1952.
Foreign Body. 1994. Video installation. **h**3.5 m. **h**137⅞ in. Musée National d'Art Moderne, Paris

Hausmann Raoul

The Spirit of our Times

An eyeglass, a ruler, a tape measure, a rubber stamp in a box and cogs of different sizes are attached to a mechanical wooden head. The juxtaposition of incongruous objects is deliberately disturbing. Implying a modern world of overadvanced technology and controlled thought, the work is evocative of man's dilemma in the rapidly evolving period after the First World War. The title of the work reinforces the bleak mood. The bizarre combination of objects links this work to Dada, a radical Berlin-based art movement of which Hausmann was a leading

member. Like many of these artists, Hausmann produced collages and photomontages made up of cuttings from newspapers and photographs. He also contributed to various avant-garde journals and composed several manifestos, taking part in the Dada festival in Prague with Schwitters in 1921. He stopped painting in the mid-1920s, only taking it up again in the early 1940s, when he moved to France.

☛ Duchamp, Frink, Heartfield, Laurens, Schwitters

Raoul Hausmann. b Vienna (AUS), 1886. d Limoges (FR), 1971.
The Spirit of our Times. 1919. Wood with leather box, stamp, ruler, cogs, eyeglass and tape measure. **h**32 cm. **h**12$\frac{2}{3}$ in.
Musée National d'Art Moderne, Paris

Hayter Stanley William

Sun Dance

The linear rhythms and bright colours of this complex and lively image activate the surface of the work, evoking figures dancing in the sun. Hayter was one of the most important printmakers of the twentieth century, taking the form beyond its more traditional function as a means of reproduction and illustration and discovering its creative potential. His best prints were made using the freehand Surrealist technique of automatism – spontaneous drawing which comes straight from the subconscious – which in this work he combines with engraving, soft-ground, and burnishing methods. In 1927 Hayter founded Atelier 17 in Paris, a studio where he worked with, among others, Picasso, Miró and Dalí. Later, he moved the studio to New York, and between 1941 and 1950, he collaborated with De Kooning, Pollock and Rothko. Hayter's own work underwent continual metamorphoses as he developed new graphic techniques including a way of producing multicoloured prints from a single plate.

☛ Dali, Gabo, De Kooning, Miró, Picasso, Pollock, Rothko

Stanley William Hayter. b London (GB), 1901. **d** Paris (FR), 1988.
Sun Dance. 1951. Engraving, soft-ground etching and scorper. **h**39.3 x **w**23.8 cm. **h**15½ x **w**9⅓ in. Edition of 200

Heartfield John

Hurray, the Butter is All Gone!

A German family is shown sitting at the dinner table eating a bicycle. The work resembles a propaganda poster; the family's loyalty to Hitler reinforced by the portrait of the Führer and the swastika wallpaper. The baby gnaws on an axe, also emblazoned with a swastika, and the dog licks a huge nut and bolt. The commentary beneath the image reads: 'Hurray, the butter is all gone! As Goering said in his Hamburg address: "Iron ore has made the Reich strong. Butter and dripping have at most made the people fat."' By taking the Nazi's rhetoric literally, Heartfield demonstrates the absurdity of their political agenda. A fervent anti-Nazi, Heartfield believed that art should be blatantly political. He was a member of the Berlin Dadaist group and perfected a technique of photomontage for reproduction in magazines and newspapers, in which parts of photographs taken from various sources were collaged together to create bizarre, usually satirical commentaries on the realities of Hitler's rule.

☛ Duchamp, Hausmann, J C Orozco, Wodiczko

Hurrah, die Butter ist alle!

Goering in seiner Hamburger Rede: „Erz hat stets ein Reich stark gemacht, Butter und Schmalz haben höchstens ein Volk fett gemacht".

Fotomontage: John Heartfield

John Heartfield. b Berlin (GER), 1891. **d** Berlin (GER), 1968.
Hurray, the Butter is All Gone! 1935. Photomontage. **h**38.7 x **w**27.3 cm. **h**15¼ x **w**10¾ in. Akademie der Künste, Berlin

Heckel Erich

Sailing Ships in the Harbour

A cluster of sailing ships, moored in a harbour, dominates the composition. In the centre stands a lone figure, picked out in orange and pink. This view of a port becomes the basis for an exercise in colour contrasts. The orange of the sails is juxtaposed against the green of the land, which in turn clashes with the pink beach. Painting boldly in broad strokes, Heckel also balances the curves of the shore against the verticals of the ships' sails. The overall result is a painting of stark, uncompromising visual richness. Heckel was a member of the German Expressionist group Die Brücke and the bold colours and harsh outlines reveal its influence. Heckel trained as an architect before abandoning his studies to become a painter. His work is characterized by bold colour combinations, and compositions which emphasize the flatness of the picture, bringing out its decorative qualities. As well as seascapes, Heckel is also known for his erotically charged female nudes.

☛ Bartlett, Derain, Dufy, Kirchner, Marin

Erich Heckel. **b** Döbeln (GER), 1883. **d** Hemmenhofen (SW), 1970.
Sailing Ships in the Harbour. 1911. Oil on canvas. **h**65.5 x **w**74.9 cm. **h**25¾ x **w**29½ in. Westfälisches Landesmuseum, Münster

Heilmann Mary

Franz West

Pools of translucent, bright colours are trapped in a grid, merging delicately with the white background. The title of this work – *Franz West* – refers to a contemporary Austrian artist known for an outdoor installation made up of metal chairs arranged in rows and covered by colourful carpets. Like a playful portrait of West's artwork, this painting is a departure from the rigidity and severity of much twentieth-century abstract art. 'What I am looking for in my work is that it have a sense of time and place', Heilmann has stated. To achieve this, she has, since the early 1970s, incorporated the imagery of advertising, folk art or the colours and textures of current fashion into her Minimalist-inspired, geometric compositions. In the case of this work, she captures a particular moment in the history of art. Combining such everyday references with the spiritual tradition of modern art, Heilmann suggests a new direction for contemporary abstract painting.

☛ R Delaunay, Louis, Rae, Rothko, West

Mary Heilmann. **b** San Francisco, CA (USA), 1940.
Franz West. 1995. Oil on canvas. **h**147.3 x **w**99 cm. **h**58 x **w**39 in. Private collection

Hélion Jean

Abstract Composition

Three-dimensional geometric forms, modelled with light and shade, seem to float on the surface of the canvas. Set against a background of flat, coloured shapes, they appear to advance towards our eyes while the background recedes. The spatial quality of the colours also adds to the feeling of depth. A pervasive sense of equilibrium is created by the balancing of colour and form and by tilting the lines away from the vertical and horizontal axes. This work owes much to Constructivism, which pared images down to their geometric essentials.

However, Hélion developed an abstract language which, unlike the work of the more strictly Constructivist artists with whom he was associated, still holds on to elements of figuration. However, he became dissatisfied with abstraction and during and after the Second World War, he developed a quirky, cartoon-like figurative style which he felt communicated more readily to people.

☛ Domela, Freundlich, Kandinsky, Le Corbusier

Jean Hélion. b Couterne (FR), 1904. d Paris (FR), 1987.
Abstract Composition. 1934. Oil on canvas. h60 x w80 cm. h23⅔ x w31½ in. Private collection

Hepworth Barbara

Three Forms

This sculpture seems almost to have been made by the forces of nature – the smooth shapes suggesting pebbles on the beach. Set on a simple grey marble base, these forms have an elegant simplicity. An autobiographical interpretation of this work would suggest that they might be highly abstract representations of Hepworth's triplets, born in 1934. Like several other artists in the 1930s, Hepworth abandoned a figure-based art and began to work with pure, abstract geometric forms. In 1932 she joined the Association Abstraction-Création in Paris. The group's aim was to create an art whose balance and harmony could stand against the chaos of modern life. Hepworth moved with her husband, Nicholson, to the small Cornish fishing village of St Ives. Here, they formed the central focus of a set of artists known as the St Ives Group, and reference to natural forms sculpted by the force of the sea became even more prominent in her work.

☛ **Brancusi, Mondrian, Moore, Nicholson**

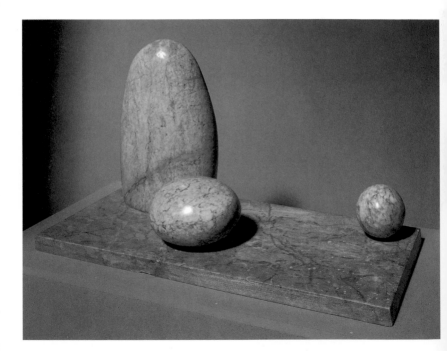

Barbara Hepworth. **b** Wakefield (GB), 1903. **d** St Ives (GB), 1975.
Three Forms. 1934. Marble. **h**25.7 x **w**47 x **l**21.6 cm. **h**10 x **w**18½ x **l**8¼ in. Tate Gallery, London

Herbin Auguste

Volutes

Dynamic curves, detached from the rectangular edges of the canvas, freely interact, giving this work a strong sense of movement. These rhythmical shapes are juxtaposed with harsher, more angular ones which seem to coalesce towards the centre of the painting. There is no evidence of brushstrokes – the surface has a uniform flatness of texture. The strongly contrasting colours enhance the dramatic and exuberant effect, creating an overall sensation of blossoming and burgeoning life. The reduction of subject matter to geometric shapes and colours owes much to the influential Abstraction-Création movement in Paris of which Herbin was a founder member. The group developed a geometric type of painting which emphasized the potential of colour as an expressive force. Herbin first exhibited with the Cubists in the celebrated 'Section d'Or' exhibition of 1912, but his work had gradually evolved towards complete abstraction by the late 1920s.

☞ Gabo, Hayter, Hélion, Kandinsky

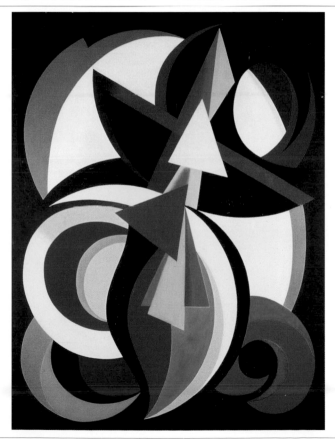

Auguste Herbin. b Quiévy (FR), 1882. d Paris (FR), 1960.

Volutes. 1939. Oil on canvas. h130 x w97 cm. h51¼ x w38¼ in. Private collection

Heron Patrick

Manganese in Deep Violet

A turquoise, five-sided star hangs suspended in a soup of purple, encroached by an arm of red. Coloured circles and part-circles float on the canvas like amoebas, evoking a calm and reflective mood. This brightly pigmented work typifies Heron's love and principal concern for colour and light. Following in the footsteps of Matisse, Bonnard and Rothko, Heron focused on the juxtaposition of colours on the canvas and the subsequent interaction and interpretation of forms. In accordance with the aesthetic of the St Ives artistic scene (he lived in Cornwall and had a close relationship with Hepworth and Nicholson), Heron's style was inspired by his natural surroundings. The artist's home, situated on the Cornish coast, with its panoramic views and bright light, had a significant impact on his work. As well as producing paintings, he also wrote art criticism, designed textiles, and taught at the Central School of Art in London. In 1993 he designed a stained-glass window for the new Tate Gallery in St Ives, Cornwall.

☞ Bonnard, Hepworth, Matisse, Nicholson, Olitski, Rothko

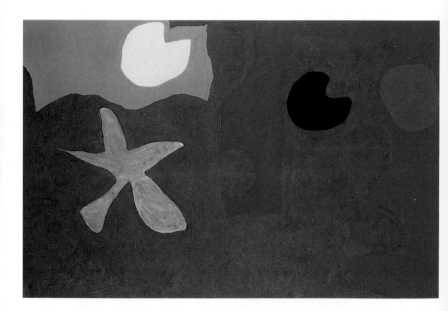

Patrick Heron. b Leeds (GB), 1920. d Zennor (GB), 1999.
Manganese in Deep Violet. 1967. Oil on canvas. h101.5 x w152.5 cm. h40 x w60 in. Collection of the artist

Hesse Eva

Contingent

Suspended like flayed hide or sodden washing, these delicate panels are a delicious blend of the high-tech and the homespun, combining modern and traditional materials. By using elements such as latex and cheese-cloth in awkward, slightly surreal combinations, Hesse teases out contradictions between the old and the new. The curved shape of some of the panels adds a human and sexual dimension to her work. Hesse is among a number of artists who, towards the end of the 1960s, translated the pared-down detachment of Minimalism

into a rich and evocative language. Often limp, dangling from ceilings or walls, these materials demanded traditionally feminine skills such as weaving, plaiting and folding. In this respect Hesse's work raises feminist issues which were being debated at the time. Blessed with an extraordinary visual wit and intelligence, Hesse has become an icon for subsequent generations. Tragically, her highly influential career was cut short in 1970 by a brain tumour.
☛ Brisley, Buren, Espaliú, Morris

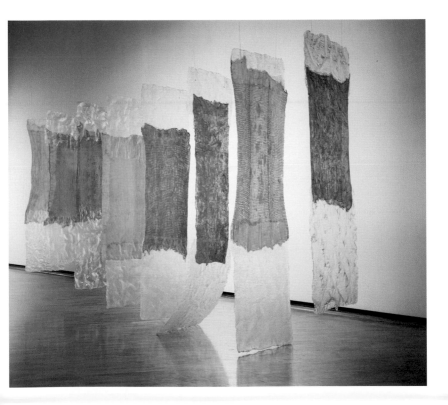

Eva Hesse. b Hamburg (GER), 1936. **d** New York (USA), 1970.
Contingent. 1969. Cheesecloth, latex and fibreglass. **h**350 x **w**630 x **l**109 cm. **h**137⅞ x **w**248¼ x **l**42⅞ in.
National Gallery of Australia, Canberra

Sixteen, variously-sized, stripped-down television screens transmit images of the fragmented body of the artist. A foot, an eye, a curved section of the spine and other anatomical parts are composed like elements in a still-life painting. Drawn in by a nearly inaudible background noise of faint, murmuring voices, the viewer remains unable to hold all the images together as one unified form. Hill uses the body to convey information or emotion, seeing it as a vehicle of communication, like language. He sometimes combines images of the body with actual texts from philosophical and religious sources. Hill often presents his work sculpturally, arranging video screens in carefully conceived formations. He started out as a sculptor working in steel, but began working with video in the mid-1970s when the form was only just being recognized as a legitimate artistic medium. He is now one of its foremost practitioners.

☛ Barry, Hatoum, Hiller, Mapplethorpe, Viola

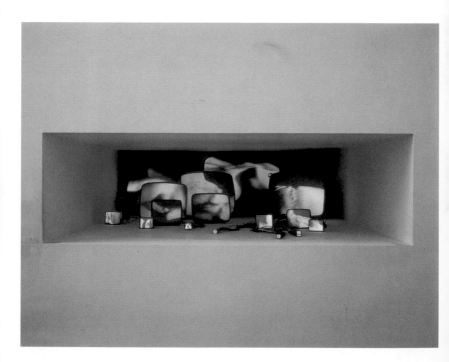

Gary Hill. b Santa Monica, CA (USA), 1951.
Inasmuch as it is Always Already Taking Place. 1990. Video/sound installation. Screens: **h**31 to 53 cm. **h**12 to 21 in. Private collection

Hiller Susan

An Entertainment

On entering the darkened space of Hiller's video installation, the viewer is confronted by giant, projected images from a Punch and Judy show. The familiar puppet voices are replaced by a matter-of-fact voice-over which serves to reveal the profoundly violent elements of the story. What is usually seen as a harmless children's seaside entertainment is transformed into a macabre and disturbing drama. Hiller shows how a very traditional and accepted part of Western culture has the effect of encouraging children to enjoy displays of aggression.

Trained as an anthropologist, Hiller attempts to understand different cultural forms, rituals and artefacts, exploring areas which are generally considered off limits in art. Hiller is not bound by any particular art form or style. She has collaborated with non-artists, created light and sound installations, and made works from the ashes of her burnt paintings.

☛ Barry, Ensor, Viola, Weight

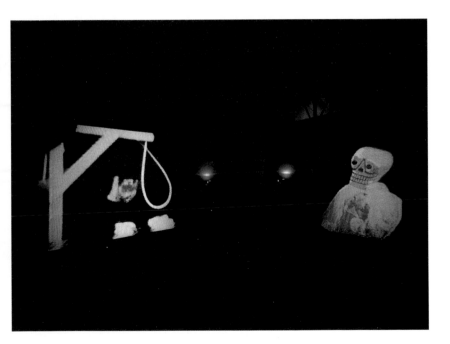

Susan Hiller. b Carson City, NV (USA), 1942.
An Entertainment. 1990. Video installation using four projectors. Dimensions variable. Tate Gallery, London

Hirst Damien

The Physical Impossibility of Death in the Mind of Someone Living

This monumental sculpture is spectacularly dramatic. The shark, a symbol of fear and aggression, and one of man's few predators, is suspended in a glass tank filled with the preservative formaldehyde. Confronting the viewer with open, razor-toothed jaws, it seems hardly contained by the glass walls. Encountering such a potent and deadly force, the viewers are brought face-to-face with the question of their own mortality. Hirst's main concerns are the fundamental questions of life – such as birth, death and love – expressed through controversial works using bisected cows, dead sheep, fish, live butterflies, and a sculpture portraying the life-cycle of the fly. Although he wishes to create provocative art, the theatrical staging of his works, with their grandiose titles, is undercut by an elegant, almost Minimalist restraint. The most influential member of a school of British artists originating from Goldsmiths' College, London, in the late 1980s, he has recently made films and pop videos.

☛ Bacon, Grippo, Judd, LeWitt, Quinn

Damien Hirst. **b** Bristol (GB), 1965.
The Physical Impossibility of Death ... 1991. Tiger shark, glass, steel and formaldehyde solution. **h**213 x **w**518 x **l**213 cm. **h**84 x **w**204 x **l**84 in.
Saatchi Collection, London

Hitchens Ivon

Balcony with Fish

Three fish lie on a plate in front of a window, through which we can see a stone balustrade on the right and the metalwork of a balcony on the left. A path in the centre leads to a gate surrounded by autumnal trees. Avoiding unnecessary detail, Hitchens paints in bold, variously directed brushstrokes, leaving the white of the primed canvas to show through in some areas. The vigorous application of paint communicates the vibrancy of this garden scene, but also stands as a direct record of the activity that went into the painting's making.

Hitchens painted in a spontaneous manner, often completing a canvas in one session. He worked in front of his subjects, which range from still lifes to the landscape near his home in the South of England. In this way he could capture the direct experience of being immersed in a particular place and time. His interiors, with their bold colours, have been compared to those of Matisse.

☞ Arikha, Hirst, Matisse, Sutherland

Ivon Hitchens. **b** London (GB), 1893. **d** Selsey Bill (GB), 1979.
Balcony with Fish. 1943. Oil on canvas. **h**106.1 x **w**52.1 cm. **h**41¾ x **w**20½ in. Estate of the artist

Hockney David

Neat Lawn

A sprinkler sprays two jets of water onto a neatly tended lawn. A building stands silently against a vivid blue sky and the bright sunshine is evoked by the strong shadows under the eaves. Apart from the movement of the water, the scene is completely still. Hockney has achieved this static feeling by his acute attention to detail (he has painted almost every blade of grass) and the way he has constructed the picture. The composition is based around a series of horizontal rectangles – the sidewalk, lawn, hedges, house and sky. *A Neat Lawn* is one of an important series of monumental canvases painted in 1967 which depict either the sudden, or continuous movement of water (in this case the spraying water) in the gardens of wealthy California. Born in Bradford in the north of England, and now living in Los Angeles, Hockney has become the official painter of California. An incredibly versatile artist, he has worked in many media including film, photography, video and the theatre.

☛ **Artschwager, Blake, Hopper, Jones, Matisse, Matta-Clark**

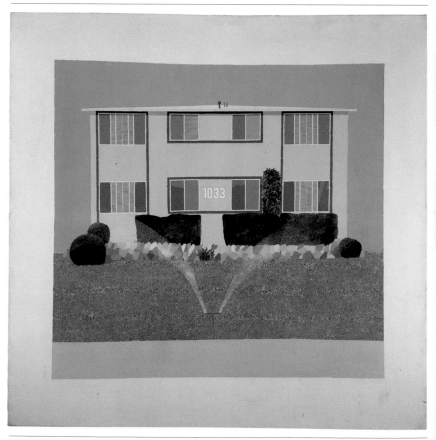

David Hockney. b Bradford (GB), 1937.
Neat Lawn. 1967. Acrylic on canvas. **h**243.8 x **w**243.8 cm. **h**96 x **w**96 in. Private collection

Hodgkin Howard

Small Durand Gardens

A patchwork of brightly coloured abstract shapes is set against a cluster of cream dots on a blue background. The curve of striped orange and blue on the left may represent a path, the three yellow forms at the bottom look like bushes, while the spotty background may evoke dappled light. The title refers to a garden which Hodgkin used to admire from a friend's flat, suggesting that this work represents his memory of the shrubs, flowers and pathways of this garden. The modest scale of the painting and the way the artist has framed the central

motif with thin veils of oil paint, draw the viewer into an intimate space of contemplation. For Hodgkin, the process of painting is lengthy – his works may take years to complete. He generally works on wood, covering the frame as well as the support with sumptuous colour. A gifted printmaker as well as a painter, Hodgkin won the Turner Prize for contemporary art in 1985.

☛ Gironella, Hitchens, Masson, Sutherland

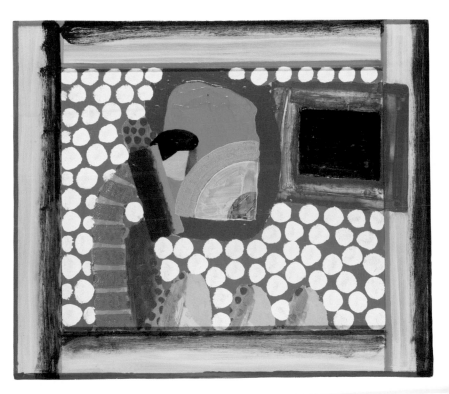

Howard Hodgkin. b London (GB), 1932.
Small Durand Gardens. 1974. Oil on wood. **h**67 x **w**66.5 cm. **h**26⅖ x **w**26⅕ in. Private collection

Hofmann Hans

Apparition

A vibrant patchwork of shapes and tones fills the canvas, revealing Hofmann's delight in colour and texture. Hofmann saw it as the artist's role to transfer feelings and reactions to light and colour onto the two-dimensional picture plane. He saw nature as the 'source of all inspiration', believing that 'artistic intuition is the basis for confidence of the spirit'. Hofmann received a rigorous, academic European training. Consequently he went through many stylistic changes incorporating the influences of Post-Impressionism, Fauvism and Cubism.

When he emigrated to the United States in the 1930s, he sought to activate the picture surface by exploring the relationship between form, space, colour and line. For him, visual tension was of great importance. A highly influential theorist and teacher in his day, Hofmann inspired many younger painters through his schools in Munich and New York and was an important influence on Abstract Expressionism.

☛ Jorn, De Kooning, Krasner, Pollock

Hans Hofmann. b Weissenburg (GER), 1880. **d** New York (USA), 1966.
Apparition. 1949. Oil on canvas. **h**101 x **w**152.4 cm. **h**39¾ x **w**60 in. Private collection

Holzer Jenny

Protect Me from What I Want

Shown on a giant electronic advertising billboard situated above Piccadilly Circus in the heart of London, the message in this work is conveyed subliminally to the passing crowds below. This slogan comes from Holzer's 'Truisms' – a series of short, simple statements which comment on a diversity of personal, social and political issues. With other 'Truisms', such as *Abuse of Power Comes as no Surprise* and *Money Creates Taste*, Holzer questions the values of contemporary society. By appropriating the techniques of mass communication,

particularly those normally associated with the world of advertising, Holzer shifts the arena for art out of the gallery and into the public domain. Her provocative slogans have also been displayed on T-shirts, baseball caps, anonymous street posters, brass plaques and sports stadium scoreboards, forming a body of work that can best be described as an urban street poetry.

☞ Burgin, Kruger, Nauman, Weiner

Jenny Holzer. b Gallipolis, OH (USA), 1950.

209

Protect Me from What I Want. 1988. LED display on Spectacolour board. Dimensions variable. As installed in Piccadilly Circus, London

Hopper Edward

Nighthawks

Three customers sit wrapped in their own thoughts at a late-night diner on the corner of a deserted street. Only the waiter appears animated, as he bends down to prepare a drink. The bright illumination of the interior contrasts with the eerie, nocturnal light of the street outside. The whole scene seems imbued with menace, and suspense, as if something is about to happen. Hopper said of this work: 'I didn't see it as particularly lonely …Unconsciously, probably, I was painting the loneliness of a large city.' He was fascinated by the movies and this work clearly owes much to that medium, both in subject matter and compositional devices. Through the atmospheric lighting effects and strange perspective, this most humdrum event takes on an ominous quality. Painted in a clear, figurative style and always dealing with everyday life, Hopper's works capture the loneliness and isolation of life in America.

☛ **Benton, Campigli, Immendorff, Liebermann, Wood**

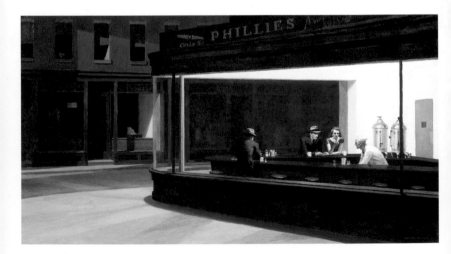

Edward Hopper. b Nyack, NY (USA), 1882. **d** New York (USA), 1967.
Nighthawks. 1942. Oil on canvas. **h**84.1 x **w**152.4 cm. **h**33$\frac{1}{8}$ x **w**60 in. Art Institute of Chicago, IL

Horn Rebecca

The Feathered Prison Fan

Luxurious white peacock feathers are attached to a frame which opens in two huge fans on either side of the performer. As well as producing a dramatic display, the feathers take on a sinister aspect, apparently smothering their occupant. They also make a wry comment on the lengths to which all animals will go to get themselves noticed. Horn began her career designing and constructing extraordinary and often cumbersome costumes for use in her performances and films. These frequently involved complex mechanical apparatus with which she transformed the wearer, either by extending the limits of the body, or by creating artificial, animal-like features and characteristics. In her recent work, the live element has been taken over by the mechanical, to create elegant and intriguing moving sculptures, yet the references to animal – and especially human – behaviour remain.

☞ Baumgarten, Beuys, Gober, Schapiro, Sterbak

Rebecca Horn. b Michelstadt (GER), 1944.
The Feathered Prison Fan. 1978. White peacock feathers, wood, metal and motor. **h**100 cm. **h**39⅓ in. Private collection

Hotere Ralph

Aramoana Nineteen Eighty-Four

Two sequences of numbers, from one to seven and eight to fourteen, are set against a black background on either side of this canvas. They frame a large white cross in the centre of the picture. Underneath, in capitals, is painted the title of the work: *Aramoana Nineteen Eighty-Four*. The cross physically links the two sets of numbers. It is also the Christian symbol of sacrifice, a theme that runs through this work. The sacrifice here is the destruction of Aramoana, the site of an albatross breeding colony. Hotere is a Maori artist and this painting has a political slant, incorporating a commentary on the land rights and traditions of his people, which he sees as being under threat. Unlike most other Maori artists, Hotere paints in a style influenced by Western art. For some years he made symmetrical, predominantly black paintings, inspired by the American painter Reinhardt. The trace of his influence remains in the monochrome background of this picture. Hotere later went on to make more gestural, expressive works.

☛ **Johns, Kawara, Klee, McCahon, Reinhardt**

Ralph Hotere. **b** Mitimiti (NZ), 1931.
Aramoana Nineteen Eighty-Four. 1984. Oil on canvas. **h**245 x **w**182.5 cm. **h**96½ x **w**71⅞ in. Waikato Museum of Art and History, Hamilton

Howson Peter

Plum Grove

A half-naked, castrated soldier has been strung up and left to die. The gaping wound is clearly visible, and the unnaturally contorted arms and legs express the soldier's absolute torment and pain. Two children play innocently alongside, already immune to the horrors of war. It is a brutal, graphic painting depicting a barbarous and inhuman atrocity. Howson's gritty, dark, realist style captures the profound depravity of war. With each thick brushstroke he expresses both anger and compassion. *Plum Grove* is from a body of work completed by Howson after his tour of Bosnia as official war artist. He rose to prominence in the early 1980s as a key figure in the Glasgow School of Painters, whose subject matter was the common man. Most of his works focus on the harsh and sometimes violent world of Glasgow city life and its hard-living, working-class people. Howson has also served in the army and worked as a nightclub bouncer.

☛ **Campbell, Golub, Guttuso, Nitsch, Pane**

Peter Howson. b London (GB), 1958.
Plum Grove. 1994. Oil on canvas. **h**213 x **w**152.5 cm. **h**83⅞ x **w**60 in. Tate Gallery, London

Huang Yong Ping

In this sculpture, Huang literally destroys traditional ideas of Art History. Taking a copy of *The History of Chinese Art* and a Chinese translation of *A Concise History of Modern Art*, he put them through a short cycle in a washing machine. He then placed the combined pulp in a tatty, old wooden box and displayed it as a work of art, calling it *The History of Chinese Art and A Concise History of Modern Art after Two Minutes in the Washing Machine*. With this act of cleansing and destruction, Huang creates a new space for his ideas and for an art unfettered by the authority of sacred texts. Huang has also participated in several performances with a group of artists called Xiamen-Dada Happenings. These included burning works and exhibiting junk and other found objects. Huang's questioning of the ideology of the Chinese art establishment and his criticism of its oppressive influence have since led to the censorship of his work from official Chinese art museums and exhibitions.

☛ **Cornell, Kabakov, Rollins, Schnabel**

Yong Ping Huang. b Quanzhou (CHN), 1954.
The History of Chinese Art ... after Two Minutes in the Washing Machine. 1987. Books, wooden box and glass.
h80 x **w**50 x **l**50 cm. **h**31½ x **w**19¾ x **l**19¾ in. Now destroyed

Iglesias Christina

Untitled (Antwerp I)

This serenely balanced sculpture is reminiscent both of an organic form and an architectural structure. Holding itself in a taut repose of suspended motion, it encloses a partial space within a fractured canopy and single, panelled wall. The thin sheets of smooth, white alabaster, held up by a web of iron, are translucent, like the wings of a dragonfly. Filtering the light, they create changing atmospheric sensations and ethereal shadows, evoking fantasies, dreams and memories. Alabaster is a favourite material for Iglesias, though she also works with other media including iron, steel and cement. Sometimes incorporating silk-screened fabrics, tapestries and the imprints of natural forms, such as leaves, in her sculptures, Iglesias builds ambiguous and poetic structures which are always attached to the walls of the gallery and interact with the architecture. In 1994 she represented Spain in the Venice Biennale.

☞ Benglis, Hesse, Phaophanit, Ryman

Christina Iglesias. **b** San Sebastian (SP), 1956.
Untitled (Antwerp I). 1992. Iron and alabaster. **h**432 x **w**270 x **l**392 cm. **h**170¼ x **w**106⅜ x **l**154½ in.
Museum Marugame Hirai, Marugame

Immendorff Jörg

Gyntiana

This overcrowded scene, set in an underground bar for lost souls, shows a dark and troubled world of conflict, isolation and anxiety. Painted in a graphic, comic-book style, the figures swirl together, as in a surreal narrative, filling every corner of the painting with their strange, hedonistic activities. But their essential loneliness is emphasized by the use of a yellow outline, enclosing each in a private world. Gyntiana is a character from the dramatist Henrik Ibsen's *Peer Gynt*, and this work is part of a cycle called 'Café de Flore', which forms a discourse on the arrogance of power and the evils of oppression. For Immendorff, painting is a political activity and his works tell of a once-divided Germany with two, equally absurd, ideological systems. Using familiar symbols of German identity such as flags, eagles and tanks, he populates his paintings with military, political and deviant characters. Immendorff studied under Beuys and his early work involved radical Dada-like activities. He is central to the figurative, Neo-Expressionist movement.

☛ Benton, Beuys, Campigli, Dix, Grosz

Jörg **Immendorff**. b Bleckede (GER), 1945.

Gyntiana. 1992–3. Oil on canvas. **h**350 x **w**700 cm. **h**137¾ x **w**275½ in. Galerie Michael Werner, Cologne

Indiana Robert

Decade: Autoportrait 1962

Set in a circle, a large star incorporating the number two forms the focus for this poster-like painting. The flat, decorative style combined with the blocks of pure colour produces a work that is both immediate and reflective. This composition is one of a series of ten, made for each year of Indiana's life from 1960 to 1970. The title is a wordplay on 'automobile' (an icon of American consumer culture), and 'self-portrait', though the representation of the artist is abstract. Indiana has been obsessed by numbers throughout his life, a situation he claims arose from having to move house 21 times as a child. Digits, emblems and words often act as central motifs in his works. Images of small-town America – gas stations, motels and diners – pervade Indiana's graphic works, in which he turns the signs and advertisements of American urban life into a hedonistic personal statement, somewhere between the paintings of Hopper and Pop Art. Indiana has also made sculptures, usually from wood and wheels.

☞ **Bickerton, Haring, Hopper, Johns, Nauman**

Robert Indiana. b New Castle, IN (USA), 1928.

Decade: Autoportrait 1962. 1971. Oil on canvas. **h**183 x **w**183 cm. **h**72 x **w**72 in. Private collection

Jawlensky Alexei von

Abstract Head

A series of simple lines and shapes gives the impression of a human head. A long, straight line represents the nose, two wavy lines suggest hair, while a series of rainbow stripes evokes the eyes. This is one of a series of works called 'Abstrakte Kopf' (Abstract Heads), begun in 1918, which were inspired both by the tribal masks of Africa and South-east Asia, and by the traditional art of Jawlensky's native Russia. He intended these paintings to be seen both as abstract combinations of shapes and colours, and also as mystical images of the archetypal human face. Like Kandinsky, Jawlensky believed that colour was a means of appealing to the soul, arguing that painting could be a visual music, where every colour corresponds to an equivalent sound. He developed this idea in a series of abstract landscapes which he called 'Songs without Words'. However, in contrast to Kandinsky, Jawlensky never made the leap into full abstraction.

☛ **Auerbach, Kandinsky, Laurens, Modigliani**

Alexei von Jawlensky. **b** Kuslovo (RUS), 1864. **d** Wiesbaden (GER), 1941.
Abstract Head. 1928. Oil on board. **h**45.1 x **w**32.4 cm. **h**17¾ x **w**12¾ in. Private collection

John Gwen

Dorelia in a Black Dress

Dorelia looks out at the viewer, her arms folded and the hint of a smile on her face. Her pink hair ribbon serves as an accent of colour in the otherwise dark colour scheme. Dorelia was a friend of the artist, and this affectionate portrait exhibits a wonderful understanding of subject, mood and tone. John specialized in gentle, understated female portraits. She also made a number of self-portraits, which reveal both her independent spirit and her habitual introspection. After a turbulent love affair with the French sculptor Rodin, John settled in France, living a reclusive life, and supporting herself by modelling for other painters. Her output was not huge, but the penetrating psychological intensity of her paintings makes her contribution to twentieth-century art unique. She died in Dieppe in 1939 in considerable poverty, largely unrecognized for her highly individual contribution to English painting.

☛ **Klimt, Modigliani, Rodin, Schjerfbeck**

Gwen John. b Haverford West (GB), 1876. **d** Dieppe (FR), 1939.
Dorelia in a Black Dress. c1903–4. Oil on canvas. **h**73 x **w**48.9 cm. **h**28¾ x **w**19¼ in. Tate Gallery, London

Johns Jasper

Zero Through Nine

The numbers from zero to nine are superimposed, producing a systematic abstract image in which none of the figures is clearly visible. The loose and colourful brushwork of light blues, reds and oranges gives the work a feeling of energy. Johns's use of numbers as the subject of his painting looks forward to the work of the Pop artists, who used imagery from everyday life and popular culture as the basis for their art. However, Johns's technique is more painterly and expressive, revealing the influence of the Abstract Expressionists, such as Pollock, who were

then creating canvases laden with emotion and personal feeling. With his choice of mundane and straightforward subject matter, such as numbers, targets and flags, and his rapid method of painting with large, gestural brushstrokes, Johns is often seen as the bridge between the two movements. He was primarily interested in the nature of painting, expanding its boundaries by combining collage and sculpture on the painted surface.

☛ Indiana, Kawara, Pollock, Rauschenberg, F Stella

Jasper Johns. **b** Allendale, SC (USA), 1930.
Zero Through Nine. 1961. Oil on canvas. **h**137.2 x **w**104.8 cm. **h**54 x **w**41¼ in. Tate Gallery, London

Jones Allen

Dancers

A male and female body are fused in this vast, mildly erotic sculpture. Cut-out sections of intertwining sheets of brightly coloured metal allow light to pass through and give the impression of dancers floating in space. Inspired by Jones's readings of the German philosopher Nietzsche, the Austrian psychoanalyst Freud and the Swiss psychologist Jung, this work combines masculine and feminine elements in an attempt to reconcile the alleged bisexual nature of the human psyche. Presenting a romanticized view of the union between man and woman, this work is typical of Jones, with its emphasis on sexuality. His art examines sexual desire, often presenting provocative and explicit images of women as seen through the fantasy of advertising and the male imagination. His borrowing of imagery from the world of mass media links him to the Pop Art movement. A contemporary of Hockney, Jones has also designed stage sets and costumes and is a talented printmaker.

☞ Calder, Hockney, Matisse, Nadelman, Segal

Allen Jones. **b** Southampton (GB), 1937.
Dancers. 1987. Painted Cor-Ten steel. **h**7.3 m. **h**24 ft. Cottons Atrium, London Bridge City, London

Jorn Asger

Dead Drunk Danes

This tempestuous blend of primary colours and furious brushwork is characteristic of Jorn's expressive output. Evoking inebriation, the forms are indeterminate but some do suggest human shapes. Jorn was a founding member of the Cobra movement, a group of artists who saw a need to return to primal instincts. Producing spontaneous, childlike works, they placed great emphasis on the process and act of painting, in common with the gestural abstraction that was flourishing in the rest of Europe. Jorn studied under Léger but spent most of his career breaking away from the rigid style he had inherited. He was also involved with the Situationists, a group of artists who believed that capitalism had turned spectators into passive consumers of media imagery, so they had to resort to revolutionary strategies to get them to look at art with fresh eyes. Whereas the French aimed at revolution in art, Scandinavians like Jorn strived for reform. A prolific painter and writer, Jorn also produced a small body of sculpture.

☛ Alechinsky, Appel, Hofmann, Léger, Pollock

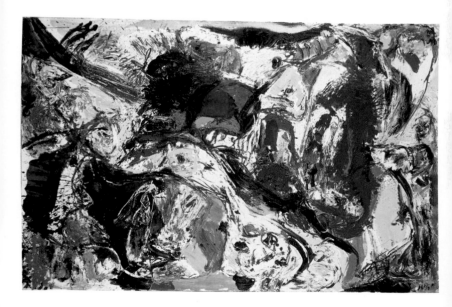

Asger Jorn. b Veyrun (DK), 1914. d Aarhus (DK), 1973.
Dead Drunk Danes. 1966. Oil on canvas. h130 x w200 cm. h51¼ x w78⅞ in. Louisiana Museum of Modern Art, Humlebaek

Judd Donald

Untitled

Three sets of shelves made of aluminium and Plexiglas have been fixed to the wall. Displayed in this way, they look more like paintings than sculptures, which usually stand on the floor. The pieces are machine-made, avoiding any trace of the artist's hand. The idea of removing the artist from the creative equation is typical of Minimalism, a movement, of which Judd became a leading figure. The radical simplicity of this work is typical of Judd. Striving for an art which was neither illusionistic nor anthropomorphic but which had a unity of its own,

Judd abandoned painting in the early 1960s and began to make reliefs and freestanding objects. The choice of three dimensions over two allowed him to use many of the new materials, such as stainless steel and Plexiglas, whose industrial qualities he found appealing. Judd's sculptures are all exquisitely crafted with great attention to detail. He is admired for his stringent, uncompromising attitudes to the making and presentation of art.

☞ Andre, Brancusi, LeWitt, Newman, Reinhardt

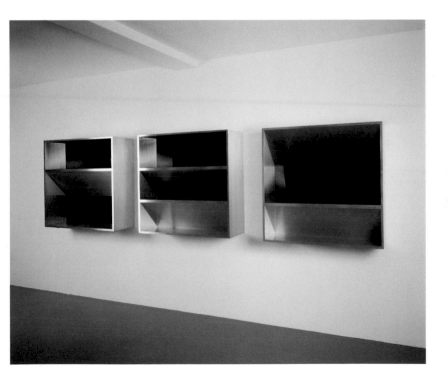

Donald Judd. b Excelsior Springs, MO (USA), 1928. d New York (USA), 1994.

223

Untitled. 1982. Aluminium and violet Plexiglas. h100 x w100 x l37 cm. h39½ x w39½ x l14½ in. Private collection

Kabakov Ilya

Incident at the Museum or Water Music

In this installation, Kabakov recreates two large rooms of a decaying, Soviet museum, complete with deep red walls, gilded mouldings and threadbare, cushioned seating. Inventing a fictitious genre painter, Kabakov has filled the rooms with paintings, themselves suffering from neglect, executed in the officially sanctioned Socialist Realist style. From the ceiling, water drips into a scattered arrangement of buckets and onto sheets of plastic, creating a mesmerizing rhythm – hence the alternative title. It is not the happy rural idylls depicted in the paintings which engage the viewer, but the sodden and dishevelled atmosphere, redolent of the grim reality of the former Soviet Union and its descent into an unmanned chaos. This piece is typical of Kabakov, a central figure of Russian Conceptual Art, whose work was repressed by the Russian Government. His witty installations often use fictitious characters, stories and scenarios in order to comment on the politics and cultural approach of his homeland.

☛ **Bartlett, Haacke, Komar and Melamid, Mukhina**

Ilya Kabakov. **b** Dnepropetrovsk (UKR), 1933.
Incident at the Museum or Water Music. 1992. Paintings, drawings, buckets and plastic sheeting. Dimensions variable. Collection of the artist

Kahlo Frida

Sitting on a simple wooden chair and dressed in a man's grey suit, the artist is surrounded by locks of hair. All that symbolized her femininity – her beautiful hair and colourful dresses – is gone. At the top of the painting above a line of music is the bitter lyric: 'Look if I loved you, it was for your hair. Now that you are bald, I don't love you anymore.' This painting was made while Kahlo was in the depths of despair following her divorce from the great Mexican muralist, Rivera. Kahlo's life was plagued by accidents and illness and her many self-

portraits often focused in a harrowingly personal way on her intense experiences and troubled inner states of mind. Fusing a style derived from traditional Spanish-American art with the experimentations of the Surrealists (who considered Mexico the most 'surreal' of places), she participated fully in the politics and art of her country during a period when the Mexican art scene was particularly vibrant.

☞ **Modigliani, J C Orozco, Rivera, Schjerfbeck**

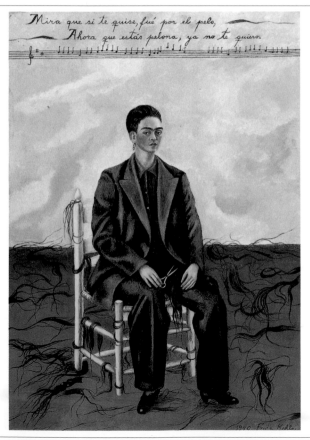

Frida Kahlo. b Coyoacán (MEX), 1907. **d** Mexico City (MEX), 1954.
Self-portrait with Cropped Hair. 1940. Oil on canvas. **h**40 x **w**27.9 cm. **h**15¾ x **w**11 in. Museum of Modern Art, New York

Kandinsky Wassily

Swinging

Coloured shapes and lines are arranged on the canvas in a vibrant composition. The shapes suggest drama and movement, the intense, vivid colours create a sense of space, while the lines give the painting a dynamic force and rhythm. The whole arrangement evokes joyful emotions, as a piece of music might do. Kandinsky was born in Russia and originally trained as a lawyer. He subsequently moved to Munich to study painting, where he established the German Expressionist movement Der Blaue Reiter (The Blue Rider), along with Marc. After the First World War, he returned to Russia and was involved in the development of artistic projects for the new Soviet state. However, he soon became disillusioned with the new regime, and moved back to Germany where he taught at the famous Bauhaus school of art and design. Kandinsky is said to have made his first abstract painting as early as 1910, and was therefore one of the founders of 'pure' abstract art.

☞ **Van Doesburg, Herbin, Klee, Lissitzky, Marc, Mondrian**

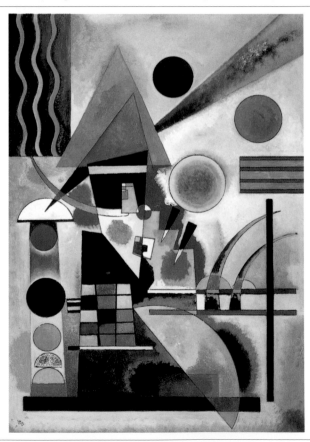

Wassily Kandinsky. **b** Moscow (RUS), 1866. **d** Neuilly-sur-Seine (FR), 1944.
Swinging. 1925. Oil on board. **h**70.5 x **w**50.2 cm. **h**27¾ x **w**19¾ in. Tate Gallery, London

Kantor Tadeusz

Edgar Warpol: The Man with Suitcases

A faceless figure bends down to lift a heavy suitcase, his back weighed down with parcels and his coat hanging in tatters round his knees. This symbolic image represents the fate of the perpetual wanderer and is partly auto-biographical. It was made for a production of the play *The Water Hen* by Stanislaw Ignacy Witkiewicz. The theme of the travelling man was a recurring one in Kantor's work. Trained as a painter, he became one of the most significant post-war artists in Poland. He was also a founder member of the influential Cricot 2 theatre group, and is best known for breaking down the barriers of traditional theatrical practice and encouraging audience participation, spontaneity and chance. His particular style spawned the Theatre of the Absurd – drama which attempts to reflect the senselessness of the human condition through bizarre devices. A multi-talented maverick, Kantor, like Beuys, brought together the disciplines of painting, theatre, performance and design.

☞ Beuys, Burri, Hammons, Horn, Shiraga

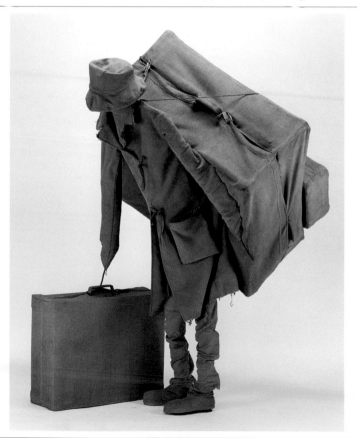

Tadeusz Kantor. b Wielopole (POL), 1915. **d** Warsaw (POL), 1990.
Edgar Warpol: The Man with Suitcases. 1967–8. Textile and metal. **h**170 cm. **h**67 in. Muzeum Sztuki w Lodzi, Lodz

Kapoor Anish

Mother as a Mountain

A thick layer of deep red powdered pigment, sculpted into ridges, covers a wooden base. Drawings on the wall behind show the initial sketches and ideas for the final piece. The form of the sculpture resembles a mountain, while the tear-shaped hole at the top evokes the vagina. Many of Kapoor's works are concerned with the female body as a universal symbol of creativity and the site of erotic pleasures. Their inner cavities or voids suggest the interior of the human body, an unknown space, both comforting and fearful, inviting discovery yet charged with the primal forces of the unconscious. Born in India and now living and working in London, Kapoor has acknowledged the influences of both Eastern and Western culture on his art. He aims to evoke the sublime in his simple abstract forms, which often elicit a powerful spiritual and physical response from the viewer. His work has been exhibited worldwide and is held in numerous private and public collections.

☞ Arp, Heron, Klein, Sarmento

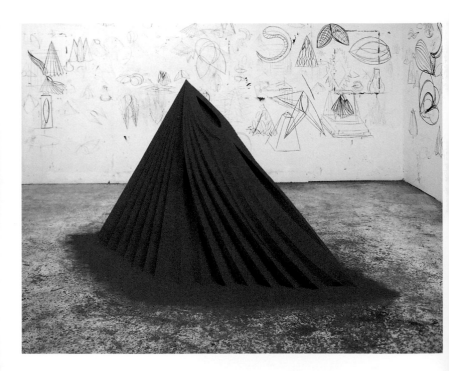

Anish Kapoor. b Bombay (IN), 1954.

Mother as a Mountain. 1985. Wood, gesso and pigment. **h**140 cm. **h**55 in. Walker Art Center, Minneapolis, MN

Kawara On

One Thousand Days One Million Years

Recording the passage of time, a sequence of dates is painted in white onto black backgrounds. Kawara is not interested in suggesting or illustrating what each day may have meant, instead he coolly displays the information, thus reducing the subjective events of the day to a sign. Since 1966, Kawara has worked on this series of 'date paintings'. He simply presents the date on which he makes each painting in the language of the country where he is working, or in Esperanto if the language has no Latin script. A Japanese Conceptual artist working in New York, Kawara is interested in the conflicting notions of time between East and West. His work also refers to the 'reading of days', an ancient Japanese ritual, practised to foresee the arrival of the gods. Therefore, these paintings speak of anticipation as well as loss. In another series, Kawara sent postcards to friends and relatives, informing them of what time he got up that morning. He frequently dispatches telegrams which simply announce: 'I Am Still Alive.'

☞ Darboven, Hotere, Kosuth, McCollum

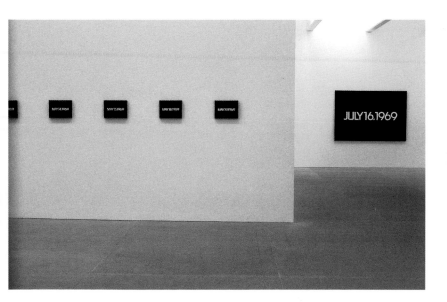

On Kawara. b Kariya (JAP), 1933.

One Thousand Days One Million Years. 1993. Liquitex on canvas. Main panel: **h**154.9 x **w**226.1 cm. **h**61 x **w**89 in.

As installed at the Dia Center for the Arts, New York

Kelley Mike

Plush Kundalini and Chakra Set

The bedraggled soft toys in this work were found by Kelley in second-hand shops. By giving new life to these once-loved, furry animals he elicits both sympathy at their abandonment and annoyance at their sentimentality. He also plays on the slightly repellent nature of things that have been played with and dribbled on. Like a delinquent youth, Kelley places his subjects in suggestive poses or groupings where they hug each other with a kind of blind compassion. Kelley is a rebellious artist whose humorous response to the downside of life finds expression through a slightly kitsch and tasteless style. His attitude of aesthetic disobedience has its roots in his rejection of the social and moral fabric of American culture. He is an influential figure in the Southern Californian art scene, which celebrates bad taste, and art forms traditionally despised by the establishment. Kelley has been involved in performances, readings, videos and bands, often in collaboration with other artists.

☛ **Duchamp, Koons, Messager, De Saint Phalle**

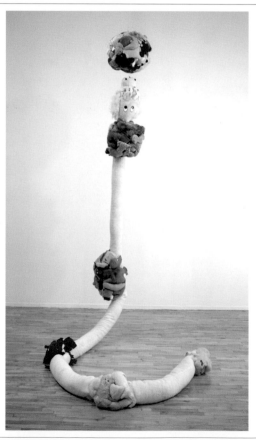

Mike Kelley. b Detroit, MI (USA), 1954.
Plush Kundalini and Chakra Set. 1987. Soft toys. **h**6.7 m. **h**22 ft. Private collection

Kelly Ellsworth

Green Relief with Blue

Two canvas panels of solid colour abut on a diagonal axis. Emphatic and self-sufficient, they claim their own space, declaring themselves irrefutably present. Unconstrained by the rectangular frame of traditional paintings, Kelly's work enters the realm of wall-based sculpture. His use of colour creates an intense optical experience without expression or symbolism. Trained in Paris, Kelly absorbed the simplified geometry of Constructivism through the work of Tatlin and Malevich. Following a visit to New York in the 1950s, however, he adjusted his work to the larger scale of American Abstract Expressionism. Since then, his sole concern has been the internal relationship between colour and form, usually explored through shaped canvases. Working from sketches, he hones his found shapes – the curve of a staircase, or shadows cast on the floor – until they cease to depict their subject altogether. Kelly is an artist searching for the essential in the commonplace through an impressive economy of means.

☞ LeWitt, Malevich, Reinhardt, Ryman, Tatlin, Tuttle

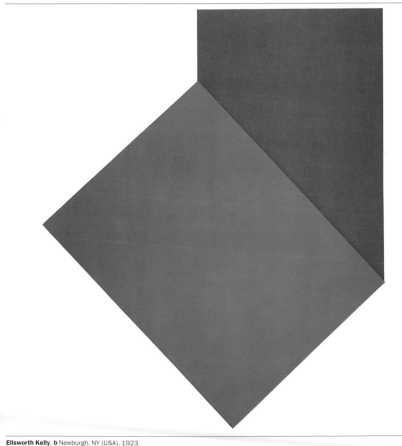

Ellsworth Kelly. b Newburgh, NY (USA), 1923.
Green Relief with Blue. 1993. Oil on canvas. h304.8 x w249.5 cm. h120 x w98¼ in. Private collection

Kelly Mary

Post-Partum Document: Documentation V

For this series of documents, Kelly has preserved, like a scientific specimen, a butterfly found by her four year-old son. Next to this, she records the date on which he asked where babies come from and a transcription of their conversation. Kelly also juxtaposes a diagram of the vagina and an index of words associated with pregnancy. This sequence forms part of *Post-Partum Document*, Kelly's ground-breaking and extremely controversial project of 1973 to 1979, which explores her relationship with her son. Executed in six sections, it details the significant stages of the child's development. Diaristic in form, *Post-Partum Document* deals with the experience of motherhood in relation to the pressures of work, and speaks candidly of the emotional highs and lows of watching a child grow. Kelly's work is central to the feminist discourse of the 1970s. As a teacher and writer, she has been a crucial participant in debates about psychoanalytical and photographic representation.

☞ Chadwick, Hatoum, Mendieta, K Smith

Fig. 9a

Fig. 9b

Mary Kelly. b Fort Dodge, IA (USA), 1941.

Post-Partum Document: Documentation V. 1977. Mixed media. **h**17.8 x **w**38.1 cm. **h**7 x **w**15 in. Australian National Gallery, Canberra

The wood-beamed loft is a sparse setting for the spirits of Germany's great cultural heroes: the nineteenth-century composer Richard Wagner, the artist Beuys and the nineteenth-century painter Caspar David Friedrich. Their names appear in lines of text that recede in proportion to the perspective of the attic, conjuring up images of a nation's past. Mythic flames burn in honour of the deceased, punctuating the intensity of the wood-grained beams and panels. In Kiefer's large-scale, often highly textured paintings, the everyday becomes a stage on which Germany's battles, its failures and triumphs, are relived. Nazism's exploitation of myth and legend haunts the images. The fractured surfaces reveal many layers of consciousness through which Kiefer detects the indelible scars left on his homeland by history. Often linked to the figurative, Neo-Expressionist painters of the early 1980s, Kiefer is also known for his drawings and enormous 'books' made of lead.

☞ Baumgarten, Beuys, Haacke, Mendieta

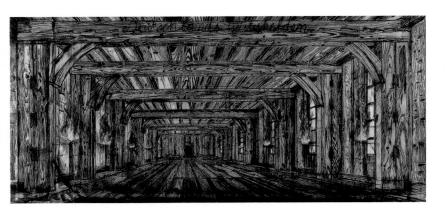

Anselm Kiefer. b Donaueschingen (GER), 1945.
Spiritual Heroes of Germany. 1973. Oil and charcoal on burlap, mounted on canvas. **h**304.8 x **w**680.7 cm. **h**120 x **w**268 in.
Private collection

Kienholz Ed and Nancy

Sollie 17

The artists have re-created a small, cramped hotel bedroom, complete with damp, peeling wallpaper, an old portable television set and a pair of underpants drying on a hanger on the right-hand wall. The three figures represent the same man at different points in time: he is shown lying on the bed reading a book, trying to escape the tedium and loneliness of his life; sitting on the edge of the bed, his head bowed; and finally getting up to look out of the window, perhaps thinking about escaping from the confines of his room. The title refers to the novel

Stalag 17, which is about a prisoner-of-war camp, re-inforcing the theme of misery and confinement. Two of the most prominent assemblage artists of the 1970s, Ed and Nancy Kienholz present a searing indictment of American society. Their contemporary allegories focus on the decay, sexual repression and violence that underlies the seemingly banal.

☛ Hopper, Magritte, Oldenburg, Segal, Spoerri

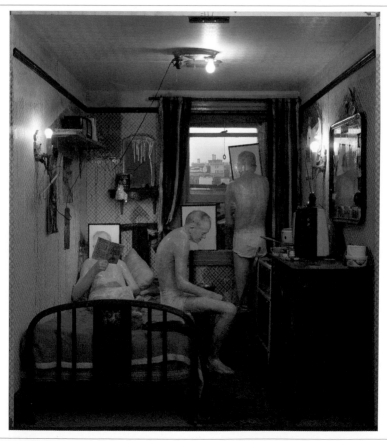

Ed and Nancy Kienholz. Ed. **b** Fairfield, WA (USA), 1927. **d** Sandpoint, ID (USA), 1994. Nancy. **b** Los Angeles, CA (USA), 1943.
Sollie 17. 1979–80. Mixed media. **h**3 x **w**8.5 x **l**4.3 m. **h**10 x **w**28 x **l**14 ft. Private collection

Kippenberger Martin Untitled

Half man and half skeleton, the artist himself stands like a warrior, defiant in the face of his own mortality. In his right hand he carries a spear, and in his left he holds a folded paper boat. The strange orange planet in the background is based on a child's rubber toy, perhaps evoking memories of Kippenberger's past. In bringing together seemingly unconnected objects and imagery, this painting owes much to the work of the Surrealists in the 1920s. Kippenberger deliberately sets out to make paintings which defy interpretation or even insult the viewer with their presence. After a strict evangelical upbringing in the Black Forest, Kippenberger rebelled, leading a varied and unconventional life. He bought a gas station in Brazil, founded his own punk band, and has even considered completing an unfinished novel by the Czech writer Franz Kafka, giving it a happy ending. He moved into the world of entertainment when he established S.O.36, a venue that hosted concerts and Happenings.

☞ **Kahlo, Modigliani, Morimura, Schjerfbeck**

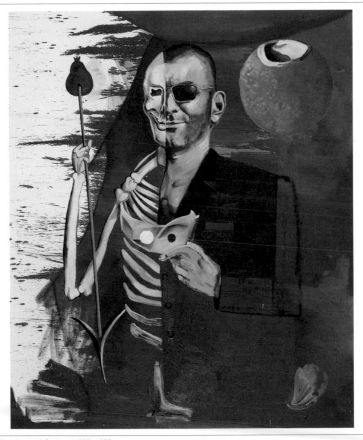

Martin Kippenberger. **b** Dortmund (GER), 1953.
Untitled. 1988. Oil on canvas. **h**240 x **w**200 cm. **h**94½ x **w**78⅞ in. Private collection

Kirchner Ernst Ludwig

Group of Artists

Three artists sit in contemplative communion. The elongated, twisted figures with their stylized, mask-like faces reflect Expressionistic distortions of line and colour. Kirchner was the most gifted of the German Expressionist group Die Brücke (The Bridge), formed in 1905 in Dresden. The artists associated with this group saw their work as forming a bridge between the art of the past and that of the future, and believed that their paintings could enrich people's lives. Kirchner's extensive output included paintings, sculptures and graphic work.

He was influenced by the vivid brushwork of Vincent van Gogh, the psychological drama of Munch and, like many of his contemporaries, by sculptures from the South Sea Islands. Sadly, the neurotic intensity of his flame-like figures was a reflection of a depressive condition. His pictures were confiscated by the Nazis and in 1938 he committed suicide.

☞ **Denis, Heckel, Munch, Renoir**

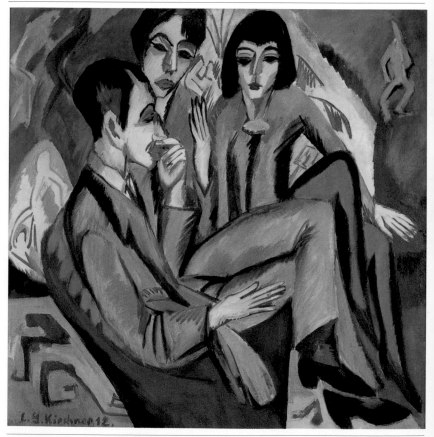

Ernst Ludwig Kirchner. **b** Aschaffenburg (GER), 1880. **d** Davos (SW), 1938.
Group of Artists. 1912. Oil on canvas. **h**96 x **w**96 cm. **h**37⅞ x **w**37⅞ in. Karl Ernst Osthaus-Museum, Hagen

Kirkeby Per

Birds Buried in Snow

A barn or log cabin is just visible through a snowstorm. Painted with rapidly applied brushstrokes in white, yellow and orange, the snow falls in abundance. In the winters in the north of Denmark, birds have little hope of surviving a storm like this. The snow is painted with energy, the layers of brushstrokes giving the impression of intense activity. There is a certain element of sentimentality in this work, particularly in the way landscape is used as a tool to express the idea of birds being buried in the snow. Kirkeby's paintings often focus on past events and times and are frequently highly expressive and gestural. His careful use of pigment reflects an interest in the emotive value of colour, typical of Expressionism. Throughout his work, there is a uneasy balance between order and chaos. He has also made a number of architectural sculptures from brick, as well as a series of abstract bronzes.

☛ Johns, Marc, Mitchell, Motherwell, Utrillo

Per Kirkeby. b Copenhagen (DK), 1938.

Birds Buried in Snow. 1970. Oil on masonite. **h**122 x **w**122 cm. **h**48 x **w**48 in. Louisiana Museum of Modern Art, Humlebaek

Kitaj R B

Land of Lakes

A vast landscape, dotted with lakes, a river, trees and buildings, resounds with the evening afterglow of sun-drenched southern soil. From the wall of a whitewashed building an eye, set in a triangle, surveys the tranquil scene. A cross and a red flag, symbols of Christianity and left-wing politics, stand in the foreground, perhaps suggesting an honourable truce. Kitaj has described this work as 'an optimistic scenic view' and 'a token of better times to come', in the aftermath of the Holocaust: the water in the painting alludes to regeneration and growth.

With idiosyncratic touch, each element has been pieced together with total clarity. Though born in the United States, Kitaj lives mostly in England and was a key figure in the British Pop Art movement. But rather than including references to popular culture, Kitaj often quotes from high art and literature in his complex work. This particular painting is inspired by a detail of *The Effects of Good Government* – Ambrogio Lorenzetti's fourteenth-century fresco in Siena.

☛ Dove, Hockney, Utrillo, Vlaminck

R B (Ronald Brooks) Kitaj. **b** Cleveland, OH (USA), 1932.
Land of Lakes. 1975–7. Oil on canvas. **h**152.4 x **w**152.4 cm. **h**60 x **w**60 in. Private collection

Klee Paul

Moonrise and Sunset

In this enchanted night-time scene, rich and vibrant yellows, oranges and blues coexist in a dreamlike, exotic landscape. The familiar shapes of buildings can be discerned, but the space they inhabit is strangely undefined and childlike. 'Taking a line for a walk' was how Klee famously described his hieroglyphic style, which was informed by a passion for music, and an interest in dreams and subconscious doodles. Klee's unique style, which many later artists have sought to emulate, is a combination of innocence and sophistication. At first, he specialized in etchings, turning to watercolours after a trip to Tunisia heightened his awareness of colour. In 1911 he became closely associated with Kandinsky, Jawlensky and Feininger who together formed the Expressionist group Der Blaue Reiter, a band of avant-garde artists working together in Munich. He taught art at the famous Bauhaus school in Weimar, but was forced to leave Germany by the Nazis because of his radical artistic tendencies.

☛ **Feininger, Gottlieb, Jawlensky, Kandinsky**

Paul Klee. b Münchenbuchsee (SW), 1879. **d** Muralto (SW), 1940.

Moonrise and Sunset. 1919. Oil on board. **h**40.5 x **w**34.5 cm. **h**16 x **w**13⅝ in. Private collection

Klein Yves

FC–11 Anthropometry – Fire

A swathe of blue paint covers the surface of this burnt paper. The image is the imprint of a naked woman's body, an unusual form of painting, somewhere between portraiture and abstraction. Klein referred to these body prints as 'Anthropometries', which literally means a study of the proportions of the human body. This particular colour of blue paint, which Klein patented as 'International Klein Blue', became a trademark of his work. It was a colour which he claimed aroused no specific associations except with the sea and the sky which are the two most intangible or abstract elements of nature. A flamboyant showman and tireless provocateur, Klein produced a wide body of work that included a series of fire paintings made with a flame-thrower. Along with Manzoni, he was one of a group of artists known as the Nouveaux Réalistes who favoured new ways of producing art, reacting against traditional oil painting on canvas.

☞ **Fontana, Hartung, Manzoni, Rotella**

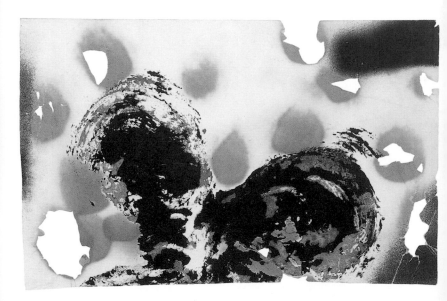

Yves Klein. **b** Nice (FR), 1928. **d** Paris (FR), 1962.
FC–11 Anthropometry – Fire. 1961. Oil on burnt paper. **h**22.5 x **w**36 cm. **h**8¾ x **w**14½ in. Nordenhake, Stockholm

Klimt Gustav

Judith and Holofernes

Judith displays the head of Holofernes and gazes provocatively at the viewer. She has a monumental, sensual power and erotic splendour. Holofernes, who was general of the Assyrian army in the time of Nebuchadnezzar, besieged the town of Bethulia, cutting off its water supply. Judith, a beautiful widow, determined to save the town, seduced Holofernes and beheaded him while he was in a drunken stupor. The gilded ornamentation based on natural forms is typical of the Secession style – the Austrian version of Art Nouveau, a decorative movement characterized by stylized, sinuous lines which revolutionized Western architecture and design at the end of the nineteenth century. An essentially decorative painter, Klimt was the principal artist of this movement, which aimed to raise the level of production of arts and crafts in Austria to that of other European countries. His move towards Symbolism and his anti-realist tendencies were considered extremely radical at the time.

☛ **John, Morimura, Munch, Schiele**

Gustav Klimt. b Vienna (AUS), 1862. **d** Vienna (AUS), 1918.

Judith and Holofernes. 1901. Oil on canvas. **h**84 x **w**42 cm. **h**33 x **w**16½ in. Österreichische Galerie, Vienna

Kline Franz

Chief

Huge swathes of black paint cut across the vast canvas in all directions, balanced by an equal spread of white, giving the effect of light and shade. The dramatic scale is augmented by the powerful intensity of the grand interlocking shapes, influenced by Oriental calligraphy. Kline 'discovered' his method by projecting a small drawing onto the wall to create the effect of an enlarged microscopic detail. The aggressive brushstrokes of *Chief* appear to be spontaneously executed, earning him the name 'action painter', but Kline prepared many sketches, often on old telephone book pages, before painting the large work with control and consideration. Kline's uneasy abstract works have been related to the unsettling socio-economic atmosphere of New York and to the landscape of industry. *Chief* was named after a famous train that Kline remembered from his childhood home in the coal mining state of Pennsylvania. Along with Pollock and Motherwell, Kline was a member of the Abstract Expressionist group.

☛ **Michaux, Motherwell, Pollock, Soulages**

Franz Kline. **b** Wilkes-Barre, PA (USA), 1910. **d** New York (USA), 1962.

Chief. 1950. Oil on canvas. **h**148.3 x **w**186.7 cm. **h**58½ x **w**73½ in. Museum of Modern Art, New York

Knizak Milan

Instant Temples

A naked woman lies on the ground, stretched out perpendicular to a log in a quarry. Knizak staged this performance in numerous locations throughout Czechoslovakia. 'In what I present here', said Knizak, 'I only want to point out the…very simple possibilities of praying to oneself, to one's body and spirit…and through them to an imaginary and necessary god, to one's dreams, imaginings, desires.' This kind of anarchic performance is typical of the Fluxus movement. Influenced by the aesthetics of Zen Buddhism and Yoga, Knizak was one of the most significant members of this group, whose diverse activities included interactive performances. In the politically charged climate of Czechoslovakia in the 1970s, his Happenings, which usually began in the street, had a great resonance. Primarily focusing on everyday items and ideas, Knizak's performances, which often include paintings and found objects, have always been anti-materialistic, almost paganistic, drawing on many disciplines from sociology to biology.

☞ **Maillol, Shiraga, K Smith, Wall**

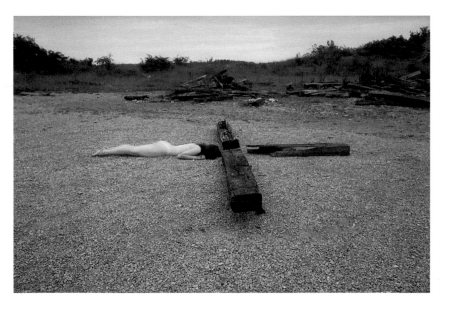

Milan Knizak. **b** Pilsen (CZ), 1940.

Instant Temples. 1970–1. Photograph of a performance at a quarry near Marienbad, Czechoslovakia

Kokoschka Oskar

London: Large Thames View

Nervous, swerving lines evoke the tumultuous noise and bustle of London, from the cars speeding down the Embankment in the bottom of the composition, to the boats sailing with their cargoes under the bridge. The luminous yellows, blues and pinks and the exuberant brushstrokes are characteristic of Expressionism, a movement which rejected naturalism, aiming to represent the emotions evoked by a particular subject. This is one of a series of Thames views on which Kokoschka worked in the 1920s. London had a particular significance for him, as he went there to escape the onset of Nazism in his native Austria, and we sense that this work presents a romantic and idealized view of the capital. Kokoschka's work was condemned by the Nazi regime as 'degenerate' in his absence, yet he remained committed to his artistic vision, producing highly personal, Expressionist landscapes and portraits throughout his career.

☛ **Derain, Dufy, Heckel, Nolde**

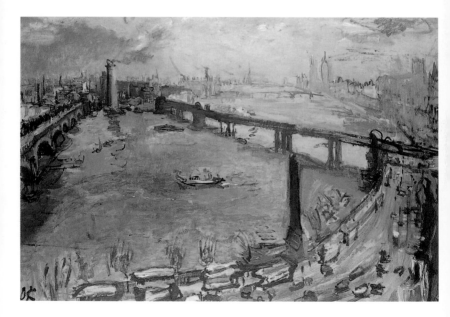

Oskar Kokoschka. b Pöchlarn (AUS), 1886. **d** Montreux (SW), 1980.
London: Large Thames View. 1926. Oil on canvas. **h**90.2 x **w**130.2 cm. **h**35½ x **w**51¼ in. Albright-Knox Art Gallery, Buffalo, NY

Kolář Jiří

Leonardo da Vinci's *Mona Lisa* and a seventeenth-century Dutch landscape have been cut into strips of equal width and then glued alternately, so that both pictures are distorted. Each retains its identity, but an entirely new and cogent work has been created. Using simple techniques, Kolář has radically altered the history of art. He has made numerous types of collage, to which he has given names such as 'Prollage', 'intercollage' and 'chiasmage'. These provide a framework for challenging the way we read images and texts. Combining a famous work of art with a decorative or kitsch motif, he questions its status in an age of mass, mechanical reproduction – a strategy that links him to the Pop Art of his American contemporaries. But a poetic resonance, influenced by Surrealism and Cubism, gives Kolář's work a distinctly European flavour. Kolář is also a poet, and was a key member of a revolutionary group of writers set up in 1942 in Czechoslovakia.

☞ Huang, Martin, Morimura, Rotella, Warhol

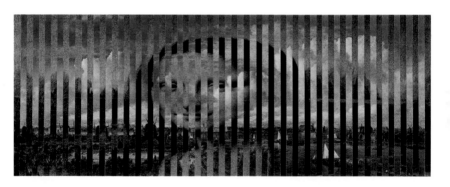

Jiří Kolář. **b** Protivín (CZ), 1914.
Smiling Landscape. 1967. Collage. **h**21.6 x **w**54.6 cm. **h**8½ x **w**21½ in. Private collection

Kollwitz Käthe

Mother with Dead Child

In this painful, tragic image, a woman engulfs the fragile body of a dead child in a desperate embrace. The woman's heavy knees, feet and hands contrast with the delicate features and bony shoulders of the child, emphasizing its vulnerability. A graphic artist and sculptor, Kollwitz witnessed the upheaval and misery of both world wars. Her son's death in the trenches focused her art on human suffering and misery, and her harrowingly intense style and subject matter have sometimes led to her classification as a German Expressionist. But her woodcuts, drawings and etchings, concentrating on working-class deprivation and the horror of war are perhaps more indebted to the searing social critiques of certain nineteenth-century artists and writers. Possibly her most innovative and compelling work is her series of self-portraits. At all ages she confronts the mirror, fearlessly depicting the sorrows and losses which have made their mark on her face as the years have passed.

☞ Bourdelle, Dumas, Kubin, Munch

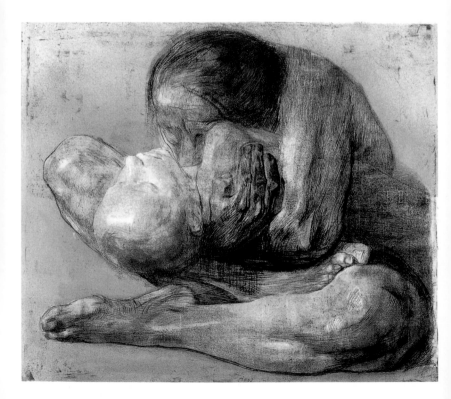

Käthe Kollwitz. b Königsberg (GER), 1867. d Moritzburg (GER), 1945.
Mother with Dead Child. 1903. Etching. **h**42.5 x **w**48.6 cm. **h**16¾ x **w**19⅛ in. Akademie der Künste, Berlin

Komar and Melamid Stalin in Front of the Mirror

Stalin stares pensively into the mirror, his face bathed in a pool of light which contrasts sharply with the darkness of the room. The red drapery of Communism covers the table at which the Soviet leader sits. A symbol perhaps of his vanity, the mirror also reflects his true self – paranoid and self-doubting. Komar and Melamid's images of Russian life employ the heroic and realistic Socialist-Realist style endorsed by Stalin, yet their imagery cleverly parodies the Soviet regime. In another painting by the artists of a meeting between Stalin and Hitler, the two leaders are accompanied not by a great statesman but by ET, the extra-terrestrial. The artists' approach is truly post-modern, in that they reject the notion of artistic originality and employ a traditional style to subversive ends. They are scavengers, drawing from high and low culture, and in this they have much in common with Pop artists. Vitaly Komar and Aleksander Melamid have worked together since meeting at art school in the 1960s, leaving Russia in 1978 to settle in New York.

☛ **Art & Language, Bellows, Kabakov, Mukhina**

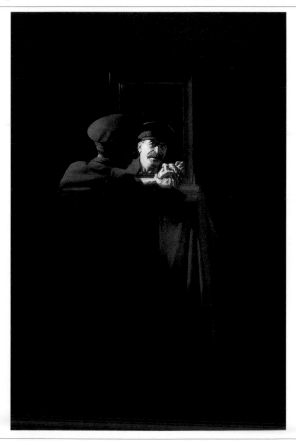

Komar and Melamid. Vitaly Komar. **b** Moscow (RUS), 1943. Aleksander Melamid. **b** Moscow (RUS), 1945.
Stalin in Front of the Mirror. 1982–3. Oil on canvas. **h**182.8 x **w**121.9 cm. **h**72 x **w**48 in. Private collection

De Kooning Willem

The Visit

A loose area of pink paint outlines the form of a woman's body. Her legs are splayed, two swathes of red suggest breasts, and a series of mottled green marks map out the eyes and mouth. The paint has been heavily applied and energetically reworked to produce a fine balance between figuration and abstraction, an attribute that distinguishes De Kooning's output from the more rigorously abstract works of his contemporaries. *The Visit* comes from a series of paintings focusing on the female body. Its title was suggested by the artist's assistant who was reminded of a medieval Visitation or Annunciation scene. De Kooning's output varied considerably in style, from his early portraits and standing figures – heavily influenced by Picasso – to his later abstract landscapes. Although of Dutch descent, he was one of the leading exponents of the American Abstract Expressionist movement that dynamically explored intense emotion on canvas and was characterized by a vision of the artist as non-conformist individual.

☞ **Auerbach, Johns, Motherwell, Picasso**

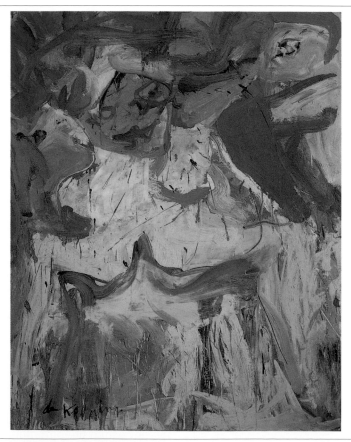

Willem de Kooning. b Rotterdam (NL), 1904. **d** New York (USA), 1997.
The Visit. 1966–7. Oil on canvas. **h**152.4 x **w**121.9 cm. **h**60 x **w**48 in. Tate Gallery, London

Koons Jeff

Bear and Policeman

A giant bear in a striped T-shirt is shown collaring a London bobby. This oversized, tacky sculpture is typical of Koons's work. He is fascinated by mass-produced consumer commodities, advertising and popular culture, and in particular by anything kitsch. His replicas of tasteless ornaments and souvenirs are made by skilled European craftsmen as oversized wooden and porcelain sculptures. Relocated within the context of the art gallery, their mundane qualities are re-evaluated and they are transformed from commonplace objects into important relics of twentieth-century consumer culture. Like the ready-mades of Duchamp and Warhol, Koons's works have been the subject of critical controversy, raising the questions of authorship and originality in art. Yet Koons has always claimed that his art is free from irony or cynical manipulation, wanting his work to appeal to a mass audience. His notoriety has been exacerbated by his collaborative pornographic work with his former wife La Cicciolina, an Italian porn star.

☛ **Duchamp, Hanson, Kelley, Ray, De Saint Phalle, Warhol**

Jeff Koons. b York, PA (USA), 1955.
Bear and Policeman. 1988. Polychromed wood. **h**215 cm. **h**85 in. Private collection

Kossoff Leon

Outside Kilburn Underground, Spring

With hastily applied brushstrokes, Kossoff has attempted to capture the urgency of urban life. Yet this sense of bustling activity is counteracted by the grim solemnity of the underground travellers. Whether close friends or anonymous city-dwellers, Kossoff's subjects usually appear isolated, consumed by thought and almost always weighed down by the thick outlines with which they are drawn. Suffering often permeates the heavily impastoed surfaces for which he is known. Born in the East End of London to Jewish immigrant parents,

Kossoff has made drawings and paintings of his native city since the age of 12. Like his friend and contemporary, Auerbach, he prefers to work from the less picturesque areas of the capital, which suit his tendency towards melancholy. Kossoff is linked to the School of London, and maintains a tradition of British urban realist painting. He represented Britain at the Venice Biennale in 1995.

☞ Auerbach, Howson, Rouault, Sickert

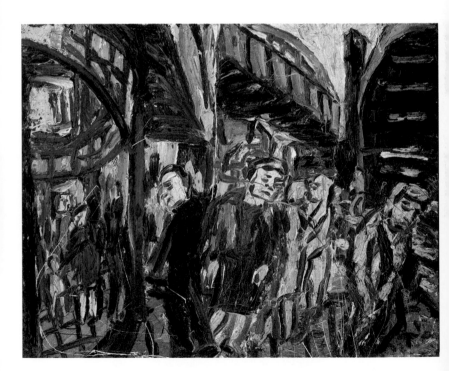

Leon Kossoff. b London (GB), 1926.
Outside Kilburn Underground, Spring. 1976. Oil on board. **h**122 x **w**152.5 cm. **h**48 x **w**60 in. Private collection

Kosuth Joseph

Titled *(Art as Idea as Idea)*, [idea]

This textual piece, which defines the origins of the word 'idea', eschews the visual almost entirely in favour of the intellectual. For Kosuth the meaning of art as it is expressed in language is more important than its appearance. In this work he neatly demonstrates the philosophy of Conceptual Art: art as idea as idea. Through his definitions, neon letters, billboards and advertisements in newspapers, he presents abstracted information to the viewer. This information simultaneously explains itself while broadening the notion of artistic practice in the mind of the viewer. He sees this as the only way in which art can maintain a critical relationship with philosophy and culture. Though his role of commentator from within verges on that of assailant, and his investigations can appear detached, Kosuth is one of the most authoritative figures of Conceptual Art. He has succeeded in creating a context for his work which is not reliant on critics for explanation or justification.

☛ Kawara, Prince, Vautier, Weiner

1. *Idea*, adopted from L, itself borrowed from Gr *idea* (ἰδέᾱ), a concept, derives from Gr *idein* (s *id-*), to see, for *widein*. L *idea* has derivative LL adj *ideālis*, archetypal, ideal, whence EF-F *idéal* and E *ideal*, whence resp F *idéalisme* and E *idealism*, also resp *idéaliste* and *idealist*, and, further, *idéaliser* and *idealize*. L *idea* becomes MF-F *idée*, with cpd *idée fixe*, a fixed idea, adopted by E Francophiles; it also has ML derivative *ideāre*, pp *ideātus*, whence the Phil n *ideātum*, a thing that, in the fact, answers to the idea of it, whence 'to *ideate*', to form in, or as an, idea.

Joseph Kosuth. **b** Toledo, OH (USA), 1945. 251

Titled *(Art as Idea as Idea)*, **[idea]** (detail). 1967. Black and white photograph. **h**121.9 x **w**121.9 cm. **h**48 x **w**48 in.

Private collection on loan to the Solomon R Guggenheim Museum, New York

Kounellis Jannis

Untitled

Three lit paraffin lamps dangle from coiled steel wires. The gentle glow of light casts delicate shadows on the harsh steel support. Arranged carefully, the wires are neatly wound into three overlapping coils. Kounellis uses the same few materials time and again in his work: timber, steel, burlap (a kind of sackcloth), coal, stone and fire. Greek by birth, he first came to prominence as a member of a group working in Italy whose style of sculpture was labelled 'Arte Povera', literally 'Poor Art'. These artists chose to use mundane and ephemeral materials, which had often been in common usage for thousands of years. Their work was frequently constructed in the most rudimentary way, with objects being piled up or placed one against another. A live element sometimes appears in Kounellis's work – he once made an installation incorporating a live parrot, and, most famously, exhibited a stable of horses in a Rome gallery.

☛ **Boltanski, Dine, Fabro, Merz**

Jannis Kounellis. b Piraeus (GR), 1936.

Untitled. 1990. Steel and paraffin lamps. **h**200 x **w**180 cm. **h**78¾ x **w**70¾ in. Anthony d'Offay Gallery, London

Krasner Lee

Cobalt Night

A dense, cross-hatched surface of luminous, singing colours cuts across the entire panorama of the canvas. The tempestuous surface of sprayed and spattered forms is testimony to the intensity of the execution. The pictorial density, which owes much to Cubism, balances colour with space. This work was painted during a particularly difficult period of Krasner's life. Her problematic husband, the famous Abstract Expressionist, Pollock, had recently died in a car accident, and Krasner's work reflected a precarious balance between destruction and spiritual rebirth. A person of immense strength and resilience, Krasner managed to gain respect as a key member of the Abstract Expressionist movement even though she was a woman in what was a fiercely macho culture. Defined by a kind of brute, gestural physicality, Abstract Expressionism was dominated by men. Krasner's style, which changed enormously throughout her career, incorporated the influence of Gorky, Matisse and De Kooning.

☞ Gorky, De Kooning, Matisse, Mitchell, Pollock

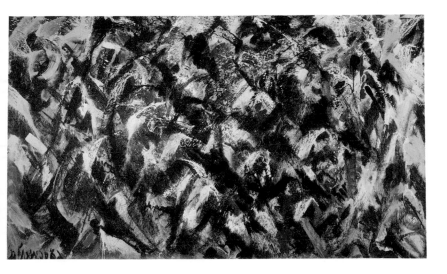

Lee Krasner. b New York (USA), 1911. **d** New York (USA), 1984.
Cobalt Night. 1962. Oil on canvas. **h**238 x **w**401 cm. **h**93½ x **w**161⅜ in. National Gallery of Art, Washington, DC

Kruger **Barbara**

Untitled (We are not what we seem)

Seen on its own, the left-hand section of this work resembles a portrait of a 1950s glamour model. As we look to the right, we are disturbed by the contrasting image of the same woman inserting a gigantic contact lens into her eye. Words placed at intervals near the centre of the composition initially distract our attention from this unsettling picture. The bold juxtaposition of word and image resembles commercial design, reflecting Kruger's past as art director on a women's magazine. Using the technique of montage, she crops or enlarges found images. These are overlaid with declarations attacking oppression, hypocrisy and the power structure by which men assume control. Kruger has had a profound influence on feminist art and theory. By working in the public arena – on billboards, T-shirts and in books – and by using a familiar style, Kruger ensures that her communications are easily accessible, increasing her effectiveness as a social commentator and political agitator.

☞ Holzer, Lichtenstein, Nauman, Vautier

Barbara Kruger. b Newark, NJ (USA), 1945.

Untitled (We are not what we seem). 1988. Photographic silkscreen on vinyl. **h**278.1 x **w**243.8 cm. **h**109½ x **w**96 in. Private collection

Kubin Alfred

Death

A strange, androgynous figure glides silently, like a disembodied soul, to another world. A distant light softly beckons, suggestive of something hopeful on the other side. Evanescently beautiful, the work is a disquieting encounter with Death. A pen and ink study, it is characteristic of the intensely romantic brand of Expressionism which Kubin shared with such artists as Nolde and Barlach. His art is inspired by the disharmony between the spirit and the senses and is expressed in haunting visions such as this. Kubin's early experiences of death

had a lasting, damaging effect. Like Munch, he lost his mother, to whom he was very close, while still a child. In 1896, at the age of 19, he made a suicide attempt on her grave and the following year suffered a severe nervous breakdown. But also like his contemporaries, Munch and Kollwitz, Kubin was able to expiate his suffering through his art. His major work was his illustrated novel *The Other Side*.

☞ **Avery, Barlach, Ensor, Kippenberger, Kollwitz, Munch, Nolde**

Alfred Kubin. b Leitmeritz (CZ), 1877. d Zwickledt (AUS), 1959.
Death. Date unknown. Pen and black ink, charcoal and grey wash on paper. **h**15 x **w**27.5 cm. **h**6 x **w**10⅞ in. Private collection

Kupka Frantisek

Swirling arcs of colour draw the eye into the centre of the composition. The bands of pink, red, green and blue are broken up by patches of black and white, giving the impression that the surface of the canvas is shimmering. Kupka was born in Czechoslovakia, but subsequently moved to Paris where he worked as an illustrator. He had a long-standing interest in spiritualism and the occult, and believed that abstract colours and shapes had a spiritual force. A pioneer of non-figurative art, Kupka began making his first abstractions in 1910, around the same time as Kandinsky. Calling these experimental works *Plans Arranged by Colour*, he sought to depict movement by breaking down objective images into vertical bands of pigment. Although he was associated with the Cubists, Kupka's interest in representing movement links him to the Futurists. It is only since the 1960s that Kupka's immense and highly original contribution to the development of abstract art has been properly assessed.

☛ **Balla, Boccioni, R Delaunay, Kandinsky**

Frantisek Kupka. **b** Opocno (CZ), 1871. **d** Puteaux (FR), 1957.
Organization of Graphic Motifs II. 1912–13. Oil on canvas. **h**200 x **w**194 cm. **h**78⅞ x **w**76⅜ in. National Gallery of Art, Washington, DC

Laib Wolfgang

Interior of Beeswax Chamber

A passage has been lined with huge blocks of beeswax, the walls heavy with its scent. It leads to a chamber, glowing golden in the light of three bare bulbs. Emerging from the density of the corridor into the near transparency of this sanctum is a dramatic and quasi-religious experience. Despite the massive size of the slabs, they seem to dissolve before our eyes. Laib often uses beeswax, a substance free from human production which has the ability to change form or liquefy, 'to become spiritual', as he puts it. He has also worked with other natural substances such as milk, and pollen, collected from the fields around his home. In 1974, he graduated from university in medicine but grew disillusioned with its reliance on logic. Turning to Eastern philosophies and religions which regarded nature in spiritual terms, he found parallels with his search for the universal. Informed by mysticism, his work evokes ancient rituals.

☞ Flavin, Hatoum, Phaophanit, Turrell, Wilson

Wolfgang Laib. b Metzingen (GER), 1950.
Interior of Beeswax Chamber. 1994. Beeswax. Dimensions variable. As installed at the Camden Arts Centre, London, 1995

Lam Wilfredo

The Reunion

Mythological creatures inhabit a dark, brooding land-scape which might be a jungle or perhaps the interior of a cave. On the left is a creature with the combined features of a horse, a fish and a woman. On the right a totem-like figure comprises elements of a fish, a bird and a skull. The whole composition teems with malevolent images which are part fantasy and part real. The title of the work perhaps relates to the hope of rejoining old comrades following the end of the Second World War in 1945. The dark mood of the painting, however, imbued with the spirit of voodoo, suggests a reunion with the dead. The use of beige, brown and black is reminiscent of the Cubist works of Picasso, who was a close friend of Lam, while the bizarre combination of imagery is typical of Surrealism, a movement with which Lam was associated. His work is full of references to his Cuban background – tribal masks, exotic animals and primeval settings.

☞ Appel, Brauner, Dominquez, Picasso, Tamayo

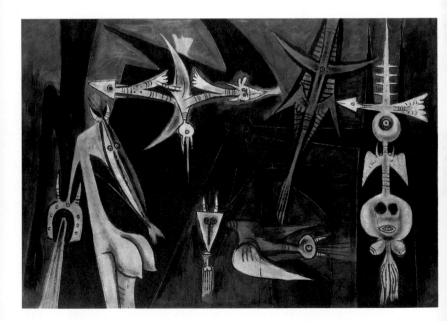

Wilfredo Lam. b Sagua la Grande (CU), 1902. d Paris (FR), 1982.
The Reunion. 1945. Oil and white chalk on paper pasted on canvas. h152.5 x w212.5 cm. h60⅛ x w83⅝ in.
Musée Nationale d'Art Moderne, Paris

Larionov Mikhail

Soldier in a Wood (The Smoker)

A soldier takes a furtive break from his work to smoke a cigarette. Looking straight out at the viewer, with his hand on his hip and the horse's reins slung over his right arm, he seems about to say something. His horse is painted with childlike simplicity, and the wood of birch and pine trees, in which he stands, has a magical charm. The naïve style recalls the peasant carvings and folk prints of Larionov's native Russia. Simple yet captivating, it is one of a series entitled 'Soldiers', begun around 1909, in which Larionov deliberately cultivated a crude, primitive style, sometimes adding verbal jokes and obscenities in a deliberate reaction against 'good taste'. He subsequently invented Rayonism, a movement which aimed to reduce form to a dynamic series of lines, evoking the rays of light given off by objects. In 1914, he and his wife, Gontcharova, travelled to Paris where they worked for the choreographer Sergei Diaghilev at the Russian Ballet. Later, they settled permanently in France.

☛ Collins, Gontcharova, Kupka, Moses, Wallinger

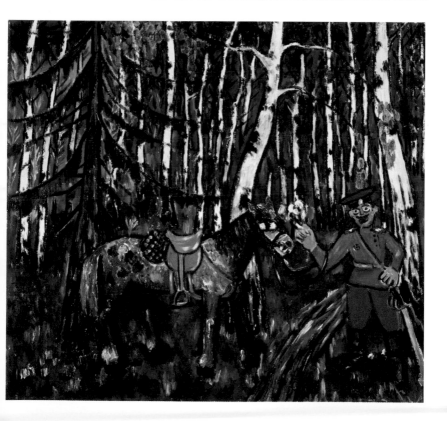

Mikhail Larionov. b Tiraspol (UKR), 1881. d Fontenay-aux-Roses (FR), 1964.
Soldier in a Wood (The Smoker). 1911. Oil on canvas. h84.5 x w91.4 cm. h33¼ x w36 in.
Scottish National Gallery of Modern Art, Edinburgh

Lasker Jonathan

Public Love

The giant swirls and grids superimposed on a caustic orange ground appear at first sight to be the result of grand, energetic gestures. In fact, this large-scale painting is based on a miniature study, measuring only inches across. These initial maquettes are used by Lasker as models for his full-scale paintings. He carries out the transformation with a passionate concern for precision and fidelity to the original drawing. Each spontaneous doodle or scribble becomes a thick trail of paint, literally squeezed from the tube onto the canvas.

The separate components are carefully built up, one element at a time. In the process of bringing together the immediacy of the initial studies with the highly considered, finished reconstruction, Lasker balances the forces of random gesture and intelligent intention. He says of painting: 'Paint bears physical record to the expressions of the human hand ... In no other art medium is creation more permanently and intimately bound to the movement of the human body.'

☞ **Gironella, Hodgkin, Marden, Scully**

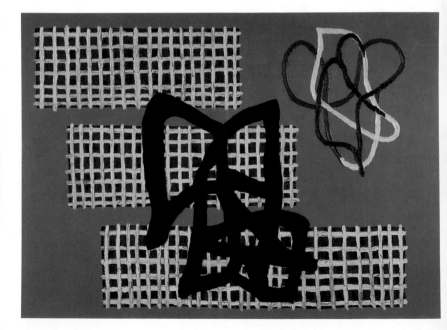

Jonathan Lasker. b Jersey City, NJ (USA), 1948.
Public Love. 1990. Oil on linen. **h**243.8 x **w**335.3 cm. **h**96 x **w**132 in. Private collection

Laurencin Marie

Two Sisters with a Cello

In this tender portrayal of sisterhood, two young girls stand with their arms wrapped affectionately round each other. The harmony between the two girls is symbolized by the cello, which they share, and by the soothing palette of muted blues and violets, characteristic of the paintings made by this French artist and poet. Often using quiet pastel colours, with which she achieved a gentle, tasteful, decorative quality, Laurencin painted many lyrical portraits of young girls in attractive settings. Her crisp, linear style and her tendency to reduce faces to mask-like simplicity reflects the influence of Japanese prints. Laurencin was one of the few women artists associated with the Parisian Cubists, but her work remained essentially more decorative, while still reflecting the kind of stylization and flattening of pictorial space typical of that movement. A self-taught artist, she lived with the poet Guillaume Apollinaire and moved in the social circle of Picasso, Braque and Matisse.

☛ Braque, Jawlensky, Matisse, Picasso, Woodrow

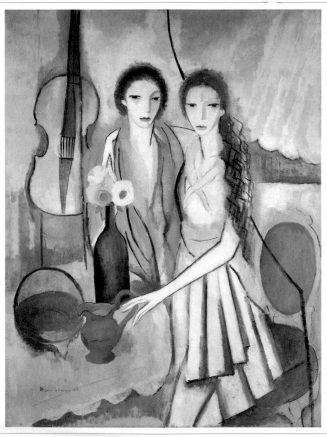

Marie Laurencin. b Paris (FR), 1883. **d** Paris (FR), 1956.
Two Sisters with a Cello. 1913. Oil on canvas. **h**115.9 x **w**89 cm. **h**45⅔ x **w**35 in. Private collection

Laurens Henri

Head of a Woman with a Necklace

This elegant, terracotta bust has a pleasing simplicity, its symmetry only disturbed by the irregular plinth and diagonally draped necklace. The rounded forms combine sensuality with a tension which is typical of Laurens' work of this period, while also hovering between figuration and abstraction. Laurens was recognized as a major Cubist sculptor influenced by Braque and Picasso, and the evidence of this movement, with its emphasis on simplified, abstracted form, can be seen here, as can traces of the African art which inspired it. During the late 1920s, Laurens had moved towards purely figurative sculpture. Like Maillol, whose influence was strong in the 1920s, Laurens began to concentrate almost entirely on the female form. At the end of his life, Laurens summed up his work: 'In a sculpture, the spaces must be just as significant as the volume. Essentially sculpture is the seizure of space, space circumscribed by forms.'

☛ Agar, Braque, Gill, Jawlensky, Maillol, Picasso

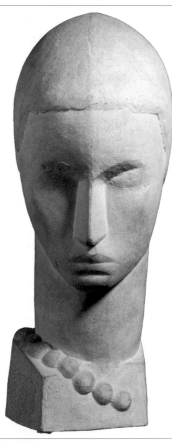

Henri Laurens. b Paris (FR), 1885. d Paris (FR), 1954.
Head of a Woman with a Necklace. 1929. Terracotta. **h**37 cm. **h**14½ in. Musée National d'Art Moderne, Paris

Lawrence Jacob

Bar 'n' Grill

Customers sit at two long bars on either side of a room, their faces depicted in a caricatured style. Barmen in white jackets hurry to serve them, distracted by an accordion player and his glamorously dressed partner in the centre of the composition. Painted when Lawrence was just 20 years old, this vibrant work captures the swinging street life of the artist's native Harlem in the 1930s. A penetrating observer of his immediate surroundings and his black heritage, Lawrence masterfully combined a modern style with a storytelling tradition. He carefully researched

African-American history for his work, at times depicting the lives of important black figures or the hardships endured throughout African-American history. A true modernist who deliberately avoided the stereotypically 'primitive' style expected of black artists at that time, Lawrence's paintings were the first by an African-American in the collection of New York's Museum of Modern Art.

☞ **Basquiat, Benton, Campigli, Hopper**

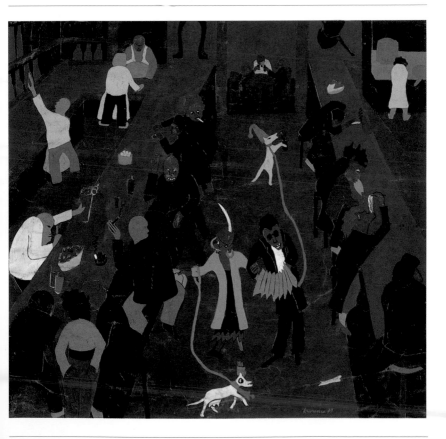

Jacob Lawrence. b Atlantic City, NJ (USA), 1917. **d** Seattle, WA (USA), 2000.

Bar 'n' Grill. 1937. Casein or tempera on paper. **h**55.8 x **w**55.8 cm. **h**22¾ x **w**22¾ in. San Antonio Museum of Art, TX

Le Corbusier

Still Life with Numerous Objects

A number of domestic objects have been reduced to flat shapes and juxtaposed on the canvas. Visible through the patchwork of colours and shapes is a carafe on the far left, an orange jug just above it, two wine bottles superimposed on the right, and in the bottom right-hand corner, just above the signature, the fluting of a column. On first sight, the objects appear to be completely flat, but in fact the artist has represented form by showing two sides of the object at once: the top of the glass, for example, at the bottom of the composition is shown as if we are looking down on it from above, while the side is depicted as if we are viewing it from much lower down. This attempt to represent different sides of the objects simultaneously reveals Le Corbusier's debt to Cubism, with its rejection of a fixed viewpoint. As well as being a highly accomplished painter, Charles-Édouard Jeanneret, more commonly known as Le Corbusier, was also one of the most brilliant and influential architects of the twentieth century.

☞ **Braque, Caulfield, Gris, Morandi, Ozenfant**

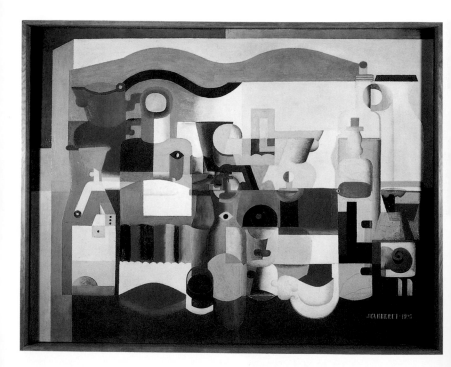

Le Corbusier (Charles-Édouard Jeanneret). b Chaux-de-Fonds (SW), 1887. **d** Cap Martin (FR), 1965.
Still Life with Numerous Objects. 1923. Oil on canvas. **h**114 x **w**146 cm. **h**44⅞ x **w**57½ in. Fondation Le Corbusier, Paris

Léger Fernand

The Acrobats (The Parrots)

Four acrobats are caught in mid-act. The figure in the centre of the composition seems to be balancing on the shoulders of the one below, while the woman on the left pirouettes behind her partner who stares impassively at the viewer. Behind them are the ladders and ropes of their tight-rope act. The flattened, geometric forms of the figures reveal the influence of Cubism, with its attempts to break away from traditional modelling. The circus was one of Léger's favourite subjects, culminating in his huge composition *The Big Parade*. He used this theme to celebrate the leisure activities of the working classes, preoccupied as he was throughout his career with creating an 'art of the people'. Léger worked in an architect's office and was fascinated by technology and the forms of machinery, an interest which had linked him to the Futurists earlier in his career. As well as painting, Léger also made the first abstract film, using objects as actors.

☞ **Beckmann, Laurens, Moore, Rouault**

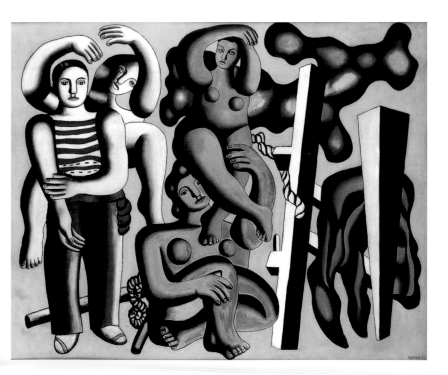

Fernand Léger. **b** Argentan (FR), 1881. **d** Gif-sur-Yvette (FR), 1955.
The Acrobats (The Parrots). 1933. Oil on canvas. **h**130 x **w**160 cm. **h**51¼ x **w**63 in. Private collection

Lehmbruck Wilhelm

Seated Youth

A young man sits with his head bowed, perhaps in grief, or caught in a moment of deep thought. The harsh, angular forms of his body add to the mood of brooding introspection. His elongated limbs seem to maximize the emotional impact, in a manner typical of Expressionism. This sculpture may be partly autobiographical, reflecting the artist's own depressive nature. Born in Germany, Lehmbruck travelled to Paris in 1910, where he was influenced by the work of Maillol and Rodin. He subsequently moved away from their naturalistic style and started making these expressive, often larger-than-life figures on which his reputation chiefly rests. He also made a number of etchings and lithographs, including illustrations for the Bible and for Shakespeare's plays. He committed suicide in 1919, at the age of 38, just as his work was being recognized, and soon after he had been elected to the Academy in Berlin.

☞ Barlach, Kollwitz, Maillol, Rodin

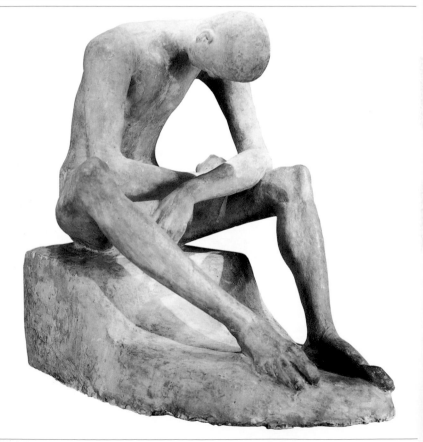

Wilhelm Lehmbruck. b Meiderich (GER), 1881. d Berlin (GER), 1919.
Seated Youth. 1917. Composite tinted plaster. **h**103.2 cm. **h**40⅔ in. National Gallery of Art, Washington, DC

De Lempicka **Tamara**

The Two Friends

A woman casually rests her arm on the knee of her friend, who is sprawled out on the bed, her eyes closed in ecstasy. Posed naked, these two 'friends' are clearly lovers, offering themselves suggestively to the viewer's gaze. Dramatically spot-lit, the bodies of the women have been reduced to a series of curves and angles, giving the work a dynamic and incisive rhythm. De Lempicka has used the simplified, geometric forms of Cubism in this canvas, the sculptural quality particularly revealing the influence of Léger. The artist plays on the traditional fascination with lesbianism, giving the work an element of controversy at the time. De Lempicka was born in Poland but later moved to Paris, where she became one of the most sought-after society painters in Europe. She mainly produced portraits of fashionable high society and her rich patrons, emphasizing their aloof glamour – her smooth and idealized style devoted to the fantasy of a perfect, rich and snobbish élite.

☛ **Cézanne, Fischl, Léger, Schad**

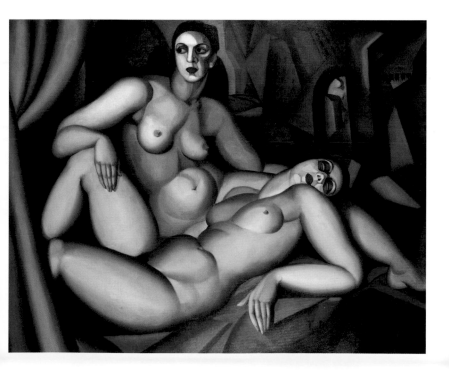

Tamara de Lempicka. b Warsaw (POL), 1898. **d** Cuernavaca (MEX), 1980.

The Two Friends. 1923. Oil on canvas. **h**130 x **w**160 cm. **h**51¼ x **w**63 in. Petit Palais, Geneva

Lewis Percy Wyndham

The Surrender of Barcelona

A group of soldiers in armour stands guard outside the city of Barcelona, while cavalrymen and foot soldiers make their way through the gates. The figure hanging from a spike in the centre of the composition symbolizes the horrors of war, while the harbour visible in the top left-hand corner provides a pleasant contrast with the main subject of the painting. The use of harsh, vertical lines, the simplification of form and the lack of illusionistic depth in the composition are typical of Vorticism, a movement that aimed to convey the noise and chaos of modern life. Vorticism was based on Cubism, combining its interest in reducing objects to lines and geometric shapes, with a fascination with the machinery and industrial forms of the modern era. Lewis founded the movement in 1914 and edited its controversial magazine *Blast*. He is best remembered for setting up the only essentially Cubist movement in Britain.

☛ Bomberg, Delvaux, Gleizes, Grosz

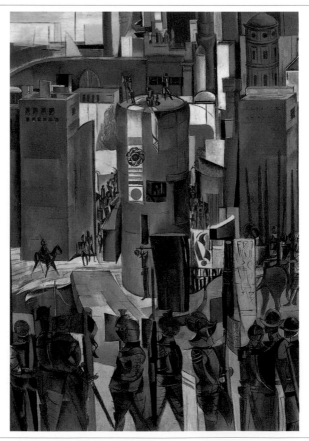

Percy Wyndham Lewis. b Nova Scotia (CAN), 1882. **d** London (GB), 1957.
The Surrender of Barcelona. 1934–7. Oil on canvas. **h**83.8 x **w**59.7 cm. **h**33 x **w**23½ in. Tate Gallery, London

LeWitt Sol

Three Cubes with One Half – Off

A white, geometric structure, reminiscent of the supports of a tall modern building, sits on the gallery floor. The three cubes, arranged to form a right angle, seem unambiguous enough, but they are in fact subject to a number of external influences. The simplicity of the piece encourages the viewer to notice shifts of perspective and the play of shadows as they move around it. The work was not made by LeWitt but by factories working to his specifications. This detachment between artist and finished product is a hallmark of Minimalism. It was

LeWitt, who coined the term Conceptual Art in 1968 to describe art in which the idea is more important than the work itself. However, despite his emphasis on ideas, LeWitt is not strictly a Conceptual artist because his work depends on elements over which he has little control. LeWitt has also made large-scale drawings which are often executed by assistants to a set of rules made to exclude personal taste and style.

☛ **Andre, Flavin, Judd, Mondrian, Reinhardt, Ryman**

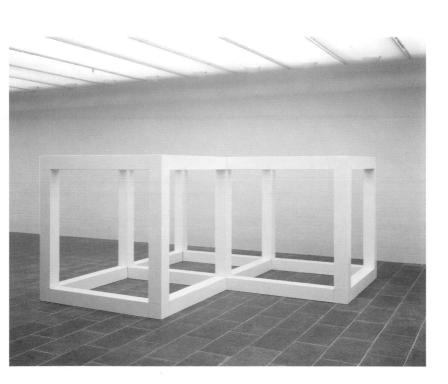

Sol LeWitt. b Hartford, CT (USA), 1928.
Three Cubes with One Half – Off. 1969. Painted steel. **h**160 x **w**305 x **l**305 cm. **h**63 x **w**120⅛ x **l**120⅛ in.
Louisiana Museum of Modern Art, Humlebaek

Lichtenstein Roy

Girl with Hair Ribbon

Painted like a close-up frame from a 1950s comic strip, this work shows an attractive, blue-eyed blonde, turning towards the viewer. Her all-American glamour, and her anxious expression suggest a narrative in which she is the vulnerable heroine in jeopardy. But despite the accessibility of the image, it is a gentle parody of, as well as a homage to, contemporary culture, treading a fine line between commercial and fine art. Lichtenstein's famous use of the cartoon is in keeping with the recycling of found objects and common household items typical of

Pop Art in the 1960s. Ruscha was the first to appropriate the comic strip, with Lichtenstein and Warhol following shortly afterwards. Lichtenstein composed his pictures of minute circles which meticulously reproduce Ben Day dots – a screening technique used in printing. He also made sculptures and a five storey-high mural for the lobby of the Equitable Life Assurance building in New York.

☛ Kruger, Rosenquist, Ruscha, Schjerfbeck, Warhol

Roy Lichtenstein. b New York (USA), 1923. d New York (USA), 1997.
Girl with Hair Ribbon. 1965. Oil and magna on canvas. h121.9 x w121.9 cm. h48 x w48 in. Estate of the artist

Liebermann Max

Garden Café on the Elbe

An elegant and fashionable crowd relaxes at a smart, lake-side restaurant, as a waiter weaves in and out of the tables balancing a tray of drinks on his shoulders. This sketchy, Impressionist study evokes the carefree and hedonistic atmosphere of the roaring twenties. Arguably Germany's foremost Impressionist artist, Liebermann painted primarily outdoor scenes, concentrating on the effects of light and shade on his subject. Liebermann's brand of Impressionism was influenced by a stay in Paris where he discovered the work of the Barbizon school, a group of nineteenth-century landscape painters, who were among the first artists to take their palettes and easels out of the studio and paint in the open air. Liebermann was held in high esteem by the establishment and was made President of the Berlin Academy. However, his world was shattered when his work was banned in 1933 because of his Jewish ancestry.

☛ **Campigli, Corinth, Hopper, Prendergast, Renoir**

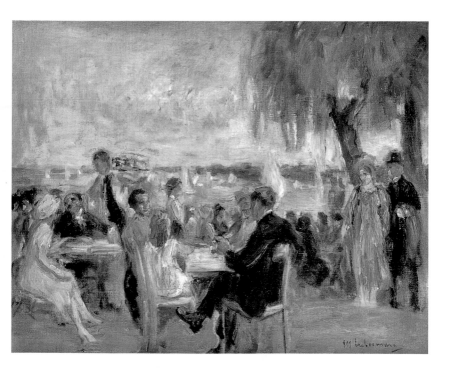

Max Liebermann. b Berlin (GER), 1847. **d** Berlin (GER), 1935.
Garden Café on the Elbe. c1922. Oil on canvas. **h**40.5 x **w**50.7 cm. **h**15⅞ x **w**20 in. Private collection

Lipchitz Jacques

Seated Woman

A rhythmic construction of heavy, angular forms suggests the figure of a seated woman. The long straight panel running the length of the sculpture looks like a chair back, the two jutting protrusions on the base resemble feet, while the small circle at the top of the composition represents the woman's eye. The forms have been pared down to such an extent that the work is also an abstract composition of shapes. The absence of traditional modelling and the powerful and original treatment of form links this work to Cubism. Lipchitz moved from his native Lithuania to Paris in 1909 to pursue his artistic career. He began working in a realistic style, but switched to Cubism after meeting Picasso and other artists of the Cubist circle. At the start of the Second World War, Lipchitz fled Paris for New York. The trauma of the war years prompted him to change his style and subject matter towards the end of his career to expressive, figurative biblical groups.

☛ **Archipenko, Duchamp-Villon, Epstein, Picasso, Schlemmer**

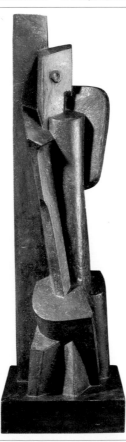

Jacques Lipchitz. b Druskieniki (LIT), 1891. d Capri (IT), 1973.
Seated Woman. Bronze cast of 1916 stone original. Bronze. **h**105.5 cm. **h**41½ in. Private collection

Lissitzky El

Untitled

Abstract, geometric shapes, painted in the primary colours of red, yellow and blue, float around each other as if suspended in space. Some of the shapes look three-dimensional, while others are flat: the yellow triangle, for example, set against the flat red circle at the bottom of the composition, is painted at an angle so that we can see it is wedge-shaped. Lissitzky's use of non-representational forms as his subject is typical of Suprematism, while the work's evocation of movement and machinery is reminiscent of Constructivism, a radical, avant-garde movement which emerged in Russia just before the revolution of 1917. An accomplished painter, Lissitzky in fact trained as an engineer, and later studied and taught architecture. His ideas on art became known through the teaching of Moholy-Nagy at the Bauhaus school. His daring architectural designs, which were thought too costly to realize at the time, have been widely influential.

☞ **Calder, Kandinsky, Malevich, Moholy-Nagy, Mondrian**

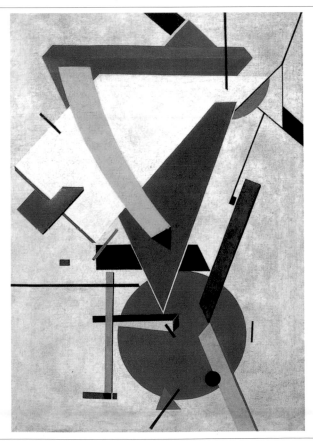

El (Eleazar) Lissitzky. b Polshinok (RUS), 1890. d Moscow (RUS), 1941.
Untitled. c1920. Tempera on canvas. **h**73.5 x **w**51.5 cm. **h**29 x **w**20¼ in. Private collection

Long Richard

A Line in Japan

This photograph records a simple, geometric sculpture made from rocks found by Long while climbing up a Japanese mountain. It is all that remains of his walk and of the resultant work, acting as a bridge between the artist and audience. The leading British exponent of Earth Art, Long sought in the late 1960s to liberate his art from the restriction of the gallery. His interventions in nature aim to sympathize with their surroundings. Whereas his American counterparts excavated vast areas and placed tons of rocks in the landscape, Long disturbed nature with nothing more violent than walking across a field, cutting the heads off daisies. His work is ephemeral, remaining either in the maps and diagrams he makes of his journeys or in the materials he collects then places in the gallery. Through his work, Long comments on our perception of the landscape which is constantly being moulded by man.

☞ Baumgarten, Dibbets, Goldsworthy, De Maria, Smithson

Richard Long. b Bristol (GB), 1945.
A Line in Japan. 1979. Photograph, framed and mounted. **h**89 x **w**124.5 cm. **h**35 x **w**49 in. Anthony d'Offay Gallery, London

Longo Robert

Untitled ('Men in the Cities')

The tortured figure in this wall-sized, highly detailed drawing is not an individual with a unique personality and personal history, but an anonymous everyman. The anguished expression, twisted face and taut, grasping hands are fixed in a frozen moment of pain, as if the figure has just been shot. Dressed in a suit, the uniform of the commercial company, he represents the traumatic battle to survive as an individual in the angst-ridden citadels of corporate culture in the 1980s. The empty white space around the figure suggests a sterile, air-conditioned environment, where everything is inhuman and artificial. Longo often produces large, monumental works, which have the power to question the values of our society. As well as drawings, Longo has made paintings and sculptures in a variety of media, often using appropriated images in his work. He has also made a feature film and music videos and has participated in performances and theatrical spectacles.

☞ Ader, Close, Estes, Rainer, Sherman

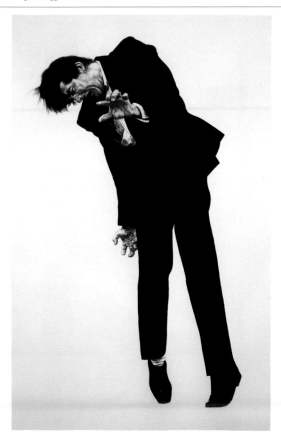

Robert Longo. **b** New York (USA), 1953.

Untitled ('Men in the Cities'). 1981–7. Charcoal, graphite and ink on paper. **h**243.8 x **w**152.4 cm. **h**96 x **w**60 in. Private collection

López García Antonio

Woman in the Bathtub

A woman relaxes in a bathtub, naked apart from her pearl earrings. Grasping the side of the bath, she looks as if she is about to slip under the water. Deep in concentration, she has a slightly haunting presence. The artist penetrates this simple subject with almost savage candour, recording the lines on the woman's forehead, the way the light catches her exposed knees and hands, and the reflection of the bath mat in the tiles of the bath. This attention to detail is typical of a brand of realism prevalent in the 1970s and 1980s. One of the

most popular contemporary Spanish painters, López García draws on the paintings of the Old Spanish Masters, such as Diego Velázquez and Francisco Zurbarán. His works are never straight, photographic portraits, but are complex meditations on time, the inertia of life and the presence of death. In 1992 Victor Erice detailed López García's painstaking and time-consuming approach in his film *The Quince Tree Sun*.

☛ **Arikha, Bonnard, Fischl, Sickert**

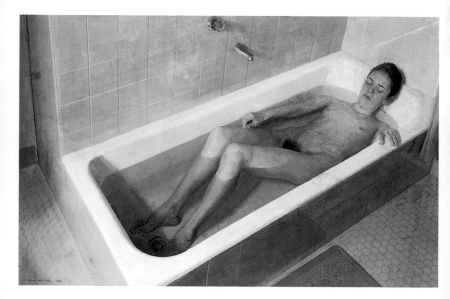

Antonio López García. b Tomelloso (SP), 1936.
Woman in the Bathtub. 1968. Oil on canvas. **h**106.7 x **w**165.1 cm. **h**42 x **w**65 in. Private collection

Louis Morris

Saf Gimmel

A vivid rainbow of colour fills the canvas. The layering of these brilliant hues gives the impression of three-dimensionality. Louis created this effect by diluting acrylic with turpentine and pouring successive layers onto the unprimed surface, so that the paint was absorbed into the canvas like ink onto blotting paper. This gave his paintings a new depth and luminosity that avoided evidence of brushstrokes. Much inspired by the techniques of fellow painter Frankenthaler, Louis in turn influenced colour-field painters who experimented with

the optical effects of different colours in the 1960s. In his later work he poured lines of colour diagonally down the canvas, in a process that became known as 'one-shot' painting. The work of Louis, along with that of Frankenthaler and Noland, was dubbed Post-Painterly Abstraction, reflecting a move away from thickly textured surfaces towards a focus on light and colour.

☞ Frankenthaler, Heilmann, K Noland, Rae

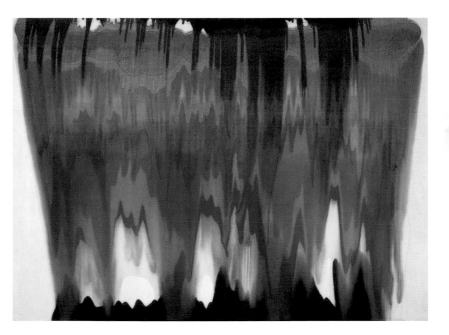

Morris Louis. b Baltimore, MD (USA), 1912. **d** Washington, DC (USA), 1962.
Saf Gimmel. 1959. Acrylic on canvas. **h**254 x **w**350.2 cm. **h**100 x **w**137⅞ in. André Emmerich Gallery, New York

Lowry L S

Market Scene, Northern Town

In a crowded market-place, people come and go, pushing babies in prams and walking their dogs. The simple, vertical forms of the shoppers in the foreground give way, in the middle of the canvas, to the diagonal roofs of the stalls. These draw the viewer's eye to the horizontals of the factory, churning out smoke in the background. Lowry is one of the best-loved British artists of this century. His popularity rests largely on his naïve, easily accessible style and familiar subject matter. His childlike depictions of the grim, industrial North where he was

born are affirmative in their sympathetic understanding of their subject. Lowry was perhaps the only British artist to devote himself to this environment. A clerk whose artistic talent was discovered only when he was in his fifties, he rejected the modernist tendency towards abstraction and spirituality, choosing instead to root his work in everyday life.

☞ Demuth, Moses, Rousseau, Wallis

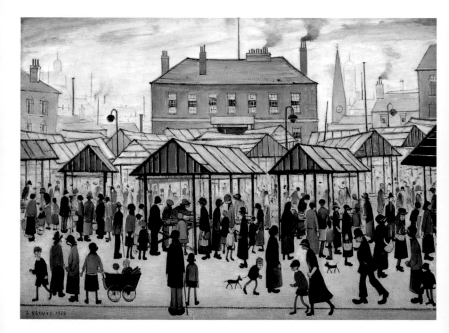

L S (Lawrence Stephen) Lowry. b Manchester (GB), 1887. d Manchester (GB), 1976.
Market Scene, Northern Town. 1939. Oil on canvas. **h**45.7 x **w**61.1 cm. **h**18 x **w**24 in. Salford Art Gallery and Museum, Salford

McCahon Colin

Are There not Twelve Hours of Daylight

The title of the work – *Are There not Twelve Hours of Daylight* – is painted in white at the top of the canvas. Beneath it is a white line, resembling the horizon of a landscape, and underneath is an elaboration on the statement above. The phrase 'but if he walks after nightfall he stumbles, because the light fails him' fades into the background, the presentation of the text reinforcing its meaning. Christianity is McCahon's overriding theme and text his dominant method of expression. The transition from bold proclamation to more tentative scrawl, as here,

is a common motif in his paintings, echoing themes of faith and doubt, and acting as a metaphor for the act of artistic creation. He has said that his first inspiration was watching a signwriter at work on a shop front, and seeing handwritten signs in markets. His work offers a commentary on the spiritual that is rare in contemporary art and which has had a huge influence on the work of other New Zealand artists.

☛ Hotere, Kawara, Kosuth, Prince, Vautier

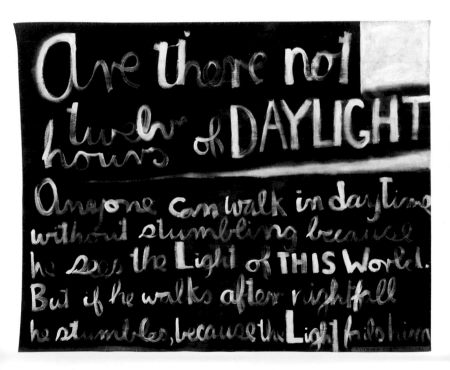

Colin McCahon. **b** Timaru (NZ), 1919. **d** Auckland (NZ), 1987.
Are There not Twelve Hours of Daylight. 1970. Acrylic on canvas. **h**203.2 x **w**254 cm. **h**80 x **w**100 in.
Waikato Museum of Art and History, Hamilton

McCarthy Paul

The Garden

The Garden is a full-scale tableau of an outdoor, wood-land scene, complete with leafy trees, shrubs and rocks. This tranquil picture of nature is rudely interrupted by the presence of a middle-aged, balding man with his trousers round his ankles, engaged in a wholly unnatural act. From one side of the installation, his actions are not immediately apparent, being partially hidden by the tree trunks and foliage, but the sound of mechanical activity draws the viewer in to discover the shocking sight of a man copulating with a tree. This robotic figure, with its endlessly repetitive movements, is both comical and crude, and is intended by McCarthy to question notions of acceptable public behaviour and sexual morality. McCarthy is a lecturer at UCLA, as well as an artist. His sculptural installations evolved out of his earlier performance work which focused on his own body engaged in extreme and disturbing acts.

☞ Acconci, Borofsky, Kienholz, Masson

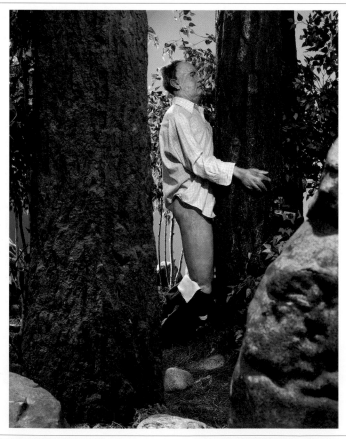

Paul McCarthy. b Salt Lake City, UT (USA), 1945.
The Garden (detail). 1992. Plants and motorized figure in an artificial garden. **h**8.5 x **w**9.1 x **l**6.1 m. **h**28 x **w**30 x **l**20 ft. Private collection

McCollum Allan

Plaster Surrogates

Tightly packed and hung on a gallery wall, these black pictures are in fact casts of framed paintings which have subsequently been painted to look like works of art again. These rectangles, produced in their hundreds by McCollum and an army of studio assistants, are all slightly different in size and proportion. Each one is unique and yet the variations are so slight that they could be perceived as mass-produced objects. This installation of repetitive forms examines the relative merits of the hand-crafted, original artwork, and objects manufactured by an impersonal mechanical process. McCollum questions the idea of authenticity and uniqueness, and the way in which these two attributes are central to defining value within the system of museums, collectors and the commercial art market. Other works have included tables covered with vast quantities of small, plastic objects, each one different from its neighbour.

☛ Bhimji, Darboven, Kawara, Reinhardt

Allan McCollum. b Los Angeles, CA (USA), 1944.

Plaster Surrogates. 1982–3. Enamel on cast hydrostone. Dimensions variable. As installed at the Marian Goodman Gallery, New York

Macke August

Russian Ballet I

This theatre scene is painted as though the artist were sitting in the audience, watching a popular ballet. The backs of the spectators' heads are just visible in the gloom of the theatre, set against the bright scenery. The graceful, sinuous curves of the dancers and the luminous colours of their costumes, enhanced by the footlights, are characteristic of Macke's very personal, poetic style. The abstract backcloth and the emotive use of colour bring to mind the work of Delaunay and Kandinsky, while the bold contours and stylized forms are typical of Expressionism. Macke joined the Expressionist group Der Blaue Reiter in 1911, encouraged by his friend Marc. Macke was particularly attracted by the movement's interest in non-Western art. At the outbreak of the First World War in 1914, many of these artists were conscripted into the army and the group was forced to disband. Macke was tragically killed during the war, at the age of 27.

☛ **Beckmann, R Delaunay, Kandinsky, Marc, Rouault**

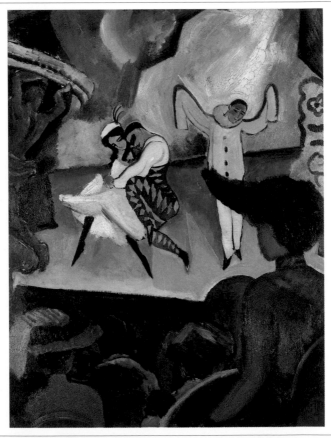

August Macke. **b** Meschede (GER), 1887. **d** Perthes (FR), 1914.
Russian Ballet I. 1912. Oil on paper. **h**103 x **w**81 cm. **h**40½ x **w**31⅞ in. Kunsthalle Bremen

Magritte René

The Human Condition

A painting of a landscape is propped up on an easel in front of a window. The scene depicted is exactly the same as the one outside, creating a disorientating confusion between the representation and the original. Through this work, Magritte questions the difference between illusion and reality. The meticulous, deadpan style, derived from the world of advertising and popular illustration, adds an almost documentary conviction to this bizarre image, challenging our beliefs about visual certainty. The illusionistic, dream-like quality is characteristic of Magritte's version of Surrealism. He became a leading member of the movement after leaving his native Belgium in 1927 for Paris, where he stayed for three years. His works are often enigmatic, playing with ambiguity and visual truth. Magritte himself said of his work: 'People who look for symbolic meanings fail to grasp the inherent poetry and mystery of the image...The images must be seen *such as they are.*'

☞ Carrington, De Chirico, Dalí, Denis, Wadsworth

René Magritte. **b** Lessines (BEL), 1898. **d** Brussels (BEL), 1967.
The Human Condition. 1933. Oil on canvas. **h**100 x **w**81 cm. **h**39⅜ x **w**31⅞ in. National Gallery of Art, Washington, DC

Maillol Aristide

Reclining Nude

The curvaceous, well-rounded nude in this drawing became so recognizable as Maillol's archetype of female beauty that the phrase 'la femme Maillol' ('the Maillol woman') was invented to describe it. Soft, pastel lines evoke the sensuality of idealized femininity. Maillol's interest in the monumental beauty of the nude allies him to earlier generations of artists. He had few other subjects, and devoted his career exclusively to perfecting his vision of the harmonious proportions of the female form. His enthusiasm for classical beauty was fired by a trip to Greece in 1908, where he saw many Ancient sculptures. The writer André Gide described Maillol's work in 1905: 'This woman is quite simply beautiful. She has no message. She is silent. I believe you would have to go a long way back in time before you found a work of art which completely disregarded everything that is alien to the simple representation of beauty.' A friend of Gauguin, Maillol started out as a painter before turning to sculpture in later life.

☞ Bonnard, Cézanne, Gauguin, Rodin, Schiele

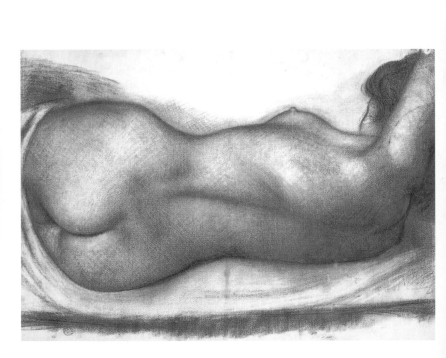

Aristide Maillol. b Banyuls-sur-Mer (FR), 1861. d Banyuls-sur-Mer (FR), 1944.
Reclining Nude. 1932. Red crayon on paper. h53.8 x w77.8 cm. h21¼ x w30⅝ in. Art Institute of Chicago, IL

Malevich Kasimir

Suprematist Composition

Red, orange and black overlapping, geometrical shapes are flatly painted on a white background. The balance and composition of the forms evokes a sense of depth, as though the shapes were eternally suspended in space, as in Kandinsky's abstract works of this period. The black dot and orange rectangle on the right appear to be pushed back in space, away from the viewer, while the black square on the left sits firmly on the picture's surface. The reduction of subject matter to simplified elements is typical of Suprematism, a movement which

Malevich founded. He described it as 'the painting of pure form' and the 'supremacy of pure feeling'. These ideas were represented in works such as his famous *White Square*, which was a white square on a white background – a work which was to become the emblem of the movement. His paring down of art to its abstract essentials anticipated the Minimalist movement of the 1960s.

☛ **Kandinsky, Lissitzky, Mondrian, Reinhardt**

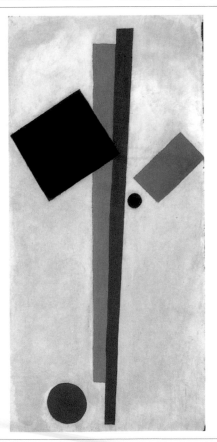

Kasimir Malevich. b Kiev (UKR), 1878. **d** St Petersburg (RUS), 1935.
Suprematist Composition. c1920–2. Oil on wooden panel. **h**62 x **w**30 cm. **h**24⅜ x **w**11⅞ in. Annely Juda Fine Art, London

Man Ray

Violin of Ingres

A woman's back is metamorphosed into a violin. In
a deft juxtaposition of apparently unrelated elements,
Man Ray creates an image which is both amusing and
enigmatic. The correspondence between the shape of
the female form and that of a musical instrument is a
cliché of literature and art, but here, using the new
medium of photography and the innovative technique
of montage, Man Ray gives a new twist to the visual
pun. The title refers to the celebrated nudes of the early
nineteenth-century painter Jean Auguste Dominique

Ingres. Man Ray started his career as a painter, but his
best-known works are photographs and he was perhaps
the first artist to recognize the potential of that medium
as more than simply a way of reproducing reality. Born in
New York, he moved to Paris, the centre of progressive
art. He became involved with the anti-art Dadaists and
then went on to produce some of the most memorable
Surrealist images.

☛ **Dalí, Maillol, Modotti, Woodrow**

Man Ray. b Philadelphia, PA (USA), 1890. **d** Paris (FR), 1976.

Violin of Ingres. 1924. Gelatin silver print. **h**38 x **w**29 cm. **h**15 x **w**11½ in. J Paul Getty Museum, Malibu, CA

Mangold Robert

½ x Series (Blue)

A semicircle, painted an intense bluish grey, is divided by lines which form a series of angular shapes. Looking intact on first sight, this shape is actually made up of two separate panels joined together: what appears to be a semicircle is in fact a group of interlocking triangles, and what seem to be vertical lines drawn on the surface of the board are in fact the shadows cast by the separate panels. Together they create a geometric pattern of triangles which appear to be the result of some complex mathematical equation rather than the artist's creative urge. This work is painted in acrylic which Mangold rolled onto the surface, so distancing himself from the more traditional technique of brush on canvas. The method of creating art with detached science rather than involved emotion links Mangold to the Minimalist movement of the 1960s. However, despite its reliance on pared-down shapes and colours, this painting also exudes a sense of space and calm, giving it an added dimension.

☞ **E Kelly, Nicholson, Reinhardt, Ryman, Schapiro, F Stella**

Robert Mangold. b North Tonawanda, NY (USA), 1937. 287

½ x Series (Blue). 1968. Acrylic and black pencil on masonite. **h**60.9 x **w**121.9 cm. **h**24 x **w**48 in. National Gallery of Art, Washington, DC

Manzoni Piero

Achrome

Covered in kaolin – a fine clay – and pleated into elegant folds, the cool, white canvas itself is the subject of this work. Manzoni created other works similar to this – reductive white paintings made from folded or stitched canvases and covered in white objects from eggshells to polystyrene balls. He called them 'Achromes' which means 'without colour'. These works paralleled the American artist Rauschenberg's experimentation with new materials for creating art. Manzoni is also known for his production of objects which attacked the hierarchy and pretensions of the art world with a wit reminiscent of the Dadaists. In the belief that anyone and anything could be a work of art he packaged a multitude of objects as art, including a sealed can of his faeces, and signed balloons of his breath and his blood, exploring and expanding the boundaries between art and life. A highly versatile artist, Manzoni was a painter, sculptor, performer and musician.

☛ LeWitt, Morris, Rauschenberg, Ryman

Piero Manzoni. **b** Soncino (IT), 1933. **d** Milan (IT), 1963.

Achrome. 1960. Kaolin on pleated canvas. **h**80 x **w**60 cm. **h**31½ x **w**23⅝ in. Private collection

Manzù Giacomo

Cardinal

This sculpture of a cardinal emanates a sense of calm, evocative of religious meditation. The absence of features and the reduction of the figure to a simple, cone-like shape emphasize the anonymity of the individual, buried beneath the official paraphernalia of rank. This work belongs to a series of cardinals begun by Manzù in the late 1930s, intended as a study of authority and power. The choice of a figure from the Roman Catholic Church relates both to Manzù's preoccupation with religious themes as well as to the specific context of the times,

when the Church was seen to be supporting Fascism in Italy. While developing a style indebted to the avant-garde, in terms of its simplicity of form, Manzù was nevertheless determined to make works using universally legible symbolism. His methods were essentially traditional, modelling with plaster or clay and then casting in metal to produce technically perfect works of extreme restraint.

☛ Brancusi, Giacometti, Marini, Rodin

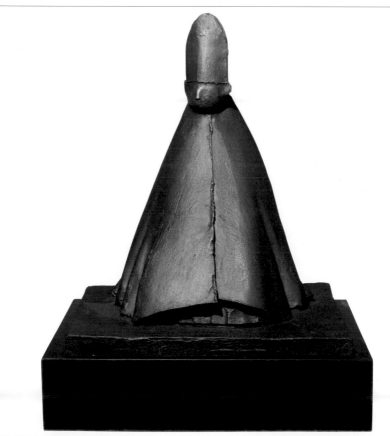

Giacomo Manzù. b Bergamo (IT), 1908. d Bergamo (IT), 1991.
Cardinal. c1972. Bronze with brown patina. h34.3 cm. h13½ in. Private collection

Mapplethorpe Robert

Thomas in a Circle

The light falls on the curves and texture of Thomas's flesh, in stark contrast to the black void behind. Constrained by a circle, he becomes a taut centre of intense energy. Mapplethorpe's stylish photographs have been subject to unprecedented controversy. His work is contentious, not only because of its frequently homo-erotic, sadomasochistic content, but also because of the implied double role of the artist as both observer and participant. The furore peaked in 1990 when the vice squad raided a posthumous exhibition in Cincinnati – the first instance of an American museum being criminally prosecuted for a show. In contrast to these works, Mapplethorpe also produced society portraits, fashion photographs and an exquisite series of flower studies. He is best remembered for his works on the theme of sexual identity, however, a subject which, in the wake of AIDS and a politicized gay movement, few artists have raised to such prominence.

☛ Haring, Hill, Lehmbruck, Man Ray, Modotti

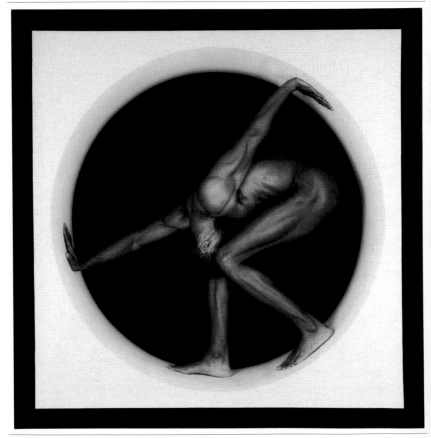

Robert Mapplethorpe. b Long Island, NY (USA), 1946. d New York (USA), 1989.
Thomas in a Circle. 1987. Platinum print on linen canvas. h66.1 x w66.1 cm. h26 x w26 in. Estate of the artist

Marc Franz

Siberian Dogs in the Snow

Two dogs trudge wearily through the snow, their white coats seeming to dissolve into their surroundings. The extraordinary luminosity of this painting owes something to the Impressionists' interest in light, while the contrasting yellow and blue shadows are influenced by Delaunay's theories of colour contrasts. Marc is best known for his paintings of animals in non-naturalistic hues, such as his blue and red horses, believing that colour had a symbolic and spiritual force all of its own. This work was painted in the year that Marc met Kandinsky and joined the New Artists' Association from which the Expressionist group Der Blaue Reiter later evolved. From this time onward, Marc moved away from the naturalism of his early animal studies, making his first abstract painting in 1913. His tragically early death in the First World War at the age of 26 cut short his brilliant early promise. His original and profoundly serious philosophy of art was to have a lasting impact on Kandinsky.

☛ R Delaunay, Gleizes, Gontcharova, Kandinsky, Kirkeby

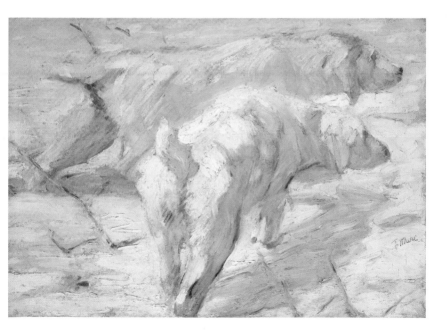

Franz Marc. b Munich (GER), 1880. **d** Verdun (FR), 1916.
Siberian Dogs in the Snow. 1909–10. Oil on canvas. **h**80.5 x **w**114 cm. **h**31¾ x **w**44⅞ in. National Gallery of Art, Washington, DC

Marden Brice

Cold Mountain 6 (Bridge)

A web of curved lines, painted with long, thin brushes and twigs, fills the picture plane. The subtle, deliberate rhythms of the grey and black lines evoke the idea of organic growth, alluding to the natural world. The title, which refers to a mountain, reinforces the theme of nature. This is one of a series of works called 'Cold Mountain', which represent nature in abstract form. Marden's aim is to depict an actual mountain, not by painting a picture of it, but by making an image which evokes the way one might feel when looking at the mountain. His reference to the natural world in the title of this work places him close to Abstract Expressionism, with its emphasis on the evocation of emotion and feeling. 'I believe that these are highly emotional paintings not to be admired for any technical or intellectual reason, but to be felt,' said Marden. Often editing and revising his work, Marden struggles to achieve this graceful equilibrium.

☞ **Kline, Lasker, Martin, Michaux, Vieira da Silva**

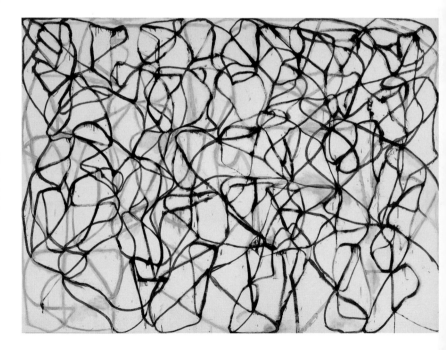

Brice Marden. b Bronxville, NY (USA), 1938.
Cold Mountain 6 (Bridge). 1989–91. Oil on linen. **h**274.3 x **w**365.8 cm. **h**108 x **w**144 in. Collection of the artist

De Maria Walter

New York Earth Room

An entire room has been filled with soil to a depth of two feet. The spectator is separated from this incongruous 'field' by a sheet of glass, which reinforces the idea of the soil as a work of art to be viewed in a gallery. Contained in an indoor space, the earth has been removed from its usual context and given a new purpose. Here, in an inversion of the normal principles of Earth Art, which traditionally takes art into the landscape, De Maria attempts to brings the outside world in, breaking down the confines of the gallery space. A version of this installation, first created in Munich in 1968, exists today in New York as a permanent installation at the Dia Center for the Arts. Like his contemporary Smithson, De Maria has been responsible for some of the grandest site-specific outdoor projects of the period, such as *Lightning Field*, a series of stainless steel poles designed to conduct lightning across a massive area in the plains of New Mexico.

☞ **Boyle Family, Long, Shiraga, Smithson**

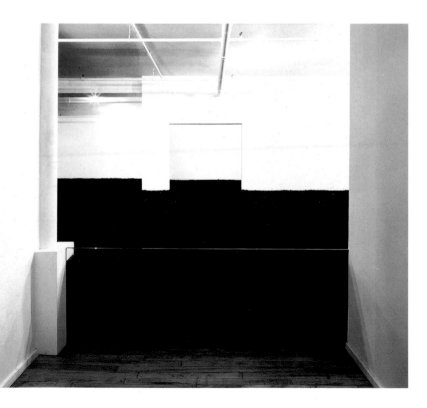

Walter de Maria. b Albany, CA (USA), 1935.
New York Earth Room. 1977. Soil. Floor space: 334 m². Floor space: 3600 ft². Dia Center for the Arts, New York

Marin John

Four-Master off the Cape-Maine Coast, No. 1

A range of blues conjures up the image of the sea off the New England coast. The presence of a masted ship provides a nostalgic, dreamy air. The atmospheric blue colour scheme and the evocative use of watercolour owes something to Expressionism. Marin often worked in watercolour, which permitted him to make works with a powerful sense of immediacy and vitality. Its fast-drying nature and flexibility as a transparent wash, can be exploited by using large brushes, and this enabled Marin to paint in broad strokes, often leaving the white of the paper showing through. Marin's paintings are predominantly dramatic seascapes or helter-skelter views of skyscrapers and the Hudson River. In 1909 he exhibited his work at the 291 Gallery in New York, which was established by the photographer Alfred Stieglitz. Through Stieglitz, Marin came into contact with the avant-garde art scene.

☞ Derain, Dufy, Heckel, Nolde, Wallis

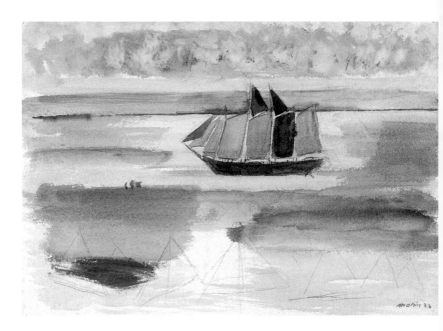

John Marin. **b** Rutherford, NJ (USA), 1870. **d** Cape Split, ME (USA), 1953.
Four-Master off the Cape-Maine Coast, No. 1. 1933. Watercolour on paper. **h**39.3 x **w**55.5 cm. **h**15½ x **w**21⅞ in.
Phillips Collection, Washington, DC

Marini Marino

Rider

A rider leans back on his horse, perhaps slipping off his mount, or maybe he is just craning his neck to look up at something in the sky. The forms have been elongated and simplified: the horse's head has been reduced to an oval shape, while the rider's feet and hands disappear into points. The texture of the horse's coat is evoked by lines incised into the surface of the bronze. Inspired by Primitive and Classical sculpture (which was often uncovered in archaeological excavations in Marini's native Italy), this stark and expressive image has an ancient feel. Marini addressed the theme of horse and rider obsessively throughout his career. His sculptures of riders falling off or being thrown from rearing horses reflect the tragedy of human existence. Never forming part of any artistic school, Marini was friendly with some of the leading artists of the day, including Picasso, Braque and Giacometti. He was also a gifted painter as well as a sculptor.

☛ Braque, Duchamp-Villon, Giacometti, Picasso, Wallinger

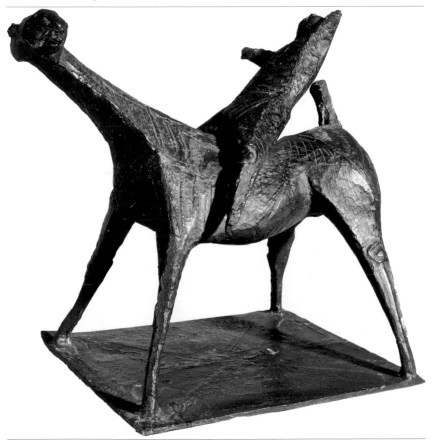

Marino Marini. b Pistoia (IT), 1901. d Viareggio (IT), 1980.

Rider. 1951. Bronze with brown patina. **h**40.7 cm. **h**16 in. Private collection

Marisol

Children Sitting on a Bench

Seven figures sit like bored school children on a bench, their feet dangling beneath them. Made up of wooden, box-like shapes, on which features have been drawn or incised, this work skilfully combines two-dimensional drawing and painting with three-dimensional carving. These striking 'children' are a strange assortment of adult figures and totem-like characters, brought together in this witty sculpture. The primitive, folk-like style reflects Marisol's Venezuelan background, as well as the influence of early American folk art. Though born in Paris, Marisol has spent much of her life in the United States, and her sculptures are a very particular mix of her ethnic roots and the Western, contemporary artists with whom she works in New York. At times adding plaster casts or found objects to her sculptures, Marisol incorporates images of herself or celebrities into these semi-realistic portraits. Her eclectic approach reflects a very personal interpretation of contemporary figurative sculpture.

☞ **Boltanski, Dumas, Funakoshi, Muñoz**

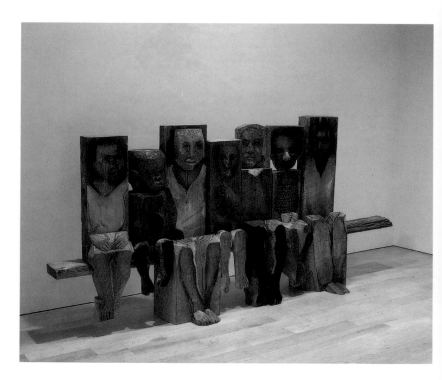

Marisol Escobar. **b** Paris (FR), 1930.
Children Sitting on a Bench. 1994. Wood and mixed media. **h**139.7 x **w**306.1 x **l**48.3 cm. **h**55 x **w**120½ x **l**19 in.
Museo de Arte Contemporaneo, Caracas

Martin Agnes

Untitled #10

Stripes of grey and white stretch across the canvas. A subtle rhythm has been created by juxtaposing two almost identical colours with delicate pencil lines. This large square encourages quiet contemplation. Martin's aim is not to depict a landscape or any other physical reality, but rather to illustrate the emotion one might feel when looking through the branches of a tree or staring at the horizon between the sea and sky. In 1967, at the height of her career, Martin left New York, the centre of the American art scene, and went to live in Taos, New Mexico, where she did not paint for seven years. In 1974, after much cajoling by her New York dealer, she took it up again. Admired by both the Abstract Expressionists and the Minimalists, Martin's work almost defies categorization. Still living today in relative isolation, Martin continues to create fields of contemplation. She has never considered herself to be intellectually motivated, maintaining a dogged resistance to calculations and concepts.

☞ Andre, Bleckner, LeWitt, Newman, Ryman

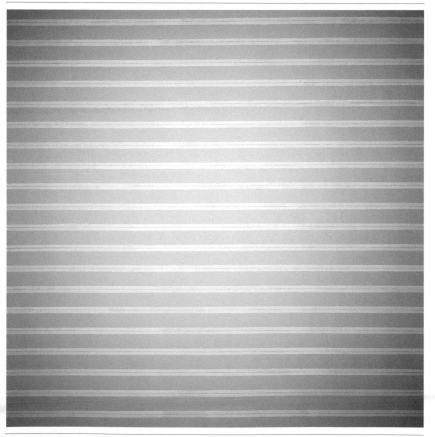

Agnes Martin. b Maklin (CAN), 1912.

Untitled #10. 1989. Graphite and acrylic on canvas. h183 x w183 cm. h72⅛ x w72⅛ in. Private collection

Masson André

In the Grass

A close-up world of vegetation and insect life in high summer is depicted in bright red, green, yellow and blue. Initially the image appears entirely innocent and decorative, however, we sense a malevolent force at work, suggested by the spiky shapes and the predatory insects, which belies the reassurance offered by the decorative colour scheme. Masson implies that beneath the beautiful surface lurk the destructive, but inevitable impulses of nature. The combination of slightly disturbing subject matter with an attractive style has links with

Surrealism, a movement of which Masson was a member. In his early works, like Miró, he favoured the techniques of 'automatism', making free-style drawings and sand paintings, but later rejected this approach, believing that one could not 'arrive by this means at the intensity essential for a picture'. His work encompasses stage sets, lithographs and drawings, as well as paintings.

☞ **Matta, Miró, G Orozco, Paik, Rousseau**

André Masson. **b** Balagny (FR), 1896. **d** Aix-en-Provence (FR), 1987.
In the Grass. 1934. Oil on canvas. **h**55.2 x **w**38.1 cm. **h**21¾ x **w**15 in. Private collection

Matisse Henri

The Dance

Set against a blue and green background, five pink figures dance joyously in a circle. They twist and turn their bodies with feeling as they lose themselves in the rhythm of the dance. They seem to be moving so fast that the woman in the centre of the picture in the foreground has lost her grip on the hand of the figure to her left. The vivid colour scheme and the expressive freedom of the women are characteristic of the bold palette and uncompromising hedonism of the Fauves, of whom Matisse was the leading exponent. 'Fauve' means 'wild beast', a term which was derogatively applied to Matisse's work by an outraged critic because of his use of wild colour. His fascination with Near-Eastern art and textiles spawned a decorative, exotic style which often incorporated highly patterned surfaces. Along with Picasso, Matisse is widely held to be the greatest artistic genius of the twentieth century, his revolutionary use of colour to evoke emotion inspiring subsequent generations of painters.

☞ Derain, Eisenman, Evergood, Heron, Nadelman, Segal

Henri Matisse. b Le Cateau-Cambrésis (FR), 1869. d Nice (FR), 1954.

The Dance. c1910. Oil on canvas. **h**260 x **w**391 cm. **h**102⅜ x **w**154 in. Hermitage Museum, St Petersburg

Matta Roberto

Untitled

A multitude of purple, insect-like shapes fills the canvas. In the centre, a reddish-yellow glow forms the focus for this luminous construction. These strange organic forms come straight from Matta's subconscious, produced by a technique called 'pure psychic automatism', whereby the artist produces spontaneous drawings directed by his inner being. This interest in the subconscious is typical of Surrealism, a movement with which Matta was closely associated. He met Dalí on a trip to Spain and subsequently became a key member of the group. Matta's mystical and disturbing paintings, which he called 'psychological morphologies', or 'inscapes', suggest scenes of chaotic violence and terror. Organic, even extraterrestrial in nature, they are preoccupied with infinite, cosmic space. Matta initially trained as an architect and worked as a draughtsman for Le Corbusier. His works were to have a significant influence on the paintings of Gorky and the American Surrealists.

☞ Baumeister, Dalí, Gorky, Le Corbusier, Masson, Tanguy

Roberto Sebastián Matta Echaurren. b Santiago (CH), 1911.
Untitled. c1951. Oil on canvas. h139.1 x w188 cm. h54¾ x w74 in. Private collection

Matta-Clark Gordon

Splitting

A derelict house stands in an unkempt garden with a ladder running to an upper storey window. Though unremarkable at first, the house is in fact sawn in two. It has become the antithesis of the stable family home. In the context of the political, social and technological upheavals of the late twentieth century, it speaks of our sense of place and the stability we equate with home. Matta-Clark's process of 'cutting' – carving huge sections from buildings – draws attention to the gaps in the fabric of society. In 1968, fascinated by Earth Art, Matta-Clark turned from his architectural training to a more radical form of intervention in the world around him. Through funding from his estranged father, the painter Matta, he devoted his attention to film and performance work, co-founding *Food,* a restaurant in New York's SoHo, where artists were sometimes guest chefs. It was here that Matta-Clark made his first 'cuttings' and coined the term 'anarchitecture' – a combination of anarchy and architecture.

☛ Artschwager, Graham, Hockney, Matta, Whiteread

Gordon Matta-Clark. **b** New York (USA), 1945. **d** New York (USA), 1978.
Splitting. 1977. Cibachrome photograph. **h**76.2 x **w**101.6 cm. **h**30 x **w**40 in. Private collection

Meireles Cildo

Zero Dollar

On the front and back of a fake dollar bill, Uncle Sam and Fort Knox replace George Washington and the White House. Designed and printed by Meireles, this work undermines the capitalist ideology of the United States. Introducing these worthless notes into general circulation, Meireles set up a system of exchange for his ideas which did not depend on the limited framework and audience of the art world. Meireles is a political artist from Brazil who has focused on his social environment, and on the economic injustices of his country, starting his

interventionist art strategies at the height of Brazil's military dictatorship. He has silk-screened onto Coca Cola bottles texts questioning the regime and rubber-stamped messages onto banknotes then sent them back into circulation. More recently Meireles has concentrated on poetic, large-scale installations dealing with the West's exploitation of the Third World for its own capitalist ends.

☞ Holzer, Oiticica, Warhol, Wodiczko

Cildo Meireles. b Rio de Janeiro (BR), 1948.
Zero Dollar. 1978–84. Print on paper. h6.9 x w15.8 cm. h2¾ x w6¼ in. Galeria Luisa Strina, São Paulo

Mendieta Ana

Volcano Series

A bright flame erupts from a volcanic shape in the earth. The mound was created by the artist who lay down on the soil and then outlined the imprint of her body with flowers and stones. She then covered it in gunpowder and set it alight. Referring visually both to the volcano and to the vagina, the work resonates with primeval sexuality. Described by the artist as an 'earth-body sculpture' it forms part of a series of works in the land. Exiled as a child by the political upheavals in her native Cuba, Mendieta was at odds both with the art world, which she regarded as male and privileged, and with the women's movement, which she felt was intrinsically European and middle-class. In 1981 she returned to her homeland and carved sensuous female forms on the walls of caves surrounding Las Escaleras de Jaruco. Her premature death in 1985, the year she married the American artist Andre, thwarted the realization of her most ambitious piece, intended for a Los Angeles park.

☞ Andre, Hatoum, M Kelly, K Smith, Smithson

Ana Mendieta. b Havana (CU), 1948. d New York (USA), 1985.
Volcano Series. 1979. Photograph of a performance at the Sharon Arts Center, Sharon, NH

Merz Mario

Fibonacci Igloo

Neon numbers punctuate the gloom of a darkened space, appearing around the room and between the blocks of an igloo-like form – a provisional shelter – made of parcels of cloth. The use of everyday materials – cloth, neon and wire – is typical of the Italian Arte Povera group, of which Merz was a member. This work forms part of a series based on a complex yet universal mathematical principal pioneered by the medieval mathematician Leonardo da Pisa, whose nickname was 'Fibonacci'. Originating as an attempt to calculate the breeding rate of rabbits, a

sequence of numbers grows by adding together the two previous figures: 1, 2, 3, 5, 8, 13 and so on. Merz uses this sequence to build up the blocks of his igloo, placing one parcel at the top, then two, three, five and so on. The system can be found in the spiral of a snail's shell, or the domes of our greatest cathedrals. Embodying the natural laws of design, this work explores metaphysical truths.

☞ Flavin, Kounellis, Miyajima, Nauman

Mario Merz. b Milan (IT), 1925.
Fibonacci Igloo. 1972. Metal tubes, cloth, wire and neon tubes. h100 x diam. 200 cm. h39⅜ x diam. 78¾ in. Private collection

Messager Annette

Lances

Long, needle-like lances pierce and display little sketches, stuffed stockings, a prickly ball and a bundle of toys. Propped up against the wall, they are like strange trophies captured from a world of pastel coloured daydreams and ghoulish nightmares. Three of the small drawings are filled with frenzied doodles, evidence perhaps of frustrated anger, while the children's toys wrapped around a black cross indicate the lost innocence of youth. Through this work, Messager examines how stereotypical views of women are constructed from the ephemera of everyday life. The original French title – *Piques* – is significant: it is a pun, meaning both a sharp weapon and a cutting remark. Messager's work consists of collected fragments of information, photographs and a myriad of seemingly insignificant objects and images. Building these disparate elements into lyrical arrangements she questions accepted notions of female identity.

☛ Eisenman, Kelley, C Noland, Richier

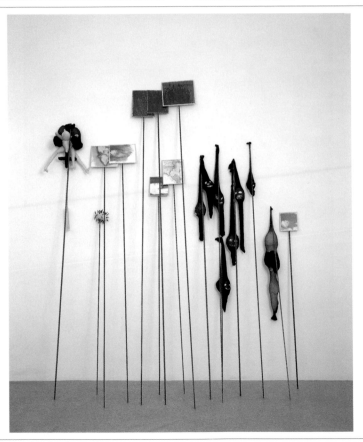

Annette Messager. b Berck-sur-Mer (FR), 1943.
Lances. 1994. Mixed media. **h**245 x **w**160 cm. **h**96½ x **w**63 in. Musée National d'Art Moderne, Paris

Metzinger Jean

At The Cycle Race-Track

A cyclist races to the finish line. The track, painted in horizontal strokes of grey and brown, appears to be flashing by at high speed. The wheel of a bicycle on the left is shown spinning round, and the crowd is visible through the cyclist's face, arm and back, as if the participants are rushing by so quickly that they hardly obscure the spectators behind. The subdued palette is close to Cubism, and the interest in the theme of speed and movement is reminiscent of Futurism. But this work is essentially a traditional figurative rendering of a subject onto which Cubist tendencies have been grafted. The figure on the bicycle is reduced to geometric shapes, his form stylized, and a section of the image has been fragmented, yet his features, the background detail of the crowd, and the treatment of space is more conventional than in most Cubist works. Metzinger was also an important theorist. His book, *On Cubism*, written in 1912, is crucial to later critical understanding of the movement.

☛ Balla, César, Duchamp, Gleizes

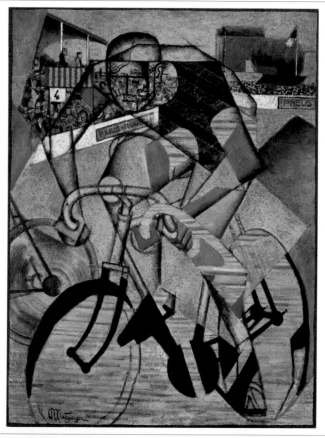

Jean Metzinger. b Nantes (FR), 1883. **d** Paris (FR), 1956.
At the Cycle Race-Track. c1914. Oil and collage on canvas. **h**130.4 x **w**97.1 cm. **h**51⅓ x **w**38¼ in. Peggy Guggenheim Collection, Venice

Michaux Henri

Untitled

A series of diagonal ink marks look as if they have been flicked onto the surface of the paper. Dancing before our eyes, they seem to have a life of their own. This particular work is part of a long series entitled 'Movements', started in 1959. By this time Michaux had begun experimenting with the hallucinogenic drug mescalin in order to release his creativity, and his pictorial style changed dramatically, becoming more spontaneous. This interest in expressing subconscious impulses is typical of Art Informel. Michaux's earlier drawings, which he called *Phantomismes*, because of their fantastical, ghostly subject matter, relied on automatic drawing and presented images in transition and metamorphosis. Suffering, alienation and angst are central to Michaux's art, which expresses the element of chance and the absurdity of life, revealing the influence of the Existentialist movement in post-war Europe.

☛ **Artaud, Kline, Marden, Pollock, Soulages, Tobey**

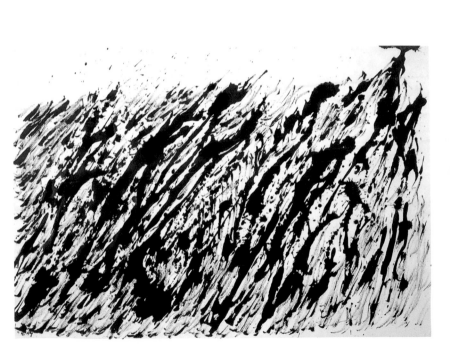

Henri Michaux. **b** Namur (BEL), 1899. **d** Paris (FR), 1984.
Untitled. 1978. Indian ink on paper. **h**74.9 x **w**107.9 cm. **h**29½ x **w**42½ in. Edward Thorp Gallery, New York

Miró Joan

Summer

Semi-human creatures – perhaps a mother and her two children – cavort on a beach in summertime. Both the shapes and the simple, primary colours suggest joyful abandon – an immersion in sensual pleasure. Miró emphasizes the flatness of the picture, reducing everything to clear outlines and bright hues. The result is as decorative as it is expressive. 'For me, a form is never something abstract; it is always...a man, a bird, or something else' said Miró. He and Dalí were the leading Spanish Surrealists. Miró belongs to the wing of

Surrealism which advocated 'psychic automatism' as a way of producing imagery – creating in the manner of a doodle, without conscious forethought. Like the other Surrealists, he was interested in the art of the untutored, such as children and the insane, admiring their freedom and exuberance. Using this spontaneous method, Miró produced semi-abstract paintings, murals and sculptures which often evoke an idyllic Mediterranean world, teeming with strange life-forms.

☞ **Dalí, Olitski, Tanguy, Wadsworth**

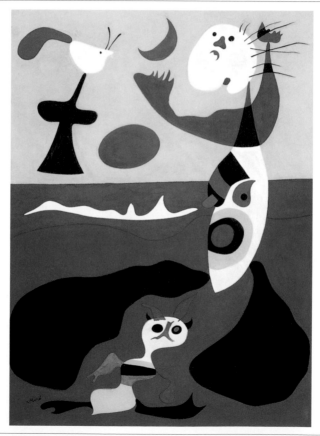

Joan Miró. **b** Barcelona (SP), 1893. **d** Palma (SP), 1983.

Summer. 1938. Gouache on paper. **h**75 x **w**55.5 cm. **h**29½ x **w**21¾ in. Private collection

Mitchell Joan

Untitled

A mass of brushstrokes fills the canvas, setting up a dynamic rhythm between the cream background and the patchwork of colour. Although abstract in form, this work is inspired by Mitchell's natural surroundings. The deep green, the blue and the bright accent of orange evoke the trees, rivers, light, rocks and in particular the remembered landscapes around Lake Michigan where the artist spent much of her childhood. The vibrant, gestural style is typical of Abstract Expressionism, a movement with which Mitchell was closely associated.

Initially influenced by De Kooning and Gorky, Mitchell went on to develop her own unique style. Unlike the brooding and macho Abstract Expressionism characteristic of Rothko or Kline, which concentrates on self-expression, Mitchell's paintings draw much of their inspiration from nature, setting her aside from her American contemporaries. Born in America, Mitchell spent much of her working life in Paris.

☛ Gorky, Kline, De Kooning, Krasner, Mondrian, Rothko

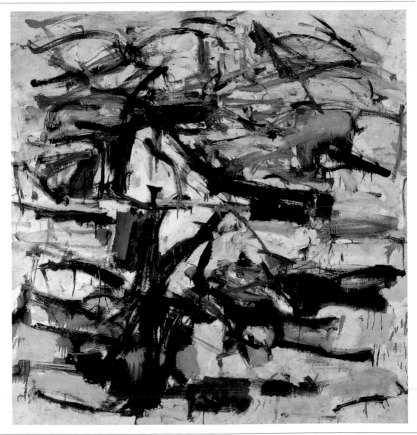

Joan Mitchell. **b** Chicago, IL (USA), 1926. **d** Paris (FR), 1992.
Untitled. 1956. Oil on canvas. **h**185 x **w**185 cm. **h**72⅞ x **w**72⅞ in. Estate of the artist

Miyajima Tatsuo

Opposite Harmony 70027/94237

Installed in a darkened space, a series of LEDs (light-emitting diodes) blink and glow, displaying all the figures between 1 and 99. Remarkably familiar as a visual medium, these electronic digits crop up everywhere in our daily life: in digital watches, calculators, sports scoreboards and Stock Exchange transaction boards. Though symbols of a high-tech world, they are used by Miyajima to invest technology with a spiritual dimension. Here, the numbers no longer operate in a functional mode by providing useful information. They are presented as metaphors for infinite change or as symbols of cosmic time. It is possible to read each number as a different, yet interconnected component of the universe – perhaps a molecule, a city, a sound, a star or a person. The LED is the basic unit of Miyajima's work. He often arranges them on the wall or the floor in geometrical configurations such as circles, lines or large-scale rectangular grids which completely fill the gallery walls.

☞ Kawara, Merz, Tansey, Zorio

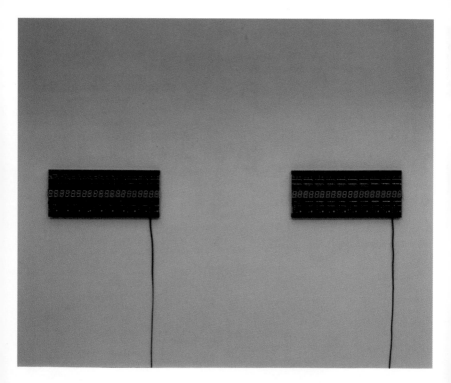

Tatsuo Miyajima. b Tokyo (JAP), 1957.
Opposite Harmony 70027/94237. 1990. LEDs, integrated circuit, electric wire and aluminium panel.
h12.1 x **w**26 x **l**4.4 cm. **h**4¾ x **w**10¼ x **l**1¾ in. Private collection

Modersohn-Becker Paula Woman with Flowers

A woman sits among vases of flowers, clutching one bloom to her chest. With a sad expression on her face and her head slumped, she seems absorbed in her own thoughts. The strong, bold outlines, the slightly naïve treatment of the figure and the overall decorative quality of this painting reveal the influence of Cézanne and Gauguin. Yet the style of this painting is more expressive and deliberately distorted than in their work. In a way, Modersohn-Becker was a precursor of the German Expressionists, who used bold colours to evoke emotions. They joined together in her native Dresden only a few years after her death. Modersohn-Becker aimed to express in the simplest way 'the unconscious feeling that often murmurs so softly and sweetly within me'. Along with her artist husband, Otto Modersohn, she started out working in a more traditional manner, but later developed her own more expressive approach.

☞ Beckmann, Cézanne, Gauguin, Pechstein

Paula Modersohn-Becker. b Dresden (GER), 1876. d Worpswede (GER), 1907.
Woman with Flowers. 1907. Oil on canvas. **h**89 x **w**109 cm. **h**35 x **w**42⅞ in. Von der Heydt-Museum, Wuppertal

Modigliani Amedeo

Self-portrait

The artist gazes out of the canvas, holding a palette and brushes in one hand and another brush in the other. Wrapped in a large brown coat with a blue scarf round his neck, he looks as if he is about to start painting. His eyes have been reduced to two black hollows, and his nose and mouth look finely chiselled, like a sculpture. The elongated and simplified features are typical of Modigliani, and reveal the influence of African art. The sombre hues give the work a melancholy air, evocative, perhaps, of the wretched conditions in which the artist lived in Paris. Modigliani mixed with the avant-garde artists of the time, but despite his exposure to new movements such as Cubism, he remained distant from their preoccupation with reducing form to geometric shapes, as this subtly modelled portrait reveals. He is also known for the tender eroticism of his nude sculptures and paintings, and for his hightly abstracted carvings of heads. He died of a combination of tuberculosis, drug addiction and alcoholism.

☞ **Kippenberger, Picasso, Schjerfbeck, Soutine, Spilliaert**

Amedeo Modigliani. **b** Leghorn (IT), 1884. **d** Paris (FR), 1920.

Self-portrait. 1919. Oil on canvas. **h**100 x **w**65 cm. **h**39⅜ x **w**25⅔ in. Museu d'Arte Contemporanea, University of São Paulo, São Paulo, Brazil

Modotti Tina

Hands of the Puppeteer

A man leans over a rough backdrop to pull on the strings of a marionette. The dramatic lighting reveals the texture of his skin, throwing into relief the veins on his hands. The dark, ominous shadow suggests the presence of death, while the strings of the puppet recall binding chains. The subject of marionettes was used by Modotti as a symbol of social repression: she implies that people are controlled by governments, just as the puppeteer controls the puppets. Born in Italy, Modotti moved to Mexico in 1923, attracted, like many other artists, by the country's beauty, artistic heritage and history of political idealism. She was a close friend of the painter Rivera and, like him and his circle, was committed to an art of left-wing social protest. She saw photography as a modern technique which could speak directly to ordinary people. In a time of the rise of dictators, Modotti's symbolic commentary was particulary apt.

☛ **Mapplethorpe, Rivera, Rodin, Siqueiros**

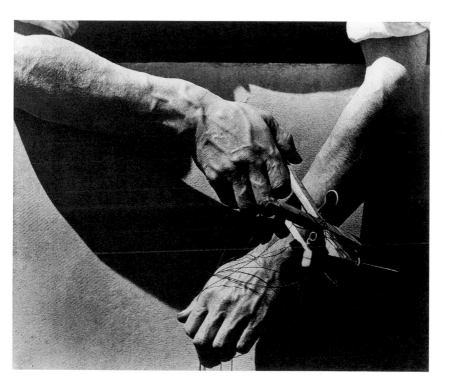

Tina Modotti. **b** Udine (IT), 1896. **d** Mexico City (MEX), 1942.
Hands of the Puppeteer. c1929. Photograph. **h**17.5 x **w**21.6 cm. **h**6⅞ x **w**8½ in. Comitato Tina Modotti, Udine

Moholy-Nagy László

Painted only in outline, two groups of curved, rectangular shapes seem to flutter like sheets of paper on the surface of the canvas. The only solid-looking elements in this composition are the small textured panel of white, just right of centre, and the striped arc of black, white and green on the top left. This work explores space, light and movement in a highly experimental way. The use of primary colours and the focus on geometric forms is typical of Constructivism, a group with which Moholy-Nagy was closely linked. Influenced by Malevich and Lissitzky, Moholy-Nagy made a huge contribution to the develop-ment of modern art, ceaselessly experimenting with new styles, techniques and materials. His actual artistic output was arguably of secondary importance to his writings and teachings, though his breakthrough in using new materials, such as Plexiglas, had a significant influence. He taught at the Bauhaus, the revolutionary school of design, crafts and architecture in Weimar, Germany.

☞ **Lissitzky, Malevich, Mondrian, Sarmento**

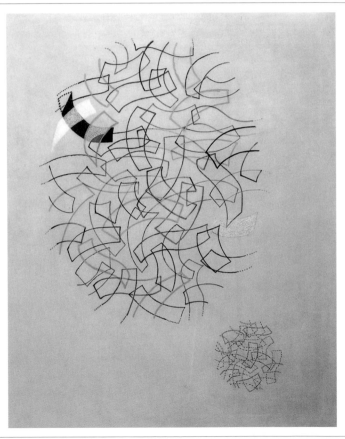

László Moholy-Nagy. b Bácsborsód (HUN), 1895. **d** Chicago, IL (USA), 1946.
CHB 4. 1941. Oil on canvas. **h**127.5 x **w**102.5 cm. **h**50¼ x **w**40⅜ in. Private collection

Mondrian Piet

Composition with Blue and Yellow

The top left-hand corner of an asymmetric grid, painted in flat yellow is elegantly balanced by a smaller area of blue. The strong black lines and rectangles of white separate the two primary colours, creating a harmonious composition. Deceptively simple, this work sets shapes and colours in perfect equilibrium. Mondrian would apparently move the colours round the grid until they appeared to be just right, as if nature had placed them there. The reduction of form to purely geometrical shapes and the restriction of colour to yellow and blue against

white and black is typical of Mondrian. In 1917, along with Van Doesburg, he formulated his ideas into the movement known as De Stijl, which held that the square, the cube and the right-angle were symbols of nature. Towards the end of his life, just before the outbreak of the Second World War, Mondrian moved to London, and subsequently to New York, where he made works influenced by the rhythms of jazz.

☞ Van Doesburg, E Kelly, LeWitt, Lissitzky, Malevich

Piet Mondrian. b Amersfoort (NL), 1872. **d** New York (USA), 1944.

Composition with Blue and Yellow. 1929. Oil on canvas. **h**52 x **w**52 cm. **h**20½ x **w**20½ in. Museum Boymans-van Beuningen, Rotterdam

Monet Claude

Waterlilies

Accents of white and pink on a sea of blue and green conjure up the impression of a cluster of waterlilies, catching the light and reflected on the surface of the water. The paint has been applied in thick, gestural brushstrokes. This preoccupation with depicting light, the spontaneity of handling and the tactile surface quality all owe much to Impressionism, the group of which Monet was a leading member. However, his concern with colour for its own sake, and his lack of interest in any formal composition moves far beyond the original aims of Impressionism, and this work has thus been termed Abstract-Impressionist. In 1890, at the age of 50, Monet bought a house and a large plot of land at Giverny, where he started to build his water garden. The subject of the waterlilies filled his artistic vision for the last 30 years of his life. He painted several other great series, including 'Poplars', 'Haystacks' and 'Rouen Cathedral', which showed the same scene at different times of the day and in different seasons.

☞ **Goldsworthy, Louis, Nolde, Pollock, Signac**

Claude Monet. b Paris (FR), 1840. d Paris (FR), 1926.
Waterlilies. c1920. Oil on canvas. h198.1 x w426.7 cm. h78 x w168 in. Museum of Modern Art, New York

Moore Henry

Family Group

With arms intertwined, a mother and father support their child. Sitting on a simple bench, these figures appear to be eroded – their features partly erased by the effects of the elements over a long period of time. By dressing them in Classical drapery, reminiscent of Greek and Roman statuary, Moore gives the figures a timeless quality. The family is society's most basic unit and is a traditional subject which has been painted and sculpted since medieval times in the form of the Holy Family. Prior to this work, Moore's subjects were exclusively women –

seated and reclining. The family group gave him the opportunity to depict a male figure for the first time. This monumental sculpture, which stands in Moore's garden, dates from a period when he retreated from the extreme experiments in abstraction which had characterized his work of the 1930s in order to address the need for a new humanistic art for a ravaged post-war Britain. Moore was the recipient of numerous awards, including the Order of Merit.

☞ **Botero, Brancusi, Hepworth, Lehmbruck**

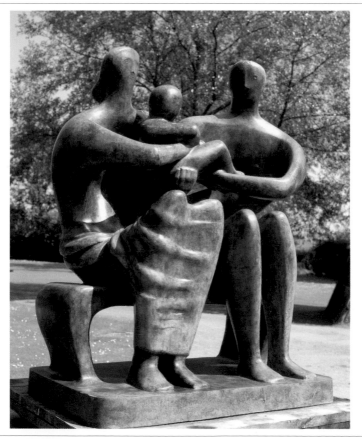

Henry Moore. **b** Castleford (GB), 1898. **d** Much Hadham (GB), 1986.
Family Group. 1948–9. Bronze. **h**152 cm. **h**59⅞ in. Henry Moore Foundation, Much Hadham

Morandi Giorgio

Still Life

Three bottles are set against a neutral background. The subtle colour scheme and balanced composition combine to produce a work of simple, meditative beauty. Morandi painted vases, bowls, bottles and jugs almost exclusively throughout his career, endorsing the simplicity of rural life. His intense concentration on form, colour and space in his unpeopled landscapes and still lifes reflects a deeply introverted, detached perspective on reality. His restrained style, which draws the spectator in through its classical, spartan qualities, is simultaneously unsettling and seductive. 'Nothing is more abstract than the visual world', he said. The relaxed tonal rhythms and limited range of colours in this work reveal Morandi as a painter who wished simply to capture the essence of objects and scenes. As well as his paintings of bottles and isolated houses set in woodland, Morandi produced many etchings which are brilliantly composed studies in light and shade.

☞ Arikha, Caulfield, Cornell, Nicholson, Spoerri

Giorgio Morandi. b Bologna (IT), 1890. d Bologna (IT), 1964.
Still Life. c1946. Oil on canvas. h28.7 x w39.4 cm. h11⅜ x w15½ in. Private collection

Morimura Yasumasa

Mother (Judith II)

A woman with long ginger hair and a bright red hat wields a jewelled sword. Wearing sixteenth-century dress and incongruously adorned with cabbage leaves, strings of sausages, sprouts and a beer-mug earring, she stands triumphant over the man she has just killed. He is represented as a potato head, surrounded by slabs of steak and cured meat. This large-scale photograph depicts the biblical story of Judith who beheaded the Assyrian general Holofernes to save her town. The image is based on a painting by the German Renaissance artist Lucas Cranach, and is presented here in a style borrowed from the fifteenth-century painter Giuseppe Arcimboldo whose figures were made up of fruit and vegetables. Morimura has transformed the original portrait into a surreal still life, the artist himself playing the part of Judith. Fusing a complex mixture of historical elements, Morimura redefines his identity as a Japanese artist influenced by, but working outside, the mainstream of European art.

☞ Bellmer, John, Kippenberger, Klimt, Popova

Yasumasa Morimura. b Osaka (JAP), 1951.
Mother (Judith II). 1991. Colour photograph mounted on canvas. **h**240 x **w**160 cm. **h**94½ x **w**63 in. Edition of 3

Morley Malcolm

Los Angeles Yellow Pages

With its torn cover and plate-like stain, the enlarged telephone directory has been rendered in an almost photographic manner. Certain elements, however, retain an indisputably painterly touch: the sky is filled with overlapping brushstrokes and the buildings have a sketchy appearance. The large crack down the middle of the image is a reference to Los Angeles's frequent earthquakes, as well as a satisfying formal device which divides the work neatly in two. Morley's early abstract compositions were followed by images of boats, inspired by a passion for the sea. He painted them in a photographic manner derived from postcards and travel brochures, often adding to their artificial quality by retaining white borders around the image. Morley was one of the first Photo-realists, a group who painted in an extremely realistic style. However, his later paintings began to break from photographic accuracy towards a more physical, painterly style.

☞ **Estes, Paolozzi, Rotella, Struth**

Malcolm Morley. b London (GB), 1931.
Los Angeles Yellow Pages. 1971. Acrylic on canvas. **h**213.4 x **w**182.9 cm. **h**84 x **w**72 in. Louisiana Museum of Modern Art, Humlebaek

Morris Robert

Seven Reds for Georgia O'Keeffe VI

A piece of dark red felt has been bolted to the wall, its pleated form casting delicate shadows on the wall behind. Folded back on itself, the cloth resembles the drooping, open collar of a shirt. As the title indicates, the work is dedicated to O'Keeffe, whose paintings of flowers and other natural forms perhaps inspired its petal-like folds. The simple outline of this piece owes much to Minimalism, a movement with which Morris was associated in the mid-1960s, but the tactile quality of the material and the evocation of organic forms mark a new departure.

A dancer as well as a prolific sculptor and influential writer, Morris also incorporated performance into his works. In one such key piece from 1961, he stood inside a rectangular plywood column and rocked back and forth until the structure toppled over. More recently, he has made fossil-like reliefs containing body and machine parts, eerily resembling human remains.

☛ Andre, Burri, O'Keeffe, Rothko

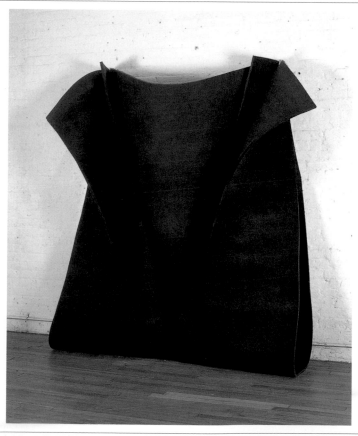

Robert Morris. **b** Kansas City, MO (USA), 1931.
Seven Reds for Georgia O'Keeffe VI. 1992. Felt and steel brackets. **h**208.3 x **w**205.7 x **l**63.5 cm. **h**82 x **w**81 x **l**25 in. Private collection

Moses Anna (Grandma)

Checkered House

Horses and carriages travel up and down a street in a New England village. In the background, the rolling hills fade into the blue sky. The buildings, people and animals appear to be flat, though a convincing sense of space has been achieved by reducing the scale and tone of the houses and haystacks in the background. 'Grandma' Moses did not begin painting until she was in her seventies. Completely untutored, she was 'discovered' by a New York collector in 1938 and by the mid-1940s her paintings had become so popular that they were being used for Christmas cards. A 'naïve' or 'primitive' artist, she made paintings which have a highly decorative quality because of the lack of realistic perspective. Painting from memory, she recorded the life of her native New England as it had been in the late nineteenth century. The childlike innocence and clarity which suffuse her paintings made them popular both to art-world sophisticates in search of an authentic vision and to a wide range of art-lovers.

☛ Gontcharova, Lowry, Rousseau, Wallis

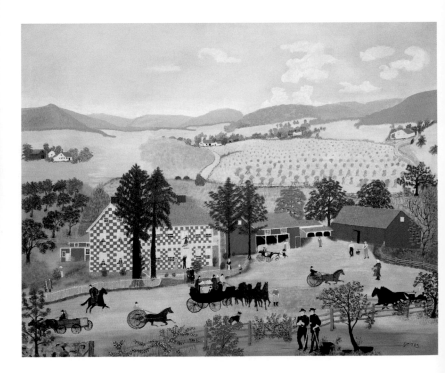

Anna (Grandma) Moses. b Greenwich, NY (USA), 1860. d Hoosick Falls, NY (USA), 1961.

Checkered House. 1943. Oil on canvas. **h**91.4 x **w**114.3 cm. **h**36 x **w**45 in. IBM Corporation, New York

Motherwell Robert

Pancho Villa, Dead and Alive

This painting looks like an abstract patchwork of colours, lines and marks, but in fact it represents a narrative. Based on a photograph of the assassinated Mexican revolutionary, Pancho Villa, this work contrasts images of life and death. On the left, the solid areas of paint show Pancho Villa alive, while on the right, the violent red and black marks represent the bullet holes that riddled his body. This work is a collage, made from pieces of painted paper pasted onto board. Motherwell was to remain interested in collage throughout his career, prompted initially by the collector Peggy Guggenheim's invitation to produce collages for an exhibition in 1944. Motherwell was a key member of the Abstract Expressionist movement, sharing their interest in spontaneous, abstract painting. He married fellow painter Frankenthaler in 1958. He was also a writer and theorist on art and an extremely talented printmaker and draughtsman.

☛ **Frankenthaler, Howson, De Kooning, Pollock**

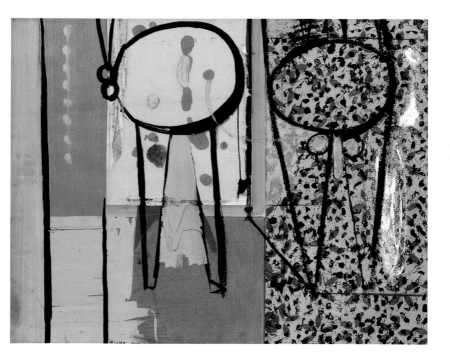

Robert Motherwell. b Aberdeen, WA (USA), 1915. d Provincetown, MA (USA), 1991.

Pancho Villa ... 1943. Gouache and oil with paper on cardboard. **h**71.7 x **w**91.1 cm. **h**28 x **w**35⅞ in. Museum of Modern Art, New York

Mucha Reinhard

Untitled

Within a large, beech wood and glass frame, which seems to suggest the view from a train window, are three small, black and white photographs of railway wagons. The central photographs document an earlier exhibition of the same images of the wagons. The right-hand section is also composed of elements from that show. Mucha has used materials and construction techniques similar to those used in coach building and railway stations, which refer to an age of skilled craftsmen. Mucha's wall-based construction is a complex, multi-layered work which reflects his long-standing fascination with railways and trains. His interest is focused in particular on his local Ruhr Valley railway system and its place in the flat industrial landscape of the surrounding area. In constructing his art from local and personal history, Mucha has created works which are vehicles in their own right – carriers of time, memory and place.

☛ McCollum, Magritte, Roy, Sheeler

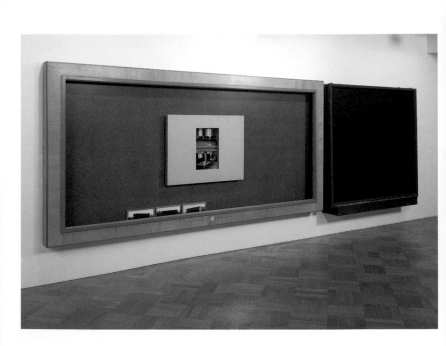

Reinhard Mucha. b Düsseldorf (GER), 1950.

Untitled. 1991. Beech wood, composition board, glass, linen and photographs. **h**166.5 x **w**340 x **l**21 cm. **h**65½ x **w**134 x **l**8¾ in.

As installed at the Karmeliterkloster, Frankfurt

Mukhina Vera

Industrial Worker and Collective Farm Girl

A hammer and sickle – symbols of the industrial and agricultural power of the Soviet Union – are held aloft by heroic workers shown striding confidently into the future. This sculpture is a smaller cast of the monumental version which was once set on top of the Soviet pavilion at the International Exhibition of Arts, Crafts and Sciences in Paris in 1937. There, it could be seen opposite the equally monumental German eagle which decorated the Nazi's pavilion. In both cases, art was used as blatant propaganda. This is an undeniably powerful work of

Socialist Realism, the officially sanctioned and heroic style of art which celebrated the Soviet state. Produced under the crippling restrictions imposed on the arts by the Soviet Communist party, such idealizations of the Soviet Union were in stark contrast to the brutal realities of Stalinism. In addition to her powerful sculptural work, Mukhina was also a graphic artist and a designer of stage sets and textiles.

☛ **Boccioni, Kabakov, Komar and Melamid, Moore**

Vera Mukhina. b Riga (RUS), 1889. **d** Moscow (RUS), 1953.
Industrial Worker and Collective Farm Girl. 1937. Bronze. **h**158.5 cm. **h**62½ in. State Russian Museum, St Petersburg

Mullican Matt

Untitled (The Computer Project)

This large colour print is a plan of an imaginary city which Mullican created using the advanced technology of a computer-design company. A scale map of an area of 18 square kilometres (seven square miles), it covers recreational, business and residential areas. Fields, streets and furniture are all included. The work exists on computer, and each element can be highlighted on screen and blown up into further prints, or even realized as three-dimensional objects. Mullican has also made a video of a simulated high-speed car journey through the city which resembles an exhilarating arcade game. This virtual city is a manifestation of Mullican's desire to create a new world where history and cultural difference are brought together to form a universal language, accessible to all through technology. He has also developed a complex system of symbols fabricated from signs, logos and corporate emblems, which he incorporates into artworks using media such as posters, flags, stained glass and carpets.

☛ Bickerton, Boetti, Kruger, Rosenquist

Matt Mullican. b Santa Monica, CA (USA), 1951.
Untitled (The Computer Project). 1989. Ink-jet print. h167.6 x w457.2 cm. h66 x w180 in. Collection of the artist

Munch Edvard

The Dance of Life

Couples dance in a green field by the coast, while two women look on. The two figures in the background on the left seem to be dancing ecstatically, while the couple in the centre appear to have stopped and are looking at each other intently. Munch based this painting on midsummer celebrations at Asgardstrand in his native Norway. The woman in white, who looks like the artist's girlfriend Tulle Larson, symbolizes virginity, the woman in red stands for carnal knowledge and the figure in black, gazing jealously at the dancers, represents old age. The distorted outlines and the symbolic use of colour in this work are typical of Munch and are exemplified most famously by his work *The Scream*. It is widely held that his style gave rise to Expressionism in Europe. This painting forms part of a series called 'The Frieze of Life', which Munch began while staying in Paris after an unhappy first love affair and the death of his father. A talented printmaker as well as a painter, Munch was one of the pioneers of modern art.

☛ **Gauguin, Matisse, Nadelman, Nolde, Rego**

Edvard Munch. b Lote (NOR), 1863. **d** Oslo (NOR), 1944.
The Dance of Life. 1899–1900. Oil on canvas. **h**125.5 x **w**190.5 cm. **h**49½ x **w**75 in. Nasjonalgalleriet, Oslo

Muñoz Juan

Wasteland

A forlorn bronze figure perches on a low, wall-mounted shelf. The floor, composed of a repeated pattern of illusionistic, geometrical shapes stretches like a wasteland towards the seated figure, creating a stage on which the viewer becomes an uneasy participant. On approaching the mute, withdrawn figure, it becomes apparent that it is a ventriloquist's dummy. Sinister and isolated, the dummy seems to represent a lapse or failure in communication. Though the different elements are perfectly balanced, the hallucinatory floor and the dramatic arrangement create a strange imbalance, like fragmented memories occurring in the space of a dream. In other works, Muñoz's cast of characters includes lonely dwarves, ballerinas and figures wearing dunce's caps. Though pervaded by melancholy, Muñoz's work, he has said, 'is not about nostalgia; it is more to do with the unbearable'.

☞ Gober, Marisol, Riley, Vasarely

Juan Muñoz. b Madrid (SP), 1954.

Wasteland. 1986. Papier mâché, paint and rubber. Dimensions variable. Private collection

Murakami Saburo

Sky

A man sits in a tent-like structure erected in Ashiya Park in Japan as part of a large, outdoor exhibition. Visitors were encouraged to enter and gaze up at a framed section of sky through the tapered hole at the top of the tent. Lying on the ground, looking up through the void, the viewer is cut off from any visual distractions, making it easier to concentrate on the luminous and ever changing subject above. *Sky* was included in an exhibition organized by the Gutai Group, an influential collection of artists who staged large-scale performances and multimedia environments in response to the reactionary artistic context of post-war Japan. Murakami was a prominent member of the group, and many of his performances involved feats of endurance. At the first Gutai exhibition in 1955, he flung himself through successive layers of gold-coloured paper screens until he collapsed exhausted. These Happenings signalled a massive departure from conventional approaches to art, and predate the emergence of similar events elsewhere by several years.

☞ **Acconci, Burden, Ono, Shiraga**

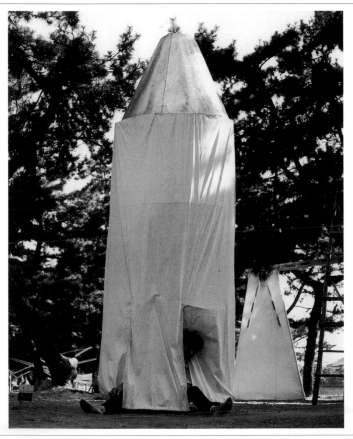

Saburo Murakami. b Kobe (JAP), 1925. d Nishinomiya (JAP), 1996.

Sky. 1956. Photograph of a performance at the second Gutai open-air exhibition, Ashiya Park, Japan

Nadelman Elie

Tango

Caught in mid-step, a stylish couple dances the tango, their mouths pursed in concentration. Dressed in formal attire, the man and woman are the epitome of elegance. This striking sculpture, made by the Polish-born Nadelman, perhaps pokes fun at the wooden stiffness of American high society. Born in Poland, Nadelman moved to Paris in 1903, where he encountered Picasso and Cubism. He subsequently moved to New York, where he quickly established himself as a popular sculptor of portrait busts. He made many sculptures of human and animal figures, circus performers and dancers. In the 1930s his career suffered a serious and lasting setback with the onset of the Great Depression in America. During this period he lost his money and much of his work was inadvertently destroyed by workmen. Nadelman's work was exhibited by the photographer Alfred Stieglitz in his famous 291 Gallery.

☛ Funakoshi, Gargallo, Jones, Matisse, Munch, Picasso, Segal

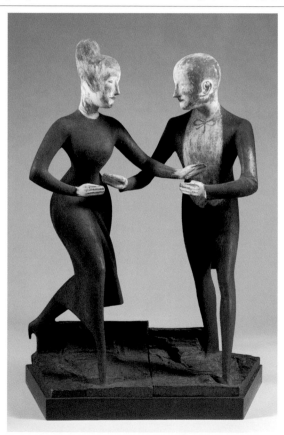

Elie Nadelman. **b** Warsaw (POL), 1882. **d** New York (USA), 1946.
Tango. 1919. Painted cherry wood and gesso. **h**91.1 cm. **h**35⅞ in. Whitney Museum of American Art, New York

Nash Paul

Landscape from a Dream

The Dorset coast is the setting for this dream sequence in which a hawk-like bird, a mirror, a sphere and a screen, are juxtaposed to create a strange scenario. The sky behind the mirror is a deep blue colour, while its reflection is an angry red. This unsettling discrepancy gives the work an air of foreboding, perhaps reflecting Nash's awareness of the impending war. The circling bird reflected in the mirror may represent the transcendent power of art. Nash was an official war artist in both World Wars and produced some of the most powerful and direct images of life in the trenches. As a result of his experience in the First World War, his work evolved from somewhat whimsical and lyrical landscapes into the spiky, unsettling style of his maturity. Nash tended towards the visionary and the imaginative, and it is no surprise that he was influenced by the dream fantasies of Surrealism, although he claimed, 'I did not find Surrealism, Surrealism found me.' As well as painting, Nash also designed and illustrated books.

☞ **De Chirico, Dali, Magritte, Tanguy, Wadsworth**

Paul Nash. b London (GB), 1889. **d** Boscombe (GB), 1946.
Landscape from a Dream. 1936–8. Oil on canvas. **h**67.9 x **w**101.6 cm. **h**26¾ x **w**40 in. Tate Gallery, London

Nauman Bruce

Window or Wall Sign

This spiralling neon light resembles a shop sign, and in its original context in the plate glass window of the artist's New York studio might have received little attention. On closer inspection, however, it reveals a personal statement about the role of the artist in society. By using the techniques of advertising, Nauman allies himself with Pop Art, but in his hands this method of mass communication conveys an unexpectedly profound message. His use of light as a medium is similar to the sculpture of Flavin. Charged with personal and social commentary, Nauman's large-scale projects involving tunnels and chambers of space and light refer to ominous visions of confinement and limitation. Preoccupied with the physical boundaries of the self, he has experimented with materials such as fibreglass, latex and wax as extensions of his own body. Nauman's extremely influential œuvre also covers sculpture, film and installation.

☛ Flavin, Holzer, Kruger, Merz, Turrell

Bruce Nauman. **b** Fort Wayne, IN (USA), 1941.

Window or Wall Sign. 1967. Blue and peach neon tubing. **h**139.7 x **w**149.9 x **l**5.1 cm. **h**55 x **w**59 x **l**2 in. Leo Castelli Gallery, New York

Neel Alice

Last Sickness

A forlorn and weary looking white-haired old woman, dressed in a checked dressing-gown, stares out of the canvas with a mixture of pride and resignation. This direct and emotive portrait is of Neel's mother who had been ill for a long time and had only a few months to live. Neel cared for her mother throughout her illness and was initially reluctant to exhibit this very personal portrait. Indeed, much of Neel's work exhibits a touching intimacy with her subject. Born in Pennsylvania, Neel spent most of her life in New York where she painted a wide range of portraits from society figures to members of the Spanish Harlem community. She came from a very ordinary background, and was forced to take a job as a civil servant in order to support her family, while she studied art at evening classes, pursuing her ambition to be a painter. Her realistic style, which is peculiarly American in its tough starkness, reflects the hardships of life and urban living.

☛ **Lipchitz, Schlemmer, Soutine, Weight**

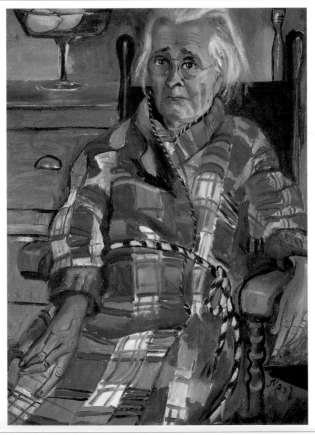

Alice Neel. **b** Merion Square, PA (USA), 1900. **d** New York (USA), 1984.
Last Sickness. 1953. Oil on canvas. **h**76.2 x **w**55.8 cm. **h**30 x **w**22 in. Estate of the artist

Nevelson Louise

Royal Tide V

Like finds from an archaeological excavation, a selection of whole and fragmented objects is assembled and displayed in crates which have been upended and fixed together to form a wall-sized unit. Unifying discarded, disparate elements found on the streets by painting them a single colour – in this instance gold, a colour synonymous with value – Nevelson draws attention to their shapes and forms. Despite the banality of the content, the totem-like structure has a haunting presence and luxuriance reminiscent of an elaborate relief or a gleaming office building. Though she uses found objects in her work, Nevelson's assemblages are closer to contemporary abstract sculpture than to simple ready-mades. Born in Russia, she moved to the United States when she was a child and later studied with Hofmann and Rivera. Though never affiliated to any particular movement, Nevelson is one of the most respected American sculptors of the post-war period.

☛ César, Chamberlain, Cornell, Gottlieb, D Smith

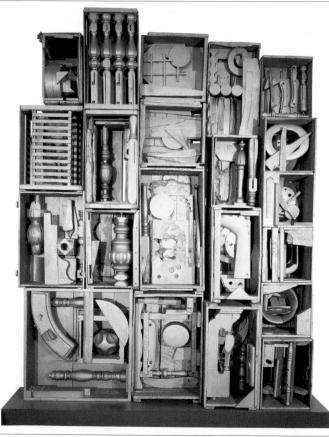

Louise Nevelson. b Kiev (RUS), 1899. d New York (USA), 1988.
Royal Tide V. 1960. Painted wood. h255 x w198 x l34 cm. h100½ x w78 x l13½ in. Private collection

Newman Barnett

Onement III

A broken line of bright red paint runs down the centre of the maroon coloured canvas, splitting the picture into two parts. One of a series of similar works, this painting has an elegant simplicity. Newman referred to these works as his 'zip paintings'. The austerity of the image and the visual intensity of the single line create a unity of opposites, while the abstract shapes and colours impart a sense of mysticism. Newman often gave his works evocative and sometimes biblical titles, reinforcing the theme of spirituality that runs throughout his *œuvre*.

Although associated with the Abstract Expressionists, Newman's pared-down style sets him apart from their more gestural approach. Born in New York to Polish Jewish immigrants, Newman worked in his father's clothing factory before turning to painting full time. A lecturer, critic and theorist, he also produced a number of large steel sculptures that echo his use of a single line in space.

☞ **Avery, Förg, Rothko, Still**

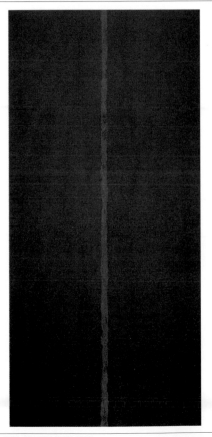

Barnett Newman. b New York (USA), 1905. **d** New York (USA), 1970.
Onement III. 1949. Oil on canvas. **h**182.5 x **w**84.9 cm. **h**71⅞ x **w**33½ in. Museum of Modern Art, New York

Nhlengethwa Sam

It Left him Cold – The Death of Steve Biko

The death of Steve Biko is depicted in stark, cold colours. Biko was the leader of the South African anti-apartheid Black Consciousness movement, and was a living symbol of the struggle against white supremacy. He died in suspicious circumstances in police custody and is shown here beaten and bruised in an interrogation chamber or cell, watched over by a police officer. His eyes are closed and his torso rigid. The collaged fragments of his body represent a man literally broken into pieces. The pencil and charcoal drawing of the room and the area beyond the door is crude and raw, suggesting the base nature of his killers, while the title may suggest that the officers felt no remorse for what they had done. Nhlengethwa is one of several South African artists who have used their art to comment and inform on the oppressive conditions under which they and other black South Africans lived during apartheid.

☞ **Heartfield, Howson, Oiticica, Samba**

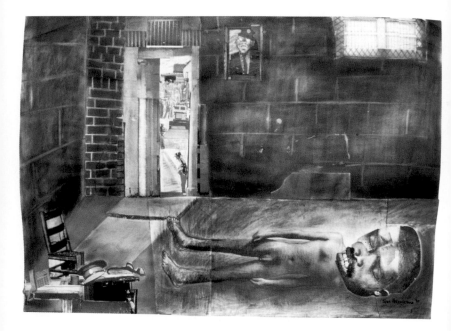

Sam Nhlengethwa. b Payneville (SA), 1955.
It Left him Cold ... 1990. Collage, pencil and charcoal on paper. **h**69 x **w**93 cm. **h**27⅛ x **w**36⅔ in.
Standard Bank Collection, Witwatersrand University Art Galleries, Johannesburg

Nicholson Ben

February 1956 (Granite)

Three angular shapes, linked together by horizontal pencil lines, are placed next to each other and overlap other forms beneath. Each element appears totally natural, as if it has been formed by nature and hewn from the earth's crust, rather than having been shaped, painted and placed in this wooden frame. Nicholson has painstakingly cut and glued different shapes and thicknesses of board to a larger backboard. The shapes have been painted and the paint has been scraped away in places, to make the work look weathered, as if eroded by time. Once he had finished it, it reminded him of granite, hence the title. It is acknowledged that Nicholson has had a greater influence on the development of abstract art than any other British artist. His subtle and delicate reliefs and semi-abstract still lifes and landscapes forged a crucial link between British art and the Cubist-Constructivism of Continental Europe. This connection was reinforced by his move to Switzerland, where he lived for 13 years between 1958 and 1971.

☛ Braque, Hélion, Hepworth, Mangold, Mondrian

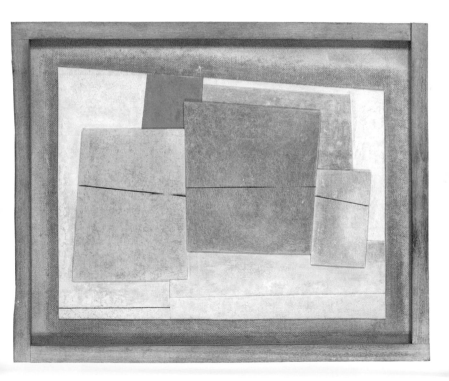

Ben Nicholson. b Denham (GB), 1894. **d** London (GB), 1982.
February 1956 (Granite). Oil and pencil on carved board. **h**50 x **w**62 cm. **h**19¾ x **w**24⅜ in. Private collection

Nitsch Hermann

80th Action

Blindfolded and dressed in a white, blood-stained shift, a man hangs from a crucifix attached to a carcass. A typical Nitsch 'ceremony', *80th Action* was a lengthy, visceral performance involving the slaughter of animals and the smearing of entrails onto naked flesh. Highly choreographed and lasting over three days, the process of disembowelling was meant as a gradual coming to terms with death and destruction, drawing attention to man's innate cruelty in a deliberately shocking manner. In 1957, Nitsch founded the group Orgien-Mysterien-

Theater, an extreme live theatre group which could deal in the most direct way possible with the issues he wished to address. Nitsch was one of the Viennese Actionists who worked in Austria during the 1960s. They were of a generation that was only just coming to terms with the horrors of the Second World War, and many of their performances could be interpreted as attempts to purge themselves of guilt through sacrifice.

☛ Artaud, Burden, Guttuso, Howson, Pane

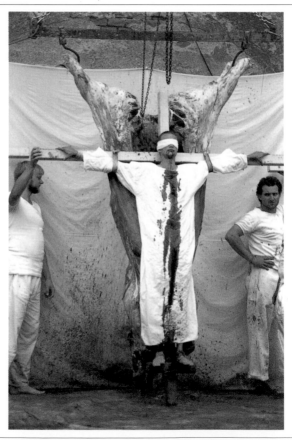

Hermann Nitsch. b Vienna (AUS), 1938.
80th Action. 1984. Photograph of a performance at Prinzendorf, Austria

Noguchi Isamu

Cloud Mountain

Galvanized steel, normally associated with industrial production, is transformed into a beautiful, poetic sculpture. The three elements resemble a solid mountain range, while the lightness of handling suggests floating clouds, hence the title. The mixture of the organic and the geometric is characteristic of Noguchi's work. A Japanese-American, Noguchi combined his Western, Modernist art training with traditional Japanese beliefs, arguing that sculpture was 'the perception of space, the continuum of our existence'. As a result, he felt at home 'everywhere and nowhere', a state of mind that brought about an interesting duality in his work which fused East and West and incorporated the early influences of Brancusi, Zen, Surrealist sculpture and Japanese calligraphy. A prolific artist, he underwent many stylistic changes over his long career. As well as sculpture, he also produced furniture and was a designer of gardens and interiors.

☛ Brancusi, Calder, Caro, D Smith

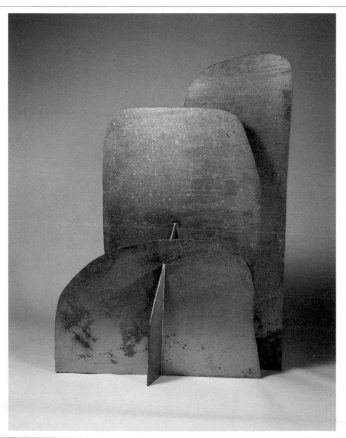

Isamu Noguchi. b Los Angeles, CA (USA), 1904. **d** New York (USA), 1988.

Cloud Mountain. 1983. Galvanized steel. **h**177 x **w**125 x **l**72 cm. **h**69¾ x **w**49¼ x **l**28¼ in. National Gallery of Art, Washington, DC

Nolan Sidney

Glenrowan

A semi-abstract figure with a square head holds up a
long club. His face is a combination of abstract shapes
and partially visible features, such as the right eye,
nose, moustache and mouth. In the background, a
simple hut stands against a deep blue outback sky.
Based on the legendary figure of Ned Kelly, an Irish-born
Australian outlaw, the painting depicts the Australian
village of Glenrowan where Kelly took his last stand.
The black square round the figure's head represents his
famous helmet. The semi-naïve style, humorous despite

the historical subject matter, is characteristic of Nolan's
output. He made many paintings on the life and times of
Ned Kelly over numerous years. According to the artist
himself, the Kelly paintings are in fact hidden self-
portraits, perhaps reflecting a rebellious streak. Nolan
often painted the landscape of the Australian outback,
with its harsh light and vast open spaces.

☛ Boyd, Motherwell, Nash, Siqueiros

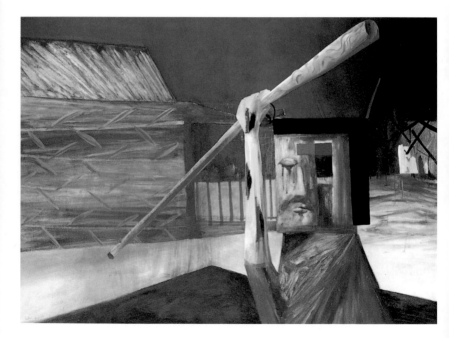

Sidney Nolan. b Melbourne (ASL), 1917. **d** London (GB), 1992.

Glenrowan. 1956–7. Ripolin on hardboard. **h**91.4 x **w**121.9 cm. **h**36 x **w**48 in. Tate Gallery, London

Noland Cady

Deep Social Space

A number of objects are incorporated into this installation, draped over, or suspended from two metal bars. In the bottom left-hand corner is a horse gate, in the middle is the lid of a barbecue and in the background on the left are the American flag and a red-checked table-cloth. These are all objects which represent the lifestyle of leisured America – horseriding, barbecuing and picnicking. Silk-screened on metal sheets leaning against the wall are images of media icons including Patti Hearst, the million-aire's daughter who was kidnapped for ransom, joined the terrorists who held her hostage, but subsequently reverted to a life as a rich socialite. The handcuffs may relate to her abduction. There is a feeling of impotence and waste created by the sparse arrangement of objects, while the small American flag, hanging limply over the railing, adds to the atmosphere of a fragmented society. Noland's work frequently explores the contradictions of success and failure which make up the American Dream.

☞ Barney, Beuys, Green, Tiravanija

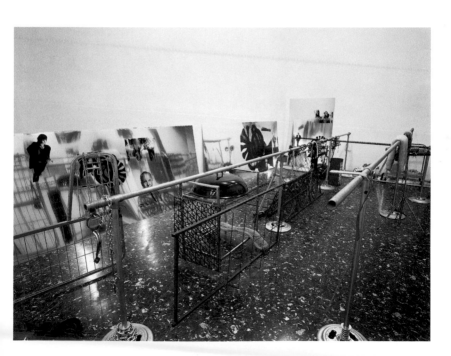

Cady Noland. **b** Washington, DC (USA), 1956.
Deep Social Space. 1989. Metal poles, riding equipment, barbecue, chains and printed metal sheets. **h**1.2 x **w**4.6 x **l**1.5 m. **h**4 x **w**15 x **l**5 ft.
Galleria Massimo de Carlo, Milan

Noland Kenneth

Another Time

On a diamond-shaped canvas, a series of parallel lines of orange, peach, white and yellow are set against a pea-green background. The simple colours and the geometric composition have been deliberately purged of any symbolic reference or realistic subject matter. The cool detachment of this work and the artist's lack of emotional involvement with his subject is typical of Post-Painterly Abstraction. Noland rejected the work of the Abstract Expressionists, dominant at that time, finding it 'too personal'. Instead, he often left some areas of the canvas bare, while others he stained with acrylic pigment in order to avoid any trace of painterly brushstrokes. A pupil of Albers at Black Mountain College, Noland is also known for his paintings of different sized circles. Although there are similarities between the two artists, Albers used geometric abstraction to explore the illusion of depth and movement while Noland uses circles and lines to emphasize the flatness of the picture plane.

☞ **Albers, Bill, Van Doesburg, Frankenthaler, Louis**

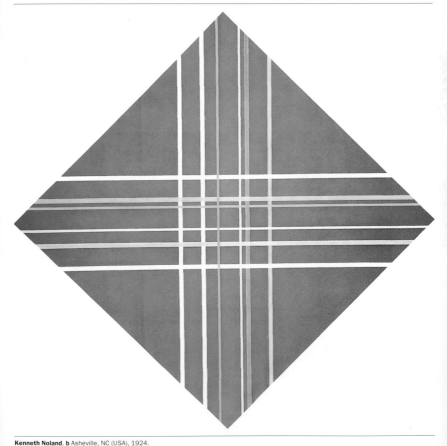

Kenneth Noland. b Asheville, NC (USA), 1924.
Another Time. 1973. Acrylic on canvas. **h**183 x **w**183 cm. **h**72 x **w**72 in. National Gallery of Art, Washington, DC

Nolde Emil

Sea and Light Clouds

This brooding, tormented seascape, painted with a subdued violence in rich ochres and darkest blues, was one of a large series of paintings made of the ocean by the German Expressionist Nolde. Born in a seaside town, Nolde was fascinated by the sea from earliest childhood. In 1910, he made a sea crossing in a terrible storm. It made a lasting impression, which he sought endlessly to recapture on canvas. Most of his works are a spiritual response to the forces of nature, though he also made many paintings of human figures. Nolde's major influences were Munch and Ensor. For a year he joined the group Die Brücke, founded in Dresden in 1905, and showed little inclination throughout his artistic career to depart from their fundamentally Expressionist style which combined exuberant colour and line. In common with these artists, much of Nolde's most powerful work was graphic art, some of it influenced by the Primitive sculpture he discovered on a trip to New Guinea.

☞ Avery, Ensor, Munch, Signac

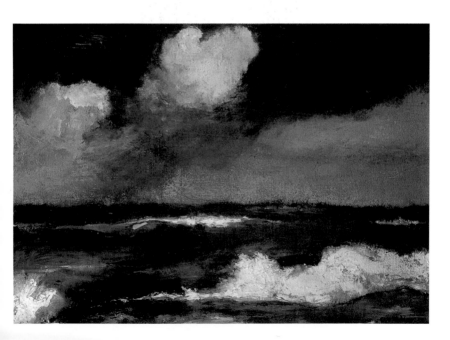

Emil Nolde. b Nolde (GER), 1867. d Seebüll (GER), 1956.
Sea and Light Clouds. c1935. Oil on canvas. h73 x w100.3 cm. h28¾ x w39½ in. Private collection

Nordman Maria

Washington and Beethoven

This composite photograph shows two views of the same room. The top picture shows the space from the inside, while the bottom one is taken from outside, with a passing car reflected in the glass doors. The room was situated on a Los Angeles street, and was encountered accidentally by passers-by who were free to enter 24 hours a day. Behind, were two further chambers, open during daylight hours. Acting as an extension to the everyday world of offices and shops, *Washington and Beethoven* presented an open forum where people could meet. Each visitor to the room became a part of it, bringing their own experiences to the work. The original proposal was that these spaces should remain indefinitely as part of the city, but in fact they existed only for a period of four months before the site reverted to its former use. In this respect, the notion of the permanence of art is raised by Nordman's work. Her work explores the concept of place and our reactions to the relationship between private and public spaces.

☞ **Graham, Laib, Oldenburg, Phaophanit**

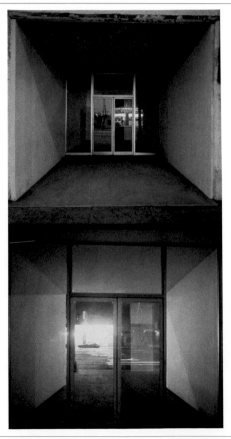

Maria Nordman. **b** Görlitz (GER), 1943.

Washington and Beethoven. 1979. Rooms, glass and drywall. Dimensions unknown. As installed in Los Angeles, CA

Oiticica Hélio

Bólide 18, B – 331 (Homage to Cara de Cavalo)

The image of Cara de Cavalo, the murdered political activist, known personally to Oiticica, lines a small container. When opened, it reveals a text and a bag of red earth. As well as a homage to a dead friend, the piece is a tribute to social revolt and a metaphorical comment on the disparity between the personal and public, the internal and external. Regarded as the most influential Brazilian artist, Oiticica is also known for his interactive works. His early, multicoloured reliefs were hung so that the viewer could walk among them, a theme developed further in environments, such as *Eden* and *Tropicalia*, which were full-scale assaults on the senses, in which the viewer, illuminated by coloured lights, mingled with flora and fauna. *Cosmococa*, his most controversial installation, invited spectators to lie on sand covered with plastic sheeting and watch a slide projection in which lines of cocaine were arranged across an image of Marilyn Monroe.

☞ Cornell, Meireles, Nhlengethwa, C Noland

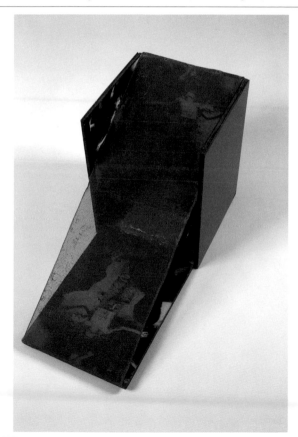

Hélio Oiticica. **b** Rio de Janeiro (BR), 1937. **d** New York (USA), 1980.
Bólide 18... 1967. Wood, photograph, fabric and plastic. **h**39 x **w**30 x **l**30 cm. **h**15⅓ x **w**11⅞ x **l**11⅞ in.
Museu de Arte Moderna, Rio de Janeiro

O'Keeffe Georgia

Jack-in-the-Pulpit No. IV

Rich blue and green forms melt into one another. Looking abstract on first sight, this work in fact depicts a flower. By cropping the image and confusing the sense of scale – techniques O'Keeffe learned from photography – she makes the flower appear as vast as a landscape. Focusing on its organic sensuality the artist saturates the painting with sexual imagery. This work reveals O'Keeffe's interest in depicting the abstract qualities of objects. One of the most important avant-garde painters in the United States before 1945, O'Keeffe assimilated the more radical tendencies in European art. She fused these with a more specifically American sensibility which has its roots in the vastness of the American landscape and in a desire to make art which can be universally understood. Flowers were a favourite subject, as were other natural forms such as mountains, rocks, bones and sunsets.

☞ Arp, Kandinsky, Louis, Morris

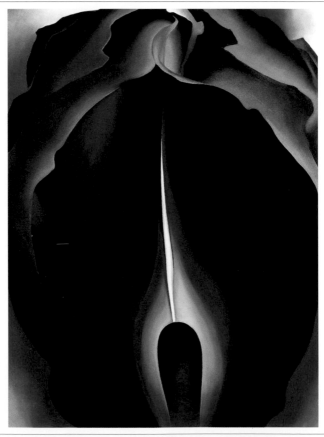

Georgia O'Keeffe. b Sun Prairie, WI (USA), 1887. **d** Santa Fe, NM (USA), 1986.
Jack-in-the-Pulpit No. IV. 1930. Oil on canvas. **h**102 x **w**76 cm. **h**40 x **w**30 in. National Gallery of Art, Washington, DC

Oldenburg Claes

Bedroom Ensemble

This recreation of a kitsch motel room looks realistic, but in fact the perspective has been subtly distorted so that, when seen close up, objects such as the bed seem to slide away from the viewer. By controlling the appearance of the scene, Oldenburg makes us question the nature of the everyday. He situates this ubiquitous motel room in a gallery, behind a cord, and thus glorifies it – raising it as an icon of modernity. Though this bedroom is not real, the purse and coat on the sofa give the impression that someone has just left. Oldenburg's trademark pieces are his 'soft sculptures' – structures made of material and stuffed with foam – which originated as props for performances in which he participated with Dine. Banal objects, such as hamburgers, were turned into absurdly large, functionless objects and public sculptures. A Swedish immigrant, Oldenburg is influenced by the consumer culture of the United States where he lives and works. This interest places him within the Pop Art movement.

☞ **Chicago, Dine, Kienholz, Warhol, West**

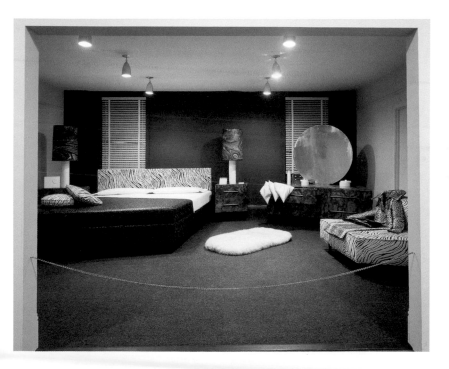

Claes Oldenburg. b Stockholm (SWE), 1929.

347

Bedroom Ensemble. 1963. Wood, vinyl, metal, artificial fur, cloth and paper. **h**300 x **w**650 x **l**524 cm. **h**118¼ x **w**256⅛ x **l**204⅞ in.

National Gallery of Canada, Ottawa

Olitski Jules

Green Jazz

A ring of cream coloured canvas has been left bare in the centre of the composition. On it float green, red and yellow amorphous forms. Engulfed by the deep blue that occupies the rest of the space in the picture, the juxtaposed colours give the work a vibrant appearance. Largely abandoning the traditional method of using a paint brush, Olitski has stained and sprayed the acrylic paint onto this canvas. This rejection of textural brushstrokes, and the interest in the visual sensation of colour is typical of a group of artists whose work was known as Post-

Painterly Abstraction. Olitski gradually moved towards this technique in the 1960s; his earlier works were paint-laden canvases executed in subdued colours. Born in Russia, Olitski went to art school in New York, going on to teach in America. As well as painting, he has also produced sculptures made from aluminium and sprayed with coloured paint.

☞ **Frankenthaler, Heron, Louis, K Noland, Pasmore**

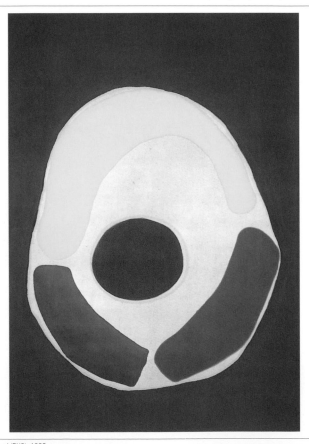

Jules Olitski. b Gomel (RUS), 1922.
Green Jazz. 1962. Oil and acrylic on canvas. **h**233.7 x **w**162.6 cm. **h**92 x **w**64 in. Private collection

Ono Yoko

Painting for the Wind

A bag filled with seeds is suspended in front of a cloth hung on a wall. The work comes with the instruction: 'Cut a hole in a bag filled with seeds of any kind and place the bag where there is wind'. This invitation to the viewer to participate in the work is typical of the Fluxus group, of which Ono was a prominent member. A loosely collected group of dancers, artists, film-makers and poets, their wide variety of work often involved some form of inter-action with the audience. Ono's art moves between the visual and performance, frequently having an element of chance, such as here, where the work incorporates the natural elements. Other works have involved burning a canvas, stepping on paint, or dripping water onto a surface. Like Dine and Oldenburg and members of the Japanese Gutai Group, Ono extends the boundaries of artistic practice. Married to Beatles star, John Lennon, with whom she collaborated on many performances, Ono has also made several films.

☞ Acconci, Hesse, Murakami, Shiraga

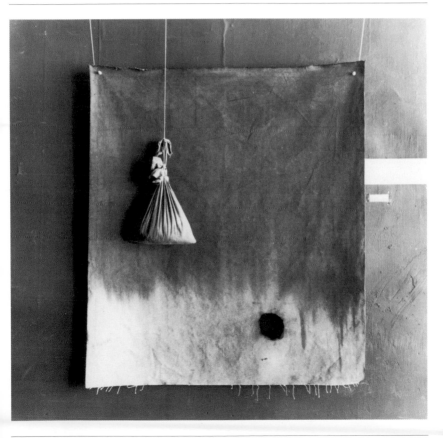

Yoko Ono. b Tokyo (JAP), 1933.
Painting for the Wind. 1961. Sumi ink on canvas, string, cloth, seeds and bamboo screen. **h**115 x **w**97 x l10 cm. **h**45½ x **w**38¼ x l3⅞ in.
As installed at the AG Gallery, New York

Opie Julian

Night Light 25/3333CB

A large white rectangular box glows with a soft, blue light and emits a low hum. Constructed from glass, plastic and fluorescent light, this work extends the boundaries of what we consider to be art. The use of machine-made parts, which remove the importance of the artist from the actual making of the artwork, is typical of Minimalism, a movement which pared down art to its bare essentials. In common with much of Opie's work, *Night Light* pays homage to the normally unnoticed objects of low-key industrial design: the cool, shiny, minimal aesthetic of refrigerated food displays and vending machines, and the furniture of public places such as airports, supermarkets, hospitals and office buildings. Though Opie has been linked to the New British Sculpture group, his use of industrial materials is close to the Minimalism of Judd and Morris and the early sculpture of Koons and Steinbach.

☞ Judd, Koons, LeWitt, Morris, Steinbach, Turrell

Julian Opie. b London (GB), 1958.
Night Light 25/3333CB. 1989. Wood, glass, rubber, aluminium, cellulose paint, fluorescent light and plastic. h186 cm. h73¼ in.
Private collection

Oppenheim Meret

My Nurse

A pair of trussed-up, high-heeled shoes lies face down on a silver platter. Miniature chefs' hats, usually found decorating cuts of meat, have been placed over the heels. Fetishistic and bizarre, this work suggests bondage and sexual domination. Using real found objects, the artist has removed the dimension of craft and apparent artistry from this sculpture, thereby rendering it disturbingly realistic and subversive. The unusual juxtaposition of objects is typical of Surrealism. One of the few female Surrealists, Oppenheim often alludes in her paintings and sculptures to the experience of being a woman, investigating, as in this work, the fine line between female sexuality and being the object of male desire. Responsible for some of the most enduring Surrealist images, such as her erotically charged teacup and saucer made of fur, and an X-ray self-portait in which only her skeleton and jewellery are visible, Oppenheim specialized in such unnerving imagery.

☞ Barney, Bourgeois, Duchamp, Horn

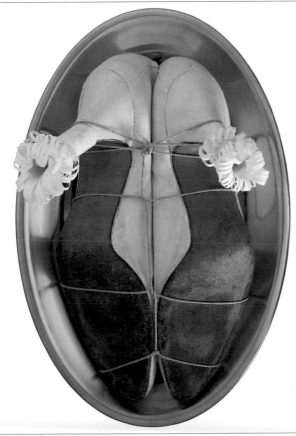

Meret Oppenheim. b Berlin (GER), 1913. **d** Basel (SW), 1985.
My Nurse. 1936. Metal, paper, shoes and string. **h**14 x **w**21 x **l**33 cm. **h**5½ x **w**8¼ x **l**13 in. Moderna Museet, Stockholm

Organ Bryan

Elton John

The singer and songwriter Elton John, wearing a T-shirt emblazoned with the face of Marilyn Monroe and his trademark, flamboyant glasses, confronts the spectator. With one hand casually in his pocket and the other placed against the wall, John is the picture of the relaxed and successful pop star. The image of Marilyn on his shirt refers to his hit single 'Candle in the Wind', which was written as a tribute to the screen idol. Painted in acrylic in a meticulous, realistic style, this portrait makes us forget that we are looking at a painting, and not the man himself.

Influenced by Sutherland's searing portraits, Organ often isolates his subject, reducing the background to an empty, minimal environment. Organ is one of the world's leading portraitists, painting many prominent personalities, including members of the British royal family such as Prince Philip, the Prince of Wales and Princess Diana (a work which was vandalized in 1981), as well as leading political figures from around the world.

☞ Hamilton, Hartley, Hockney, Rotella, Sutherland

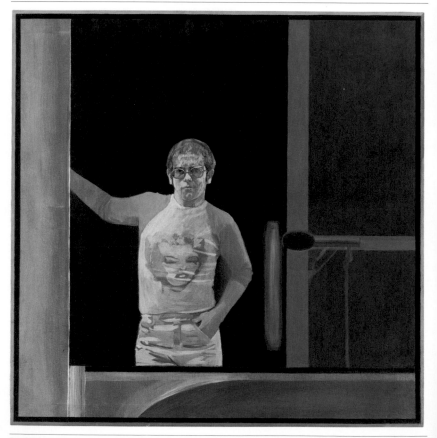

Bryan Organ. b Leicester (GB), 1935.
Elton John. 1973. Acrylic on canvas. **h**152.4 x **w**152.4 cm. **h**60 x **w**60 in. Private collection

Orozco Gabriel

Sleeping Leaves

A sleeping bag has been partly opened to reveal a row of overlapping palm fronds. By juxtaposing these two objects which we would not normally place together, Orozco makes us think of the leaves as a person sleeping. The idea of sleep is important to Orozco, reflecting the way in which he perceives the world to be full of dormant sculptures waiting to be brought into being. He creates ephemeral and inventive sculptures from found objects, frequently leaving them as he finds them. He is usually the only person to see his artworks. The presentation of his work therefore often takes the form of photographs, which have included ripples in a pool of water, a puddle with a circular pattern of bicycle tyre tracks, and a deserted Mexican market with a single lemon placed on each rickety, wooden stall. He has also rearranged goods on supermarket shelves and rolled a large plasticine ball through the streets of New York, collecting the city's rubbish.

☞ Baumgarten, Goldsworthy, McCarthy, Mendieta, Paik

Gabriel Orozco. b Veracruz (MEX), 1962.
Sleeping Leaves. 1990. Cibachrome. **h**31.8 x **w**47.3 cm. **h**12½ x **w**18⅝ in. Private collection

Orozco José Clemente

Table of Universal Brotherhood

A group of men, drawn from all over the world, sit around a monumental table. They represent the brotherhood of man, yet there seems to be very little communication between them. Instead the atmosphere is one of serious contemplation. The significance of the open book, its pages blank and unmarked, is not immediately clear but perhaps it is the starting-point for a discussion, for a rewriting of history. A keen activist, Orozco used his work to express his political views. This fresco, which was painted for the walls of a progressive academic institution then recently established in New York, seems to be using the theme of universal brotherhood as a metaphor for the League of Nations. At the time he painted this starkly realist work, that organization was ingloriously failing to stem the rising tide of totalitarianism and war throughout the world. Orozco worked periodically in the United States between 1917 and 1934 and undertook several commissions for public buildings.

☛ Heartfield, Kahlo, Rivera, Siqueiros

José Clemente Orozco. b Zapotlán (MEX), 1883. **d** Mexico City (MEX), 1949.
Table of Universal Brotherhood. 1930–1. Fresco. **h**195.6 x **w**424.2cm. **h**77 x **w**167 in. New School for Social Research, New York

Ozenfant Amédée

Smoking Room: Still Life

A slender clay pipe, issuing forth a billowing cloud of dark smoke, lies to one side of two white bowls, one of them placed inside the other. The smoke curves and blends into the swirling, fiery background behind. The objects form a deliberate, simplified composition of considerable grace. The contrast between the simple white bowls and the black vortex of smoke and the relative positions of each item has been carefully considered. Ozenfant's use of sinuous curving forms in this work is unique but his paring down of the various

elements is typical of Purism, a movement of which he was a founder member. This painting is one of a series of still lifes dating from the 1920s which show his gradual transition away from a more decorative style towards the clearcut forms of Purism. A co-author with the architect Le Corbusier of the Purist manifesto *After Cubism*, Ozenfant advocated an architecturally simple art, which focused on real objects and adhered to the functional principles of the machine.

☛ **Arikha, Cornell, Le Corbusier, Morandi, Polke**

Amédée Ozenfant. **b** Saint-Quentin (FR), 1886. **d** Cannes (FR), 1966.
Smoking Room: Still Life. c1923. Oil on canvas. **h**73 x **w**60.3 cm. **h**28¾ x **w**23¾ in. Private collection

Paik Nam June

TV Garden

Planted amid living vegetation, randomly placed TV sets emit a familiar yet unnatural glare, their upturned screens blooming like alien flowers. Of particular relevance to this work is Paik's famous statement: 'TV has attacked us all our lives; now we're hitting back.' This installation confronts the dominance of an all-pervasive medium. Due to the technological advances of the 1960s and 1970s, artists have increasingly used TV and video in their work. Paik is one of the most significant figures in the evolution of Video Art. Not only concentrating on the complex images transmitted on screen, Paik's installations often include an interactive element. Reflecting his association with Fluxus – the anarchic association of multimedia artists who rebelled against traditional art forms – collaboration has played a vital role in his work. In 1963, at Paik's first exhibition to include TV, Beuys gave an impromptu performance. Later Paik constructed a remote-controlled robot, K-456, and became involved in Performance Art.

☛ **Beuys, Hill, Hiller, McCarthy, Masson, Viola**

Nam June Paik. b Seoul (KOR), 1932.

TV Garden. 1974–8. Television monitors and live plants. Dimensions variable. Collection of the artist

Pane Gina

Psyche

In this painful image blood runs from a razor-cut in the artist's stomach. It is taken from a performance in which the artist applied make-up while cutting parts of her body and face with a blade as she sat in front of a mirror. Throughout the grizzly display, her impassive stare increased her detachment. Excruciating, both to herself and for her audience to watch, Pane's art addressed the anaesthetization of a society numbed by the violence in everyday life. During the 1970s, Pane was the star of Body Art, a phenomenon that used the body itself as its primary material. 'One has to understand "My Body in Action" not as the skin of a painting enclosing its interior but as a WRAPPING/UNFOLDING bringing back depth to the edge of things,' said Pane. In her extreme acts of self-mutilation, Pane equated masquerade with masochism, questioning the relationship between vulnerability and violence. Like other feminist art, her work also explored the sexual stereotypes of female passivity and male aggression.

☛ **Burden, Howson, Nitsch, Schneemann, Wilke**

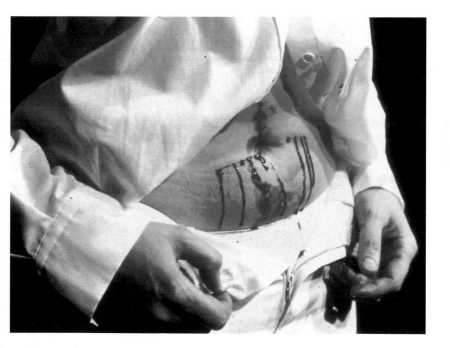

Gina Pane. **b** Biarritz (FR), 1939. **d** Paris (FR), 1990.
Psyche. 1974. Photograph of a performance at the Galerie Stadler, Paris

Paolozzi Eduardo

I Was a Rich Man's Plaything

The image of a fleshy, stocking-clad, smiling brunette forms the centrepiece of this colourful collage. Paolozzi took the illustration from the cover of *Intimate Confessions*, a 1940s women's magazine, and added a selection of items which epitomized contemporary American culture: a Coca-Cola bottle, a bomber, a cherry pie and a gun firing the word 'Pop'. During the 1940s, Paolozzi collected scraps of newspaper, images from magazines and printed ephemera, and began to create collages such as this which rely on unlikely juxtapositions of images, most of them taken from the fantasy world of American consumer culture. A founding member of the London-based Independent Group, Paolozzi was instrumental in introducing Pop Art into Britain. The landmark Independent Group exhibition, prophetically entitled *This is Tomorrow*, was held at the Whitechapel Art Gallery in London in 1956 and displayed many of the staples of the Pop Art movement, taking contemporary life as its subject matter.

☛ **Hamilton, Rosenquist, Rotella, Schwitters, Warhol**

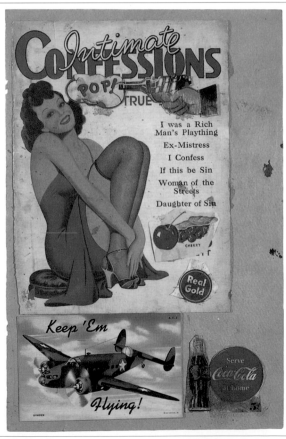

Eduardo Paolozzi. **b** Edinburgh (GB), 1924.
I Was a Rich Man's Plaything. 1947. Mixed media. **h**36 x **w**23 cm. **h**14⅛ x **w**9 in. Tate Gallery, London

Pasmore Victor

Wandering Journey

Amorphous, hazy green shapes crowd onto the canvas, producing an interlocking mosaic of monochromatic colour, which is only occasionally interrupted by blue, red and yellow dots and a black line. Like a maze seen from above, or a primitive map, the painting seems to represent a wandering path which has no obvious point of departure or arrival but meanders peacefully through a calm green landscape. The natural environment, and particularly the Cornish countryside, had a profound impact on Pasmore's art, as did the work of earlier

British artists such as John Constable and J M W Turner. Light, which glows from this canvas, remained the principal concern in his celebratory works. Largely self-taught, Pasmore began as an abstract artist, turned to figuration and then returned to abstraction. In the early 1950s, he exhibited with Hepworth and Nicholson and later went on to produce reliefs which were similar to the geometric abstractions of the Constructivists.

☛ Hepworth, Heron, Nicholson, Olitski

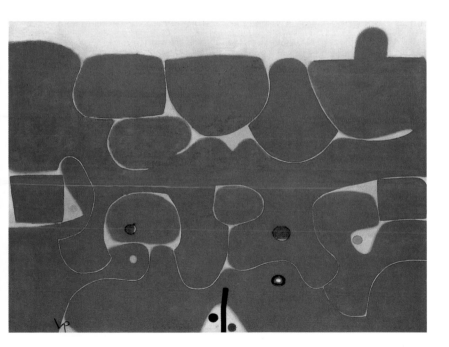

Victor Pasmore. b Chelsham (GB), 1908. d Malta (MAL), 1998.
Wandering Journey. 1983. Oil on canvas. h114.3 x w150.2 cm. h45 x w59⅛ in. Marlborough Fine Art, London

Pechstein Max

Tale of the Sea

A woman in a scarlet dress leans forward to talk to a young girl who has her back to the viewer, while another woman looks on. The title of the work suggests that she is telling a story about adventures at sea. Pechstein uses strong black outlines and dramatic, contrasting colours, setting the red of the dress against the green and blue of the sea. Colour and line were central to Pechstein's work and link him to the group of German Expressionists known as Die Brücke. Pechstein was the only member of the group to have had a formal art training. Often painting nude figures in landscape settings, he sought to evoke a sense of man in harmony with nature. Pechstein's work developed principally under the influence of Matisse and Vincent van Gogh, but by the time he made this painting, he had become interested in Primitive art, a source of inspiration that is reflected in the mask-like angularity and wide eyes of the woman's face.

☛ Heckel, Kirchner, Matisse, Modersohn-Becker

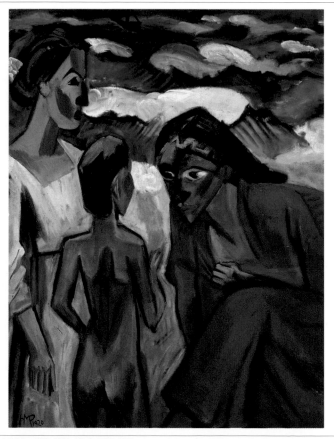

Max Pechstein. b Zwickau (GER), 1881. d Berlin (GER), 1955.
Tale of the Sea. 1920. Oil on canvas. **h**120 x **w**90.5 cm. **h**47¼ x **w**35⅔ in. Private collection

Penck A R

System-Painting-End

The dark forms of a snake and a winged creature loom menacingly over a turbulent scene which is littered with graffiti-like signs. The band of fleeing stick figures and the variations of scale and pace suggest an unstable territory, perhaps in the throes of a bitter conflict. Penck was born Ralf Winkler in Germany during the Second World War and grew up in a divided and defeated nation. The sense of fear and threat in this work reflects that background and expresses the artist's feelings of troubled uncertainty. His rise to fame was fuelled by a renewed interest in figurative painting – a reaction to the detached abstraction of Minimalism. Although his eclectic blend of primitive symbols, gestural brushwork and political subject matter is typical of Neo-Expressionism, Penck does not consider himself part of that movement. Rather, he likens his studies to those of a social scientist, creating various means of expressing the confrontations and failings in today's society and the way in which it differs from the past.

☛ Basquiat, Gottlieb, Haring, Spero

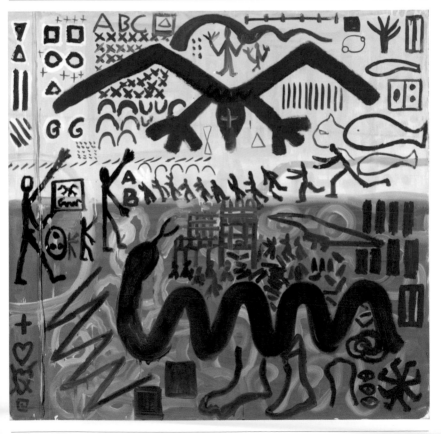

A R Penck (Ralf Winkler). **b** Dresden (GER), 1939.

System-Painting-End. 1969. Acrylic on canvas. **h**145 x **w**150 cm. **h**57 x **w**59 in. Private collection

Penone Giuseppe

Helicoidal Tree

Carved in the twisting shape of a helix, Penone's 'tree' emerges from a length of wood as though it has been discovered fossilized inside it. Each branch and shoot has been carefully left in place, for this work is an act of reclamation, an attempt to discover the natural shape of the tree within the man-made form. Penone is a member of Arte Povera, a movement which dominated the Italian art scene in the 1960s and concentrated on everyday materials and natural elements. As in this work, he uses wood to explore the central theme of the relationship between man and his environment. By digging through the growth rings of the wood, and gradually peeling away the surface layers, he appears to have exposed the skeleton of the tree within. In the same way, Penone has made a number of works in which he demonstrates the similarities between eye, leaf and tree forms. He has more recently made drawings which combine the growth rings of a tree with the enlarged whorls of his own fingerprint.

☛ Brancusi, Cragg, Knizak, Merz

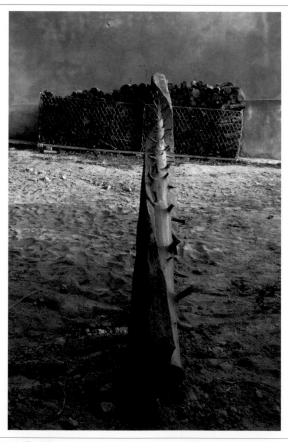

Giuseppe Penone. b Garessio (IT), 1947.
Helicoidal Tree. 1988. Wood. h30 x w30 x l800 cm. h11⅞ x w11⅞ x l315⅛ in. Fondo Rivetti per l'Arte, Turin

Pepper Beverly

Thel

A sweep of lawn appears to buckle as if to internal pressure, generating this pyramidal form. At its peak, one surface of the turfed structure opens to reveal an inner construction of white metal mesh, contrasting with the surrounding grass. Like most of this American sculptor's work, *Thel* is integral to its environment and was made specifically for this setting while significantly altering it. In contrast, however, to much abstract sculpture, Pepper's work is also emotionally charged and explores what she has termed 'an interior life of feeling'.

The title *Thel* comes from *The Book of Thel*, a poem by the eighteenth-century poet and painter William Blake. Pepper's sculpture, which has varied from her ribbon-like steel structures of the 1960s to her 'Amphisculptures' of the mid-1970s – circular, concrete structures recalling Roman amphitheatres – prompts the viewer to experience an ordinary outdoor setting as an unexpected, unpredictable environment.

☛ **Chillida, Kapoor, Serra, Smithson**

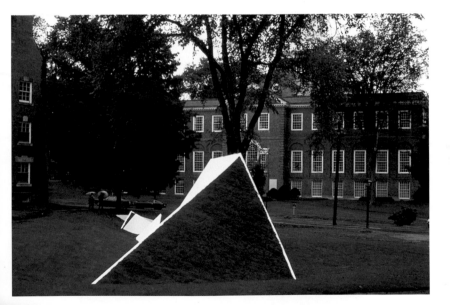

Beverly Pepper. b Brooklyn, NY (USA), 1924.
Thel. 1976–7. Cor-Ten steel and ground covering. **h**38.1 x **w**45.7 x **l**342.9 cm. **h**1'3 x **w**1'6 x **l**11'3 ft.
As installed at Dartmouth College, Hanover, NH

Phaophanit Vong

What falls to the ground but can't be eaten

An imposing, lead-clad archway, inscribed with fragments of text written in Phaophanit's native Laotian language, stands enigmatically before a forest of hanging bamboo canes. Entering through the arch, the viewer moves among the suspended bamboo and passes into a central spot-lit clearing, leaving the poles gently swaying and knocking together like a giant wind chime. Phaophanit's poetic installation is imbued with distant memories of his childhood in Laos, from which he is now exiled. Though the viewer can sense feelings of tranquillity, melancholy and loss, the exact meaning of this work remains a riddle. In other works, sometimes designed for outdoor sites, Phaophanit uses similar materials which have an everyday use in Laos, such as rice and rubber. Photographic fragments of his past are also utilized to reflect the impact of a lost history. Yet Phaophanit resists explaining his work simply in terms of his background, leaving the viewers to make their own personal interpretations.

☛ **Durham, Hatoum, Laib, Nordman**

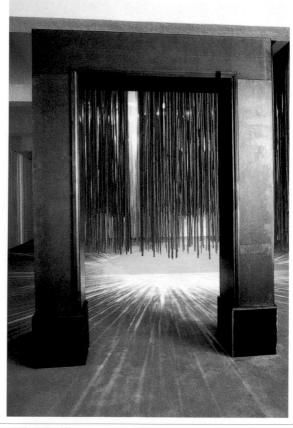

Vong Phaophanit. b Savannakhet (LAO), 1961.
What falls to the ground but can't be eaten. 1991. Bamboo and lead. Dimensions variable. As installed at the Chisenhale Gallery, London

Picabia Francis

Catax

The face of a woman is shown from a number of different angles. Superimposed over the top of the composition is a representation of the entire body, and details of the hands and the iris of the eye. The separate forms float amorphously, as if in space, intertwined with cascading roses – symbols of love. This work is one of Picabia's series of 'Transparencies' – so-called because one image is visible beneath another. The interest in representing a figure from a series of varying viewpoints to suggest three-dimensionality links Picabia to Cubism. However,

the irrational juxtaposition of forms reveals the influence of Surrealism and Dada – an anti-art group with which Picabia was closely involved; he was a close friend of Duchamp, one of the leaders of the group. However, although Picabia constantly questioned accepted values through his work, he did not take the anti-art stance of many fellow Dadaists.

☛ Braque, Duchamp, Modersohn-Becker, Picasso

Francis Picabia. b Paris (FR), 1879. **d** Paris (FR), 1953.
Catax. 1929. Oil on canvas. **h**104 x **w**73.5 cm. **h**40⅞ x **w**28⅞ in. Tate Gallery, London

Picasso Pablo

Les Demoiselles d'Avignon

Five women from a brothel on the Carrer d'Avinyo (Avignon Street) in Barcelona confront the viewer. The curtain and furniture are fiercely segmented into lozenge-shaped sections, adding urgent dynamism to the already explosive composition. The figures are shown from a variety of angles simultaneously: the seated figure has her back to us and yet she stares out of the canvas. Painted with anarchic exuberance, the faces of the two women on the right and the one on the left owe much to the African sculpture which Picasso saw in the Palais du Trocadéro in Paris. The geometric treatment of the figures and the rejection of naturalism exemplified by this painting were crucial to the development of modern art, heralding the birth of Cubism, the revolutionary movement founded by Picasso and Braque. Throughout his long life, Picasso constantly challenged accepted ways of seeing. His versatility, technical brilliance and inventiveness have earned him the well-deserved accolade of the most influential artist of the twentieth century.

☞ **Braque, Cézanne, Gauguin, Matisse, Picabia**

Pablo Picasso. b Malaga (SP), 1881. **d** Mougins (FR), 1973.
Les Demoiselles d'Avignon. 1907. Oil on canvas. **h**244 x **w**233 cm. **h**96 x **w**92 in. Museum of Modern Art, New York

Piper Adrian

Self-portrait Exaggerating my Negroid Features

Piper, an artist of mixed black and white parentage, stares out at the viewer in this powerful drawing. Yet, as the title states, this is not a straightforward self-portrait. It is a work which urges those who look at it to think about why the artist has chosen to represent herself in this way and which challenges their own racial prejudice. Piper uses the space of the art gallery, often seen as a bastion of white, middle-class liberalism, and the traditional medium of drawing to tackle deep-rooted issues of identity and race. In this intensely personal and complex drawing, as in much of her other work, Piper differs from other artists dealing with political issues. Ignoring situations which can be viewed as the responsibility of official organizations, she chooses to confront the audience with their prejudices and forces them to examine their reactions. Since the late 1960s, Piper has used a variety of media to produce demanding Conceptual work, in which the idea behind the piece is paramount.

☛ Hartley, Laurens, Schjerfbeck, Tagore

Self-Portrait Exaggerating My Negroid Features

© Adrian Piper
6/21/81

Adrian Piper. b Harlem, NY (USA), 1948.
Self-portrait Exaggerating my Negroid Features. 1981. Pencil on paper. **h**25.4 x **w**20.3 cm. **h**10 x **w**8 in. John Weber Gallery, New York

367

Piper John

Seaton Delaval

The dramatic façade of this early eighteenth-century country house in Northumberland looks imposing and majestic, silhouetted against the night sky. The theatrical lighting and the patches of purple and yellow give the impression that the building is on fire, perhaps relating to the real nocturnal fires raging in the cities of England during the Blitz, which might also threaten such national treasures as this. This is one of a series of works which Piper made during the Second World War, recording the architectural glories of Britain which were then being threatened by German aerial bombardment. In the 1930s he had worked as a geometric abstract artist influenced by Braque and Brancusi. His move towards figuration was heralded as part of a more general shift in British art away from radical Modernist experimentations towards a more traditional, picturesque style. Piper published two books of poetry in the early 1920s and has also designed stage sets and stained-glass windows.

☛ **Artschwager, Brancusi, Braque, Whiteread**

John Piper. b Epsom (GB), 1903.
Seaton Delaval. 1941. Oil on panel. **h**71 x **w**88.5 cm. **h**28 x **w**34¾ in. Tate Gallery, London

Pistoletto Michelangelo

Venus of the Rags

Positioned with her back to the viewer, a Classical statue of Venus seems to be engrossed in the pile of multi-coloured rags in front of her. Although commonplace, the rags offer an alternative beauty to the traditional ideal represented by the statue. By contrasting impoverished materials with those of historical art, Pistoletto questions preconceived ideas about value in art and society. This is true to the concerns of Arte Povera, the name given to a group of Italian artists who, in the late 1960s, used previously rejected materials in their work. Pistoletto, as a member of this group, has experimented with a diverse range of media, from sculpture and painting to Performance Art, taking his rag pieces onto the street in a series of theatrical improvisations. The common theme throughout Pistoletto's diverse *œuvre* is the relationship between artist and audience. For this, he found his most poignant metaphor in the mirror, which can either reflect, multiply, or divide.

☛ Beuys, Brisley, Broodthaers, De Chirico, Hesse, Kounellis

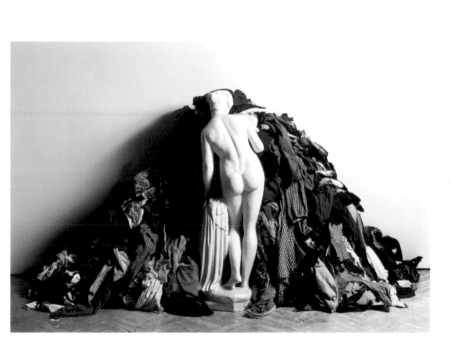

Venus of the Rags. 1967. Cement, mica and rags. **h**130 x **w**100 x **l**100 cm. **h**51¼ x **w**39⅜ x **l**39⅜ in. Edition of 3

Poliakoff Serge

Diptych

A series of interlocking blocks of solid colour fit together like a visual puzzle, their soft edges blurring subtly. This work is made of two separate panels joined together and known as a diptych. The match between the two halves of the work is not exact; it is as if the artist is deliberately playing with our expectations of symmetry. This effect is enhanced by the way in which the forms seem to float against a neutral background which extends right up to the edges of the support, creating a sense of spatial dislocation characteristic of Suprematist works.

Malevich and the Suprematists were among the many influences which proved to be key in Poliakoff's artistic development. Born in Russia, his enthusiastic use of rich colours was clearly drawn from the traditional deep hues of Russian icons. Poliakoff moved to Paris in 1923 and in 1937 he met Kandinsky. Inspired by him, and by frequent visits to the Delaunays' studio, he turned to abstraction.

☛ **R Delaunay, S Delaunay, Heron, Kandinsky**

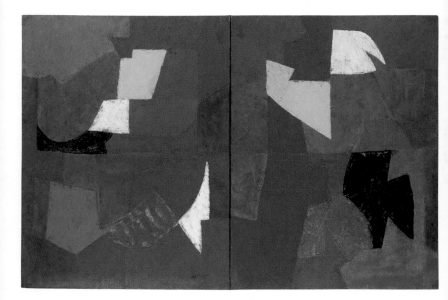

Serge Poliakoff. **b** Moscow (RUS), 1906. **d** Paris (FR), 1969.

Diptych. 1954. Oil on burlap. **h**116.5 x **w**179 cm. **h**45⅞ x **w**70½ in. Private collection

Polke Sigmar

Opium Smoker

An oriental illustration of an opium smoker has been superimposed onto a sketchily painted picture of an archway. The curves and waves of the background image complement the decorative elements of the print, the overall effect evoking the delirious intoxication of opium. The red 'Polke' dots fading gradually towards the bottom of the painting are the artist's trademark and provide an echo of Lichtenstein's Ben Day dots. Polke often uses superimposed images to create interesting juxtapositions and to throw up witty contrasts. By placing a humble

opium smoker against an inspiring piece of architecture, he is dismissing the distinction between low and high culture. One of the earliest and most innovative manipulators of incongruous subject matter, Polke's interest in consumer culture led to his formation with Richter of the German Pop Art movement. His appetite for provocative experimentation has resulted in his use of poisonous substances and heat-sensitive paint in his work.

☛ Lichtenstein, Ozenfant, Richter, Salle, Schnabel

Sigmar Polke. b Oleśnica (POL), 1941.
Opium Smoker. 1982–3. Lacquer, paper and acrylic on linen. **h**259.1 x **w**200.1 cm. **h**102 x **w**79 in. Private collection

Pollock Jackson

Full Fathom Five

Great arcs of paint cover the canvas, apparently at random, to produce an intense and energetic abstract plane. Found objects – cigarettes, nails and buttons – lie purposely embedded in the richly textured surface. Pollock was the most famous of the American Abstract Expressionist painters, earning the name 'Jack the Dripper' because of his method of dribbling and splashing the paint onto a canvas laid on the floor. Commentators from around the world found Pollock's paintings shocking since they broke the mould of representational art and, in his use of new techniques, demonstrated the artist's physical involvement in his work. Although Pollock's works may appear chaotic, his method was, to some extent, controlled and systematic. Part of a group of Americans working on large-scale, gestural paintings, Pollock placed an emphasis on the process behind the painting, and in doing so was to have a profound influence on European art.

☛ **De Kooning, Michaux, Mitchell, Motherwell**

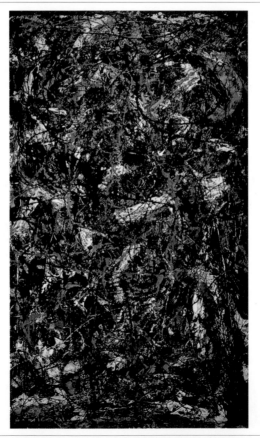

Jackson Pollock. b Cody, WY (USA), 1912. **d** Springs, Long Island, NY (USA), 1956.
Full Fathom Five. 1947. Oil on canvas with found objects. **h**129.2 x **w**76.5 cm. **h**50⅞ x **w**30⅛ in. Museum of Modern Art, New York

Popova Liubov

Cubist Nude

This figure appears almost to be dressed in armour: all the curves of her body have been transformed into fragmented, geometric shapes, giving a sense of movement in time and space. The subdued palette of browns and dark greens recalls the early Cubist works of Picasso and Braque, as does the simplification of form to its bare essentials. Popova painted this nude the year after she arrived in Paris from her native Russia in 1912. Closely associated with the Cubists in Paris, Popova was particularly influenced by Metzinger. She worked with him in his studio for a while, learning his techniques and methodology at first hand. Popova returned to Russia in 1913 where she came into contact with Tatlin. She became one of the key figures of the Russian avant-garde, and taught art in the new Soviet republic. She also designed stage sets, costumes and printed textiles, demonstrating her belief that art objects could make a practical contribution to people's lives.

☞ Archipenko, Braque, Metzinger, Picasso, Tatlin

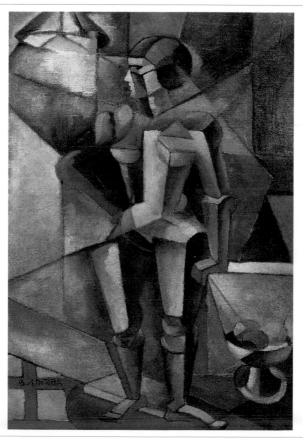

Liubov Popova. b Moscow (RUS), 1889. **d** Moscow (RUS), 1924.
Cubist Nude. 1913. Oil on canvas. **h**92 x **w**64 cm. **h**36¼ x **w**25¼ in. Annely Juda Fine Art, London

Prendergast **Maurice**

Salem Cove

A festive crowd is enjoying a day out at Salem Cove near Boston. The breeze ruffling the leaves of the trees and stirring up waves on the ocean can almost be felt by the viewer. This is the type of scene most often favoured by Prendergast who found himself drawn to promenades, carnivals and outdoor spectacles of people at leisure. The free, loose daubs or spots of colour are inspired by Pointillism, a technique whereby contrasting accents of colour are placed next to each other, imparting a luminosity and sense of movement to the scene. The bold, black contours around the figures and trees are reminiscent of Japanese prints, but perhaps relate more directly to the decorative approach of the Nabis group whom Prendergast encountered during his period in Paris in the 1890s. Prendergast was brought up in Boston and returned there after his student years in Paris, setting up a successful studio where he produced the watercolours for which he is also known.

☛ Avery, Liebermann, Monet, Signac

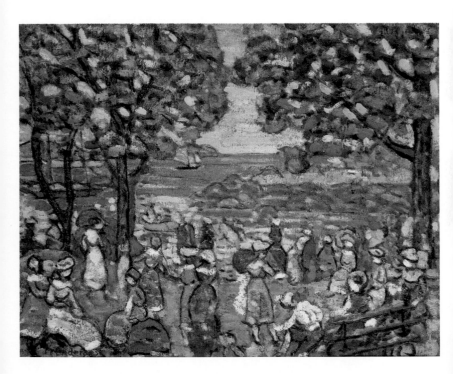

Maurice Prendergast. b St John's, Newfoundland (CAN), 1859. d New York (USA), 1924.
Salem Cove. 1916. Oil on canvas. h61.3 x w76.5 cm. h24⅛ x w30⅛ in. National Gallery of Art, Washington, DC

Prince Richard

Untitled (Joke)

A blunt, deadpan joke has been silk-screened onto the canvas. The joke, which is one of many collected by Prince from a variety of sources, is not immediately funny, but on closer examination, its absurdity is revealed. The aspect of mistaken place and identity alludes to Prince's own uncertainty in an anxious world where nothing is ever what it seems. It also implies that the act of making such a painting is a joke in itself, mocking the seriousness of the Minimalists, who produced monochromatic paintings like this one. Prince also questions the idea of authorship and the traditional role of the artist, taking something from the everyday world and transforming it into an art object. Much of his work involves the post-modernist technique of appropriation, borrowing anonymous images from magazines and advertising. He is also known for his fascination with people who live on the fringes of society, such as cowboys and motorcycle gangs, whom he celebrated in a series of photographs called *Spiritual America*.

☛ **McCahon, Vautier, Warhol, Weiner**

A traveling salesman's car broke down one evening on a lonely road and he asked at the only farm house in sight. "Can you put me up for the nite?" "I reckon I can," said the farmer. "But you'll have to share the room with my young son ." "How about that!" gasped the salesman. "I'm in the wrong joke."

Richard Prince. b Panama City, FL (USA), 1949.
Untitled (Joke). 1987. Acrylic on canvas. **h**142.2 x **w**121.9 cm. **h**56 x **w**48 in. Private collection

Quinn Marc

Self

A cast of the artist's head has been made from eight pints of his own frozen blood – the exact amount present in the human body. It has then been preserved within a refrigerated container and placed on a plinth. In this arresting and disturbing image, Quinn offers a brutally realistic perspective on the nature of self-portraiture and self-expression as a whole. Instead of using conventional media such as marble or bronze, he has drained himself of his very life-blood in order to communicate with others in the most immediate way possible. The title 'Self' can be taken literally; not only is it a cast of the artist's own head, but it is actually made from his own bodily fluid. Resembling a death mask and playing on the fearful associations of blood, which have taken on particular intensity following the onslaught of AIDS, the image also confronts the viewer with ideas of mortality. Quinn frequently uses unorthodox materials, including bread and latex, in works which are always confrontational and often based on the human body.

☛ González, Hirst, Nitsch, Pane

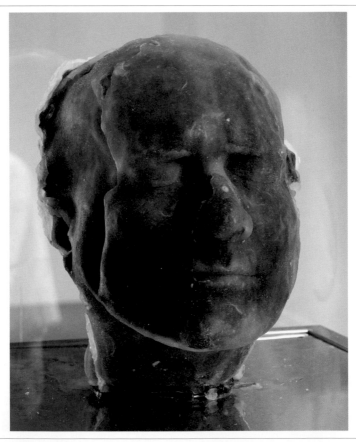

Marc Quinn. b London (GB), 1964.
Self (detail). 1991. Blood, stainless steel, perspex and refrigeration equipment. **h**205 x **w**60 x **l**60 cm. **h**81 x **w**23½ x **l**23½ in.
Saatchi Collection, London

Radziwill Franz

In the Land of the Germans

A barren and desolate urban setting opens out onto a celestial scene symbolic of redemption. Through a flower-studded sky an angel and a red carnation fall earthward. Below, among the ruins, sits a small figure – perhaps the artist – who seems oblivious to what is going on around him. The title of this work, painted in 1947, directly relates to the devastation of Radziwill's homeland during the Second World War. However, such apocalyptic visions had haunted him from the beginning of his career, and from the early 1930s all his work was suffused with a quasi-mystical aura as though he were imagining the last days of the *Book of Revelations* erupting through the calm surface of everyday life. Although stylistically linked to Surrealism, Radziwill was not part of this group and instead worked on in isolation, even choosing to remain in Germany during the Nazi period. He was forced to give up painting in 1972 due to failing eyesight.

☞ Delvaux, Grosz, Haacke, Kiefer

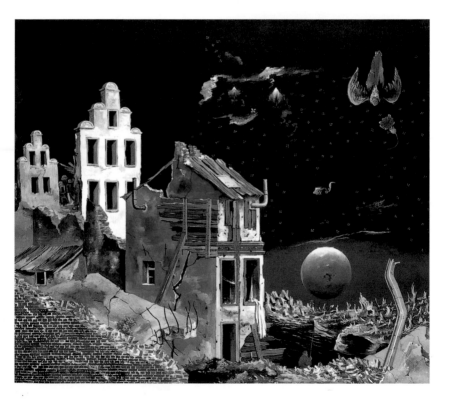

Franz Radziwill. b Strohhausen (GER), 1895. **d** Wilhelmshaven (GER), 1983.
In the Land of the Germans. 1947. Oil on canvas. **h**92.1 x **w**105.1 cm. **h**36¼ x **w**41⅜ in. Private collection

Rae Fiona

Untitled (yellow with circles I)

Great, sweeping, multicoloured brushstrokes collide with brightly hued floating discs. Swooping lines spin through the composition, dissecting the canvas into overlapping circles. The work is both spontaneous and highly considered. It exudes a sense of controlled, frenetic energy. There is no immediate, recognizable reference to everyday reality in this painting. Rather, the work seems to speak of an unknown place in the cosmos, where chemical reactions and proto-organic forms coexist in a state of chaotic flux. Many of Rae's paintings, such as

this, are full of elements appropriated from the paintings of other artists, including Polke and Richter. Fragments of imagery from Disney cartoons also sometimes appear, as do heraldic symbols, and other floating shapes, figures and motifs. Along with Hirst, Rae is one of the hugely successful young British artists who graduated from Goldsmiths' College, London, in the late 1980s.

☞ Hirst, Hofmann, Kandinsky, Polke, Richter

Fiona Rae. **b** Hong Kong, 1963.
Untitled (yellow with circles I). 1996. Oil and pencil on canvas. **h**213.4 x **w**213.4 cm. **h**84 x **w**84 in. Saatchi Collection, London

Rainer Arnulf

Bereavement

Beneath violent, coloured crayon marks lies a photograph of the artist, his face pulled into an exaggerated expression of grief whose source is indicated by the work's title. Rainer is best known today for these photographic self-portraits which have often been almost completely obliterated in this way. His photographs are carefully staged and then decorated to suggest new angles and new ways of looking at the body. Rainer's interest in the nuances of body language was originally sparked off when he noticed that he grimaced as he drew. He decided to document his facial expressions in the series 'Face Farces'. He has also used video and film to explore physical expressions of emotion and the fundamental themes of life and death, bringing these ideas to a dramatic conclusion in his 'Death Mask' series. During the late 1960s and early 1970s, Rainer was allied to the Viennese Actionists who used their bodies in an extreme, ritualistic manner to highlight the violence of man.

☞ Ader, Burden, Longo, Nitsch, Pane, Wilke

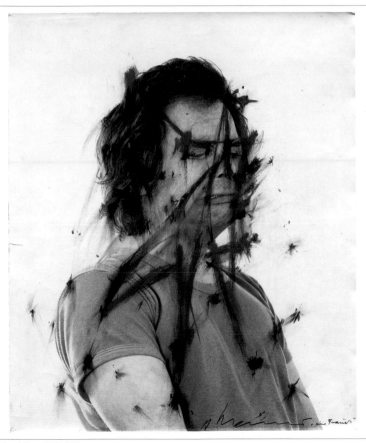

Arnulf Rainer. b Vienna (AUS), 1929.

Bereavement. 1970. Oil crayon on photograph. **h**59.7 x **w**50.2 cm. **h**23½ x **w**19¾ in. Galerie Ulysses, Vienna

Rauschenberg Robert

Doric Circus

A random collection of magazine cuttings and pieces of material has been stuck to a wall in the manner of a bulletin board. A red light and a mirror on the right provide interesting optical effects. The diverse components which make up this assemblage, or 'combine painting' as Rauschenberg called such works, do not make a coherent point. Instead they simply stand for the confusing plethora of visual signs which surround us in an age of consumer culture and mass media. The title of the work indicates that a visual connection with the straight Doric columns of Ancient Greek temples is intended. In this way, the mad circus or confusion of everyday life is contained within a colonnade of precise Classical pillars. Rauschenberg came to prominence in the mid-1950s as part of a tendency which is often dubbed Neo-Dada. He is now considered to be one of the most significant artists associated with American Pop Art, a movement which derives its imagery from popular culture and new technology.

☞ **Blake, Dine, Opie, Rosenquist**

Robert Rauschenberg. b Port Arthur, TX (USA), 1925.

Doric Circus. 1979. Mixed media on board. **h**243.8 x **w**346.7 x **l**66 cm. **h**96 x **w**136½ x **l**26 in. National Gallery of Art, Washington, DC

Ray Charles

Fall '91

In Ray's hallucinatory, Alice-in-Wonderland world, nothing appears as it should. *Fall* takes the dressed-for-success, modern businesswoman and blows her up into an oversized, all-powerful Amazon. An encounter with this disconcerting sculpture is both an anxious and amusing experience. *Fall* makes the room around it, and the viewer, shrink. Ray interrupts the accepted order of things, often adapting the scale of his mannequins to create surreal works which challenge notions of normality. His work *Family*, in which a father, mother,

son and daughter were either reduced or increased in scale so that each was the same height, is a disturbing example of this technique. His manipulation of space and scale owes much to the formal strategies of the abstract sculptor Caro – an artist who has had a profound influence on Ray. He has also experimented with self-portraiture, attaching a cast of his genitals and some of his pubic hair to a generic shop mannequin.

☛ Caro, Hanson, Longo, Sherman, K Smith

Charles Ray. b Chicago, IL (USA), 1953.
Fall '91. 1992. Mixed media. **h**244 cm. **h**96 in. Private collection

381

Redon Odilon

Ophelia among the Flowers

The poetic, fantasy world of Shakespeare's Ophelia provides the inspiration for this painting. Ophelia appears, shortly before her watery death, in a dreamy, trance-like state, and it is almost as if the flowers, which fall in front of her face, represent her ecstatic vision. The painting has a kind of hallucinatory sensuality, an aspect which led to Redon's adoption by the hippie, drug-culture of the 1960s. The artist's earlier 'Noirs', the morbid, sinister black and white works of his youth, were his response to a wretched and isolated childhood. He was separated from his family, probably because they could not come to terms his epilepsy. In 1897, however, when the family home in Bordeaux was sold, he appears to have been released from these 'painful origins' as he called them, and his works became more vibrantly coloured, as here, and they found much greater favour with the public. Redon's preoccupation with the subconscious mind was to be an important source for the Surrealists.

☞ Bonnard, Chagall, Klimt, Masson

Odilon Redon. b Bordeaux (FR), 1840. **d** Paris (FR), 1916.
Ophelia among the Flowers. c1905–8. Pastel on paper. **h**64 x **w**91 cm. **h**25½ x **w**35⅞ in. National Gallery, London

Rego Paula

The Dance

In this moonlit scene, smiling couples and a family are entwined in joyful revelry, while a single woman is left to dance by herself. In the background is a rocky hill topped by a brooding castle and the sea glints in the distance. Rego's use of heavy chiaroscuro – starkly contrasted light and shade – with its suggestion of the disturbing secrets hidden in the shadows, gives her paintings a mysterious atmosphere reminiscent of the works of the Surrealists De Chirico and Ernst. Her figurative paintings have an enchanting, though often sinister, power.

Constructed with awkward perspective and a strange distortion of scale, the eerie figures act out scenarios that transport the viewer into a timeless, nostalgic world. Rego's childhood memories and her formative adult experiences have had a powerful influence over her creative process – fear, innocence, domination, sexuality and escape all recur as familiar themes. Rego's inspiration has also come from books of nursery rhymes, many of which she has illustrated.

☞ **Campbell, De Chirico, Ernst, Matisse, Munch, Nadelman**

Paula Rego. b Lisbon (POR), 1935.

The Dance. 1988. Acrylic on paper on canvas. **h**213.4 x **w**274.3 cm. **h**84 x **w**108 in. Tate Gallery, London

Reinhardt Ad

Black Painting No. 34

Black paint engulfs the canvas. Only the trace of two rectangular forms remains, just visible through a veil of paint. Reinhardt has pared down painting to its bare essentials. One of a series, this work sums up his paradoxical attitude to art. Regarding the production of art as a continual reaction to the work of the past, Reinhardt aimed for a style 'without illusion, allusion, delusion'. He ignored the work of previous artists and believed that it was impossible to represent the idea of an actual object on canvas. His series of black paintings sum up the Modernist tradition and also link him to reductive Minimalism, which was emerging at the time. A complex artist, Reinhardt was against the emptiness of geometric abstraction, but was unwilling to surrender himself to notions of beauty. He spent a lifetime satirizing the art world through a series of witty cartoons and comic strips. The 'Black Paintings', which vary very slightly in tone, were the final statement on his singular attitude to painting.

☛ Brancusi, Judd, LeWitt, Malevich

Ad Reinhardt. **b** Buffalo, NY (USA), 1913. **d** New York (USA), 1967.
Black Painting No. 34. 1964. Oil on canvas. **h**153 x **w**152 cm. **h**60¼ x **w**60⅛ in. National Gallery of Art, Washington, DC

Renoir Pierre Auguste

Portrait of Ambroise Vollard

Ambroise Vollard, dressed formally in a business suit, is depicted admiring one of Renoir's sculptures. Turning it round in his hands, he seems deep in thought. The whole surface of the canvas is suffused with rich, warm colours, giving the scene an intimate air. The epitome of the connoisseur, Vollard was Renoir's friend and dealer and ran a gallery on rue Lafitte in Paris which became a showcase for the work of many of the leading Impressionists and Post-Impressionists. The artist presented this portrait to Vollard as a sign of his gratitude and respect. Renoir, who is also known for his paintings of the vitality of Parisian life, was a leading member of the Impressionists, who were predominantly concerned with the treatment of light in their work. Their aim was not to make a direct representation of a scene but to capture the visual impression of a particular time and place. Yet despite the Impressionist interest in landscape, Renoir remained chiefly a figure painter, especially of sun-drenched, voluptuous nudes.

☛ **Denis, Kirchner, Modigliani, Vuillard**

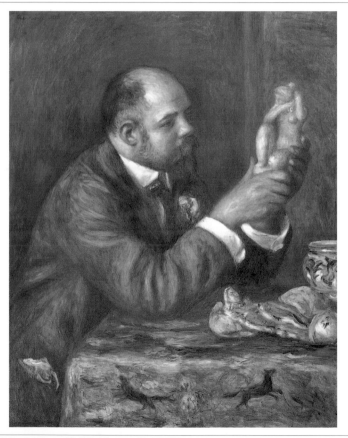

Pierre Auguste Renoir. b Limoges (FR), 1841. **d** Cagnes-sur-Mer (FR), 1919.
Portrait of Ambroise Vollard. 1908. Oil on canvas. **h**81 x **w**64 cm. **h**32 x **w**25¼ in. Courtauld Institute Galleries, London

Richier Germaine

Don Quixote

A faceless and painfully thin figure stands alone, with one hand outstretched and a long staff held in the other. The rough, pitted surface of the bronze and the loneliness of this figure suggest both humility and vulnerability, strength and survival. Don Quixote is the foolhardy and idealistic hero of the famous romance by the seventeenth-century Spanish writer Cervantes and perhaps symbolizes Richier's lonely quest for perfection in her work. The theme of isolation was also common to Existentialism, a philosophy of individual and personal

responsibility that pervaded the post-war Paris in which Richier worked. Richier's sculptures often fused animal and human elements and she sometimes substituted limbs and body-parts with found objects such as twigs and wires. The legs of this figure are cast from real branches. This anthropomorphic approach was partly derived from Surrealism, although the most important of Richier's diverse influences was the work of Giacometti.

☛ **Borofsky, Gargallo, Giacometti, Kubin**

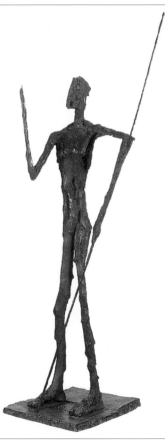

Germaine Richier. **b** Grans (FR), 1904. **d** Montpelier (FR), 1959.
Don Quixote. 1952. Bronze. **h**206 cm. **h**81½ in. Edition of 6

Richter Gerhard

794–1 Abstract Painting

Layers of red, blue and green paint have been dragged across the surface of the canvas, leaving a residual presence like the shock waves from an earth tremor. This painting is one of a series of his works which Richter has labelled 'Abstract'. Using squeegees and spatulas, he has created the impression that the work has been produced by mechanical means and that the hand of the artist has not had any direct involvement. There is a sense that the idea of composition and the notion of colour juxtaposition have been left to chance.

A prolific artist, Richter has made large, sombre monochromatic canvases, works based on colour charts and figurative paintings derived from snapshots or press photographs. In these, an initially sharp photograph is progressively blurred and then completely obliterated with brushstrokes. Melancholy and atmospheric, these contemplative works are often about death, pain and memory. Existing at the threshold of painting and photography, they question the status of both media.

☛ **Art & Language, Pollock, Rae, Rothko**

Gerhard Richter. b Dresden (GER), 1932.
794–1 Abstract Painting. 1993. Oil on canvas. **h**240 x **w**240 cm. **h**94½ x **w**94½ in. Private collection

Riley Bridget

August

A dazzling kaleidoscope of colours, meticulously arranged in thin diamond-shaped strips, cascades across the canvas. The arrangement of overlapping colours and patterns creates an optical illusion, giving the work an intense, mesmeric feel. Riley is a leading exponent of the Op Art movement, which focuses on playing perceptual games with the viewer and creating the impression of movement on a static canvas. She enjoys experimenting with variations in tone and colour. Riley's work is deeply rooted in tradition and shows diverse influences ranging from the use of colour in Post-Impressionist painting to the dynamism of the Futurist paintings of Balla. She began by painting black and white stripe paintings, later introducing colour to set up visual vibrations and rhythms suggesting musical tonalities. International recognition came very early in her career when she was awarded the Grand Prize for Painting at the Venice Biennale in 1968.

☛ Albers, Balla, Bleckner, Vasarely

Bridget Riley. b London (GB), 1931.
August. 1995. Oil on linen. h164.8 x w228.6 cm. h64⅞ x w90⅛ in. Karsten Schubert, London

Riopelle Jean-Paul

Abstraction Orange

The riotous web of vibrant primary colours employed in this painting creates a joyful and dynamic effect. The surface of the canvas is covered in a thick layer of paint which has been applied with a palette knife directly from the tube, using a technique known as impasto. In response to the clinical style of the abstract painters of previous generations, Riopelle's work focuses on colour and surface texture. Often weighing the canvas down with pigment, Riopelle applies the colours in systematic clusters and forces them together to heighten the tension. This method of production connects Riopelle with Art Informel artists, who used free brushstrokes and a dense application of paint in their attempt to create a new abstract artistic language. Born in Montreal, Riopelle has lived in Paris since 1948. Early in his career, Riopelle worked in a manner influenced by the automatism of Surrealism, but by the 1960s, a more considered abstraction had taken over.

☞ Art & Language, Ayres, Fautrier, Pollock, Tobey

Jean-Paul Riopelle. b Montreal (CAN), 1923.
Abstraction Orange. 1952. Oil on canvas. **h**97 x **w**195 cm. **h**38¼ x **w**76¾ in. Private collection

Rivera Diego

Distribution of the Arms

In this work, the artist, who was an ardent Communist, shows a scene of revolution in Mexico. At the centre is his wife, the artist Kahlo, helping to distribute weapons to the workers. This work belongs to an ambitious cycle of murals which Rivera completed for the Mexican government in the late 1920s. An extensive social and political panorama of the history and aspirations of the Mexican people, the series contains both real and imaginary events. The elements of Rivera's compositions are clearly outlined, and depicted in bold, contrasting areas of colour. This style, which exerted a considerable influence on Mexican art, was intended to make the narrative structure of the work as legible as possible. Like other Social Realists, he believed that art should serve a direct social and political function, and that rather than limit themselves to small-scale easel painting, artists should make works for public spaces as they had during the Renaissance.

☛ Golub, Kahlo, J C Orozco, Siqueiros

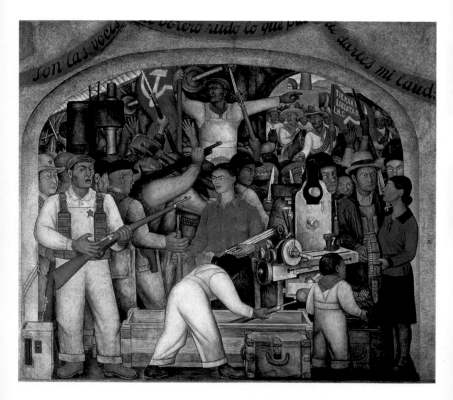

Diego Rivera. b Guanajuato (MEX), 1886. **d** Mexico City (MEX), 1957.
Distribution of the Arms. 1928. Fresco. **h**203 x **w**398 cm. **h**80 x **w**156⅞ in. Ministry of Education, Mexico City

Rivers Larry

Parts of the Body: French Vocabulary Lesson

The various body-parts of a loosely painted, naked female figure are annotated with stencilled letters in the manner of a French vocabulary lesson. The work lies somewhere between an erotic portrait and a matter-of-fact, educational illustration. The spontaneous brush-strokes are typical of the Abstract Expressionist style of painting and show the influence of De Kooning. However, in his collage-like combination of images and visual clichés from consumer society, Rivers has demonstrated his individuality and his affiliation with Pop Art. Moving to figuration from his early training as an abstract painter, Rivers is more interested in manipulating the relationship between image and process than in the actual content of his work. A professional saxophonist, he has also made videos and sculptures, written poetry, worked as a stage designer and graphic artist and travelled widely. His eclectic work, which never quite fits into any school, reflects this diversity.

☞ Fischl, De Kooning, Sarmento, Schiele, Severini

Larry Rivers. b New York (USA), 1923.

Parts of the Body: French Vocabulary Lesson. 1961–2. Oil on canvas. **h**182.8 x **w**121.9 cm. **h**72 x **w**48 in. Private collection

391

Rodchenko Aleksandr

Untitled

Dynamic, diagonal lines cut across the painting, creating the sensation of colours and shapes floating freely in space. The reduction of forms in this painting to abstract, geometric essentials proclaims Rodchenko's affiliation with Russian Constructivism, a movement which believed that art should reflect the forms and processes of modern technology. Together with his wife, Varvara Stepanova, and Tatlin, Rodchenko was the principal artist within the movement. He proclaimed the need for an organized art, advocating the 'absoluteness of industrial art and Constructivism as its sole expression'. Constructivism had come into being partly as a means of building up the new post-revolutionary Russia. From the mid-1920s, when there were fewer opportunities for shaping the new regime, Rodchenko turned largely to photography, joining the debate which was then raging about the relative merits of painting and photography as a means of representing reality.

☛ Demuth, Kandinsky, Lissitzky, Malevich, Tatlin

Aleksandr Rodchenko. b St Petersburg (RUS), 1891. d Moscow (RUS), 1956.

Untitled. 1919. Watercolour and oil on board. h49.5 x w35.5 cm. h19½ x w14 in. Annely Juda Fine Art, London

Rodin Auguste

The Cathedral

Sensitive, graceful hands are left in a disembodied state, emerging from a block of bronze. They can be seen as a visual metaphor for prayer and religious love. In this work Rodin created a new form of sculpture – the fragment as a finished work. Rodin was very much influenced by the unfinished figures of the Renaissance artist Michelangelo, particularly by the way in which he gave some parts of his work a delicate finish while leaving others deliberately rough and unresolved. Rodin was the most celebrated sculptor of the late nineteenth/early twentieth century.

His genius lay in revitalizing sculpture by bringing it back to focus on the human body. When he exhibited the standing male nude *The Age of Bronze* in 1877, it appeared so lifelike that he was accused of having cast it directly from the model. Many of Rodin's most famous sculptures in marble, such as *The Kiss*, possess a powerfully erotic quality. His free approach to modelling had a major impact on subsequent developments in modern sculpture.

☞ **Bourdelle, Gaudier-Brzeska, Modotti, Moore**

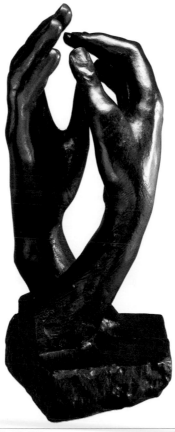

Auguste Rodin. **b** Paris (FR), 1840. **d** Meudon (FR), 1917.
The Cathedral. 1907. Bronze. **h**63.5 cm. **h**25 in. Private collection

Rollins Tim and KOS

Amerika VI (South Bronx)

Pages from the novel *Amerika*, written by the Czech writer Franz Kafka in 1927, form the background to this work. Superimposed on the text are various images, including the initials HB which stand for Howard Beach in Queens, New York, the site of a fatal racial attack. The golden horns come from a scene in Kafka's story and are embroiled in a violent struggle. The design was conceived through preparatory drawings and then painted directly on top of the grid. This work comes from a series of 12 paintings based on Kafka's novel. Rollins, an artist and teacher, formed his collaborative group KOS (Kids of Survival) in 1982 with high-school students from the South Bronx, an area of New York known for its high crime rate and poverty. Books provide the background, both literally and figuratively, for their work. Other works have been inspired by Lewis Carroll's *Alice in Wonderland* and Herman Melville's American classic, *Moby Dick*.

☞ Basquiat, Boyle Family, Campbell, Nevelson

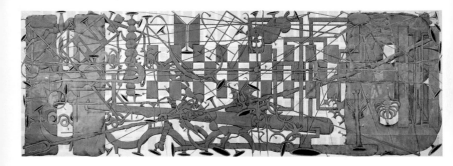

Tim Rollins and KOS. Tim Rollins. **b** Pittsfield, MA (USA), 1955.
Amerika VI (South Bronx). 1986–7. Watercolour, charcoal, acrylic and pencil on book pages. **h**167.6 x **w**480 cm. **h**66 x **w**189 in.
Saatchi Collection, London

Rosenquist James F-111

The image of a supersonic jet-fighter plane, called simply F-111, is punctuated visually by a series of vertical panels. These show the trappings of contemporary culture: tinned spaghetti, an atomic cloud, a smiling child under a hairdrier, a deep-sea diver and a racing tyre. With these popular references, Rosenquist hints at the positive, as well as the negative, aspects of scientific advance. He wishes to highlight the triumph of the man-made object, rebelling against the mystification of the Abstract Expressionist painters who preceded him. But the fragmented appearance of the jet and its over-whelming size reflect the partial knowledge, and therefore the political impotence, of the individual in a technological world. This mural, which is 26 metres (86 feet) in length, was originally displayed on all four walls of a gallery. Its huge scale, glossy, close-up images and references to technology are characteristic of the diverse and complex work of Rosenquist, an American Pop artist who started his career as a billboard painter.

☛ Kruger, Mullican, Paolozzi, Warhol

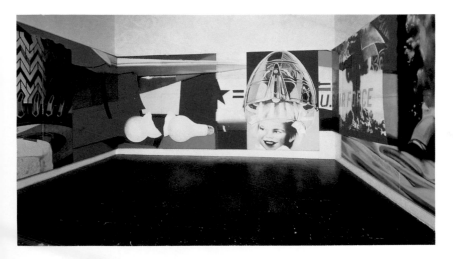

James Rosenquist. b Grand Forks, ND (USA), 1933.
F-111. 1965. Oil on canvas with aluminium. h3 x w26.2 m. h10 x w86 ft. Private collection

Rotella Mimmo

Marilyn Monroe

A film poster, showing Marilyn Monroe and Robert Mitchum, has been torn to shreds and pasted onto a canvas, revealing what look like layers of other posters beneath. An inspirational icon to many artists, Monroe has been practically destroyed by Rotella. Such destruction is central to his work. He is known for his collages made of posters torn from the streets, which he called 'Decollages'. Later, he glued the posters to canvas, then partially tore them again, naming the technique 'Double Decollage'. Artists working in this way were known as Affichistes, from the French term 'afficher', which means 'to stick up'. Through juxtaposition and slight alteration, slogans and images collide and accidental conjunctions occur. By the late 1950s, Rotella had become a leading figure among the Nouveaux Réalistes, who used the debris of urban life to comment directly on the society in which they lived. Through his use of advertising and commercial art forms, Rotella is also linked to the Pop Art movement.

☛ **Blake, Morley, Organ, Paolozzi, Schwitters**

Mimmo Rotella. **b** Catanzaro (IT), 1918.

Marilyn Monroe. 1962. Torn posters on canvas. **h**196 x **w**140 cm. **h**77¼ x **w**55⅛ in. Private collection

Rothenberg Susan

United States II

The silhouette of a horse lends a noble, almost mythical air to the large canvas. Bridging the light and dark halves of the painting, it is an emblem of unity, as the title suggests. Rothenberg has not depicted her subject realistically, but as flat blocks of colour which form part of the picture plane. While the result may seem naïve, the work is in fact extremely sophisticated, both indebted to the simplicity of Minimalism and anticipating later movements. Rothenberg's rise to prominence at the end of the 1970s was symptomatic of the changing art market. Following a decade of Performance and Installation Art, and largely unsaleable Conceptual work, huge paintings were once again in vogue. Rothenberg was among an élite whose work was capable of commanding huge sums. Yet in comparison with her contemporaries, such as Schnabel and Salle, she is something of a traditionalist, as her figurative works evolve from drawings, and are not just made up of motifs from the works of the past.

☛ Dominguez, Marini, Salle, Schnabel, Wallinger

Susan Rothenberg. b Buffalo, NY (USA), 1945.
United States II. 1976. Acrylic and tempera on canvas. **h**193 x **w**228.6 cm. **h**76 x **w**90 in. Private collection

Rothko Mark

Red on Maroon

A large, undefined frame of red seems to hover in front of a maroon background. The soft, luminous colours and the expansive scale of this dramatic canvas compete against each other with serene subtlety, engulfing the viewer with a sense of passion, tragedy and the sublime. Rothko wanted to seduce the spectator into the picture plane with his colours, inducing a reaction of emotional immediacy. He was more interested in expressing basic human emotions through his work than in exploring abstraction and the relationship between colour and form. He regarded the shapes in his paintings – usually rectangles – as 'things', even portraits. Rothko's paintings exhibit the spontaneity of expression typical of the New York-based group of painters known as the Abstract Expressionists. Within that movement Rothko's affiliation lies with the Colour Field painters who expressed themselves through the use of colour rather than gestural marks on the canvas. Rothko committed suicide in 1970.

☛ Förg, Newman, Richter, Still

Mark Rothko. b Dvinsk (RUS), 1903. d New York (USA), 1970.
Red on Maroon. 1959. Oil on canvas. **h**266.5 x **w**239 cm. **h**105 x **w**94 in. Tate Gallery, London

Rouault Georges

Two Clowns

Two melancholy clowns are starkly outlined in black. The bold colours of their costumes contrast with their sombre mood. An 'outrageous lyricism' was how Rouault aptly described this characteristic of his work. The combination of dark outline and luminous colour recalls the appearance of stained glass, a craft in which Rouault had received an apprenticeship, while the dramatic colour scheme owes much to Expressionism, a movement which was interested in the emotive value of colour. Rouault painted a series of clowns, using the theme to suggest the tragicomic aspects of the performer's life – the tears behind the mask. Picasso had also explored this idea in his 'Saltimbanques' – a series of paintings depicting acrobats and performers. In Rouault's works on this theme, however, there is a strong element of self-identification. He appeals to us by making us witnesses to human frailty and suffering, deliberately choosing characters who elicit a powerful emotional response.

☛ Beckmann, Léger, Macke, Pechstein, Picasso

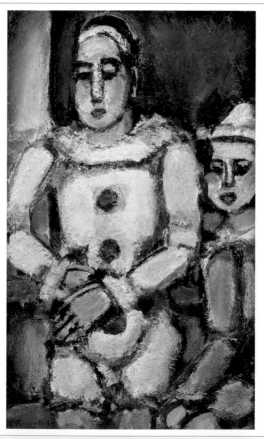

Georges Rouault. b Paris (FR), 1871. **d** Paris (FR), 1958.
Two Clowns. c1935. Oil on canvas. **h**47.3 x **w**28.5 cm. **h**18⅝ x **w**11¼ in. Private collection

Rousseau Henri

Tropical Forest with Monkeys

Two chimpanzees swing on the trees, while another sits by a stream in this fantastical tropical forest, painted in rich, contrasting colours. The decorative, linear style, and the lack of perspective owe much to graphic art, perhaps reflecting Rousseau's occasional job as a sign-painter. Nicknamed 'Le Douanier' – the customs official – because he worked in a customs house, Rousseau received no formal artistic training, using his day off on Sunday to paint. He made a singular contribution to avant-garde art, however, and his picture-book style anticipates the Pop Art of the 1960s. His naïve vision was originally derided by the art world, but was to find favour with both Picasso and the poet Guillaume Apollinaire. A dinner in his honour was given in Picasso's studio in 1908, an event which helped establish Rousseau as a symbol of sophisticated interest in pseudo-primitive art.

☞ Burra, Lowry, Masson, Moses, Picasso, Wallis

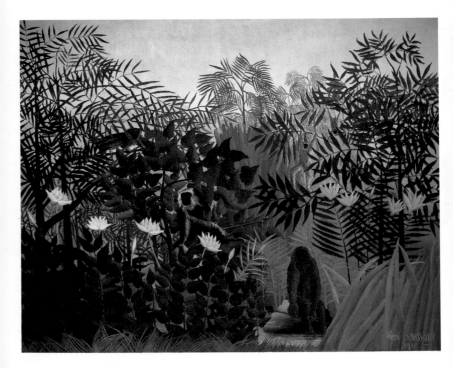

Henri Rousseau (Le Douanier). b Laval (FR), 1844. d Paris (FR), 1910.
Tropical Forest with Monkeys. 1910. Oil on canvas. h130 x w163 cm. h51 x w64 in. National Gallery of Art, Washington, DC

Roy Pierre

A Naturalist's Study

A group of seemingly unconnected objects is assembled in a compressed, box-like room. At first sight, the different elements look quite realistic, but on closer examination it becomes apparent that the wheel, propped up against the wall on the right, cannot function as there is no hole through the hub; the wheels of the cart behind the train cannot move as they are coupled together; and the steam from the train's whistle is blowing in the opposite direction to the smoke from the chimney. Painted shortly after the death of the artist's wife, this work, with its sense of life having stopped, reveals Roy's state of mind, left, as he was, with a nine-year-old son to bring up. The juxtaposition of bizarre objects and the dream-like quality of this work link Roy to the Surrealists. Like them, Roy was deeply influenced by Sigmund Freud's theories of the unconscious. He aimed to capture the strangeness of the dream through the use of a realistic painting style.

☛ De Chirico, Dalí, Magritte, Nash

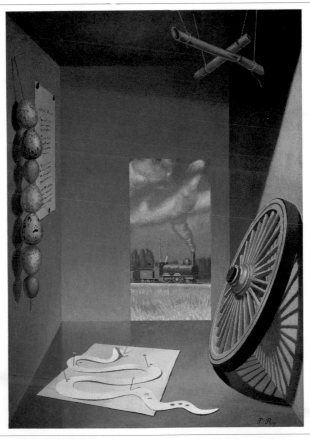

Pierre Roy. b Nantes (FR), 1880. d Milan (IT), 1950.
A Naturalist's Study. 1928. Oil on canvas. **h**92.1 x **w**65.4 cm. **h**36¼ x **w**25¾ in. Tate Gallery, London

Ruscha Ed

Noise

The word 'NOISE', applied in bold yellow letters, fills the width of the canvas. Emblazoned against a solid, dark background, it forms an arresting image which seems to shout out at the viewer, appealing impossibly to one of the senses that painting cannot reach. Adding to the debate about what art can and cannot represent and thus questioning its role in society, Ruscha is here emphasizing the idea behind the piece, revealing his affinities with Conceptual Art. A key figure in the Californian Pop Art movement of the 1960s, Ruscha's interest in contemporary culture and society has ensured that his work has an appeal for many younger artists. In the mid-1960s he began to combine words with images, as in *Adios*, a work in which the letters are formed by the gathering of spilled liquids. Since then he has produced a series of works exploring stains made by common substances. The silhouettes of objects, animals and urban landscapes lend a shadowy and unreal air to his recent work.

☞ **Kawara, Kosuth, Prince, Vautier**

Ed Ruscha. **b** Omaha, NB (USA), 1937.
Noise. 1963. Oil on canvas. **h**182.9 x **w**170.2 cm. **h**72 x **w**67 in. Private collection

Ryman Robert

Winsor 6

Regular bands of white paint fill the canvas. Taking a two-inch brush loaded with pigment, Ryman placed it on the upper left-hand corner and pulled it to the right until the paint ran out, then started again. Ryman's works are not about subject matter, but are concerned with the physical act of painting. He said: 'There is never any question of what to paint, but how to paint.' He has been painting variations on the theme of the white monochrome for most of his career, using white paint as a tool to explore the boundaries of painting. The title of this work is taken from the name of the company Winsor and Newton, who produced Ryman's chosen brand of paint. In his effort to enhance the importance of the actual process of creating a work of art, Ryman sometimes leaves bare details of the frame, the screws and the supporting bolts which have been used to hold the canvas together or fix it to the wall. His quest has less to do with the expression of some kind of philosophy than with an exploration into the potential of paint.

☞ Iglesias, LeWitt, Manzoni, Martin, Turrell

Robert Ryman. b Nashville, TN (USA), 1930.
Winsor 6. 1965. Oil on linen. **h**192.5 x **w**192.5 cm. **h**75¾ x **w**75¾ in. Private collection

403

Sage Kay

Lost Record

In the eerie atmosphere of some apparently post-apocalyptic world, the desert landscape is empty except for a lifeless tree and two strange forms. These might be geological or are perhaps the melted remains of man-made objects. The title of the work implies that their purpose has been obliterated by time or disaster. Long shadows, reminiscent of those in the paintings of De Chirico, with whom Sage shows a strong affinity, fall menacingly across the featureless ground. Marrying the painter Tanguy in 1940, Sage became an important recruit to Surrealism in its exile to the United States during the Second World War, when this work was painted. Sage's output is similar to Tanguy's in terms of themes and style, but is often characterized by a closer engagement with recognizably urban or natural forms. Like Tanguy and the other 'dreamscape' Surrealists, such as Dalí and Magritte, Sage used the Western tradition of figuration in order to evoke the mysterious topography of the unconscious.

☛ De Chirico, Dalí, Magritte, Nash, Tanguy

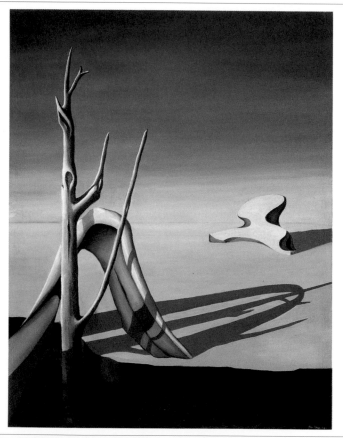

Kay Sage. **b** Albany, NY (USA), 1898. **d** Woodbury, CT (USA), 1963.
Lost Record. 1940. Oil on canvas. **h**91.4 x **w**70.5 cm. **h**36 x **w**27¾ in. Indiana University Art Museum, Bloomington, IN

De Saint Phalle Niki Death

Death, a bloated female figure with skeletal head, sits on a blue horse, painted with stars and moons. Brandishing a scythe, she is surrounded by fragments of human bodies and dead creatures. This idiosyncratic depiction of the Grim Reaper is both macabre and playful. As a celebration of the power of women, it is characteristic of De Saint Phalle's work. She started her artistic career with an innovative series of 'shooting paintings' in which household objects and tins of paint were embedded into the canvas and then shot at from a distance. This led

her to join the Nouveaux Réalistes who incorporated elements of performance as well as items from everyday life into their work. She is best known for her expressive, fetishistic assemblages depicting holy figures, large women and monsters. One of her most famous sculptures is a vast model of a woman. Visitors enter between the legs and explore inside the body until they reach various points: a 12-seat cinema in the left arm, and a planetarium in the left breast.

☛ Kelley, Kollwitz, Koons, Kubin, Ray

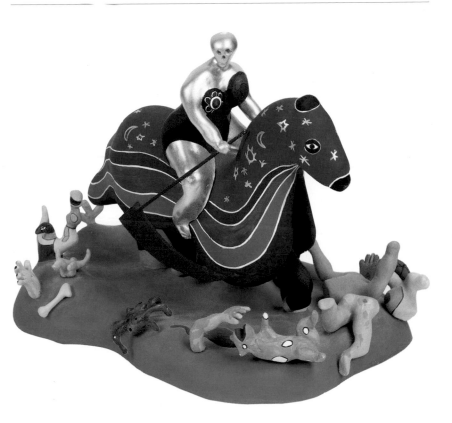

Niki de Saint Phalle. **b** Neuilly-sur-Seine (FR), 1930.

405

Death. 1985. Painted polyester. **h**34.3 x **w**26.7 x **l**45.7 cm. **h**13½ x **w**10½ x **l**18 in. Private collection

Salle David

The Burning Bush

This work combines anonymous images of women from film stills, advertisements and pornographic magazines with geometric patterns and expressionistic doodles. The pictorial elements are not arranged by any narrative structure, giving the painting a deliberately vague quality. The title puns on the slang sexual meaning of 'bush' and the Biblical story of God's revelation to Moses, as though Salle is engaged in an exercise in free association. In Salle's paintings, images and icons of contemporary culture collide in a haphazard juxtaposition of styles and traditions. In a typically post-modern eclecticism, Symbolism, Expressionism, Realism and Pop are all used in a pastiche that collapses the history of painting into fragmented components. Salle is a central figure of the Transavantgarde, a European and American grouping of post-modernist painters who question the whole tradition of painting, and its value and relevance as an art form in an age of electronic communication.

☛ Polke, Richter, Schiele, Schnabel

David Salle. b Norman, OK (USA), 1952.
The Burning Bush. 1982. Oil and acrylic on canvas. **h**234 x **w**300 cm. **h**92 x **w**118 in. Saatchi Collection, London

Samba Chéri

Mr Poor's Family

The local scribe sits at the table on the left, composing letters on behalf of villagers asking for money from wealthy relatives. The texts on the table and behind the starving figures are written in Lingala, the native language of Zaire, and tell a pitiful tale of hardship and the need for charity. A threadbare and potbellied boy takes one of the letters to the wealthy relative seen on the far right, dressed in a smart suit and sitting comfortably in front of his modern home. In the two sides of this painting Samba creates a poignant contrast between rich and poor. A self-taught artist, Samba first earned his living painting advertisements and drawing newspaper cartoons. In 1975 he began to paint his cartoons onto canvases – preserving the narrative format which enables him to make clear statements about his country's government and society. Samba's works provide a vivid and thought-provoking picture of contemporary African life.

☛ **Moses, Nhlengethwa, Rousseau, Severini**

Chéri Samba. b Kinto M'Vuila (ZAI), 1956.
Mr Poor's Family. 1991. Acrylic on canvas. **h**66 x **w**81 cm. **h**26 x **w**32 in. Annina Nosei Gallery, New York

Sarmento Juliao

Being Forced into Something Else

A sequence of fragmented images, some figurative, others more abstract, creates an uneasy pictorial and thematic tension. The faint, partially effaced profile of a standing woman hovers on the right-hand side of the canvas. She holds a circular object in one hand. Behind her, the simplified shape of an arm seems to push her forwards. Below, the outline of a pair of arms gives the impression of a silhouette. These images are seductive and suggestive, leaving the viewer, who is drawn in like a voyeur, to piece together the veiled meaning of the picture. This is one of a series of works, called 'White Paintings', which are hesitant and introspective, but humorous in their approach to subject matter. Through a fusion of Expressionist and cartoon techniques, Sarmento's paintings are both immediately accessible and emotive. Erotic desire and nostalgia are central themes in his work. His earlier works draw on popular culture, and use imagery gleaned from consumer magazines.

☛ Picabia, Rothenberg, Ryman, Salle, Tuymans

Juliao Sarmento. b Lisbon (POR), 1943.
Being Forced into Something Else. 1991. Mixed media on canvas. **h**289.6 x **w**267.2 cm. **h**114 x **w**105½ in. Sean Kelly Inc., New York

Schad Christian

Self-portrait with Model

In this study of decadent vanity, the artist paints his self-portrait, glaring back at himself, while a naked woman lies provocatively behind him, physically close but emotionally distant. He wears a see-through top which resembles a layer of skin, stitched together at the chest. The woman has an unseemly scar across her cheek. Behind her a phallic flower – a symbolic Narcissus – rises up, and beyond them both we can glimpse the rooftops of the grim industrial city. Schad often dealt with subjects of psychological intensity such as this, communicating a sinister chill by means of a detached, realistic style. He belonged to a tendency in post-war Germany dubbed Neue Sachlichkeit. These artists rejected abstraction in favour of a stylized realism, aiming to capture the alienation of modern life through a linear style which harked back to the artists of the German Renaissance. Schad worked with the Dada artists early in his career, experimenting with innovative photographic processes.

☛ **Dix, Grosz, De Lempicka, Spencer**

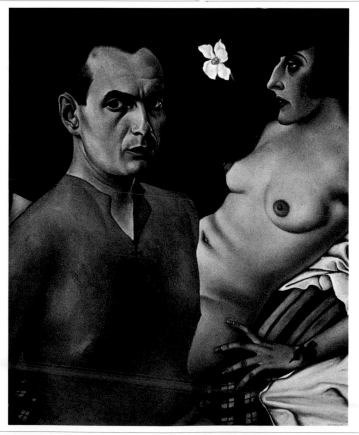

Christian Schad. b Miesbach (GER), 1894. **d** Keilberg (GER), 1982.
Self-portrait with Model. 1927. Oil on wood. **h**76 x **w**61.5 cm. **h**30 x **w**24¼ in. Private collection

Schapiro Miriam

Barcelona Fan

Richly patterned fabric has been attached to the canvas, to create this huge, decorative fan. Emblazoned with colour, it is a tribute to traditional female crafts, such as embroidery. By elevating such skills to the status of art, Schapiro challenges the traditionally male preserve of painting. The fan, a simple female accessory, here becomes an art object. This interest in the role of women links Schapiro to the feminist artists of the 1970s. Their aim was to define the female experience through art, and they brought to the art scene a flowering of traditional female skills such as tapestry, ceramics and quilt-making. Starting out as an Abstract Expressionist, Schapiro went on to make collages of doilies, aprons and chair covers which she called 'Femmages', and which draw on the associations of a collective female past. However, a new generation of feminists were to find the idea of a universally shared language increasingly alien to their own experiences.

☛ Brossa, Chicago, Horn, Mangold, Trockel

Miriam Schapiro. b Toronto (CAN), 1923.
Barcelona Fan. 1979. Fabric and acrylic on canvas. **h**182.9 x **w**365.8 cm. **h**72 x **w**144 in. Metropolitan Museum of Art, New York

Schiele Egon

Recumbent Female Nude with Legs Apart

The blatant eroticism and sense of abandon in the pose of this woman, painted in 1914, is startling even now. The distortion, elongation and sense of isolation in this nude study reveal the influence of Expressionism, although Schiele never thought of himself as belonging to that movement. At the time these nude studies were seen as deeply outrageous, making the artist notorious, and eventually leading to his brief imprisonment for 'making immoral drawings'. Schiele began these drawings around the time of his meeting with Klimt at the Viennese Workshop, the influential group of artists and designers associated with the Viennese Secession. Aiming to raise the level of artistic production in Austria to that of other European countries, Secessionist artists were inspired by the flowing, organic style of Art Nouveau, an influence which is evident in Schiele's work. By the time of his final exhibition, Schiele was at last beginning to gain wider recognition. He died in a flu epidemic in 1918.

☞ **Balthus, Fischl, Klimt, Maillol, Rivers**

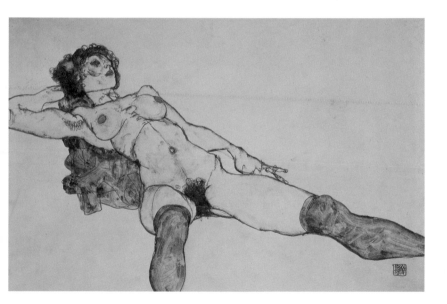

Egon Schiele. b Tulln (AUS), 1890. **d** Vienna (AUS), 1918.

Recumbent Female Nude with Legs Apart. 1914. Pencil and gouache on paper. **h**30.4 x **w**47.1 cm. **h**12 x **w**18⅝ in.

Graphische Sammlung Albertina, Vienna

Schjerfbeck Hélène

Self-portrait

The artist scrutinizes herself with an unflinching eye, penetrating the reality behind her clown-like mask. Emerging from a gloomy background of blue and brown, Schjerfbeck exudes a melancholic and solemn air. The colours are muted, the only bright areas provided by her one aquamarine eye, echoed by the colour of her collar. The hair, pulled back severely, gives her an almost masculine appearance. Far from self-aggrandizing, Schjerfbeck depicts herself with a naked candour, the vulnerable stare combined with the blotches of paint on her face and touches of unnaturally strong colour, giving the work a feeling of unease. This self-portrait, part of a series produced throughout her life, was made when the artist was 50 years old. Influenced by Munch in her emphasis on conveying inner feeling, Schjerfbeck can be linked to Expressionism. Her self-portraits were her major achievement but she also painted highly simplified still lifes, landscapes and figurative compositions.

☛ Cahun, Kahlo, Modigliani, Munch, Spilliaert

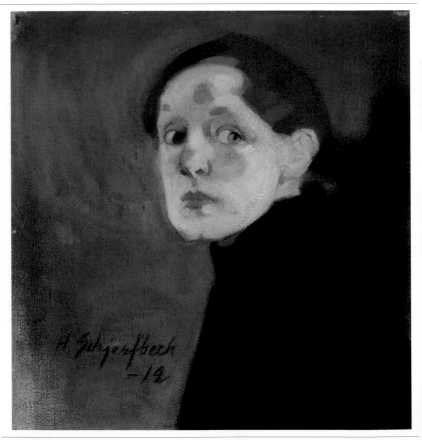

Hélène Schjerfbeck. b Helsinki (FIN), 1862. d Saltsjöbaden (SWE), 1946.
Self-portrait. 1912. Oil on canvas. **h**43 x **w**42 cm. **h**16⅞ x **w**16½ in. Private collection

Schlemmer Oskar

Rear View of a Woman Sitting at the Table

A woman sits on a high-backed wooden chair, with her back to the viewer. With one arm resting on the table and the other dangling over the back of the chair, the woman is set symmetrically within the picture frame. Her blue dress contrasts with the sombre and brooding colour scheme of the room. She looks more like an elegant vase than a human being. She has no visible features and seems a strange, alien creature who might almost have been hewn from wood. A painter, stage designer and sculptor, Schlemmer also taught at the Bauhaus school during the 1920s. In all his work, whether paintings or sculptures, he eliminates movement, creates an unreal sense of space and reduces the human figure to an almost abstract pattern of simplified convex and concave shapes. A close friend of Baumeister, Schlemmer produced controlled and carefully constructed compositions. His work is seen as the antithesis of the emotional excesses of Expressionism.

☛ Baumeister, Hartley, Lipchitz, Neel

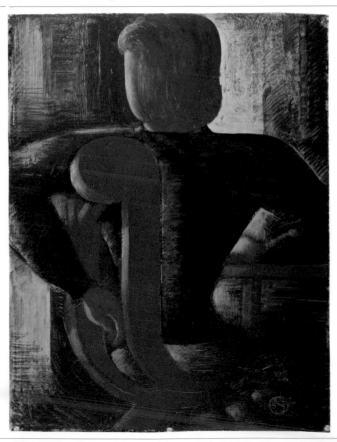

Oskar Schlemmer. b Stuttgart (GER), 1888. **d** Baden-Baden (GER), 1943.
Rear View of a Woman Sitting at the Table. 1936. Oil on canvas. **h**75.3 x **w**59.3 cm. **h**29⅝ x **w**23⅜ in. Museum Folkwang, Essen

Schnabel Julian

Blue Nude with Sword

A naked blue warrior with a sabre-like sword straddles two Classical columns. Free-floating, they seem detached from history. Smashed plates glued onto an uneven wooden board form the ground for this painting. This dramatic technique creates a mosaic-like surface. The crude figuration and pictorial content are matched by the dynamic energy vested in the materials. Schnabel presents these effects in a mock-heroic, ironic manner. The idea of a fragmented world, where high and low culture iconographies collide, is a theme common to all

Schnabel's paintings. His ironic style is typical of post-modernism which uses techniques of pastiche and discontinuity in order to criticize established theories about art. At a time when other media were generally considered more relevant by contemporary artists, Schnabel's works were seen as a breakthrough in painting. By his late twenties he had achieved unprecedented levels of commercial and critical success.

☞ **Baselitz, Polke, Salle, Spoerri**

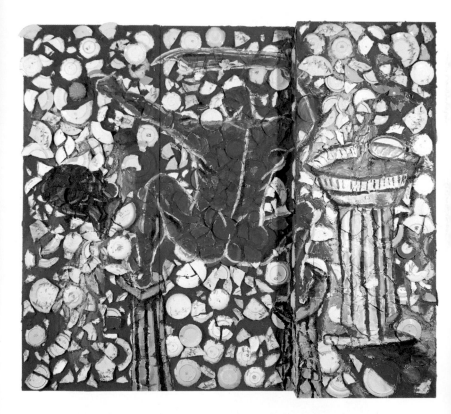

Julian Schnabel. b New York (USA), 1951.
Blue Nude with Sword. 1979–80. Plates, oil and watercolour on masonite panel. **h**244 x **w**274.5 cm. **h**96⅛ x **w**108⅛ in.
Galerie Bruno Bischofberger, Zurich

Schneemann Carolee

Eye Body: 36 Transformative Actions

Covered in paint, chalk, ropes and plastic, Schneemann herself has become part of the work of art. Schneemann is a central figure in Performance Art, and this photograph documents an early piece in which the artist explored feminist concerns, interacting with her slippery, oozing materials to evoke primal forces that transform her into a sacred Earth Goddess. The title alludes to the body as a territory of art and to the transformative possibilities of performance, in which the artist journeys towards self-knowledge. Performance Art, which could neither be bought nor sold, offered a radical alternative to the art market. *Meat Joy*, Schneemann's best-known work, staged in 1964, was an exuberant celebration of flesh, featuring naked participants, fish, chickens and wet red paint. She has also contributed important essays on sexuality and feminism. Her work, *Cézanne, She Was a Great Painter*, formed part of the performance *Interior Scroll*, read from texts secreted in her vagina.

☞ Nitsch, Pane, Shiraga, Wilke

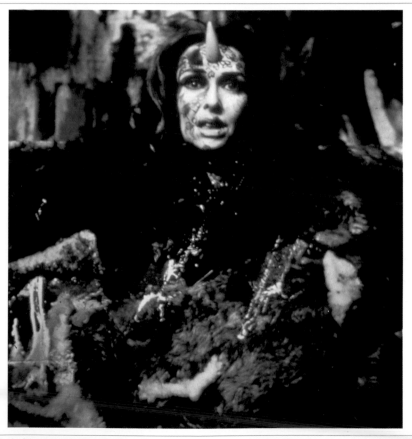

Carolee Schneemann. b Fox Chase, PA (USA), 1939.
Eye Body: 36 Transformative Actions. 1963. Photograph of a performance in the artist's loft apartment, New York

Scholte Rob

After Us the Flood

Burning battleships and blasting canons explode across this vast mural. It is the largest wall-painting in Japan and covers the interior dome of a full-size replica of a Dutch, seventeenth-century palace. Dutch artist Scholte, who created this monumental work with some 40 assistants, chose the city of Nagasaki, site of the atomic bomb, for his giant anti-war message. The title expresses our seeming lack of concern for the generations who will follow us. Naval battles from the fifteenth to seventeenth centuries, when the Europeans first began sailing and conquering the New World, are combined with an unwelcoming sign, 'Please go away', warding off both invaders and further calls to arms. The tradition of investing paintings with moral or spiritual messages is an inheritance from the Dutch Old Masters, who, like Scholte, filled their pictures with symbolic objects. Scholte also borrows images from billboards and illustrations to compose a highly readable art which he has defined as 'cartoons for adults'.

☞ **Davila, Dufy, Vautier, Wallis**

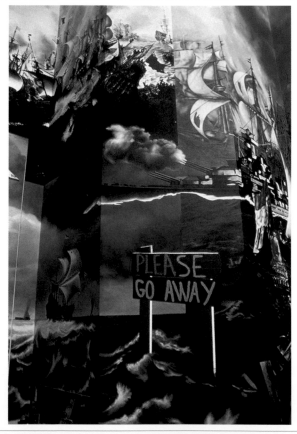

Rob Scholte. **b** Amsterdam (NL), 1958.
After Us the Flood. 1991–5. Acrylic on canvas. Each wall: **h**20 x **w**11 m. **h**65'8 x **w**36'1 ft. Paleis Huis Ten Bosch, Nagasaki

Schütte Thomas

United Enemies

Two figurines are bound together, apparently in a state of extreme angst and discomfort. They are modelled from Fimo, a brightly coloured modelling clay, normally used by children. Dressed in loose wraps of towelling and scraps of fabric, their legs made from wooden sticks, they have a sense of poverty and fragility. The couple's facial expressions border on the grotesque, straining away from each other as though tortured by some inner pain. The figures are displayed on a round, wooden plinth and encased within glass, emphasizing the sense of entrapment. In bringing the two 'enemies' together with such indivisible proximity, Schütte shows how the human condition is unavoidably shared, subject to the common laws of society. Schütte has made other strange representations of the human figure, complemented by his architectural maquettes of imaginary spaces and interiors which have the same distorted, anxious quality.

☛ **Campigli, Marisol, Nadelman, Ulay & Abramovi**

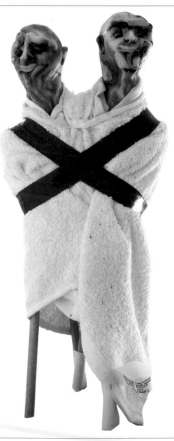

Thomas Schütte. b Oldenburg (GER), 1954.
United Enemies. 1993–4. Fimo, cloth, glass, wood and PVC. **h**188 x **w**21.5 x **l**21.5 cm. **h**74 x **w**8½ x **l**8½ in. Tate Gallery, London

Schwitters Kurt

Circle

Overlapping squares and rectangles of textured and mottled paper are juxtaposed on a round board, and combine to produce a dynamic composition. This collage of objects on board is an example of 'Merz', a term Schwitters applied to his art from the 1920s. 'Merz' was a nonsense term, gleaned at random from a newspaper, and became Schwitters's playful trademark, which he translated as 'freedom'. He worked with the Dadaists, an anarchic group of artists who eschewed the methods of fine art. Schwitters's first collages in 1918 led to a passion for collecting rubbish – bus tickets, corks, worn-out shoes – to create 'art from non-art'. In his three 'Merzbau' – constructions in Hanover, Norway and London – he filled entire houses with found objects. These are now widely recognized as the forerunners to Installation Art. Schwitters received virtually no recognition during his lifetime. It is only recently that his immense contribution to the avant-garde has been properly assessed.

☛ **Boyle Family, Braque, Hausmann, Nicholson, Rotella**

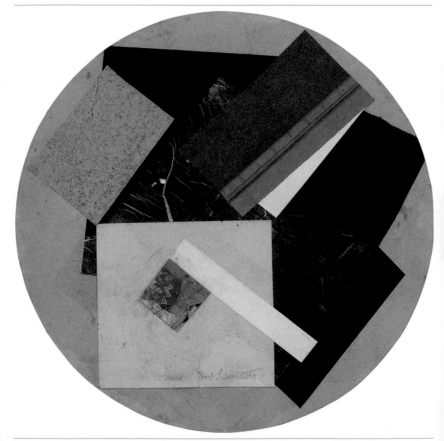

Kurt Schwitters. b Hanover (GER), 1887. d Ambleside (GB), 1948.

Circle. 1925. Collage on board. **diam.** 32.7 cm. **diam.** 12⅞ in. Annely Juda Fine Art, London

Scully Sean

Why and What (Yellow)

Alternate, horizontal and vertical stripes of densely worked oil paint cover panels which have been joined together to create a single painting. Contrasting sharply with the dull yellow and white bands, two smaller sections have been inserted, one comprising deep red and blue stripes, the other a steel plate. The interruptions are deliberately discordant and add to the sense of conflict between the misaligned panels. This abstract configuration seems to refer to the grids, surfaces and tensions of downtown Manhattan, the artist's home for the last 20 years. Scully's work has a strong architectural element and a sense of rugged urbanity. Through the design and colour combination of each painting, he is able to express a range of emotions using limited means. Though his works address the everyday, they are resolutely abstract and maintain a curious balance between the gestural energy of Abstract Expressionism and the rigorous self-discipline of American Minimalism.

➔ Andro, LeWitt, Martin, Mondrian, Riley, Ryman

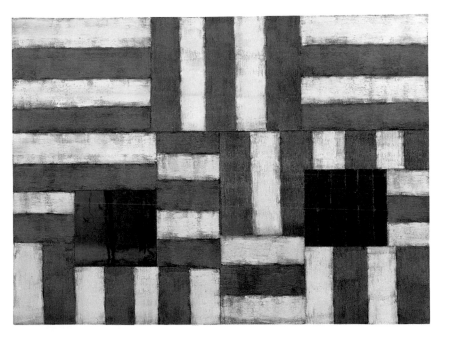

Sean Scully. b Dublin (IRE), 1945.
Why and What (Yellow). 1988. Oil on canvas with steel insert panel. **h**243.8 x **w**304.8 cm. **h**96 x **w**120 in.
Hirshhorn Museum and Sculpture Garden, Washington, DC

Segal George

The Dancers

Four naked female figures, their arms splayed for balance, perform a silent dance. Ghostly and free-standing, they are captured in mid-action. Segal made such immediate figurative works over several decades, often using plaster-soaked bandages over casts of his friends and family to make the figures. Everyday situations and simple gestures are transformed into motionless studies of human behaviour. A melancholic detachment runs throughout Segal's work, both a reflection of his Jewish heritage and a comment on our splintering community and the anonymity of modern life. Communication, or the lack of it, is a central theme: many of the sculptures are placed in isolation within a constructed interior or scene. Props may range from a simple chair to whole environments. Although he trained as a figurative painter, Segal turned to sculpture, particularly influenced by Performance Art and Pop Art, which also focus on everyday activities.

☛ **Kienholz, Matisse, Nadelman, Rego, K Smith**

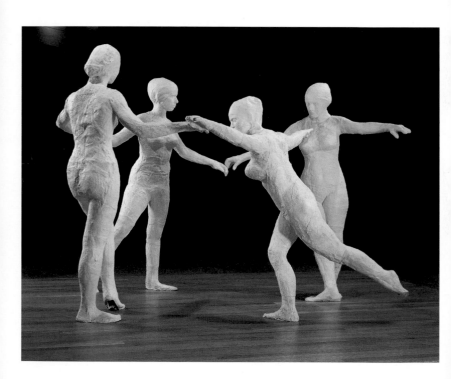

George Segal. **b** New York (USA), 1924. **d** New Jersey, NJ (USA), 2000.
The Dancers. 1971. Plaster. **h**179 x **w**269 x **l**180 cm. **h**70½ x **w**106 x **l**71 in. National Gallery of Art, Washington, DC

Seligmann Kurt

Game of Chance No. 2

Three grotesque creatures, part-human, part-insect, part-vegetable, play a nonsensical game of chance with an unmarked dice. The central figure is reminiscent of Napoleon with his black hat and epaulettes; the other two are probably female. The hat of the figure on the right doubles as a bird. There is no indication of a specific setting or context, though some reference is clearly being made to a moment in history, perhaps even to contemporary events. Seligmann specialized in such strange, composite creatures, products of an imagination fuelled by his interest in alchemy and the occult. Connected through his bizarre imagery with the Surrealists, Seligmann emigrated permanently to the United States in order to escape the Second World War. He reacted to the American landscape with a series of visionary works entitled *Cyclonic Forms* and, with his whimsical brand of Surrealism, became extremely successful.

☛ **Arp, De Chirico, Ernst, Sage, Tanguy**

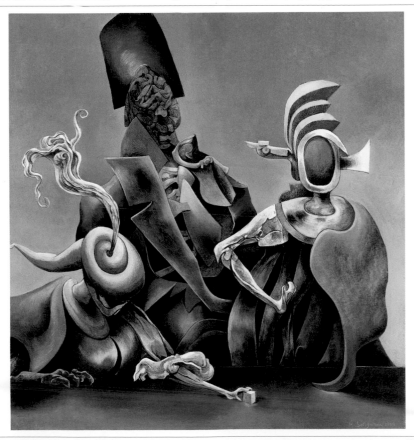

Kurt Seligmann. **b** Basle (SW), 1900. **d** Sugar Loaf, NY (USA), 1962.

Game of Chance No. 2. 1949. Oil on canvas. **h**108.9 x **w**104.1 cm. **h**42⅞ x **w**41 in. Private collection

Serra Richard

Tilted Arc

A curved wall of rusting steel bisecting the paved ground looks severe and threatening set in this square. Serra was commissioned in 1979 by the General Services Administration to create this piece for the Federal Office Plaza in Manhattan. By that time, he had gained a worldwide reputation for his powerful, gravity-defying, Minimalist sculpture, which relies on the appearance of precarious balance for its drama. The presence of this work gave rise to complaints from public and government officials alike, who viewed it as a menace to personal and national security. The unforeseen arguments over aesthetics, context and politics were hotly contested. Minimalist artists espoused site-specific work as a means of marking the consciousness of passers-by. Although Serra protested that the relocation of *Tilted Arc* would render the piece impotent, it was eventually removed. The acrimony surrounding this work is proof of the deep-rooted divisions that can occur when public sculpture meets its audience.

☛ Andre, Buren, Jones, Judd, LeWitt, Pepper

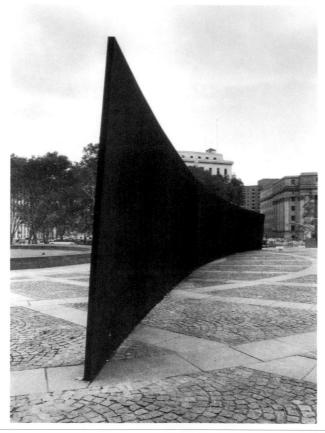

Richard Serra. b San Francisco, CA (USA), 1939.
Tilted Arc. 1981. Cor-Ten steel. **h**365.8 x **w**3658 x l6.4 cm. **h**144 x **w**1440 x l2½ in. As installed in the Federal Office Plaza, New York

Severini Gino

Brown, grey and green waves of colour all converge towards three soldiers operating a cannon. The one on the left in the foreground bends down to light the fuse, while the other two on the right look as if they are about to re-load it. Superimposed onto this dramatic image are words and phrases about war and fighting: Bboumm, goes the cannon; 100,000 ripping flashes; annihilation; ripping open of the ground; come on boys! These pithy, staccato phrases act as a commentary on the violence of the image beneath. This painting was one of a group

which Severini made between 1914 and 1918, during the First World War. The swirling, dynamic sense of movement and speed and the focus on modern machinery are typical of Futurism, whose manifesto Severini signed in 1910. The extensive use of words and letters, however, is unique to Severini. He later went on to produce works in a more naturalistic style, including a series of frescos in Montegufoni near Florence.

☞ **Balla, Boccioni, Carrà, Golub, Grosz**

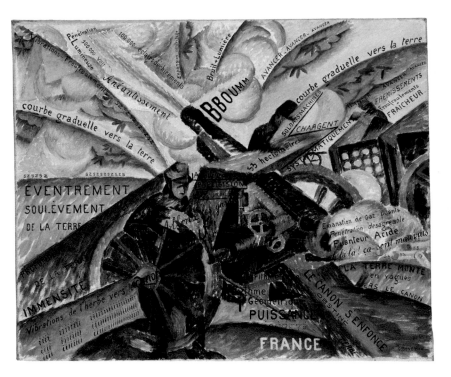

Gino Severini. **b** Cortona (IT), 1883. **d** Paris (FR), 1966.
Cannons in Action (Words on Liberty and Forms). 1915. Oil on canvas. **h**50 x **w**60 cm. **h**19⅝ x **w**23⅝ in. Paolo Baldacci Gallery, New York

Shahn Ben

Death on the Beach

A man lies in a pool of blood, his hands pressed up against his face, his skull stained red by a fatal wound. Despite the anonymity of the figure, and though the work is not based on a real story, there is a strong sense of narrative in this painting. Shahn moved to the United States from Lithuania, and, as a Jew, he struggled to come to terms with American society. Witness to the hardships and abuses to which outsiders were subjected, Shahn often focused on the concept of justice in his work. This painting reflects his Socialist views. His works deal with life during the Depression, as well as the plight of the persecuted. Urban decay, workers' rights and the effects of McCarthyism are all explored with sensitivity. Working as a photographer, illustrator, painter and writer, Shahn travelled extensively throughout Europe. His graphic, realist style lent itself particularly well to the many murals he produced for public buildings.

☛ Neel, Nitsch, Pane, Quinn

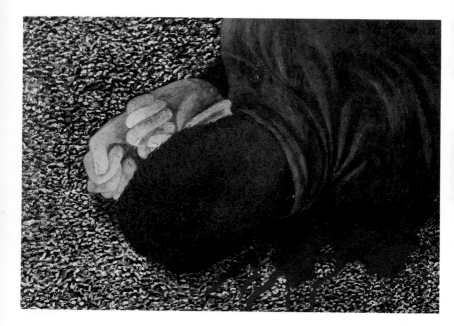

Ben Shahn. **b** Kovno (LIT), 1898. **d** New York (USA), 1969.
Death on the Beach. 1945. Tempera on board. **h**25.4 x **w**35.6 cm. **h**10 x **w**14 in. Private collection

Sheeler Charles

Rolling Power

The wheels, pistons, rivets and screws of a powerful locomotive are painted with great accuracy, in keeping with Sheeler's interest in the purity and beauty of machines. His dynamic curves and lines animate the picture surface, but he has cleansed his train of all grease and dirt. Sheeler's hard-edged style was influenced by his work as a photographer. (His photograph, *Drive Wheels*, also of 1939, records the same subject – with grease.) His style pre-empts that of the Pop artists and the Photo-realists who emerged later in the century. In his paintings he tried to create a modern form of classicism – an art based on architectural order that would address the new realities of industrial and urban society. Sheeler and fellow-painter Demuth were known in the 1930s as the Precisionists. Unlike the Futurists who had focused on the dynamism of modern life, they chose to depict such things as railway trains, automobiles, skyscrapers and factories, in a way which emphasized their static grandeur and formal harmonies.

☞ Balla, Demuth, Estes, Mucha

Charles Sheeler. b Philadelphia, PA (USA), 1883. d New York (USA), 1965.
Rolling Power. 1939. Oil on canvas. h38.1 x w76.2 cm. h15 x w30 in. Smith College Museum of Art, Northampton, MA

Sherman Cindy

Untitled (No. 122)

This work is part of a series of photographs in which Sherman modelled clothes by a top designer. Unlike the women in traditional fashion photographs, Sherman appears anxious and dishevelled, the clothes hanging uncomfortably from her tense frame. She exposes the falsity of fashion's promise of beauty and happiness and the negative, unattractive side of glamour, forever edited out of artificial ideals of female perfection. Sherman has produced over 300 of these self-portraits which explore ideas and images of female identity. Never appearing as herself, she becomes an anonymous, neutral woman in whom people recognize something of themselves. Her protagonists range from those based on the heroines of films from the 1950s and 1960s, to historical and art-historical female characters, and to grotesque dolls with prosthetic body-parts whose bodies appear to be dislocated or decomposing. Her thought-provoking work has had a profound influence on a subsequent generation of feminist artists.

☞ Cahun, Longo, Ray, Schjerfbeck, Schneemann

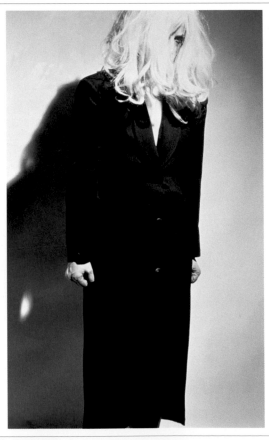

Cindy Sherman. **b** Glen Ridge, NJ (USA), 1954.

Untitled (No. 122). 1983. Colour photograph. **h**221 x **w**147.3 cm. **h**87 x **w**58 in. Saatchi Collection, London

Shiraga Kazuo

Challenging Mud

The artist wrestles with a pile of mud. Only when his cuts, bruises and eventual exhaustion win over will he stop. Mud was thought to possess a spirit of its own with which the artist had to do battle. This kind of performance/endurance test was characteristic of the Gutai Group, of whom Shiraga was a key member. An influential collection of artists who reacted against the traditionalism and sentimentality that characterized post-war Japan, they engaged in performance, theatrical events and multimedia environments. Shiraga's work was particularly physical. Such performance-related work, which extended to gestural, abstract painting, meant that the artists directly interacted with the material used. Predating the arrival of the Happenings of the late 1950s and early 1960s in New York – a combination of events and performances which often involved the audience – the Gutai Group attracted the notice of a number of American and European abstract painters including Tobey and Pollock.

☛ Murakami, Pollock, Tobey, Yoshihara

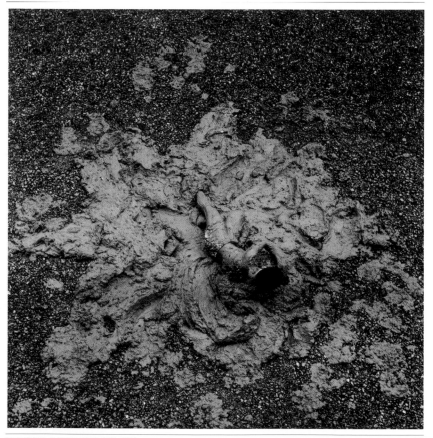

Kazuo Shiraga. b Amagasaki City (JAP), 1924.

Challenging Mud. 1955. Photograph of a performance at first Gutai Exhibition, Ohara-Kaikan, Tokyo

Sickert Walter

Mornington Crescent Nude, *Contre-jour*

A woman reclines on a bed in a gloomy interior, with her back to the window, the light casting rather unflattering shadows on her heavy form. This is one of a series of nudes painted in Mornington Crescent, North London, where Sickert once lived, and demonstrates the artist's interest in murky, seedy settings. The rough, textural handling of the paint is characteristic of Sickert's wholly original approach to oils, while the treatment of light and shade illustrates his debt to the nineteenth-century French painter Edgar Degas. His visit to Degas' Paris studio as a young man profoundly affected him. Born in Germany, Sickert moved to England as a child, and later lived for a while in Dieppe and Venice. He was one of the most important British Impressionists and his studio became a meeting-place for avant-garde artists of the day. He formed the Camden Town Group in 1911, a group of artists who concentrated on scenes of everyday, working-class life.

☛ Balthus, Bonnard, Fischl, López Garcia, Maillol

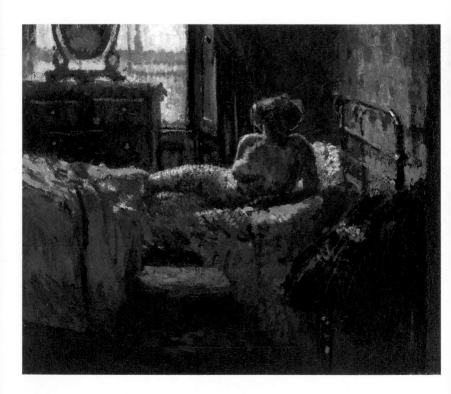

Walter Sickert. **b** Munich (GER), 1860. **d** Bathampton (GB), 1942.
Mornington Crescent Nude, *Contre-jour*. 1907. Oil on canvas. **h**50.8 x **w**61 cm. **h**20 x **w**24 in. Art Gallery of South Australia, Adelaide

Signac Paul

Antibes: The Pink Cloud

A solitary boat glides across the bay at Antibes in the reflection of the setting sun. The swirling pink clouds above lend a dramatic air to this tranquil scene. The tiny strokes of colour which conjure up the impression of this Mediterranean idyll show Signac's affiliation with Pointillism, a technique invented by the nineteenth-century painter Georges Seurat, whereby instead of mixing colours before applying them to the canvas, the artist would place them separately on the picture surface so that at a certain distance they would fuse in the

spectator's eye. Signac used the technique throughout his career to create a vivid luminosity in his landscapes. He especially liked to paint the coastal regions of the South of France where he spent extended periods of time. Signac was the most articulate theorist of the Neo-Impressionists. His book *From Delacroix to Neo-Impressionism*, published in 1899, is a key work on the movement.

☞ Dufy, Marin, Monet, Nolde, Prendergast, Vlaminck

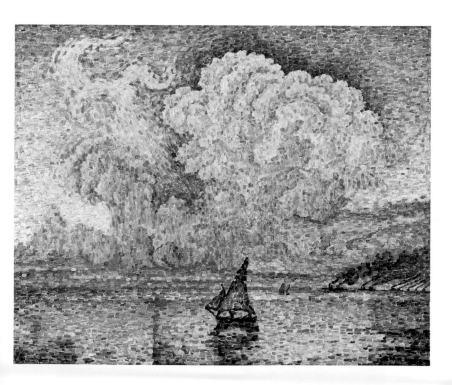

Paul Signac. b Paris (FR), 1863. d Paris (FR), 1935.
Antibes: The Pink Cloud. 1916. Oil on canvas. **h**73 x **w**92 cm. **h**28¾ x **w**36¼ in. Private collection

Siqueiros David Alfaro

Zapata

Emiliano Zapata, whose portrait this is, led the landless peasants against the government during the Mexican Civil War (1910–20). He became a symbol of liberty for ordinary Mexicans, and here Siqueiros depicts him as a somewhat menacing figure, hemmed in between prison-like walls, but seemingly ready at any moment to break out and join his army. Siqueiros belonged to a group of Social Realist artists, including Rivera and Orozco, who worked primarily on murals for the public buildings of Mexico's new left-wing government. Themes were usually taken from Mexican or Latin-American history, and the style, while figurative, strove for, and often achieved great clarity, expressiveness and power. Siqueiros was one of the first artists to use industrial paints, sometimes applied with a spray gun. The Abstract Expressionist painter Pollock worked briefly in the Experimental Workshop which Siqueiros founded in New York in 1936, where he probably first encountered the Duco paint he used in later works.

☛ Kahlo, Nolan, J C Orozco, Pollock, Rivera

David Alfaro Siqueiros. b Chihuahua (MEX), 1896. **d** Cuernavaca (MEX), 1974.
Zapata. 1931. Oil on canvas. **h**153.3 x **w**105.7 cm. **h**60⅜ x **w**41⅝ in. Hirshhorn Museum and Sculpture Garden, Washington, DC

Smith David

Voltri VII

This iron sculpture combines both functional and non-functional elements, juxtaposing wheels with abstract forms. It is part of a series of works which use metal structures rescued from obsolete steel mills. Bits of agricultural machinery and other found objects frequently provided the starting-point for Smith's works. Descended from a blacksmith and skilled in metalwork, Smith had a deep understanding of raw materials and a love of machinery. His art often evoked what he called the 'great quiet of stopped machines'. One of the most important sculptors of the post-war generation, Smith created works that were monumental in scale yet intimate in content, offering a poetic, personal reflection on our industrial society. Initially influenced by the iron sculptures of Picasso, he combined the Surrealist-based sculptural style of González with the formal elements of Cubism and Constructivism. Despite the abstracted forms, Smith's humanistic approach ensures that his objects are never inaccessible.

☛ **Caro, Chillida, Deacon, González, Noguchi, Picasso**

David Smith. b Decatur, IN (USA), 1906. **d** Benington, VT (USA), 1965.
Voltri VII. 1962. Iron. **h**216 x **w**311 x **l**110 cm. **h**85 x **w**122¾ x **l**43½ in. National Gallery of Art, Washington, DC

Smith Kiki

Train

In this unnervingly realistic female sculpture, the trail of glass beads expelled from between the figure's legs represents menstrual blood. It was produced by making a direct cast of a woman's body. Using harsh, visceral and explicit imagery, Smith expresses the pain and cost of inhabiting the female form. Questioning traditional notions of feminine purity, she transforms a bodily process of excretion into something fascinating to behold. Using similar techniques, Smith has fashioned the heart, womb, hands, legs, spinal column and even skin into independent sculptural objects. Women's bodies have been represented throughout art history as the subject for male artists. Smith's work, in common with that of many feminist artists of the latter part of the century, attempts to reclaim the female form, and to explore the controlling influences which determine how it appears and is perceived by both the individual and by society.

☞ Chadwick, Gilbert & George, Hatoum, Mendieta, Segal

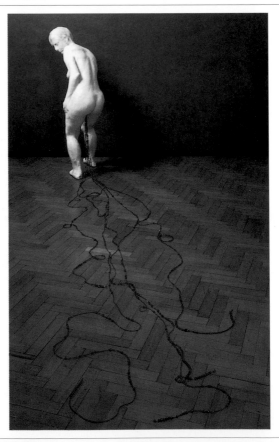

Kiki Smith. **b** Nuremberg (GER), 1954.

Train. 1993. Wax with glass beads. **h**134.6 cm. **h**53 in. Private collection

Smithson Robert

Spiral Jetty

A jetty, constructed from earth, spirals from the shore of the Great Salt Lake in Utah. Like a huge, archaic symbol in the vast landscape, it speaks of the infinite. Incongruous, yet subject to the same climatic conditions as its surroundings, the piece questions the division between the natural and the man-made. Though eventually swallowed by the rising lake, *Spiral Jetty* recently re-emerged, prompting a poignant reconsideration of Smithson's investigations into place and time. Having initially made cool Minimalist objects,

Smithson reacted against the confines of the gallery space by taking his art into remote territories. A leading Land artist, he aimed to address the function of art in the real world. These massive projects, in which the erosions of nature were an integral element, could be viewed best from the air. For Smithson, this had tragic consequences. In 1973, he was killed in a helicopter crash while inspecting a work.

☛ Christo, Goldsworthy, Long, De Maria

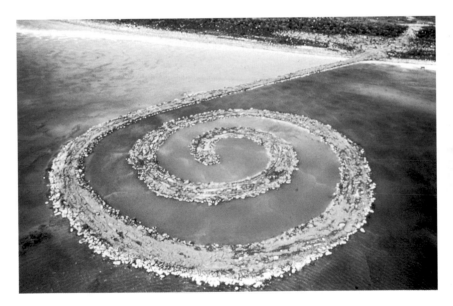

Robert Smithson. b Rutherford, NJ (USA), 1938. d Amarillo, TX (USA), 1973.
Spiral Jetty. 1970. Rock, salt crystals, earth and water. diam. 457 m. diam. 1500 ft (approx). Great Salt Lake, UT

Soulages Pierre

Untitled

Fat, vertical and horizontal swathes of dark paint overlay each other, forming a lattice which dominates the picture plane. The thick paint applied in large sweeping strokes emphasizes the physical process of painting. Blue has been mixed with black in this work. In other works by the artist black dominates, mixed with green, grey or brown. For Soulages, the visual effect was the most important element of his paintings and any illusion of recognizable forms was unintentional. He wished to depict a visual tension that would suggest emotions such as loss, hope and frustration. Such works often look larger than the actual size of the canvas suggests. Soulages was a member of a group of artists whose style was known as Tachisme. Influenced by the calligraphic art of Eastern Asia, their work was dynamic, spontaneous and above all, expressive of the process of painting, recording the gestures of hand and arm in applying paint to canvas.

☞ Fautrier, Hartung, Kline, Michaux, De Staël

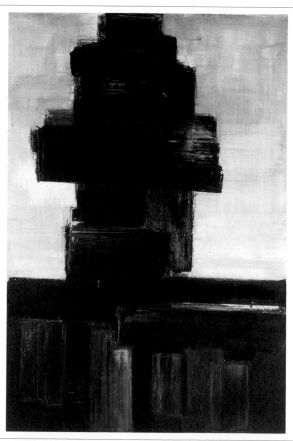

Pierre Soulages. b Aveyron (FR), 1919.
Untitled. 1956. Oil on canvas. **h**195 x **w**130 cm. **h**76¾ x **w**51⅛ in. Private collection

Soutine Chaim

The Boy in Black

An emaciated boy looks mournfully out at the viewer. Set against a dark ground, the figure has a haunting and melancholy air. Soutine evokes strong emotions through his use of sombre colours and exaggerated brushstrokes. This emphasis on feeling rather than realistic representation is typical of Expressionism. There is a bleak sadness about Soutine's work, a sense of isolation exuded by his protagonists, which is heightened by the frequent use of heavy impasto and swirling brushstrokes. Soutine was influenced by fellow artists Modigliani and Chagall, whom he met in Paris in the 1920s, but his strange elongations also owe something to the sixteenth-century Mannerist painters, Jacopo Tintoretto and El Greco. Soutine is also well known for his landscapes, inspired by Cézanne, and for his still lifes in which he often depicted rotting carcasses. His emotional three-quarter-length portraits inspired the American Abstract Expressionist painter, De Kooning.

☛ **Cézanne, Chagall, De Kooning, Modigliani, Spilliaert**

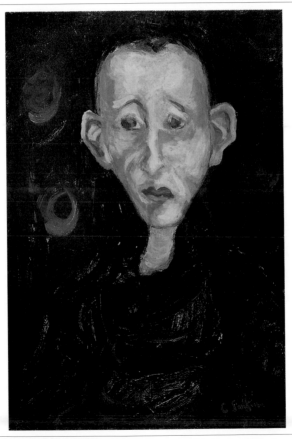

Chaim Soutine. b Minsk (RUS), 1893. **d** Paris (FR), 1943.
The Boy in Black. 1924. Oil on canvas. **h**46.7 x **w**32.1 cm. **h**18⅜ x **w**12⅝ in. Private collection

Spencer Stanley

Self-portrait with Patricia

The artist himself poses with his back towards the viewer, his head turned at an awkward angle. Behind him his wife lies on their bed, her expression vacant, possibly post-coital. The uneasy, high-focus realism of this work, and the unidealized poses of the figures force the viewer into an embarrassingly intimate relationship with the couple. Spencer has often been marginalized as an 'eccentric', an artist who followed his own increasingly idiosyncratic vision, oblivious to trends in art at the time. But though he did not abandon figurative art in favour of abstraction, his works show the influence of progressive tendencies such as the use of distorted anatomy and space, and complex psychological states. In most of his paintings, Spencer celebrates in a whimsical, childlike, sometimes disturbing manner his Christian faith and life in the Thames Valley village of Cookham where he was born. He is also well known for his vast mural decorations in Burghclere Chapel, Hampshire.

☞ Freud, De Lempicka, Modigliani, Schad

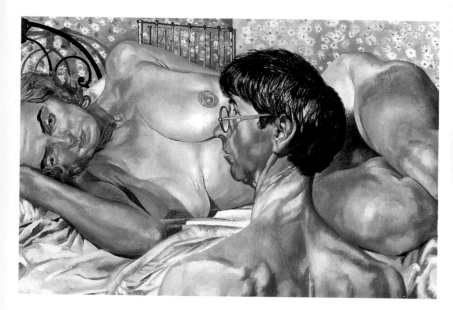

Stanley Spencer. b Cookham (GB), 1891. d Cliveden (GB), 1959.
Self-portrait with Patricia. 1936. Oil on canvas. h61 x w91.5 cm. h24 x w36 in. Fitzwilliam Museum, Cambridge

Spero Nancy

Sky Goddess/Egyptian Acrobats

Female figures in a variety of poses have been cut out and pasted onto 11 vertical panels. Arranged in this format, they resemble hieroglyphics, and seem to be telling a story. The sky goddess who features in this work is an amalgam of the Egyptian goddess, Nut, and the she-wolf, mother of Romulus and Remus from Classical mythology. From mythical goddesses, to Celtic fertility symbols and contemporary imagery often culled from press photography, each diverse element of Spero's work is treated in sharp, concise, graphic form. Often displayed on the architecture of a gallery, or on horizontal scrolls, Spero's works are strewn with episodes of violence and anguish. Through playful repetition, her hand-printed personal emblems quote and parody the way in which the female form has been represented by men, while celebrating the ancient, mythic attributes of femininity. Within Spero's arena, the female body acts as a vehicle to explore differing concepts of sexuality and power across space and time.

☛ Dumas, M Kelly, Léger, Salle

Nancy Spero. b Cleveland, OH (USA), 1926.
Sky Goddess/Egyptian Acrobats. 1987–8. Hand-printing and printed collage on paper. **h**274 x **w**671 cm. **h**108 x **w**264⅜ in.
Private collection

Spilliaert Léon

Self-portrait

The artist stares suspiciously over his left shoulder at the viewer, his face sharply illuminated. Nothing detracts from the impact of the painter's mistrustful gaze. The tark simplicity and brooding colours of this confrontational self-portrait link Spilliaert with Expressionism's aim to convey inner feelings. The slightly elongated proportions emphasize the sense of anxiety and isolation exuded by the portrait. It is an incredibly bold image for its time. Spilliaert, like fellow Expressionist Ensor, lived virtually his entire life in his birthplace, the Belgian town of Ostend. He was a self-taught artist and, partly because of this, developed an individual style combining visionary qualities with realism. His emphasis on dream-like motifs was later to have a bearing on Surrealism. Spilliaert was on friendly terms with the poets Maurice Maeterlinck and Émile Verhaeren. Like theirs, his work reflects the nervous anxiety that marked the turn of the century.

☛ Ensor, Kippenberger, Modigliani, Schjerfbeck

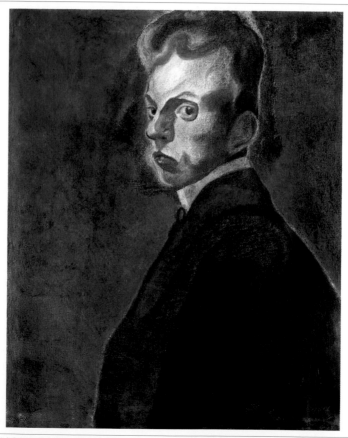

Léon Spilliaert. **b** Ostend (BEL), 1881. **d** Brussels (BEL), 1946.
Self-portrait. 1907. Watercolour and pastel on paper. **h**75.3 x **w**60 cm. **h**29⅝ x **w**23⅝ in. Private collection

Spoerri Daniel

Trap Picture

This bird's-eye view of a table reveals the remains of a meal. Empty coffee cups, cigarette ends, a candle, cutlery, a glass and several empty bowls are the visual signs of an everyday ritual. Although the image appears to be the documentation of a real event, Spoerri has spent much time carefully ordering the objects. He called these versions of the still life 'Trap Pictures', an ongoing series which was intended to reflect common interactive experiences. The idea of assemblage – incorporating ordinary objects into artworks – was of primary importance to the Nouveaux Réalistes, a group co-founded by Spoerri along with Klein and others, who used everyday items for aesthetic ends. A sense of performance and occasion was a key element in their activities, which had roots in Dada and Surrealism. A one-time banana-seller and trained ballet dancer, Spoerri also co-published *Matérial*, a journal of concrete poetry, in which the visual appearance of the words expresses their meaning.

☛ **Klein, Le Corbusier, Morandi, Ozenfant, Schnabel**

Daniel Spoerri. b Galati (ROM), 1930.

Trap Picture. 1972. Objects on painted wood in Plexiglas box. **h**70 x **w**70 x **l**33 cm. **h**27½ x **w**27½ x **l**13 in. Private collection

De Staël Nicolas

Countryside

Thick bands of textured colour, ranging from lemon yellow to burgundy red, cover the canvas. Although this work is abstract in appearance, the title suggests that it represents a landscape, where fields, paths and sunlight have been reduced to the bare minimum. Applying the oils with a palette knife to give the surface a tactile quality and increase the sense of his painterly activity, De Staël concentrated on working with a diversity of textures and colours. Unlike his contemporaries, who were interested in making gestural blots and marks purely for expressive, introverted ends, De Staël wanted to expand the boundaries of painting, drawing on a wide range of artistic influences, from the works of the seventeenth-century Dutch painter, Rembrandt, to Léger. From 1953 until his death two years later, he returned to a pared-down form of figuration. Of Russian descent, De Staël, along with Poliakoff, injected freshness into the painting circles of post-war Paris.

☛ **Diebenkorn, Francis, Léger, Poliakoff**

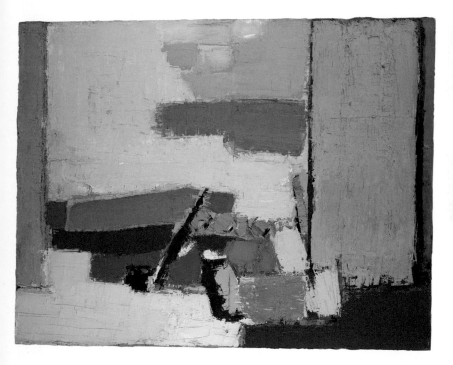

Nicolas de Staël. **b** St Petersburg (RUS), 1914. **d** Antibes (FR), 1955.
Countryside. 1952. Oil on canvas. **h**114 x **w**146 cm. **h**44⅞ x **w**57½ in. Private collection

Steinbach Haim

supremely black

Three boxes of washing powder and two jugs are set on a red and black Formica shelf. These ordinary consumer products are arranged like objects in a shop window, as well as displaying the formal and compositional qualities of a work of art. Steinbach has selected the objects to match the colour scheme, while the shelf looks just like a pared-down, Minimalist sculpture. Raising the question of how art is valued, this is a unique artwork, yet it is constructed from mass-produced goods. The satisfying arrangement of the different elements highlights the way in which aesthetic choices are made in everyday life in the purchase of consumer goods and household objects. Steinbach has made a number of similar works which all include angled Formica shelves – an element which has become his trademark. He has used a diverse range of goods, including sports shoes, digital clocks, cooking pots and pedal bins, to create works that transform familiar objects into trophies of consumer culture.

☛ Duchamp, Hanson, Judd, Warhol

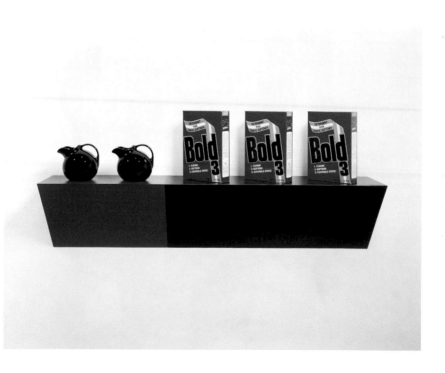

Haim Steinbach. b Rehovot (IS), 1944.

supremely black. 1985. Plastic, laminated wood shelf with ceramic pitchers and cardboard detergent boxes.
h73.7 x **w**167.6 x **l**33 cm. **h**29 x **w**66 x **l**13 in. Private collection

Stella Frank

Jarama II

Snaking curves decorated with flamboyant patterns project from the wall. Typical of Stella's work of the 1980s, this violently coloured relief forces the viewer to consider the point at which painting becomes sculpture or a curving abstract form becomes a snake. This bright, three-dimensional painting is a total contrast to Stella's early work of the late 1950s and 1960s, in which he tested how pure abstract painting could be. The results were monochrome paintings whose overall symmetry emphasized the flatness of the canvas. Important in the development of Minimalism, these works were followed by a famous series of large, unusually shaped canvases where monochrome stripes echo the form of the canvas. What unifies Stella's diverse work are the questions he asks about the nature of painting itself and his attempt to free it from being an allusion to some external reality, making the actual physical object the focus of his attention.

☛ **Calder, Haring, Hofmann, Johns, Riopelle**

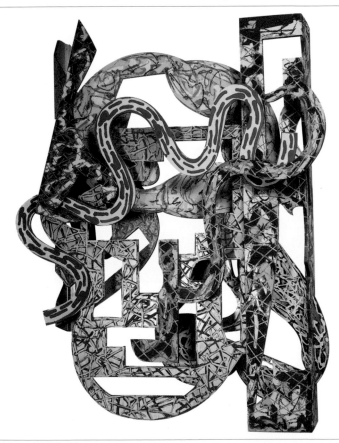

Frank Stella. **b** Malden, MA (USA), 1936.
Jarama II. 1982. Mixed media on etched magnesium. **h**319.9 x **w**253.9 x **l**62.8 cm. **h**126 x **w**100 x **l**24¾ in.
National Gallery of Art, Washington, DC

Stella Joseph

Brooklyn Bridge

The fractured image of Brooklyn Bridge emerges from a mass of prism-like forms. Visible through the dense patchwork of rich colours and criss-crossing lines in the centre of the composition is one of the towers at the end of the bridge, the road vanishing through the double arch. Part figurative and part abstract, this work celebrates urban technology. The dynamic fragmentation of forms and the interest in modern construction is typical of Futurism, a movement which Stella encountered during his time in Italy and France between 1909 and 1912. He went on to become the leading Futurist in America. Stella painted several pictures of Brooklyn Bridge, describing it as 'the shrine containing all the efforts of the new civilization – America'. He also executed many drawings of his neighbourhood in New York's Lower East Side, as well as of the mining towns of West Virginia and Pittsburgh, recording the life of industrial America.

☛ **Demuth, Derain, Gris, Grosz**

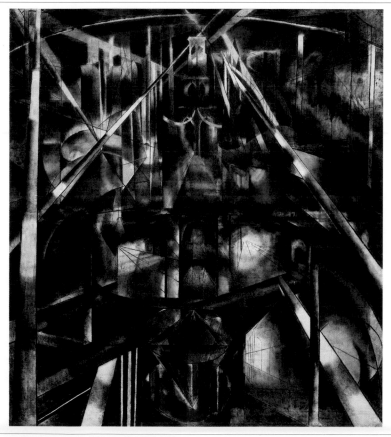

Joseph Stella. **b** Muro Lucano (IT), 1877. **d** New York (USA), 1946.
Brooklyn Bridge. 1918–20. Oil on canvas. **h**214.5 x **w**194 cm. **h**84½ x **w**76½ in. Yale University Art Gallery, New Haven, CT

Sterbak Jana

Cage for Sound

A bizarre, tube-like cage made from bamboo is set on wheels. The leather strap is intended to be attached to the body of a runner who circuits a sports stadium, pulling the contraption behind. The body is the central focus in Sterbak's work, which often incorporates elements of performance. Using a diverse range of materials including chocolate, slabs of meat, cotton, rubber, video and photography, Sterbak's pieces reflect the vulnerability and impermanence of the body. Many of her sculptures contain the human form in some kind of protecting shell and combine the elemental and animalistic with the mechanistic. The theme of constraint present in this work can be read on both a personal and a political level. Though Canadian, Sterbak was born in Czechoslovakia, and her work reveals the influence of Eastern European literary and theatrical traditions of the absurd as a vehicle for political irony.

☞ **Deacon, Espaliú, Horn, D Smith, Tinguely**

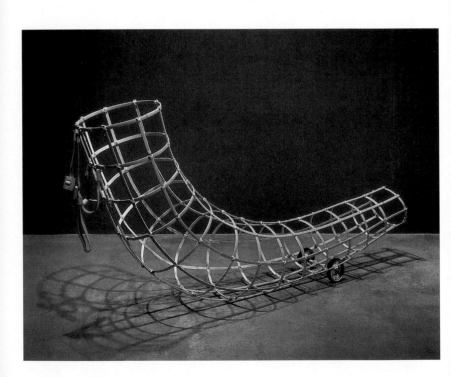

Jana Sterbak. b Prague (CZ), 1955.
Cage for Sound. 1994. Bamboo, wheels and leather straps. **h**63 x **w**210 x **l**99 cm. **h**24$\frac{7}{8}$ x **w**82$\frac{3}{4}$ x **l**39 in. Donald Young Gallery, Seattle, WA

Still Clyfford

Untitled

All the detail has been pushed to the edges of this picture, leaving the middle a vast sea of orange. The jagged shapes have been likened to the raw landscape of the Midwest of America, though the artist himself claimed there was no such reference intended. Instead, he said he wished to create purely abstract and emotionally charged compositions which would be detached from associations with things or places. Hence the work is untitled – we are invited to experience it as an object of interest in its own right, not as a representation of

something else. The scale is huge, the paint laid on thickly. The colours have been chosen in order to generate a powerfully physical and emotional effect. Still was associated with the Abstract Expressionists in the late 1940s and 1950s, and like them, he aimed to maximize the direct, physical impact of his painting through scale, texture, colour and simplicity of image.

☛ **Diebenkorn, Förg, Newman, Rothko**

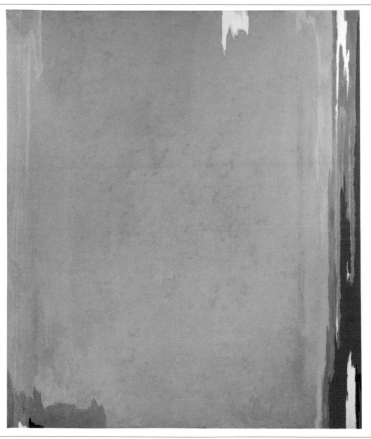

Clyfford Still. **b** Grandin, ND (USA), 1904. **d** New Windsor, MD (USA), 1980.

Untitled. 1951. Oil on canvas. **h**274 x **w**235 cm. **h**108 x **w**92½ in. National Gallery of Art, Washington, DC

Stockholder Jessica Sea Floor Movement to Rise of Fireplace Stripping

In this installation, Stockholder assembles found objects – from the boxes and drawers on the left, to the richly patterned blankets on the right – with large, pink Plexiglas panels, reminiscent of the Colour-Field paintings of Newman. The light bulbs, suggestive of the light source in paintings, give off heat, thus adding a physical dimension to the work. The artist weaves all these elements into the gallery space – the beams of the room and the windows forming part of the work. The poetic title seems to suggest that the work is about the natural and man-made worlds, as the artist brings order to the disparate objects which surround us. Stockholder combines painting, sculpture and assemblage in site-specific installations which often resemble the controlled chaos of a junkyard or construction site as much as works of art. Drawing upon an endless inventory of materials, fixed together in a variety of ways, she balances all the elements at a point somewhere between imminent explosion or implosion.

☛ Brisley, Dine, Hesse, Newman, Rauschenberg

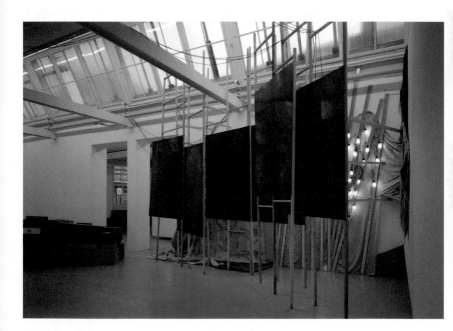

Jessica Stockholder. b Seattle, WA (USA), 1959.

Sea Floor Movement ... 1992. Pink Plexiglas, light bulbs and fixtures, blankets and furniture. **h**500 x **w**483 cm. **h**197 x **w**190½ in.

As installed at the Kunsthalle, Zurich

Struth Thomas

'South Wabash Avenue' Chicago 1992

In this photograph of South Wabash Avenue in Chicago, we almost feel as if we know the street depicted. The advertising hoardings and shop signs, and the view into the mid-distance make us feel as if we are actually standing on the pavement. The absence of people and the lack of movement gives the impression of a ghost town. Photography has the ability to document places, people and personal experiences with such accuracy that the images can be stronger and more evocative than our actual memories. With this work, Struth pushes the power of the medium to the extreme. His portraits of people have a similar sense of immediacy and presence, though their still poses give them the eerie look of wax-work dummies. In another series, Struth photographed visitors to museums and galleries looking at paintings, establishing a fascinating relationship between the spectators and the works of art.

☛ Burgin, Davis, Estes, Wall

Thomas Struth. b Geldern (GER), 1954.

'South Wabash Avenue' Chicago 1992. 1992. Black and white photograph. **h**45.4 x **w**58.7 cm. **h**17⅞ x **w**23⅛ in. Edition of 10

Sutherland Graham

Entrance to a Lane

The entrance to a country lane emerges from a dense patchwork of colour. The overhanging leaves and branches at the top of the canvas suggest a real landscape, while the amorphous forms and discordant colours introduce an element of abstraction. Sutherland often used the landscape as a vehicle for spiritual expression, producing a particular vision of the English countryside that occasionally verged on the gothic. 'I am fascinated by the whole problem of the tensions produced by the power of growth,' he said. His melancholic, unpopulated landscapes, painted in fiery reds, murky greens and flashing yellows, and his images of devastation made as a war artist, have the intensity of religious works. Like fellow war artist Nash, Sutherland used abstraction for his own expressive ends. Ironically, despite the detachment of his work from the everyday, Sutherland painted many highly regarded society portraits as well as public commissions which include a tapestry for Coventry Cathedral.

☛ Hitchens, Hodgkin, Nash, Redon

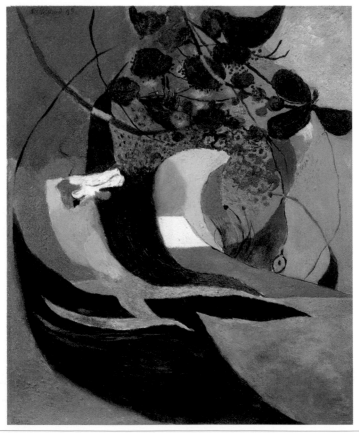

Graham Sutherland. b London (GB), 1903. **d** London (GB), 1980.
Entrance to a Lane. 1939. Oil on canvas. **h**145.4 x **w**123.2 cm. **h**57¼ x **w**48½ in. Tate Gallery, London

Tagore Rabindranath

Untitled

The image of a woman is conjured up from a rich mass of inky lines, smudges and blots. She seems to be quietly absorbed in thought, gazing out at the viewer, and beyond, into infinity. The slatted chair-back acts as a geometric counterpoint to the brushy outline of the figure. Tagore has created this image out of a spontaneous play of line and tone, aiming to make it a symbol of some higher reality. Tagore had already established himself as the foremost poet and writer of his generation in India when, in 1928, at the age of 67,

he turned to painting. Like his writing, his painting is suffused with a visionary quality which has links with Symbolism, where colours and forms stand for states of mind rather than reality. Tagore fused Western and Indian cultural traditions, producing a body of work which is an early instance of the fruitful dialogue between ancient traditions and beliefs and the use of modern techniques in art.

☛ John, Kapoor, Neel, Schlemmer

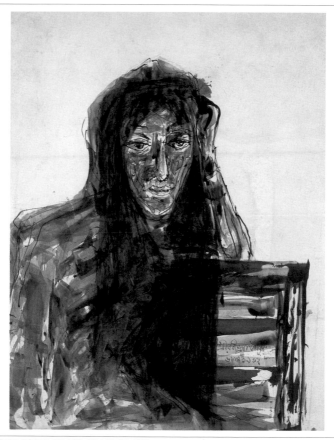

Rabindranath Tagore. b Calcutta (IN), 1861. **d** Calcutta (IN), 1941.
Untitled. 1932. Ink on paper. **h**55 x **w**38.5 cm. **h**21⅔ x **w**15⅛ in.
Rabindra Bhavan Archive, Visva-Bharati University, Santini Ketan, West Bengal

Tamayo Rufino

Children Playing with Fire

Two children dance with abandon, silhouetted in front of a raging fire. The dislocated forms in this painting owe much to Cubism and the colours are reminiscent of Gauguin. But Tamayo also drew on pre-Columbian history, incorporating in his work references to the culture of the Aztec, Toltec and Mayan civilizations. Often depicting simple figures and animals, as here, he limited his range of warm and earthy pigments to ochre, orange, brown, blue and yellow – colours highly symbolic of Mexico's spiritual strength. Tamayo's hybridized approach, which some Mexicans found difficult to accept, epitomized Mexico's double heritage of Spanish and American-Indian culture. Tamayo was one of the most important Mexican artists of the century along with Rivera and Kahlo. Although he was part of the Mexican League of Revolutionary Painters that included the muralists Orozco and Siqueiros, Tamayo transcended the political. 'The Sun is in all his pictures', said Mexican writer Octavio Paz.

☛ Appel, Gauguin, Kahlo, Lam, J C Orozco, Rivera, Siqueiros

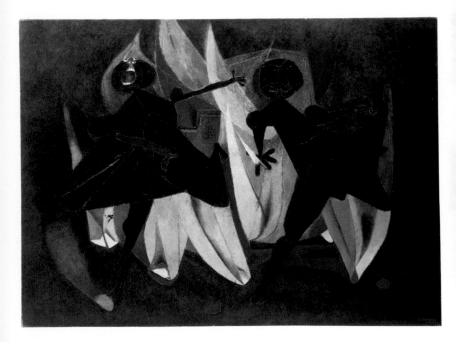

Rufino Tamayo. **b** Oaxaca (MEX), 1899. **d** Mexico City (MEX), 1991.

Children Playing with Fire. 1947. Oil on canvas. **h**127 x **w**172 cm. **h**50 x **w**67¾ in. Private collection

Tanguy Yves

The Ribbon of Extremes

In a mysterious, nocturnal desert, or lunar landscape, strange organ-like shapes are strung together. Although they suggest animals or plants, they are unidentifiable as anything real. The colour scheme is particularly beautiful, with a subtle gradation of tone from the cream foreground, through to the warm purple tones of the sky. The poet and critic André Breton wrote of Tanguy's work: 'The tide ebbs, revealing an endless shore where hitherto unknown composite shapes creep … They have no immediate equivalent in nature and it must be said that

they have not as yet given rise to any valid interpretation.' The dream-like atmosphere of this painting links it to Surrealism. Like the other Surrealists, Tanguy was very interested in the ideas of the psychoanalyst Sigmund Freud. He believed that a painting could be a 'dream scene' onto which he could project subconscious mental activity. Tanguy spent two years in the merchant navy before taking up painting in 1923, after being inspired by the work of De Chirico.

☞ De Chirico, Dali, Nash, Sage

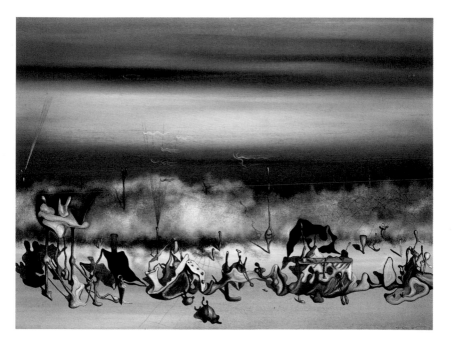

Yves Tanguy. **b** Paris (FR), 1900. **d** Woodbury, CT (USA), 1955.
The Ribbon of Extremes. 1932. Oil on canvas. **h**35 x **w**45 cm. **h**13¾ x **w**17¾ in. Private collection

Tanning Dorothea

A Little Night Music

A girl in a torn, white dress, her hair streaming upwards, stands in front of an enormous sunflower whose broken stem reaches out towards her like a thick, green tentacle. Nearby, another girl, almost naked to below the waist, leans against a numbered door. This girl holds a sunflower petal in her hand; two other petals lie on the stairs. Standing in this rather gloomy, dilapidated corridor, the girls appear static and fixed in time. Along the hallway a door stands ajar, revealing an eerie light. The title of the painting alludes to Mozart's famous musical work, giving the painting an aural dimension. Tanning's work often combines a sinister sexuality with a fairy-tale, childlike sensibility evoking childhood fantasies and nightmares. Apart from two weeks spent at the Chicago Academy of Fine Art, Tanning was a self-taught artist. In 1942 she met Ernst in New York. In 1946 the couple were married and moved to France, where Tanning worked as a painter, graphic artist and designer of stage sets and costumes.

☞ **Carrington, Delvaux, Ernst, Fischl**

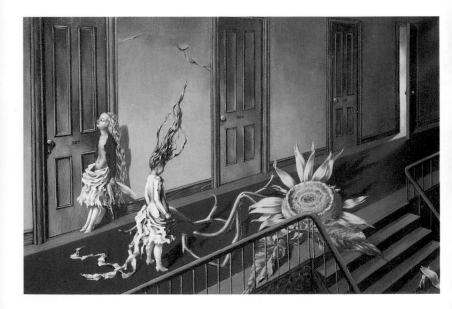

Dorothea Tanning. **b** Galesburg, IL (USA), 1910.
A Little Night Music. 1946. Oil on canvas. **h**41 x **w**61 cm. **h**16⅛ x **w**24 in. Private collection

Tansey Mark

Action Painting II

A group of amateur artists paint the launch of a space shuttle. The one in the centre of the foreground is putting the finishing touches to the cloud of smoke billowing out of the rocket, while another on the right stands back to admire his work. Painted in a range of blues, this image has the feel of a newspaper photograph. However, closer examination reveals that the work is in fact far from realistic: the artists have almost finished their pictures of an event which is only just taking place. The title refers to a group of painters, including Pollock and De Kooning, who emphasized the physical act of painting by dripping or even throwing paint directly onto the canvas, and were known as 'action painters'. In this work, Tansey's 'action painters' are of quite a different kind, patriotically depicting American technology under the country's flag. Tansey is one of a group of artists who placed a new focus on figurative painting in the 1980s.

☛ De Kooning, Magritte, Miyajima, Modigliani, Pollock

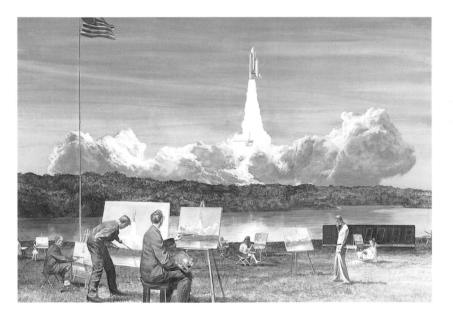

Mark Tansey. b San Jose, CA (USA), 1949.
Action Painting II. 1984. Oil on canvas. **h**193 x **w**279.4 cm. **h**76 x **w**110 in. Montreal Museum of Fine Arts

Tàpies Antoni

Ochre

The surface of this picture has been scraped in places with a palette knife and daubed with accents of black and white paint like a form of graffiti. The paint is encrusted with a mixture of sand and asphalt, giving the work an added texture. The mottled brown background and the lacerated canvas make this picture look as if it has been affected by the passage of time. Tàpies's use of everyday materials, such as sand and asphalt, is reminiscent of the work of Arte Povera artists, who transformed the simplest of elements into artworks, while the random jottings owe something to Art Informel, a movement which focused on abstract works inspired by the artist's subconscious. Born in Barcelona, Tàpies witnessed the events of the Spanish Civil War at first hand. The war had a significant impact on his work, giving it a powerful dimension and occasionally a political slant. Tàpies is one of the most important Spanish artists of the post-war period, admired for the haunting beauty of his works.

☛ **Burri, Fautrier, Tuymans, Yoshihara**

Antoni Tàpies. b Barcelona (SP), 1923.
Ochre. 1963. Paint, sand and asphalt on canvas. **h**275 x **w**400 cm. **h**108⅜ x **w**157⅝ in. Louisiana Museum of Modern Art, Humlebaek

Tatlin Vladimir

Complex Corner Relief

Pieces of wood and sheet metal are joined together and suspended from the corner of a room to produce a lively juxtaposition of contrasting shapes and materials. Picasso's Cubist collages, which combine different media, were the original inspiration for Tatlin's radical reliefs. He constructed them out of a variety of materials, though he often contrasted wood and metal. The work illustrated is a modern reconstruction of the original. Tatlin's reliefs were exhibited as a series in 1915, and they prompted the formation of the Constructivist circle

which included Tatlin, Rodchenko and his wife Varvara Stepanova. They believed that art should adopt the forms, materials and techniques of modern technology. Tatlin's most famous work, *Monument to the Third International*, a model for a tower that was never built, reflects his utilitarian, socially based approach to art. He was one of the few artists to remain in Russia after the Soviet authorities abandoned their very brief interest in avant-garde art.

☛ **Domela, Flavin, Gabo, Rodchenko**

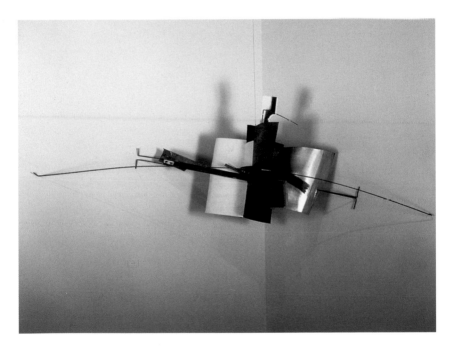

Vladimir Tatlin. b Kharkov (UKR), 1885. **d** Novodevichye (RUS), 1953.
Complex Corner Relief. 1915. Iron, aluminium and zinc. **h**73 x **w**152 x **l**76 cm. **h**28¾ x **w**59⅞ x **l**29⅞ in. Annely Juda Fine Art, London

Tchelitchew Pavel

Excelsior

A group of boys, gazing distractedly into the mid-distance, is drawn into some kind of communion with a higher state of being. The presence of butterflies, traditionally symbolizing the soul, adds to this sense of mysticism. A white butterfly – the colour of purity – rests on the eyes of the boy in the foreground, blinding his physical sight so that his spiritual vision can hold sway. He is surrounded by a mysterious, golden aura. Another butterfly – this time blue, a colour often associated with the spiritual dimension – flies towards the next boy. A third insect hovers above their heads. Although the strangeness of his imagery and the handling of space links Tchelitchew with the Surrealists, his art was essentially more traditional, deriving from nineteenth-century Romanticism and Symbolism. He was born in Russia, but spent his early years in Paris before emigrating to the United States shortly before the outbreak of the Second World War, where he remained until 1952.

☞ **M Kelly, Laurencin, Redon, Tanning**

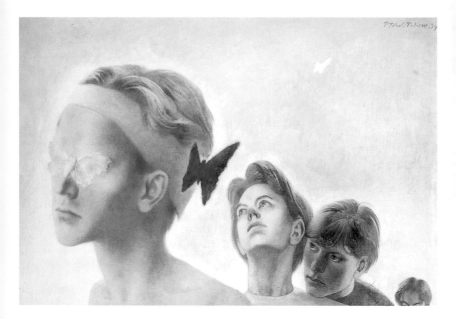

Pavel Tchelitchew. b Kaluga (RUS), 1898. **d** Grotta-Ferrata (IT), 1957.
Excelsior. 1934. Oil on canvas. **h**79 x **w**114.5 cm. **h**31 x **w**45 in. Private collection

Themerson Franciszka

Pietà Apocalypse

Three figures dominate the canvas, joining together to create one composite form. In the background, a complex web of lines and grooves etches out more images, some abstract, some figurative. The religious connotations of the title give the work a spiritual dimension. Themerson's Expressionist line, which was often incised into the surface of the canvas, is characteristic of her unique painting style, which is based on drawing. Also an illustrator, set designer, film maker, publisher and satirist, the Polish-born artist started her career by producing a series of influential Surrealist films, along with her husband Stefan. Her intuitive and energetic drawing and her acute observations of human foibles and characteristics combine the poetic with the tragic. Along with Stefan, she set up the Gaberbocchus Press, a small but important publishing house in London. A dexterous and underrated artist, Themerson lies outside immediate categorization.

☛ **Artaud, Dubuffet, Gottlieb, Guston, Tuymans**

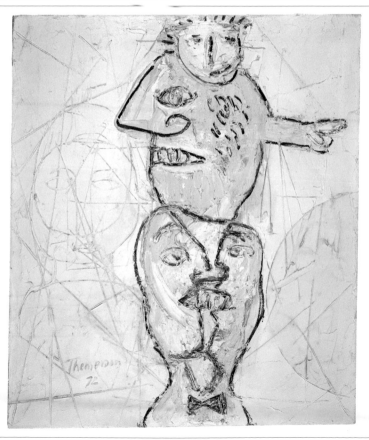

Franciszka Themerson. b Warsaw (POL), 1907. **d** London (GB), 1988.
Pietà Apocalypse. 1972. Oil on canvas. **h**100 x **w**85 cm. **h**39⅜ x **w**33½ in. Private collection

Thiebaud Wayne

Woman and Cosmetics

A head and shoulders portrait of a naked woman is juxtaposed with a display of the cosmetics she uses. Set against a stark blue background, the woman is unmasked and her artifice revealed – her lipsticks, eyeliners, brushes, powder pots and mirror are displayed for all to see. Thiebaud's realistic style and everyday subject matter have links with Pop Art, as he celebrates the banal with an ambiguous blend of familiarity and emotional detachment. The blue, purple and green colours in this painting are typical of his style and are derived from artificial lighting and the bright sunlight of California where he lives and works. Usually painting his subject from memory, Thiebaud produces works which are nostalgic in content and often humorous in tone. His accessible style has a particularly urban-American feel. A one-time sign-painter and cartoonist, Thiebaud has also painted witty images of cakes, pinball machines and hot dogs, executed in bright colours.

☞ **Bonnard, Laurens, Organ, Ray**

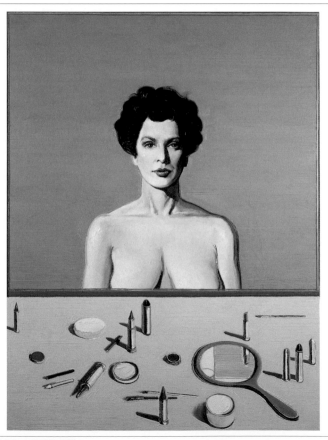

Wayne Thiebaud. **b** Mesa, AZ (USA), 1920.
Woman and Cosmetics. 1963–6. Oil on canvas. **h**121.9 x **w**91.4 cm. **h**48 x **w**36 in. Private collection

Tillers Imants

Partition of Place

This large piece is made up of 120 small canvas boards, individually painted then joined together. In the centre of the composition is a landscape, with words and numbers superimposed. Above, at the top, is a painted number two which looks just like a work by Johns; to the right is a portrait of a woman which resembles a Picasso; and at the bottom is a reference to Paik. Tillers is interested in the narrative that comes about through combining a number of different images. He is Australian, and this borrowing may reflect a reliance on reproductions of

works of art due to geographical isolation from the cultural capitals of Europe. Displacement, authorship and authenticity are central concerns for Tillers, whose hybrid works explore Australian identity. The self-consciousness of Tillers's appropriations also reflects a more general doubt about the value of painting in contemporary society.

☛ Boyd, Davila, Gottlieb, Johns, Paik, Picasso

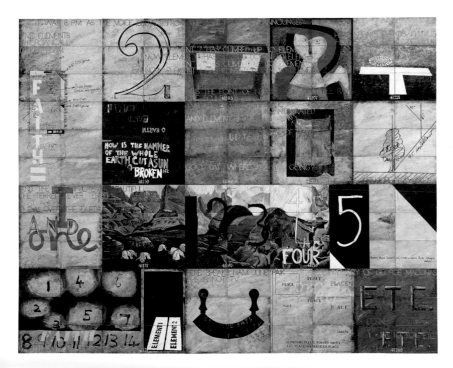

Imants Tillers. **b** Sydney (ASL), 1950.

Partition of Place. 1994. Oilstick, gouache and synthetic polymer paint on board. **h**305 x **w**381 cm. **h**120 x **w**150⅛ in.

Private collection

Tinguely Jean

Chariot MK IV

A series of cogs and wheels has been assembled to create a working machine. The sculpture appears to have a purpose, but in fact the moving parts have no use. Tinguely's early machines were constructed to produce automatic, abstract drawings; this was partly as a parody of Abstract Expressionism, the movement which valued spontaneous gesture as a means of creative release, and partly to satisfy his love of spectacle and movement. Often comprising found objects, his sculptures are a simple celebration of science. Bold and humorous, they became popular in the post-war period when many scientific and technical advances were made, and when there was an interest in art which laid emphasis on physical construction. The use of movement links Tinguely to Kinetic Art, while his incorporation of everyday objects allies him to the Nouveaux Réalistes. Later, he staged large-scale outdoor, multimedia events in which the viewer was encouraged to interact with his massive sculptures.

☛ **Borofsky, Bury, Calder, Deacon, D Smith, Sterbak**

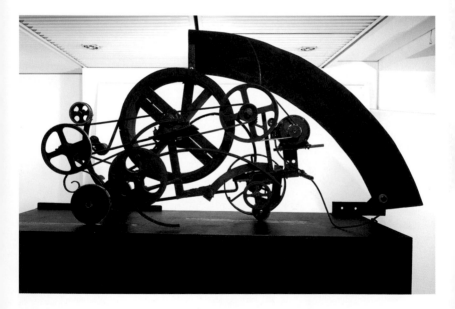

Jean Tinguely. **b** Fribourg (SW), 1925. **d** Fribourg (SW), 1991.
Chariot MK IV. 1966. Iron. **h**210 x **w**106 x **l**65 cm. **h**82¾ x **w**41¾ x **l**25⅔ in. Moderna Museet, Stockholm

Tiravanija Rirkrit

Untitled (Free)

For this installation, a New York gallery was cleared of its usual equipment and transformed by Thai artist Tiravanija into a functioning kitchen offering free Thai curry to all visitors. The gallery was turned inside out, the contents of the office and storage areas were moved into the main gallery, while the rear office housed the exhibition, namely a temporary canteen for the artist to prepare and serve food. Connecting art and food has a long tradition, dating back to Ancient Egyptian depictions of banquets to seventeenth-century still-life painting. Tiravanija, however, does not create a traditional art object, such as a painting or sculpture, but sets out to expand the limits of what we consider to be art. His aim is to dismantle the singular position of the artist, by making his art/food available to everyone. For Tiravanija, art is a spiritual activity concentrating on acts of generosity and human contact – for example, cooking a meal.

☞ Beuys, Brisley, Green, C Noland, Stockholder

Untitled (Free). 1992. Tables, stools, food, crockery and cooking utensils. Dimensions variable.
As installed at the 303 Gallery, New York

Tjapaltjarri Clifford Possum

Kangaroo Dreaming

Kangaroo Dreaming tells a story from the 'Dreaming', the sacred world of the spirit ancestors who are believed by the Aborigines to have created every creature and entity that exists in the world. Despite its abstract character, *Kangaroo Dreaming* is in fact a map or plan of a specific tribal site, detailing its particular history and importance. An insight into the meaning of the complex layering of symbols is essential to any full understanding of the painting. The red footprints, for example, represent moving kangaroos, while the curved shapes denote kangaroos

lying down by a dried-up river bed. Hunters with body paint are visible, as are the camp sites. The work has its roots in the ancient Australian tradition of sand-painting which goes back many thousands of years. Tjapaltjarri is a key figure in the group of artists known as the Western Desert Painters who have reinvented their aural and visual traditions in the modern form of painting on canvas.

☛ Boyd, Hotere, Rae, Tillers

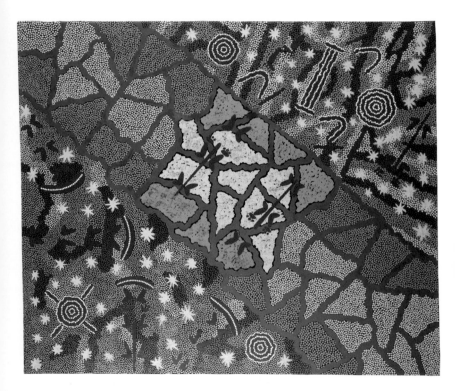

Clifford Possum Tjapaltjarri. **b** Nabberby Creek (ASL), 1932.

Kangaroo Dreaming. 1986. Acrylic on canvas. **h**137 x **w**152 cm. **h**54 x **w**60 in. Private collection

Tobey Mark

Untitled

A seemingly chaotic labyrinth of spidery black lines covers the surface of the paper. Weaving in and out of each other, they set up a dynamic rhythm, making the whole composition look as if it is moving. Although, superficially, it looks like the work of Abstract Expressionist painters such as Pollock, the ideas behind it are quite different. Unlike Pollock, who was interested in the actual process of painting, Tobey was motivated by a spiritual goal, and viewed painting as a form of meditation, not an action. This approach is in keeping with his religious beliefs: he

was a convert to the Bahá'í Movement which emphasizes the unity of all religions, and his art reflects a more universal approach to the world. Starting his career as a fashion illustrator, Tobey had no formal training in art, in common with Mondrian and Kandinsky before him, but went on to become a painter of international stature.

☛ **Art & Language, Kandinsky, Michaux, Mondrian, Pollock**

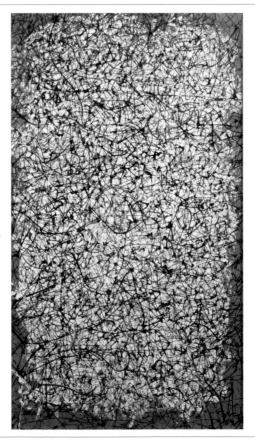

Mark Tobey. **b** Centerville, WI (USA), 1890. **d** Basle (SW), 1976.
Untitled. 1959. Gouache on paper. **h**34.3 x **w**19.5 cm. **h**13½ x **w**7⅝ in. Private collection

Torres-Garcia Joaquin

Universal Art

Images of a man and a woman, the sun and moon, clocks, houses, astrological signs and a Greek cross are arranged in a tight, grid-like pattern on the canvas. These references to man, nature, civilization, astrology and religion suggest that this work is about the fundamental elements of human existence. The overall bronze colour of this work makes it look more like a sculpture than a painting, the naïve and childlike style perhaps reflecting the influence of the pre-Columbian sculpture of Torres-Garcia's native Uruguay. The combination of a grid with

universal symbols is typical of the artist's style, reflecting his strong belief in the ancestral power of Latin America. Born in Uruguay, Torres-Garcia studied art in Barcelona and later moved to New York, returning to his native Montevideo in 1933. A writer, teacher, theoretician and sculptor as well as a painter, he is widely considered to be one of the most important figures in twentieth-century Uruguayan art.

☞ **Gottlieb, Nevelson, Turnbull, Wölfli**

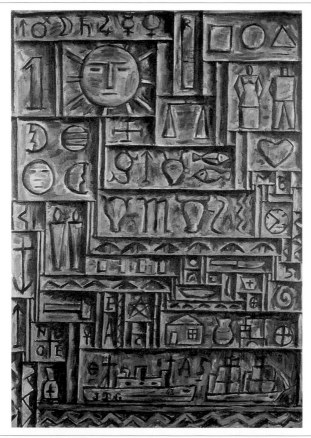

Joaquin Torres-Garcia. b Montevideo (URU), 1874. d Montevideo (URU), 1949.
Universal Art. 1943. Oil on canvas. h106 x w75 cm. h41¾ x w29½ in. Museo Nacional de Artes Visuales, Montevideo

Trockel Rosemarie

Playboy Bunnies

The logo of a soft-porn magazine has been incorporated into a piece of machine-knitting which has been stretched and mounted like a canvas. This work has a feminist slant, referring to the exploitation of women through pornography. It comes from a series of 'knitting paintings' which incorporate familiar signs and logos such as the pure wool sign and the hammer and sickle. The emblems are chosen from pattern books and women's magazines and the work is contracted out to knitting factories. The fabric is also used to make tapestries and garments. In using a traditionally handcrafted medium, typically designated as women's work, Trockel subtly questions the place of the woman artist in what, historically, has been a male-oriented art world. Presenting her machine-made knitted fabrics as art, Trockel also makes an ironic reference to Minimalism, which aimed to remove the artist from the making process. Trockel's *œuvre* is diverse, and includes sculpture, objects, paintings and photographs.

☛ **Boetti, Brossa, Paolozzi, Schapiro**

Rosemarie Trockel. b Schwerte (GER), 1952.
Playboy Bunnies. 1985. Wool. **h**40 x **w**50 cm. **h**15¾ x **w**19¾ in. Fundación Caja de Pensiones, Madrid

Turnbull William

Queen 2

A delicate pattern of lines covers the surface of this monolithic bronze sculpture. Set on a small plinth, it looks like a spearhead, eroded by the ravages of time. The totem-like form of this work and its pitted surface reflect the influence of African and Ancient Cycladic sculpture. Turnbull was first impressed by the art of other cultures when he visited the Museum of Mankind in Paris with Paolozzi in 1947. The powerful stillness of this work is typical of Turnbull and reveals the impact of the contemplative works of the Abstract Expressionists such as Rothko, whose paintings he admired. Born in Dundee, Turnbull learned to draw at evening classes, and started out by illustrating stories for magazines. After serving in the RAF he studied at the Slade School of Art in London and subsequently travelled to Paris, where he met Brancusi, among others. A painter as well as a sculptor, Turnbull has described his works as 'provocations to contemplation and order'.

☛ **Brancusi, Hamilton-Finlay, Paolozzi, Rothko, Torres-Garcia**

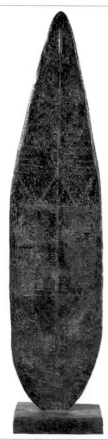

William Turnbull. **b** Dundee (GB), 1922.
Queen 2. 1988. Bronze. **h**214 cm. **h**84¼ in. Edition of 4

Turrell James

Rayzor

In this remarkable installation, light is isolated in a pristine architectural chamber to create an ethereal, visual phenomenon which can be experienced directly. A wall is positioned in front of a window at the far end of the room, leaving a narrow gap all round. This partition wall is then back-lit by fluorescent and natural light, causing the boundaries of the different surfaces to dissolve into a hazy plane of wall and light. Turrell paints with light, giving it such presence that it can almost be touched or felt. The strange, disorientating effect is reminiscent of the optically mesmerizing paintings of Rothko, or the luminous monochromes of Klein. For several years, Turrell has been engaged in a momentous Land Art project. He has bought a gigantic crater in the Arizona desert and is planning to build a number of chambers within it in order to capture and observe dramatic light effects from the sun, the moon and the stars.

☛ Flavin, Klein, Merz, Nauman, Opie, Rothko

James Turrell. b Los Angeles, CA (USA), 1943.

Rayzor. 1982. Fluorescent and natural light. Dimensions variable. Fundación Caja de Pensiones, Madrid

Tuttle Richard

Pink Oval Landscape

This simple, wall-bound sculpture is composed of four ovals of pink canvas, mounted on wood. The pleasing symmetry of the work and the delicate colour scheme help to create a moment of inner contemplation, away from the deluge of mass-media imagery and noise. Tuttle's work spans the ill-defined boundary between Minimalism and Post-Minimalism, which is the term used to describe the work of artists who questioned the hard-edged, machine-led aesthetic of abstract, Minimalist sculpture. The references to real-life objects, such as the title of this work, were the means by which the Post-Minimalists added another dimension to their work, beyond the purely abstract. Tuttle, while persistent in his quest for simplicity, has always used less austere materials than the Minimalists. Through his work, he achieves a deeply affecting balance between the autonomous object and its relationship to its surroundings.

☛ **Andre, Judd, E Kelly, Ryman**

Richard Tuttle. b Rahway, NJ (USA), 1941.
Pink Oval Landscape. 1964. Painted canvas on 4 wooden supports. Larger pieces: **h**43.5 x **w**9 x l6 cm. **h**17⅛ x **w**3½ x l2⅜ in.
Private collection

Tuymans Luc

Body

At first glance, *Body* seems an anonymous and incon-sequential painting. It shows the torso of a child's zip-up pyjama case, a small, near-abstract composition, painted with an almost careless disregard. Tuymans deliberately wishes to avoid the appearance of sophistication, seeing virtuosity as a self-indulgent vice. He uses cheap paints, badly stretched canvases, and sometimes employs a medium for the base coat which causes the surface layers of the painting to crack, resulting in premature ageing. The effect is of quiet, empty desperation.

Tuymans's colours are dismal and sickly, like the nicotine-stained walls of a decaying mental hospital. His paintings are a catalogue of fragmented moments, lost in history, already dead. Blood cells, an American candy jar, old newspaper photographs, even a Nazi gas chamber, are all encountered with the same disconsolate, troubled detachment. These are paintings from a long, inescapable era of anxiety.

☛ **Fautrier, Ryman, Sarmento, Tàpies**

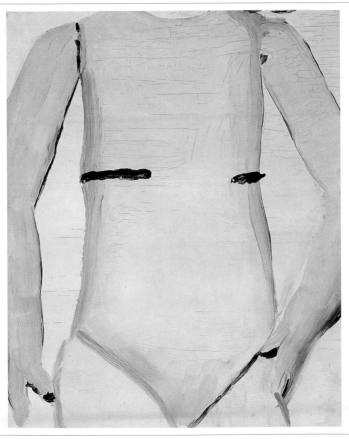

Luc Tuymans. b Antwerp (BEL), 1958.
Body. 1990. Oil on canvas. **h**49 x **w**35 cm. **h**19⅓ x **w**13¾ in. Museum van Hedendaagse Kunst, Ghent

469

Twombly Cy

First Part of the Return from Parnassus

A complex mass of abstract, coloured marks fills a sheet of paper. Red diagonal lines cross through a series of coloured sections and shapes with apparent abandon. Twombly's particular style of drawing, with its graffiti-like messiness of execution, combines the act of painting with writing. He often quotes from Classical myths, either through subject matter, by scrawled text (in this work the reference is to the holy mountain of Parnassus, sacred to the Muses of the arts), or through the epic scale of his works. Having studied under Motherwell and Kline,

Twombly was influenced by the spontaneity of the Abstract Expressionists, but unlike these artists he works in an individualistic manner, combining art and language and elements of the unconscious. A major inspiration for Twombly was the work of Klee, whose self-proclaimed stylistic method of 'taking a line for a walk' was adopted by the younger artist.

☛ Artaud, Basquiat, Klee, Kline, Motherwell

Cy Twombly. **b** Lexington, VA (USA), 1928.

First Part of the Return from Parnassus. 1961. Mixed media on paper. **h**70 x **w**100 cm. **h**27½ x **w**39⅜ in. Private collection

Ulay & Abramovic

Relation in Time

This photograph of the artists back to back with entwining hair is taken from a static performance. Central to the work is the notion of balance, the interwoven hair forming an umbilical-like cord between male and female body. The result is strangely androgynous. Although the physical link is ever-present, the purpose of the piece is for the artists to arrive at a point where mentally they consider themselves individual once more. To overcome the physical in this way requires immense focus. In this respect, the work is an act of endurance in which attachment and separation create cycles of activity. As partners, Ulay and Abramovic challenge stereotypical gender roles in performances which rely on mutual dependence. Attached to a crossbow and arrow, they become counterweights in a dangerously poised game. Joined in a passionate embrace, they suck oxygen from each other's mouthes in ever desperate breaths. In their work, the idea of the couple oscillates between the life-giving and the parasitic.

☛ Burden, Chadwick, Gilbert & George, Schütte

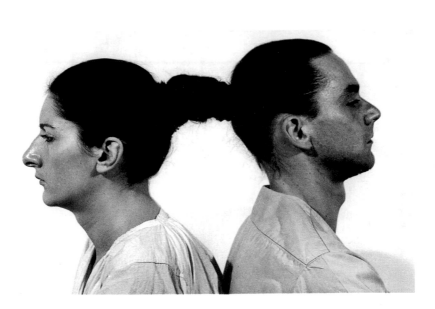

Utrillo Maurice

The Moulin de la Galette in Snow

Figures trudge wearily through the snow past the Moulin de la Galette in Paris, a windmill whose blades are starkly outlined against the bleak, wintry sky. The tufts of grass in the foreground on the right and the branches of the trees are painted sketchily, with rapid brushstrokes, conjuring up the impression of the scene. The style of this work, with its attempts to capture the essence of a townscape during the winter, is closer to the art of the Impressionists of the nineteenth century, than to that of Utrillo's contemporaries. Utrillo is best known for these wintry

urban scenes, which were sometimes painted from postcards rather than from direct observation. He had no formal artistic training, and initially took up painting as a hobby, in an attempt to combat his extreme alcoholism, which began early in life. The son of the painter Suzanne Valadon, Utrillo also designed stage sets for the choreographer Sergei Diaghilev. He is principally admired for his ability to express the loneliness and detachment of urban life.

☞ **Gauguin, Kirkeby, Liebermann, Marc, Monet, Wols**

Maurice Utrillo. b Paris (FR), 1883. d Le Vésinet (FR), 1955.
The Moulin de la Galette in Snow. 1923. Oil on canvas. **h**46.1 x **w**54.6 cm. **h**18⅛ x **w**21½ in. Private collection

Varo Remedios

The Flight

Two lovers flee in a magic, furry shell across a wind-swept desert, moving towards the safety of a grotto or mountain range. As in many of Varo's works, the figures are set in a strange, imaginary landscape, travelling to a mysterious destination. They seem emotionless in their quest, and their dress is timeless, although the woman's blue robe evokes images of the Virgin Mary. Varo painted classic, Surrealist images throughout her lifetime, using fiction, fantasy and dream-worlds as primary inspiration. Her style and subject matter remained consistent through-out her career, drawing heavily on her knowledge of Old Master paintings. The delicately modelled draperies here owe much to fifteenth-century Flemish art and the rocky landscape harks back to numerous earlier representations of Saint Jerome in the wilderness. As well as more typical Surrealist paintings, Varo also produced strange beasts, sometimes part-human, and weird contraptions. A painter of Basque origin, she spent most of her working life in Mexico.

☛ **Carrington, Chagall, Modotti, Tanning**

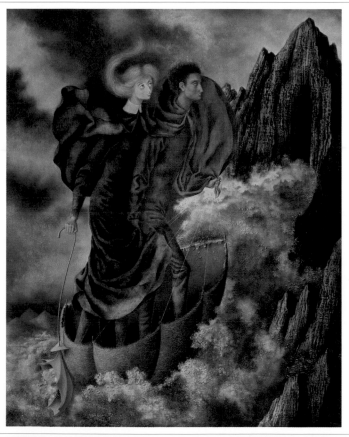

Remedios Varo. b Angles (SP), 1908. **d** Mexico City (MEX), 1963.

The Flight. 1962. Oil on masonite. **h**122 x **w**99 cm. **h**48 x **w**39 in. Museo de Arte Moderno, Mexico City

Vasarely Victor

Vega–Gyongiy–2

A large globe made up of multicoloured circles and squares hovers above a two-dimensional image of the same format. The immediate visual effect is the illusion of space and depth. Vasarely was a founder of Op Art, a movement that focused on the deceptive effects of manipulated lines and shapes. He based his method on the rigid principles of the influential German art school, the Bauhaus, but transformed its use of harsh outlines and hard edges to produce anonymous, geometric and precise forms that play tricks on the eye. His is a fiercely anti-nostalgic art which, like the work of the Futurists in the 1920s, actively celebrated and embraced the machine age and the advance of technology. Vasarely always viewed his work as performing a social function in local communities, and its graphic, illustrative quality has been most effective in the form of urban murals and three-dimensional architectonic structures.

☛ Albers, Bleckner, Goldstein, Riley

Victor Vasarely. **b** Pécs (HUN), 1908. **d** Paris (FR), 1997.
Vega–Gyongiy–2. 1971. Acrylic on board. **h**80 x **w**80 cm. **h**31½ x **w**31½ in. Private collection

Vautier Ben

Art is Useless, Go Home

'Art is useless, go home', reads the bold text in French, emblazoned in simple, white lettering on a scarlet background. This statement of aggressive wit is typical of Vautier, who has made a career out of questioning the validity of art. His *modus operandi* is 'art as strategy', in which he takes on the role of an outsider, issuing verbal one-liners in order to parody the hierarchical nature of art history and the artistic environment. Vautier's adolescent playfulness and irreverent attitude to art, often expressed by means of interactive performances, connect him with the Fluxus movement, an iconoclastic group which aimed to upset the art establishment. Characteristic actions included lying face down in the middle of a busy pavement and waiting for passers-by to walk over him, or sitting at a table outside a gallery with a sign saying: 'Ben signs other people's paintings.' His immediate and accessible form of social propaganda has included the production of leaflets, postcards, posters and small books.

☞ Kosuth, McCahon, Prince, Ruscha, Weiner

Ben Vautier. b Naples (IT), 1935.
Art is Useless, Go Home. 1971. Acrylic on canvas. **h**97 x **w**130 cm. **h**38½ x **w**51⅛ in. Galerie Bruno Bischofberger, Zurich

475

Vieira da Silva Maria-Elena Composition No. 4045

A highly intricate mosaic of blue, mauve and white interlocking squares covers the canvas. The surface is almost uniform except for a horizontal line of smaller squares which draws the viewer into the picture. Despite the abstract simplicity of the content, the painting works at many levels. The use of fleeting light links the artist's work to that of the nineteenth-century Post-Impressionist, Georges Seurat, and the grid format is reminiscent of Klee's colourful compositions. Vieira da Silva often attempted to transpose her love of architectural perspective onto canvas, but in this work the forms have been flattened, leaving only the idea of three-dimensional space. Vieira da Silva studied under the influential tutelage of Hayter in his school, the Atelier 17, before embarking on her own idiosyncratic style. Light and space were her main areas of enquiry and most of her output has focused on expressing these elements in abstract form.

☞ Fautrier, Hayter, Ryman, Scully

Maria-Elena Vieira da Silva. b Lisbon (POR), 1908. d Paris (FR), 1992.

Composition No. 4045. 1955. Oil on canvas. h116 x w137 cm. h45¾ x w54 in. Galerie Jeanne Bucher, Paris

Viola Bill

Nantes Triptych

This work consists of three, large-scale panels of projected video images. On the left a young woman is giving birth, while on the right an old woman is dying. Both are recordings of real events. In the centre, a naked figure is submerged under water, floating in a state of limbo, alternately still then moving in a turbulent manner, as if drowning. The polarities of birth and death are here seen as a continuum, linked through the chaos and temporary tranquillity of our lives. Viola uses advanced video technology to explore the most ancient and fundamental human mysteries. The videos are often projected in dark spaces to create atmospheric environments which are experienced three-dimensionally by the viewer. Viola is influenced by his extensive travels, studying local religions, and investigating different cultural responses to man's relationship with nature and other universal questions of existence.

☛ **Barry, Doherty, Dumas, Hatoum, Hill, Hiller**

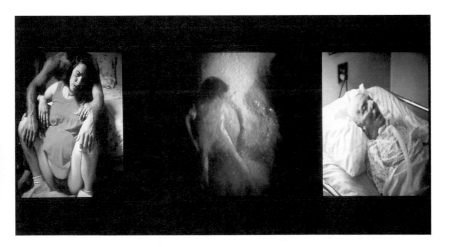

Bill Viola. **b** New York (USA), 1951.
Nantes Triptych. 1992. Video projection. Dimensions variable. Tate Gallery, London

Vlaminck Maurice de

Houses on the Banks of the Seine at Chatou

The rich, vivid colours in this landscape pulsate with energy, conjuring up the image of the Seine at Chatou, a small suburb of Paris where Vlaminck shared a studio with Derain. The juxtaposition of white and blue on the water evokes the light reflecting on the surface, while the swirling brushstrokes in the sky suggest that there may be a storm brewing. The bold colouring in this work links Vlaminck with the Fauvists. This term sprang from a derogatory remark made by a critic who baulked at the violent execution and outrageous colours of paintings by

Matisse, branding him a 'fauve' or 'wild animal'. Vlaminck was later to write of this crucial period of artistic development: 'I heightened all tones. I transposed into an orchestration of colour all the feelings of which I was conscious. I was a barbarian, tender and full of violence.' A self-taught painter, Vlaminck initially supported himself by playing the violin and writing novels.

☛ **Derain, Dufy, Matisse, Nolde, Signac**

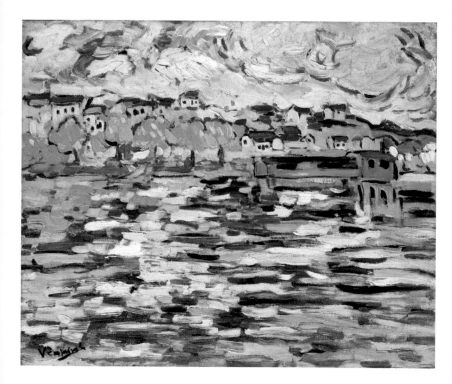

Maurice de Vlaminck. **b** Paris (FR), 1876. **d** Rueil-la-Gadelière (FR), 1958.
Houses on the Banks of the Seine at Chatou. 1906–7. Oil on canvas. **h**54 x **w**64.5 cm. **h**21¼ x **w**25⅜ in. Private collection

Vuillard Édouard

The Newspaper

A man sits in an armchair, his face partially obscured by the newspaper he is reading. On his right is a pile of books, and behind him is a table, draped with a heavy, red patterned cloth. Through the window, we catch a glimpse of a bleak and wintry landscape – a pleasing contrast to the warm interior. The glowing colours and the emphasis on surface pattern and decoration, particularly in the wallpaper on the left, reflect Vuillard's formative years in the Nabis circle. This group of French artists was inspired by Gauguin's method of painting in pure colour, and their works are characterized by broad areas of pattern and colour. Vuillard was also influenced by the flattened and simplified perspective of Japanese colour prints. Like his friend Bonnard, Vuillard focused on everyday life in his work. He often depicted the domestic interiors of the bourgeoisie, and is admired for his vibrant and sensual palette.

☞ Bonnard, Gauguin, Renoir, Sickert

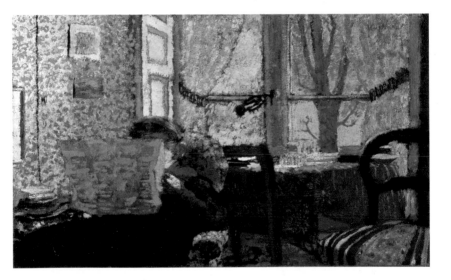

Édouard Vuillard. b Cuiseaux (FR), 1868. **d** La Baule (FR), 1940.
The Newspaper. c1910. Oil on cardboard. **h**34.2 x **w**55.2 cm. **h**13½ x **w**21⅜ in. Phillips Collection, Washington, DC

Wadsworth Edward

Tomorrow Morning

A jetty stretches out into the sea on a breezy day. At first glance the scene appears quite natural, but on closer inspection it generates a sense of unease and foreboding. A brightly coloured fishing hook seems to melt into the jetty and a star shines in the glorious blue sky. A heavy strand of seaweed balances precariously on a wooden pole, while an identical piece of seaweed covers a cluster of shells and fishing tackle, lying beneath a life saver and the figure seven, which perhaps suggests the seven deadly sins. 'Seaside Surrealism' was a term coined to describe the work of Wadsworth and other British painters which, while influenced by Continental Surrealism, nevertheless seemed to have a distinctively British character and took its subject matter from the sea. Wadsworth had an intimate connection with the sea, working for the Royal Naval Volunteer Reserves, in the First World War on camouflage for ships.

☛ **De Chirico, Dali, Nash, Tanguy**

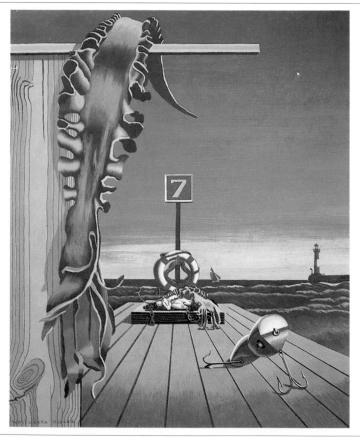

Edward Wadsworth. **b** Cleckheaton (GB), 1889. **d** London (GB), 1949.
Tomorrow Morning. 1929–44. Tempera on panel. **h**76.2 x **w**64 cm. **h**30 x **w**25 in. Private collection

Wall Jeff

The Stumbling Block

In a busy street, a man, wrapped in protective clothing like a futuristic mummy, lies nonchalantly on the pavement, waiting for passers-by to trip over him. A girl is caught mid-fall. The man sitting on the ground on the right seems to be recovering from a similar accident, while the boy on the left has obviously seen it all before. This work is a large-scale, cibachrome transparency, lit from behind by fluorescent lights. Resembling an illuminated advertising display, this unsettling image has an immediate impact and holds the viewer's attention.

Wall has constructed this elaborate and detailed action shot to look like a real event, but offers no explanation for the bizarre incident. Seeing himself as a cinematographer, Wall directs each of his photographs like scenes from a film, manipulating certain elements during processing. Trained as an art historian, Wall's works are complex and contain allegorical references.

☞ Estes, Longo, Lowry, Struth

Jeff Wall. **b** Vancouver (CAN), 1946.
The Stumbling Block. 1991. Cibachrome transparency, fluorescent light and display case. **h**229 x **w**337 cm. **h**90¼ x **w**132¾ in.
Ydessa Hendeles Art Foundation, Toronto

Wallinger Mark

A Real Work of Art

A Real Work of Art is an actual thoroughbred racehorse, named by Wallinger in an ironic gesture that questions traditional notions of what we understand an artwork to be. Bought by the artist and a group of partners, and trained at a professional stables, the horse raced under the colours of the suffragette movement – violet, green and white – and each race was recorded as a separate artwork. This work developed out of Wallinger's passion for horse-racing and his interest in this sport as a parallel world of aesthetics, genetics, class issues and breeding.

Unfortunately, the horse was seriously injured and could no longer race, and was subsequently sold to an art collector. Wallinger works in a variety of media, and has produced paintings, photographs, installations and videos. Focusing on particular notions of Englishness, such as humour, the education system and football, he explores the cultural and social structures that frame individual and national identities.

☞ **Dominguez, Duchamp, Marini, Rothenberg**

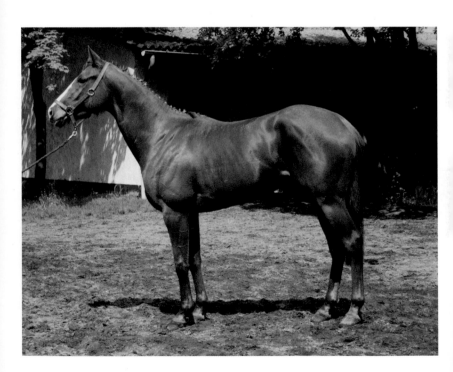

Mark Wallinger. b Chigwell (GB), 1959.
A Real Work of Art. 1995. Racehorse. Private collection

Wallis Alfred

The Golden Light Penzance

A masted ship, complete with sails and rigging, floats above two fishing boats and a small rowing boat. The distorted perspective and scale, and the use of flat, contrasting black and white give this image a childlike quality. The title, written at the top of the work, only adds to this impression. Wallis's subject matter was almost exclusively his immediate surroundings – the boats and harbours of Cornwall where he used to work. A retired and widowed fisherman, he began painting on old card or irregularly shaped pieces of wood when he was in his late sixties. In 1928 he was 'discovered' by the artist Nicholson and the St Ives group of painters, who found in his pictures the kind of spontaneous, direct vision which they felt many artists lost through formal training. Wallis rapidly became known as a primitive or naïve artist and his works entered important collections such as the Tate Gallery, London and the Museum of Modern Art in New York.

☛ **Bartlett, Dorain, Dufy, Heckel, Marin, Nicholson**

Alfred Wallis. b Devonport (GB), 1855. **d** St Ives (GB), 1942.

The Golden Light Penzance. c1935. Oil and boat paint on board. **h**19 x **w**24.8 cm. **h**7½ x **w**9¾ in. Private collection

Warhol Andy

Soup Can

This brightly coloured picture of a tin of Campbell's soup is one of a number produced on the same theme. Warhol started by painting each image by hand, but then went on to screenprint them, attaching a stencil to a screen stretched on a frame, and forcing the colour through the unmasked areas of the screen. In mass-producing images of everyday items such as this soup can, he questioned both authorship and the validity of uniqueness. By repeating the same motif, he also achieved an aesthetic distance from his work. He named his fashionable gallery/studio 'The Factory'. Through diverse subject matter – Marilyn Monroe, Jackie Kennedy, race riots and the electric chair – Warhol aimed to demystify major themes such as fame and death. He also made numerous films and was manager of the cult rock band the Velvet Underground. A brilliant self-publicist, he turned himself into an enigma. He had a huge influence on subsequent generations of artists.

☞ Kruger, Lichtenstein, Rosenquist, Steinbach

Andy Warhol. b Pittsburgh, PA (USA), 1928. d New York (USA), 1987.
Soup Can (detail). 1961–2. Synthetic polymer paint on canvas. h50.8 x w40.6 cm. h20 x w16 in. Private collection

Waterhouse John William A Tale from the Decameron

Five girls in lavish costumes gather round some steps in a garden, enthralled by a minstrel's tale. This is a scene from *The Decameron*, the fourteenth-century classic by Italian writer Boccaccio, in which a group of aristocrats, fleeing the plague in Florence, pass the time in a country villa by telling each other stories. The charm of the subject and setting owes much to the Pre-Raphaelites, a group of nineteenth-century artists who looked back to medieval art in their quest for a representation of ideal beauty. Waterhouse's presence in the second decade of

the twentieth century is a reminder that at a time when many artists were exploring abstraction, some continued to work within the realist tradition. By the early twentieth century, this kind of literary and representational painting had in fact become the dominant, officially sanctioned style, but it was targeted by the avant-garde as false to the contemporary social experience which could better be reflected in abstract works.

☛ **Barlach, Klimt, Morimura, Redon**

John William Waterhouse. b Rome (IT), 1849. d London (GB), 1917.
A Tale from the Decameron. 1916. Oil on canvas. **h**102 x **w**159 cm. **h**40 x **w**62½ in. Lady Lever Art Gallery, Port Sunlight

Wearing Gillian

My Favourite Track

A series of five television monitors play videos of a succession of people singing along to their personal stereos. The result is a discordant cacophony of tune-less singing. But Wearing does not intend to embarrass her guest performers, whom she approached in the street like a journalist conducting an interview. It is an affectionate portrait of fans emulating their musical heroes and heroines. Wearing's approach is to give a voice to ordinary people, presenting a kind of realism through the documentary use of video. Other works include a video of the artist dancing in a shopping mall; photographs of people holding up signs on which they have written the slogan of their choice; and a video of a mock shoot-out between cowboy enthusiasts. In representing ordinary life, Wearing reveals that human emotions and behaviour are both strange and familiar, and that while all the characters in her work are different, they experience and feel things which everyone can understand.

☞ Barlach, Barry, Hill, Viola

Gillian Wearing. b Birmingham (GB), 1963.

My Favourite Track. 1994. Video installation. Dimensions variable. Private collection

Weber Max

Two Musicians

A pianist and a double-bass player are visible through a web of geometric shapes. Dressed in formal attire and depicted in a dark green interior, they are the epitome of cocktail musicians, perhaps entertaining customers in a bar. Different sides of their heads can be seen at the same time, conjuring up the illusion of continuing activity as they play. This technique owes much to Picasso and Braque's early Cubist works and the device later known as simultaneity, where objects are depicted from different angles to suggest movement or three-dimensionality. The muted palette of greens and browns also proclaims Weber's Cubist origins. Born in Russia, Weber moved to New York in 1891. He went to Paris in 1905, where he came into contact with Cubism. He subsequently fought free of Cubism's sombre hues, employing a brighter, more vibrant use of colour. This was to become increasingly more marked in his later work which concentrated on themes from Jewish life.

☛ **Braque, Gris, Laurencin, Picasso**

Max Weber. **b** Bialystok (POL), 1881. **d** New York (USA), 1961.
Two Musicians. 1917. Oil on canvas. **h**101.9 x **w**76.5 cm. **h**40⅛ x **w**30⅛ in. Museum of Modern Art, New York

Wegman William

Cinderella

In this amusing photograph, Wegman has dressed up his pet dog as Cinderella, complete with flowery smock and brush and dustpan, posed as if in a traditional portrait. Wegman's beloved Weimaraners – Fay Ray and Man Ray – have featured in some of the wittiest images of recent years, often appearing in comedic roles mimicking the lifestyle of leisured America. Dressed in a variety of costumes, from fairytale to *haute couture*, they are docile characters onto whom the nuances of American popular culture are projected. These playful photographs provide a wry and sophisticated commentary on the absurd elements of contemporary life and human behaviour. Wegman has also made short films and videos, which include *The Hardly Boys*, a re-enactment of an adventure from the children's story *The Hardly Boys*, starring an exclusively canine cast. Most recently, he has diversified into painting with a series of aqueous views of real and imagined places.

☛ Hanson, Morimura, Sherman, Wallinger

William Wegman. b Holyoke, MA (USA), 1943.
Cinderella. 1994. Photolithograph on paper. **h**52.1 x **w**43.8 cm. **h**20½ x **w**17¼ in. Edition of 120

Weight Carel

The Visitor

A neat and composed elderly lady, with hands folded, sits on a chair in the middle of the picture. Behind her, a skeleton lurks outside a red door. What initially appears to be a simple portrait emerges as an allegorical tale about old age and the inevitable arrival of death – the 'visitor'. The concentration on the details of the domestic interior, such as the wallpaper and dresser, is typical of Weight's deliberate attempt to create a false sense of security, undermined in this case by the tilting perspective of the canvas which makes the woman's feet appear

improbably large in relation to her head. Apart from a spell as a war artist, Weight concentrated on painting figures in everyday situations such as at the shops, or in houses and parks in south London where he lived. A unique sense of drama and a feeling of impending doom pervades his paintings. His works are often claustrophobic, reflecting such diverse influences as Munch and Spencer.

☛ Ensor, Hiller, Kubin, Munch, Neel, Spencer

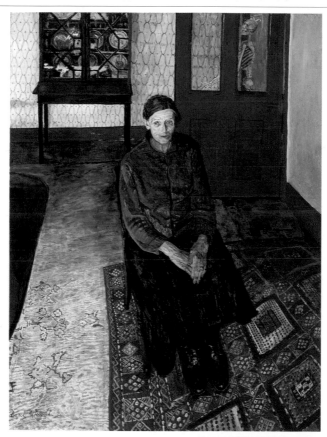

Carel Weight. b London (GB), 1908. d London (GB), 1997.
The Visitor. c1952. Oil on canvas. **h**101.6 x **w**76.2 cm. **h**40 x **w**30 in. Private collection

Weiner Lawrence

Pearls Rolled across the Floor

A series of statements, executed in a simple, anonymous typeface, slant across a wall. Weiner is using language to replace the visual images of pearls rolled across the floor or cannonballs stacked as high as they will go. The phrases, unrelated and out of context, make the viewer question the meaning of the work, and conjure up their own mental image of the descriptions. This interest in the idea behind a work of art, rather than in the work of art itself, is typical of Conceptual Art, a movement with which Weiner is associated. However, Weiner encourages the viewers to piece together the meaning of the image for themselves, whereas other Conceptual artists often impose a more rigid reading on the spectator. 'Once you know about a work of mine, you own it. There's no way I can climb into somebody's head and remove it,' he has said. Weiner has also made videos, films and posters, and has participated in performances.

☛ **Kosuth, McCahon, Prince, Vautier**

Lawrence Weiner. **b** New York (USA), 1940.

Pearls Rolled across the Floor. 1994. Enamel on gallery wall. Dimensions variable. Private collection

West Franz

Rest

A number of sofas have been laid out to face the sun. They have been made in a simple manner from rough steel rods and sections of foam, clad in loose covers of a bold, geometrical design. *Rest*, installed outdoors on the roof of the Dia Center for the Arts in New York, was made specially for this location. Visitors were invited to take the opportunity to relax and bask in the sunshine. Through interaction with this work, the audience became collaborators, fully realizing the potential of the sculpture, which would otherwise remain inert and ineffective. This kind of active participation is central to West's approach, both towards the production and the exhibition of his work. His many different kinds of interactive art have included sculptures which can be picked up, worn and carried around the gallery. He has frequently collaborated with other artists, incorporating their paintings, sculptures or fabric designs into his work.

☞ Buren, Cragg, Heilmann, Oldenburg, G Orozco

Franz West. b Vienna (AUS), 1947.

Rest. 1994. Mixed media. Dimensions variable. As installed at the Dia Center for the Arts, New York

Whiteread Rachel

Untitled (House)

The interior of a derelict Victorian house has been cast in concrete. Whiteread has literally turned it inside out, creating a ghostly negative of the building. Imbued with a haunting sense of melancholy and loss, the work traces the presence of a profound absence. Like a sarcophagus or a sacred tomb, the eerie sculpture preserves the memory of time and life passed by. Planned as a temporary, site-specific poroject, this technically ambitious work was demolished amid controversy after three months. To many, it was a monument to everyday life, to others it was a blot on the wasteland in Grove Road in the East End of London where it stood. Whiteread has cast many other, smaller-scale domestic objects, or the spaces around and underneath them, often in plaster, and more recently in fibreglass and rubber. Wardrobes, old mattresses, the insides of bathtubs and hot-water bottles have all been transformed into sculptures which evoke similar feelings of fleeting sorrow.

☞ **Artschwager, Becher, Graham, Hockney, Matta-Clark**

Rachel Whiteread. **b** London (GB), 1963.

Untitled (House). 1993. Concrete and plaster. **h**10 m. **h**32½ ft (approx). Now destroyed

Wilke Hannah

SOS Starification Object Series

Chewing gum, shaped into petal-like or labial folds, appears like growths on the artist's skin. In each photograph Wilke adopts a different pose, a masquerade evoking various feminine, sexual roles. The use of chewing gum, with its associations of biting and eating, addresses certain areas of psychoanalytical thought on sexuality. Like many contemporary feminist artists, Wilke uses her own naked body to locate the female form as an arena for display, challenging the construction of female identity in society. Never afraid to confront taboo issues, in the late 1970s and early 1980s Wilke began a series of photographs dealing with her mother's battle with cancer. Her own diagnosis of cancer in 1987 prompted a series of defiantly humorous, large-scale cibachrome photographs detailing the atrophying effects of the condition. In her obituary in the New York publication, *Village Voice*, Arlene Raven described Wilke's true subject as 'the guts she wanted to show "through" her skin and her intention to get under yours'.

☞ Gober, Rainer, Schneemann, Sherman

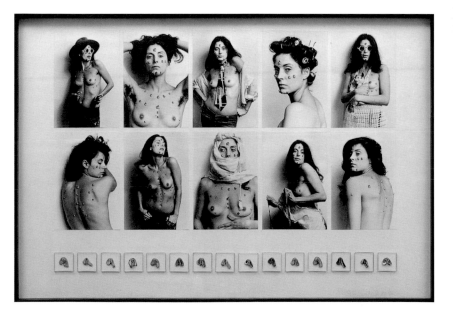

Hannah Wilke. b New York (USA), 1940. **d** New York (USA), 1993.
SOS Starification Object Series. 1974–82. Black and white photographs and gum sculptures. **h**104.1 x **w**147.3 cm. **h**41 x **w**58 in.
Private collection

493

Wilson Richard

20:50

20:50 is a site-specific installation which totally transforms the room it inhabits into a beguiling and wondrous illustration of form and space. The rapidly narrowing, trench-like walkway suspends the viewer in the middle of a steel tank holding a 2,500-gallon lake of used sump oil. Fear of drowning in an uncontrollable flood of dirty, thick oil adds a dramatic tension to this strange experience. It is impossible to see beyond the dense, black surface, which acts as a mirror, perfectly reflecting everything beyond itself. Looking at *20:50*, we are drawn into a re-examination of the immediate surroundings, becoming more fully aware of our own presence and of our relationship with architectural space. Wilson's other installations deal similarly with a re-ordering and subverting of three-dimensional space, and include drilling a hole in a gallery floor to reach the underground water table, and inserting a suspended greenhouse through a gallery wall.

☞ **Hatoum, Laib, De Maria, Serra**

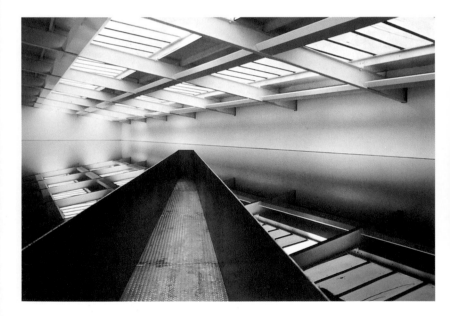

Richard Wilson. **b** London (GB), 1953.
20:50. 1987. Used sump oil and steel. Dimensions variable. Saatchi Collection, London

Wodiczko Krzysztof

Projection on South Africa House

A swastika is projected onto the pediment of the Neoclassical façade of South Africa House in Trafalgar Square, London, the South African embassy. By doing this, Wodiczko makes explicit the dangerously racist agenda of apartheid, drawing attention to the oppressive political forces at work in the upholding of the South African government's power and authority of the time. Wodiczko's art is aimed at addressing audiences outside the art system. His interventions take place in the public arena of the city and are intended to provide a critical dimension to the urban experience, raising social consciousness and political awareness. Using night-time photographic projections, Wodiczko disrupts the normally unchallenged symbolic status of prestigious architecture and buildings, opening up their meanings to new interpretation. Wodiczko, like Holzer and Haacke, is a manipulator of signs, using art as a weapon to criticize the ideology of institutions and their monuments.

☛ Barry, Christo, Haacke, Heartfield, Holzer

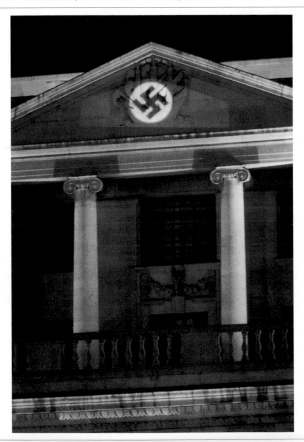

Krzysztof Wodiczko. **b** Warsaw (POL), 1943.

Projection on South Africa House. 1985. Video projection. Dimensions variable.

As projected on South Africa House, Trafalgar Square, London

Wölfli Adolf

St Adolf Diamond Ring

Resembling a complex mosaic floor, the surface of this work is covered with an extraordinarily detailed web of writing, musical notation, symbols and decorative devices. Visible in the centre are four castle-like structures, while at the bottom of the composition in the middle is a multi-coloured face, staring out at the viewer. Following several arrests for the attempted molestation of young girls, Wölfli was committed to a psychiatric clinic in 1895, where he remained until his death in 1930. After four years in the clinic, he began to draw, encouraged by an enlightened doctor. Wölfli's works have become some of the most celebrated examples of Outsider Art, art produced by the untutored outside the artistic establishment. His extraordinary output, produced in the most extreme states of mind, is clearly the product of a logic manifest only to himself. Meanwhile, the viewer can only sense this purpose and marvel at the obsessive creativity which went into its making.

☛ Artaud, Dubuffet, Moses, Torres-Garcia, Wallis

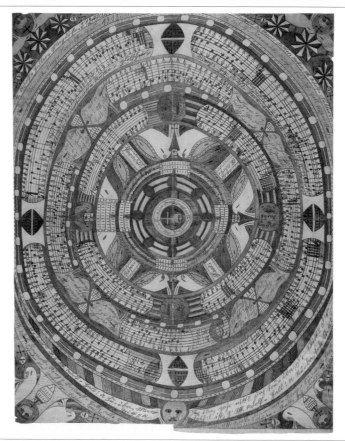

Adolf Wölfli. **b** Bowil (SW), 1864. **d** Berne (SW), 1930.
St Adolf Diamond Ring. 1913. Pencil and coloured pencil on paper. **h**98 x **w**74.7 cm. **h**38⅔ x **w**29⅜ in.
Adolf Wölfli Foundation, Museum of Fine Arts, Berne

Wols

The Windmill

A dense web of black lines radiates from the centre of the canvas, conjuring up the impression of the blades of a windmill. The patches of green on the left and right perhaps evoke a landscape setting, while the yellow background suggests a sunny sky. The paint has been applied with hasty brushstrokes, and squeezed and scraped on the canvas, giving the surface a tactile quality. The expressive brushstrokes and thick layering of paint are typical of Art Informel, a group which aimed to discover a new artistic language by giving rein to spontaneous creative impulses. Wols was one of the key members of this group, producing works of mesmerizing intensity, inspired by his subconscious, but heavily influenced by nature and aspects of the world around him. Born in Berlin, Wols studied at the famous Bauhaus school, and went on to earn a living as a photographer. He later turned to drawing and painting and is admired for his expressive, abstract works.

☛ **Fautrier, Kirkeby, Twombly, Utrillo**

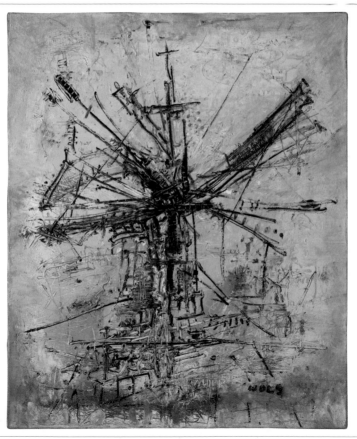

Wols (Alfred Otto Wolfgang Schulze-Battmann). b Berlin (GER), 1913. d Paris (FR), 1951. 497
The Windmill. 1951. Oil on canvas. **h**73 x **w**60 cm. **h**28¾ x **w**23⅝ in. Westfälisches Landesmuseum, Münster

Wood Grant

Haying

The curious perspective in this work gives the picture a mysterious, even ominous air. We sense that there is something hidden beyond the brow of the hill, and the rows of cut hay create strange shapes which are almost like hieroglyphics. There is no one in sight, but the scene is full of signs of human presence, for example the abandoned jug, placed centrally in the foreground. The artist has created this eerie atmosphere by employing a very high horizon and by arranging the various lines in the work so that they lead the eye off in several different directions. Wood was part of a group of American artists called the Regionalists who deliberately turned their backs on progressive European art of the 1930s and its abstract tendencies, choosing instead to depict in a realistic style their native Midwestern world and the lives of ordinary people. His crisp, linear style was influenced by early Flemish painting which he saw when he was in Europe in the 1920s.

☛ **Hockney, Moses, Sutherland, Wyeth**

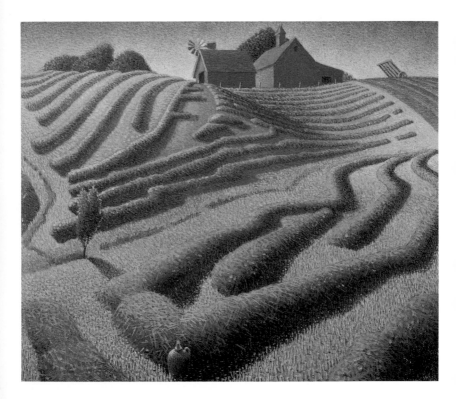

Grant Wood. b Anamosa, IA (USA), 1892. **d** Iowa City, IA (USA), 1942.

Haying. 1939. Oil on canvas mounted on board. **h**32.8 x **w**37.7 cm. **h**12⅞ x **w**14⅞ in. National Gallery of Art, Washington, DC

Woodrow Bill

Cello Chicken

A cello and a chicken are hewn from a couple of car bonnets, the new forms still attached to their source by a twisted metal umbilical cord. Woodrow creates a poetic transition from scrap metal to art object, transforming the material from one purpose to another. This sculpture is characteristic of Woodrow's work, constructed from pieces of junk found in the street or on the local dump – old car doors, discarded washing-machines, office cabinets. From these he chops, cuts and hammers together rough-edged representations of familiar objects, reminiscent of Picasso's musical instruments made of sheet-metal. Physically deconstructing factory-made consumer goods, he cannibalizes and recycles them in a kind of post-apocalyptic tribal art. He intuitively chooses both his initial material and the resultant objects, the relationship between the two often bordering on the surreal. Woodrow's empathy with the urban environment of his immediate surroundings links him to the New British Sculpture group.

☛ César, Chamberlain, Cragg, Laurencin, Man Ray

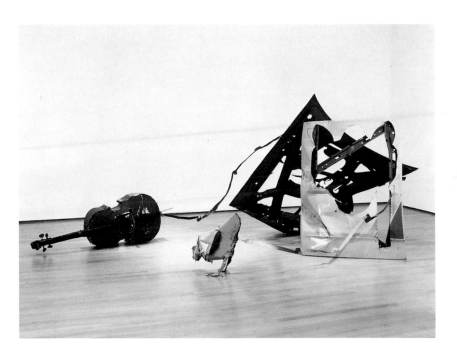

Bill Woodrow. b Henley (GB), 1948.
Cello Chicken. 1983. Two car bonnets. **h**150 x **w**300 x **l**300 cm. **h**59 x **w**118 x **l**118 in. Saatchi Collection, London

Wyeth Andrew

Field Hand

A farm-labourer leans against a tree trunk at the top of a hill, taking a break from his work. His prosthetic arm, in the form of a hook, forms the bizarre focal point of the work. The loneliness of the labourer's existence, his battle with nature and his will to survive are reflected by the potent symbol of his false limb. This highly evocative and sentimental picture, painted with meticulous realism, is typical of Wyeth's work. Using traditional painting techniques, he achieves a timelessness which links the harsh conditions of working on the land in the pioneering era to contemporary rural life in America. Small figures – often with some form of mental or physical disability – set in large, barren landscapes are common in Wyeth's work. An isolated child, Wyeth was educated by private tutors and studied art with his father. In his nostalgic works, he celebrates the simple life, unhindered by the constraints of the technological era.

☞ Baselitz, Hockney, Penone, Wood

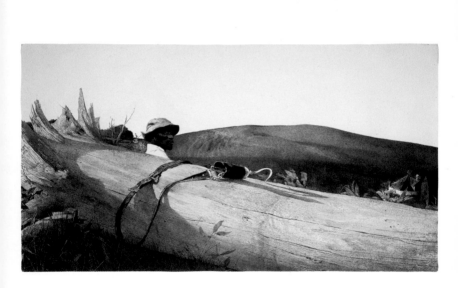

Andrew Wyeth. b Chadds Ford, PA (USA), 1917.

Field Hand (recto). 1985. Dry brush watercolour on woven paper. h55.3 x w100.7 cm. h21¾ x w39⅝ in. National Gallery of Art, Washington, DC

Yeats Jack Butler

Waiting for the Long Car

Two travellers, an elderly man and woman, wait by the side of the road for a horse-drawn carriage in the blustery, watery climate of the west of Ireland. Paint is laid on vigorously, almost carelessly, with a frenetic energy which whips up the surface of the canvas into continuous activity. The freely handled brushwork and violent colour, slashed on with the palette knife, exemplify the freer, more Expressionistic style that Yeats developed after initial influence from the French Impressionists. It is the Expressionist style in which

Yeats depicted the world of rural Irish folklore that is unsettling, and this no doubt reflected the anxiety of the times. Although Yeats stayed largely aloof from politics, he felt a passionate attachment to his homeland and his pictures increasingly concerned the actual experience of being Irish. Born in London but brought up in Sligo in western Ireland, Yeats was the brother of the celebrated poet W B Yeats.

☛ **Auerbach, Kantor, De Kooning, Kossoff**

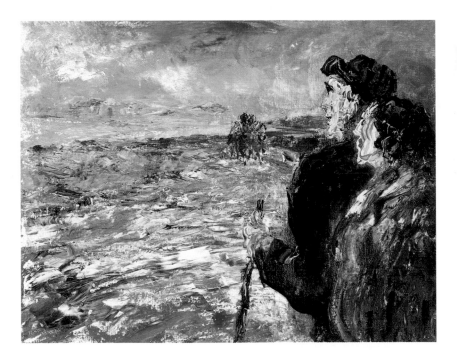

Jack Butler Yeats. b London (GB), 1871. d Dublin (IRE), 1957.
Waiting for the Long Car. c1948. Oil on canvas. **h**34 x **w**45 cm. **h**13½ x **w**17¾ in. Private collection

Yoshihara Jiro

Painting

A dramatic slash of black paint cuts across the surface of the canvas, balanced by a patch of black on the left which leaves a dripping trail of paint down the side of the composition, reminding us of the act of painting. The two elements are separated by a dense layering of black, white and grey, which adds a vibrant note. Including elements of Eastern calligraphy, this painting reflects Yoshihara's Japanese background. The spontaneous handling of paint is typical of the Gutai Group, which Yoshihara founded in Osaka in 1954. It was a radical movement that incorporated performance, theatre, paintings and multimedia events. Its focus on the actual process involved in making a work of art was of international importance, influencing a wide range of artists in the West, including the Abstract Expressionist Pollock. Yoshihara's ground-breaking output also included daubing chicken's feathers with paint, and building a flooded environment. He was the leading member of the group until his death in 1972.

☞ **Fautrier, Murakami, Pollock, Shiraga**

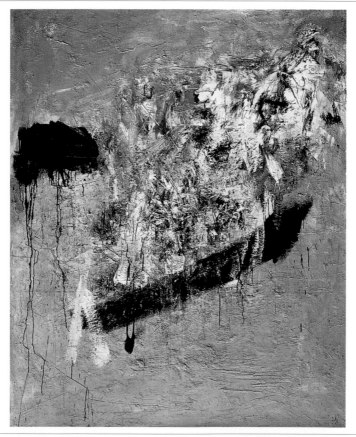

Jiro Yoshihara. **b** Osaka (JAP), 1905. **d** Osaka (JAP), 1972.
Painting. 1959. Oil on canvas. **h**162 x **w**130 cm. **h**63⅞ x **w**51¼ in. Galerie Stadler, Paris

Zorio Gilberto

Utopia – Reality – 1

A room is bathed in a deep blue light. Punctuating the gloom is the neon sign reading, in Italian, 'È utopia la realtà è rivelazione', which translates as 'reality is utopia is revelation'. By making a proclamation about the nature of reality using high-tech materials which generate heat and energy, Zorio fuses the celestial, cerebral and technological. Like an alchemist, he extracts metaphysical truths from modern materials. His use of fluorescent light is close to the work of the Minimalists, who often used industrial materials in their work, in their attempts to

distance themselves from the actual process of making a work of art. However, his art is less emotionally detached than theirs, and has affinities with Arte Povera, a group of Italian artists who used natural elements such as mud, twigs and cloth to make artworks. Zorio has stated that his work is never finished but 'continues to live by itself, while I place myself in the role of the spectator, both of its reactions and the reactions of the viewers'.

☛ **Davila, Flavin, Holzer, Merz, Nauman, Turrell**

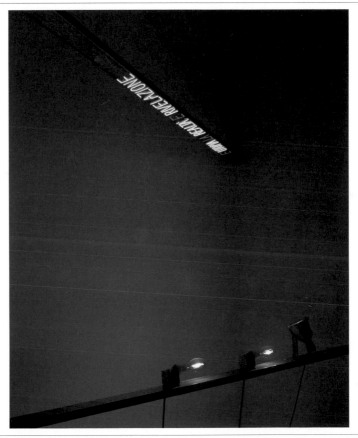

Gilberto Zorio. b Andorno Micca (IT), 1944.

Utopia – Reality – 1. 1971. Phosphorescent wax, fluorescent lamps and iron. Dimensions variable. Collection of the artist

Glossary of terms

Abstract, Abstraction

A form of art which does not seek to represent the world around us. The term is applicable to any art that does not represent recognizable objects, but refers particularly to forms of twentieth-century art in which the idea of art imitating nature has been abandoned. Kandinsky, Mondrian and Malevich were among abstraction's early pioneers.

Acrylic

A synthetic paint, first used in the 1940s, combining some of the properties of **oil** and **watercolour**. It can be used to create a variety of effects from thin washes (see Frankenthaler and Louis) to thick brushwork (see Förg).

Anti-art

A term allegedly invented by Duchamp around 1914 to describe revolutionary forms of art. His addition of an obscene caption and a moustache to a copy of Leonardo da Vinci's *Mona Lisa* is an example of anti-art. The term also sums up many of the anarchic experiments of the **Dadaists**. It was later used by the **Conceptual** artists of the 1960s to describe the work of those who claimed to have retired altogether from the practice of art, or at least from the production of works which could be sold. Baldessari's exhibition of the ashes of his burnt paintings was seen as a typical anti-art gesture.

Art Brut, Outsider Art

A French term, coined by Dubuffet in 1947, which translates as 'Crude Art' but is often referred to as 'Outsider Art'. It is used to describe work produced outside the established art scene by the untutored, such as children, the insane and criminals (see Wallis and Wölfli). It is often considered to be a more authentic, spontaneous form of expression than much of the art in museums and galleries.

Assemblage

The incorporation of three-dimensional, non-art materials and **found objects** into a work, originally inspired by the techniques of **collage**. The roots of assemblage lie in the early part of the twentieth century when Picasso began using real objects in his Cubist constructions – adding, for example, a spoon to his witty sculpture, *Glass of Absinthe* (1914). One of the earliest and most famous antecedents of assemblage was Duchamp's bicycle wheel attached to a stool, which he labelled the '**ready-made**'. Later, the **Dadaists** and **Surrealists** based their work on surprising conjunctions of disparate objects and images. The technique was particularly popular in the late 1950s, when artists, such as Arman and Dine, made assemblage works, assimilating various materials, which included food and junk, into painting and sculpture. The growth of the use of assemblage in twentieth-century art reflects an anarchic approach to formal artistic practice.

Body Art

The use of the body itself as the raw material for art. This prime means of expression became widespread during the 1960s and 1970s. Body Art has been the most direct way of exploring issues of gender and sexuality (see Acconci). Often it has tested the limits of human endurance, as exemplified by the artist Nitsch, who attached himself to a crucifix for a performance. At times, it has involved gruesome acts of self-mutilation, such as Pane's slashing of her stomach with a razor blade. Alongside **Performance**, **Land** and **Conceptual Art**, it has taken art beyond the confines of the gallery and raised questions of ownership and permanence.

Collage, *Papier Collé*, Photomontage

Collage, which is derived from the French word 'coller' (meaning 'to stick'), is a technique in which pieces of paper and cloth are pasted onto a flat surface. A *papier collé* is a type of collage which includes pieces of patterned paper. Braque and Picasso were the first to use collage as a serious artistic technique. Photomontage applies the same principles to the use of photographs (see Heartfield). It was an important technique in **Dada** and **Surrealism** (see Schwitters), and has also been used by **Pop** artists such as Paolozzi.

Earth Art *see* Land Art

Feminism

Primarily a political movement, feminism has had a huge impact on twentieth-century art. Its rejection of the notion that a heterosexual, white, male view of the world is a universal one has influenced not only artists but also art historians and critics. The term 'feminist art' (which can be applied to the work of artists such as M Kelly, Chicago and Spero) emerged only in the 1960s, but women artists have been fighting for, and winning, increased visibility since the start of the twentieth century. As a move away from male-dominated traditions of painting, they have been experimenting with crafts, film, video, performance, installation and text-based art. By changing the ground rules of how art is both made and perceived, feminism has influenced the work of a number of artists such as Kruger and Sherman, who examine the way in which women have been represented by men. Feminists have also questioned the accepted orthodoxies of art history, initiating research into women artists who had been overlooked by generations of scholars.

Figurative

Art which depicts recognizable images of the world around us. These images may be acutely accurate (see Close and Estes) or heavily distorted (see Braque). The term 'representational art' is used synonymously with figurative art.

Found Object, *Objet Trouvé*

An everyday object, found by the artist and incorporated into a work of art. Also known as an *objet trouvé*, a found object often forms part of an **assemblage**, or is displayed on its own in an art context as a **ready-made**. Duchamp's exhibition of a real bicycle wheel attached to a stool is the original example of this art form, which was later taken up by the **Dadaists** (see Schwitters), the **Surrealists** (see Oppenheim), the **Pop** artists (see Paolozzi) and the **Nouveaux Réalistes** (see Arman and Spoerri). By elevating ordinary objects to the status of art, these artists challenged accepted ideas about what constitutes art.

Gouache

Opaque **watercolour**, also known as body colour. The pigments (particles of colour) are bound together with glue; lighter tones are achieved by adding white. Gouache thus differs from transparent watercolour, where tone can be lightened simply by adding water. The thick texture of gouache can produce the same effects as oil paint, but it has the disadvantage of producing a final tone which, when dry, is lighter than it appears during application (see Bakst).

Happening

A fusion of art, theatre and dance performed in front of an audience, and often involving participation. The term was coined by the artist Allan Kaprow in 1959 and comes from the title of his multimedia event at the Reuben Gallery in New York, which was called *18 Happenings in 6 Parts*. Originating in the **Dadaist** performances at the Cabaret Voltaire in Zurich, and in the activities of the Japanese **Gutai Group** (see Murakami and Shiraga), Happenings attempted to bring art to the attention of a wider public (see Knizak). They were particularly used by the **Fluxus** group and some of the **Pop** artists, including Dine, Oldenburg and Warhol.

Impasto

This term has two meanings. It is thickly applied pigment such as oil or acrylic, which often carries visible brushstrokes (see Auerbach, De Kooning and Yeats), or the marks of a palette knife (see Riopelle). It also refers to the technique of application, which artists have used to evoke emotion, to create drama through texture or emphasize their struggle with paint.

Installation

Originally used to describe the process of positioning works in the gallery setting, installation has also come to denote a distinct kind of art-making. In Installation Art, the individual elements arranged within a given space can be viewed as a single work and are often designed for a particular gallery (see Tiravanija and West). Such works are known as **site-specific** and cannot be reconstructed anywhere else: the setting is as much part of the work as the things it contains. First appearing in the late 1950s and the early 1960s, when **Pop** artists such as Warhol began to design environments for **Happenings**, Installation Art typically involves theatrical dramatizations of space (see Kabakov and Haacke). Installations are frequently temporary, and, due to the fact that they are often unsaleable, most permanent installations are created specifically for major private collections.

Kinetic Art

Used to describe art which incorporates real or apparent movement, the term Kinetic Art was first introduced in the 1920s by Gabo, but only came to be distinguished as a specific art form during the 1950s and 1960s. Kinetic Art may be quite simple, such as Calder's wind-driven mobiles, or complex, such as Tinguely's motorized sculptures. The term may also be applied to works of art that use light effects to give the viewer the illusion of movement.

Land Art, Earth Art

A form of art which uses natural elements. Arising in the mid-1960s as a reaction against the growing commercialization of art, and the traditional context of the gallery or museum, Land Art (also known as Earth Art) entered into a direct dialogue with the environment. Some artists brought nature into the gallery (see De Maria), while others worked in the landscape, transforming it into abstract formations through ploughing, digging, levelling out and cutting away, which often required the use of bulldozers and mechanical excavators (see Smithson). A more delicate strain of Land Art can be seen in the work of British artists Goldsworthy and Long, who have produced works made of leaves and rocks and set them in the landscape. Often large-scale and situated in remote places, Land Art is frequently impermanent and subject to the erosive forces of nature. It therefore relies on photography as a means of documentation.

Modernism

More of an attitude than a specific style, Modernism was a phenomenon which first arose in the early part of the twentieth century, and was an affirmation of faith in the tradition of the

new. From the **Impressionists'** depictions of the fashionable bourgeoisie (see Liebermann), to the radical new style of the Cubists (see Braque and Picasso), artists became more and more concerned with finding a visual equivalent to contemporary life and thought. Modernism encompasses many of the avant-garde movements of the first half of the twentieth century.

Objet Trouvé see Found Object

Œuvre

French word meaning the accumulated body of works produced by an artist over the course of his or her career.

Oil, Oilstick

Oil paint consists of pigment (colour) bound together with oil, usually linseed oil. It has the advantage of being slow to dry and therefore reworkable. Oil paint can be applied with a brush (see Fischl) or a palette knife (see Riopelle), generally onto a canvas. Oilsticks combine some of the properties of oil paint with those of **pastel** crayons. They come in various sizes and can either be gripped in the hand like a pencil and applied 'neat', or diluted with a suitable medium.

Outsider Art see Art Brut

Papier Collé see Collage

Pastel

A drawing material consisting of a stick of pigment (colour) bound together with resin or gum. It is generally used on paper and a variety of different effects can be achieved, from sharply defined lines to soft shading (see Redon). The powdery nature of pastel means that without careful handling the drawn image can quickly deteriorate.

Performance Art

Closely related to dance and theatre, Performance Art is also linked to **Happenings** and **Body Art**. Its origins lie in the New York **Happenings** of the late 1950s, in which artists concocted theatrical contexts for their work in order to interact more immediately with their audiences. Performance Art was characterized in the 1960s by its use of the body as a sculptural element in work which took place over a period of time before a live audience. In the 1970s, artists influenced by popular culture, stand-up comedy and video began taking Performance Art out of the gallery and into theatres and clubs. Today the distinctions between Performance Art and other kinds of theatrical manifestations, whether they take place in the gallery or elsewhere, have blurred and they all come under the umbrella term of 'live art' (see Acconci, Pane and Schneemann).

Photomontage see Collage

Prints

A variety of techniques can be used to make prints, including engraving, etching, silkscreening, screenprinting and lithography. In engraving and etching, the design is incised into a metal plate, or in the case of etching, bitten into the plate by means of acid (see Hayter). In silkscreening and other forms of screenprinting, a stencil is attached to a screen (traditionally made of silk) stretched on a frame, and colour is forced through the unmasked areas of the screen (see Warhol). With lithography, the design is drawn with wax onto a slab of stone and through the opposition of grease and water, areas which receive and reject the printing ink are separated.

Psychoanalysis

A method of studying the mind through an exploration of the subconscious, psychoanalysis was developed by the Austrian psychiatrist Sigmund Freud in the early twentieth century, and focuses on dreams or slips of the tongue – moments when the mind expresses its true desires and fears. Psychoanalysis has been used in the visual arts to analyse the hidden meanings of images – meanings which may be different from the creator's conscious intentions. Freud's ideas were particularly important to Dalí and the **Surrealists**, who attempted to free themselves from rational thought, creating works which sprang from the impulses of their subconscious.

Public Art

An extremely loose term describing any artwork made for a public space outside the gallery or museum. Public Art flourished in the 1960s, when governments started to allocate funding for community projects, and artists began to make large-scale outdoor works. Controversially, such works are not always commissioned in consultation with the local community (see Serra). Many artists use communal spaces in order to reach a non-art audience, and to make political statements. In addition to public squares and parks, artists have appropriated billboards (see Holzer), bus shelters, derelict houses (see Whiteread) and underground stations as sites for their work.

Ready-made

A term originally coined by Duchamp to describe a **found object** selected by the artist and placed on its own in an art context. The most famous example is the urinal which Duchamp exhibited in its original state, calling it *Fountain*. His intention was to challenge the viewer's preconceptions about what created 'value' in art. He implied that it was not the object itself which carried artistic content, but the context in which the object was

displayed. Many subsequent artists have incorporated ready-mades into their work, including Beuys, Kelley and Steinbach, among others.

Realism

A type of art which attempts to reproduce the world around us accurately. The term originated in the nineteenth century, and was used to describe the work of Gustave Courbet and a group of painters who rejected idealization, focusing instead on everyday life. In the twentieth century, artists have used realism for particular purposes, including the **Surrealists** (see Dalí), the painters of the **Neue Sachlichkeit** group (see Schad) and the **Socialist Realists** (see Mukhina). In the 1980s, some artists used an exaggerated, realistic style, making works which are disturbing because of their photographic accuracy (see Close and Estes).

Site-specific

Art which is conceived and produced for a particular location or environment. The meaning of a site-specific work is often closely related to the place in which it is situated. Political, social or geographical aspects are taken into consideration and are intended by the artist to frame the viewer's experience and interpretation of the work (see Wodiczko). In some cases, the intention of this approach has been an explicit rejection of the traditional context of the museum and other institutional spaces (see Holzer). It often takes the form of **installation** (see Haacke), **Land Art** (see Smithson) and **Public Art** (see Serra).

Video Art

Artists have used video since the 1960s, both to make a record of performances and other impermanent works, and as a medium in its own right. The growth of Video Art coincides with the development and availability of video technology, and its use is historically linked to artists' forays into film-making. While some Video Art is made for television programmes, much is designed for galleries and other spaces, often in the form of **installations** (see Hatoum). Video Art is not constrained by the small screen – artists have projected videos onto buildings or other objects (see Barry and Wodiczko), worked with multiple screens (see Doherty, Hill, Wearing and Viola), or made complex juxtapositions of video with lighting, sound and sculptural elements (see Hiller).

Watercolour

Pigment (colour) bound by a water-soluble medium such as gum arabic. This is usually diluted with water to the point where it is translucent, and applied to paper in broad areas known as washes. White paper is often left exposed to create highlights, and washes are applied over one another to achieve gradations of tone (see Marin). Because of its fast-drying, easily portable nature, it is traditionally prized as a sketching medium for outdoors.

Glossary of artistic movements

Abstract Expressionism

A movement in American painting that developed in New York in the 1940s. The Abstract Expressionists invariably used huge canvases and applied paint rapidly and with force, often employing large brushes, sometimes dripping or even throwing the paint directly onto the canvas. This expressive method of painting was often considered as important as the painting itself. Other Abstract Expressionist artists were concerned with adopting a peaceful and mystical approach to a purely abstract image. Not all the work from this movement was abstract (see De Kooning and Guston) or expressive (see Newman and Rothko), but it was generally believed that the spontaneity of the artists' approach to their work would release the creativity of their unconscious minds.

☞ Francis, Guston, Hofmann, Kline, De Kooning, Motherwell, Newman, Pollock, Rothko, Still

Art Informel

The French word 'informel' means 'without form' rather than 'informal'. In the 1950s Art Informel artists were looking for a new way to create images without using the recognizable forms characteristic of their predecessors (see **Cubism** and **Expressionism**). Their aim was to abandon geometrical and figurative forms and to discover a new artistic language. They invented shapes and methods that came about by improvisation. The work of Art Informel artists is extremely varied but they often used free brushstrokes and thick layering of paint. Like **Abstract Expressionism**, which developed simultaneously in the United States, Art Informel is a very broad label and includes figurative and non-figurative painters. Although centred mainly on Paris, its influence reached other parts of Europe, notably Spain, Italy and Germany.

☞ Burri, Fautrier, Hartung, Riopelle, Tàpies, Wols

Art Nouveau

A French term which translates as 'new art', Art Nouveau was a decorative style of architecture and interior design which appeared in Europe and the United States in the 1890s, transforming art and design. The movement was characterized by stylized, sinuous lines and curving, organic forms such as tendrils and leaves. Art Nouveau painting is typified by extravagant patterns and elegant female figures with long, flowing hair (see Klimt). The sophisticated graphic work of Aubrey Beardsley represents its tendencies to eroticism and decadence (see also Schiele), while the designs of Charles Rennie Mackintosh present a more restrained, geometric version. The style was taken to new heights of fantasy by the Spanish architect Antonio Gaudí.

☞ Klimt, Munch, Schiele

Arte Povera

Arte Povera – literally 'Poor Art' – was first defined as a movement in 1967 by the Italian critic Germano Celant, who became its main propagandist. Predominantly an Italian tendency, it remained influential until the late 1970s. The works, which were primarily three-dimensional sculptures, were made from the simplest of materials and natural elements. Mud, twigs, cloth, rags, paper, felt and cement were all used in an attempt to fuse nature and culture in a reflection of contemporary life. The artists were like alchemists, extracting metaphysical truths from these basic materials. Opposed to the cold detachment of **Minimalism**, they desired a more sensory and impassioned type of art.

☞ Kounellis, Merz, Penone, Pistoletto, Zorio

Bauhaus

The Bauhaus school was founded by the architect Walter Gropius at Weimar in 1919 and became the centre of modern design in Germany in the 1920s. Reflecting some of the socialist currents in Europe at the time, its aim was to bring art and design into the domain of daily life. Gropius believed that artists and architects should be considered as craftsmen and that their creations should be practical and affordable. The characteristic Bauhaus style was simple, geometrical and highly refined. In 1933 the school was closed by the Nazi government who claimed that it was a centre of communist intellectualism. Although the school was physically dissolved, its staff continued to spread its idealistic precepts as they left Germany and emigrated all over the world.

☞ Albers, Feininger, Kandinsky, Klee, Moholy-Nagy

Der Blaue Reiter

A group of German **Expressionists** founded in Munich in 1911. The name translates as 'The Blue Rider' and was taken from a painting by Kandinsky. Although not strictly a movement with a defined programme, the group did veer more towards mysticism and spirituality than the other major **Expressionist** organization, **Die Brücke**. Key artists included Marc and Macke, who were joined by Klee and Delaunay in 1912.

☞ R Delaunay, Kandinsky, Klee, Macke, Marc

Die Brücke

A group of **Expressionist** artists formed in Dresden in 1905. The name translates as 'The Bridge', and suggests that they saw their art as a bridge between that of the past and the future. A loose association rather than a coherent group, Die Brücke artists favoured vibrant colours (influenced in part by the **Fauvists**), simplified, natural forms and an expressive use of line, which lent itself particularly well to graphic work. Artists

associated with the group included Kirchner, Nolde and Pechstein. The group moved to Berlin in 1910, and was disbanded in 1913.

☞ Heckel, Kirchner, Nolde, Pechstein

The Camden Town Group

A group of English painters formed in 1911, who often met in Sickert's studio in north London. They took much of their subject matter from urban working-class life and were influenced by the strong forms and colours used by artists such as Vincent van Gogh and Gauguin. In 1913 the group amalgamated with other associations, notably the **Vorticists**, to become the London Group.

☞ Sickert

Cobra

An international association of artists that existed in Europe from 1948 to 1951. The name Cobra was made up from the first letters of the cities in which the original members of the association were living (Copenhagen, Brussels and Amsterdam). Cobra artists promoted free expression of the unconscious and they used thick handling of paint and striking colours to give their work vitality and force. They included in their paintings fantastical imagery derived from Nordic folklore and from mystical symbols, rather than purely abstract forms.

☞ Alechinsky, Appel, Jorn

Colour-Field painting

A form of **Abstract Expressionist** painting which emphasized the use of colour, rather than gesture, as the principal means of expression. Colour-field paintings are characterized by expanses of intense and saturated colour and typified by the work of Rothko, Newman and Still. These artists' rejection of expressive brushstrokes helped pave the way for **Post-Painterly Abstraction** and **Minimalism**.

Conceptual Art

The notion that it is the 'concept' behind the work, rather than the technical skill of the artist in making it, that is important. Conceptual Art became a major international phenomenon in the 1960s and its manifestations have been very diverse. The ideas or 'concepts' may be communicated using a variety of different media, including texts, maps, diagrams, film and video, photographs and performances, and the resulting works may be displayed in a gallery or designed for a specific site. In some cases the landscape itself becomes an integral part of the artist's work, as in the **Land Art** of Long or the environmental sculptures of Christo. The ideas expressed through Conceptual work have been drawn from philosophy, **feminism**,

psychoanalysis, film studies and political activism. The notion of the Conceptual artist as a maker of ideas rather than objects undermines traditional views about the status of the artist and the art object.

☞ Art & Language, Burgin, Christo, Kabakov, Kawara, Kosuth, Long, Merz, Weiner

Constructivism

An abstract art movement founded in Russia in 1913. Constructivism swept away traditional notions about art with its belief that art should imitate the forms and processes of modern technology. Sculpture was 'constructed' using industrial materials and techniques, and in painting, abstract forms were used to create structures reminiscent of machine technology. Although 'pure' Constructivism was current in Russia only during the early years of the Revolution, its aims and ideals have been used by artists throughout the twentieth century.

☞ Gabo, Lissitzky, Moholy-Nagy, Rodchenko, Tatlin

Cubism

This revolutionary method of making a pictorial image was invented by Picasso and Braque in the first decade of the twentieth century. Although it may appear abstract and geometrical, Cubist art does in fact depict real objects. The objects are 'flattened' onto the canvas so that different sides of each shape can be shown simultaneously. Instead of creating the illusion of an object in space, as artists had endeavoured to do since the Renaissance, Cubist art defines objects in terms of the two-dimensional canvas. This innovation gave rise to an extraordinary reassessment of the interaction between form and space and changed the course of Western art forever.

☞ Archipenko, Braque, Gleizes, Gris, Laurens, Léger, Lipchitz, Metzinger, Picasso, Popova

Dada

The name Dada is deliberately meaningless and was given to an international **anti-art** movement that flourished from 1915 to 1922. Its main centre of activity was the Cabaret Voltaire in Zurich, where like-minded poets, artists, writers and musicians would gather to participate in experimental activities such as nonsense poetry, 'noise music' and automatic drawing. Dada was a violent reaction to the snobbery and traditionalism of the art establishment. A typical Dada work of art was the **ready-made**, essentially an ordinary object taken from its original context and exhibited as art. The Dada movement, with its cult of the irrational, had an important influence on **Surrealism** in the 1920s.

☞ Arp, Duchamp, Hausmann, Man Ray, Picabia, Schwitters

Expressionism

An artistic force concentrated mainly in Germany from 1905 to 1930. Expressionist artists sought to develop pictorial forms which would express their innermost feelings rather than representing the external world. Expressionist painting is intense, passionate and highly personal, based on the concept of the painter's canvas as a vehicle for demonstrating emotions. Violent, unreal colour and dramatic brushwork make the typical Expressionist painting quiver with vitality. Vincent van Gogh, with his frenzied painting technique and extraordinary use of colour, was the inspiration for many Expressionist painters.
☛ Beckmann, Heckel, Kokoschka, Marc, Munch, Nolde, Pechstein, Rouault, Schiele, Soutine

Fauvism

In 1905 an exhibition was held in Paris which included a room full of paintings by Derain, Matisse and Vlaminck, among others, that blazed with pure, highly contrasting colours. One critic dubbed the creators of these paintings 'les fauves' – French for 'wild beasts' – and the name stuck. This 'wildness' manifested itself mainly in the strong colours, dynamic brushwork and expressive depth of their pictures, which evoke a fantastical, joyous world of heightened emotion and colour. Matisse is generally considered to be the leader of this group, whose pictures include colourful landscapes and portraits.
☛ Derain, Van Dongen, Matisse, Vlaminck

Fluxus

Active between the early 1960s and the mid-1970s, Fluxus was as much a state of mind as a particular style. The term was first used in 1961 by George Manciunas, and was intended to describe a condition of perpetual activity and change. Fluxus had a similar iconoclastic ideology to **Dada** and was focused on a loosely interconnected, revolutionary group of artists in Europe and the United States, who reacted against traditional art forms. The style manifested itself in **Happenings**, interactive performances, videos, poetry and **found objects**, and was important in paving the way for **Performance** and **Conceptual Art**.
☛ Knizak, Ono, Paik

Futurism

An avant-garde movement founded in Milan in 1909 by the Italian poet Filippo Marinetti. Its members aimed to liberate Italy from the weight of its past and to glorify modernity. The Futurists were fascinated by modern machinery, transport and communications. In painting and sculpture, angular forms and powerful lines were used to convey a sense of dynamism. One of the main features of Futurist art was its attempt to capture movement and speed: this was usually achieved by depicting several images of the same object or figure in slightly differing positions all together, giving the impression of a flurry of movement.
☛ Balla, Boccioni, Carrà, Metzinger, Severini

Gutai Group

The first radical, post-war group in Japan, founded by the painter Yoshihara in Osaka in 1954 in response to the reactionary artistic context of the time. This influential group, otherwise known as Gutai Bijutsu Kyokai, was involved in large-scale, multimedia environments, performances and theatrical events. Precursors to the **Happenings** of the late 1950s in New York, many of the group's activities involved physical acts of exertion (see Murakami). Paintings were produced as part of performances, and this emphasis on the process and act of creating a work of art was to have a significant impact on Pollock and the **Abstract Expressionists**.
☛ Morimura, Shiraga, Yoshihara

Impressionism

A movement in painting that originated in France in the 1860s. Impressionist painters were fascinated by the relationship between light and colour, painting in pure pigment using free brushstrokes. They were also radical in their choice of subject matter, avoiding traditional historical, religious or romantic themes to concentrate on landscapes and scenes of everyday life. The movement's name was initially coined in derision by a journalist, who saw one of Monet's paintings entitled *Impression – Sunrise*. Monet's late series of paintings of waterlilies, with their interest in colour for its own sake, paved the way for abstraction.
☛ Bonnard, Corinth, Liebermann, Monet, Utrillo

Independent Group

A loose body of British artists, including Hamilton and Paolozzi, who used to meet at the Institute of Contemporary Arts in London in the early to mid-1950s. Their meetings covered many interdisciplinary subjects, particularly science and technology, music, theatre and art. Together they were responsible for introducing the notion of popular culture and mass media to British art, organizing a landmark exhibition called *This is Tomorrow* at the Whitechapel Art Gallery in London, which focused on the subject of contemporary life, and prompted the birth of **Pop Art**.
☛ Hamilton, Paolozzi

Minimalism

A trend in painting and sculpture that developed primarily in the United States during the 1960s and 1970s. As the name

implies, Minimalist art is pared down to its essentials; it is purely abstract, objective and anonymous, free of surface decoration or expressive gesture. Minimalist painting and drawing is monochromatic and is often based on mathematically derived grids and linear matrices; yet it can still evoke a sensation of the sublime. Sculptors used industrial processes and materials, such as steel, perspex, even fluorescent tubes, to produce geometric forms, often made in series. This sculpture has no illusionistic properties, relying instead on a bodily experience of the work by the spectator. Minimalism can be seen as a reaction against the emotionalism of **Abstract Expressionism**, which had dominated modern art through the 1950s.
☛ Andre, Flavin, Judd, LeWitt, Mangold, Martin, Morris, Ryman, Serra, F Stella

Nabis

A small group of French artists, active in the 1880s, who were inspired by Gauguin's method of painting in pure colour. Their approach is epitomized by a statement by the painter Denis, one of the group's members: 'Remember that a picture, before being a horse, a nude, or some kind of anecdote, is essentially a flat surface covered with colours.' Their pictures are characterized by broad areas of flat colour or patterns. As well as painting, the group was interested in printmaking, posters, book illustrations, textiles and theatre design.
☛ Bonnard, Denis, Vuillard

Neo (-Dada, -Expressionism)

The prefix 'neo', meaning 'new', refers to a revival of previous trends or ideas. Neo-Dada, for example, was used in the late 1950s to describe the work of artists who looked back to the original **Dada** movement, incorporating **found objects** into paintings. Neo-Expressionism refers to the re-emergence of **Expressionist** characteristics in the work of artists in the United States and Europe, especially Germany in the early 1980s. Neo-Expressionist works tend to be highly personal, often executed with violent fervour.
☛ (Neo-Dada) Rauschenberg; (Neo-Expressionism) Baselitz, Immendorff, Kiefer

Die Neue Sachlichkeit

A stylistic tendency within the German **Expressionist** movement in the 1920s which reflected the cynicism that pervaded Germany after the First World War. It translates as 'The New Objectivity'. Artists of the Neue Sachlichkeit group, who included Dix and Grosz, tended to put a greater emphasis on social criticism and political comment than other **Expressionists**, who dealt with more subjective and emotional themes.
☛ Dix, Grosz, Schad

New British Sculpture Group

A group of sculptors associated with the Lisson Gallery in London in the early 1980s. There is no specific characteristic style which links them together and yet they all worked with ordinary and conventional materials, and attempted to connect the meaning of their work with everyday life (see Cragg). What also defined these artists was their return to the production of individual, autonomous objects, after the innovations of **Conceptual** and **Performance Art**, which had dominated the previous decade.
☛ Cragg, Deacon, Opie, Woodrow

Nouveau Réalisme

A European movement that emerged in the late 1950s, and focused on using everyday items and **found objects** for aesthetic ends. The term was coined by the French critic Pierre Restany in 1960, and translates as 'New Realism'. Primarily based in France, the Nouveaux Réalistes reacted against the gestural paintings of the **Abstract Expressionists**, producing works which were rooted in contemporary experience. Superficially resembling **Pop Art**, the work of the Nouveaux Réalistes is in fact closer to the **assemblages** of Dine and Rauschenberg, with their emphasis on the use of discarded materials for poetic ends.
☛ Arman, César, Klein, Spoerri

Op Art

A movement in abstract art that developed in the 1960s. Op Art (short for 'optical art') exploits the fallibility of the human eye. The artist plays games with the viewer by creating images which appear to shimmer and pulsate. Although the work of art itself is static, the forms and colours used cause an optical illusion of movement.
☛ Riley, Vasarely

Orphism

A term used by the French poet Guillaume Apollinaire in 1913 to describe the work of Delaunay, which he saw as a new type of abstract art which was not based in reality, but had its own, independent language. Delaunay was interested in the effect of different colours on the canvas and produced a series of paintings which explored the emotional impact of pure colour. He adopted Apollinaire's term and developed his theories into the movement of the same name, along with his wife Sonia.
☛ R Delaunay, S Delaunay

Pittura Metafisica

A movement founded in Italy in 1917 by De Chirico and Carrà. Its name translates as 'Metaphysical Painting'. It is character-

ized by distorted perspectives, unnatural lighting and strange imagery, often using tailors' dummies and statues instead of the human body. By placing objects in unlikely contexts, the Metaphysical painters aimed to create a dream-like, magical atmosphere. In this respect the movement has much in common with **Surrealism**, but it differs from **Surrealism** in its concern with rigid compositional structure and architectural values.

☛ Carrà, De Chirico

Pop Art

A movement in the United States and Britain that emerged in the 1950s and took its inspiration from the imagery of consumer society and popular culture. Comic strips, advertising and mass-produced objects all played a part in this movement, which was characterized by one of its members, Hamilton, as 'popular, transient, expendable, low cost, mass-produced, young, witty, sexy, gimmicky, glamorous and Big Business'. The brashness of subject matter is often emphasized by hard-edged, photograph-like techniques in painting and minute attention to detail in sculpture. **Photomontage**, **collage** and **assemblage** are also common in Pop Art. Some Pop artists also participated in **Happenings**.

☛ Blake, Dine, Hamilton, Hockney, Johns, Kitaj, Lichtenstein, Oldenburg, Rauschenberg, Rosenquist, Thiebaud, Warhol

Post-Painterly Abstraction

A term coined by American critic Clement Greenburg in 1964. He used it to describe the work of a group of artists who had moved away from the gestural and emotional style of **Abstract Expressionism**. These artists rejected the painterly and spontaneous style of their predecessors and instead they often stained the canvas with pigment to avoid any trace of brush-strokes.

☛ Frankenthaler, Louis, K Noland, Olitski

St Ives Group

A group of artists who lived and worked in the Cornish seaside town of St Ives in the early 1940s. Key members of the group were Hepworth and Nicholson, who moved to St Ives during the Second World War. Although each had their own individual style, they all worked in the abstract tradition, producing works influenced by the light, sea and landscape of their immediate surroundings.

☛ Hepworth, Heron, Nicholson, Wallis

The Viennese Secession

An avant-garde group founded in 1897 by the artist Klimt. Its aim was to break away from the established artistic bodies and raise the level of production of arts and crafts in Austria to that of other European countries. Many of the group were based at the movement's headquarters, the Viennese Workshop. The Secession style was close to **Art Nouveau**. Other Secession groups were formed in Munich and Berlin at around the same time.

☛ Klimt, Schiele

Situationism

A radical artistic movement formed in Europe in 1957 which aimed to upset the establishment. While having no one style, the Situationists shared certain common views, believing that capitalism had turned spectators into passive consumers of media imagery. To counter this, they had to resort to revolutionary strategies to force people to look at art in a new way. They proposed an art which overturned traditional notions of authorship and questioned established art contexts. Their ideas were disseminated principally through the writings of Guy Debord. Involved in the French general strike of 1968, the Situationists influenced a number of artists to focus on the relationship between politics, ideology, art and social change.

☛ Burgin, Jorn, Kruger

Socialist Realism

The official style of art in the Soviet Union and communist countries, sanctioned in 1934, when Stalin turned against artistic experimentation. It aimed, in the words of the Statute of the Union of Soviet Writers, for 'the truthful, historically concrete portrayal of reality in its revolutionary development'. In practice, Socialist Realist art was characterized by idealized representations of heroic workers and soldiers, in a naturalistic style.

☛ Komar and Melamid, Mukhina

Spazialismo

An avant-garde movement founded in 1946 by the Italian artist Fontana. Trying to break away from the two-dimensional plane of a painting, Fontana made holes or cuts in his canvases in his attempts to bring real space into his work – hence the name 'Spazialismo', which translates as 'Spatialism'. He also made a 'Black Spatial Environment' in 1947, a room painted black, which predates **Installation Art**. His cerebral approach to painting helped pave the way for **Conceptual Art**.

☛ Fontana

De Stijl

A movement and magazine founded in Holland in 1917 by Van Doesburg and Mondrian. These men believed that art should strive towards complete harmony, order and clarity in a constant process of refinement. The work of De Stijl was therefore

austere and geometrical, using mainly square forms. It was composed of the simplest elements: straight lines and pure, primary colours. The movement's aims were deeply philosophical and were rooted in the idea that art should in some way reflect the mystery and order of the universe. The movement came to an end in 1931 after Van Doesburg's death, but had a profound effect on architecture and art in Europe.
☛ Van Doesburg, Mondrian

Suprematism

A movement founded by the Russian painter Malevich in 1915. An entirely abstract art, it insisted on the supremacy of geometric forms. The representation of either objects or ideas was completely ruled out. Malevich's ideas were summed up in his famous painting, *White Square* – a white square on a white background – which was to become the emblem of the movement. Although the movement had a limited following and impact in Russia, it had a significant influence on Kandinsky and artists of the **De Stijl** group, while the paring down of art to its essentials anticipates **Minimalism**.
☛ Kandinsky, Lissitzky, Malevich

Surrealism

Surrealism originated in France in the 1920s. In the words of its main theorist, the writer André Breton, its aim was to 'resolve the previously contradictory conditions of dream and reality', and the ways in which this was achieved varied widely. Artists painted unnerving and illogical scenes with photographic precision, created strange creatures from collections of everyday objects, or developed techniques of painting which would allow the unconscious to express itself. The Surrealists were particularly interested in **psychoanalysis** and the ideas of Freud. Their pictures, while figurative, represent an alien world, whose images range from dream-like serenity to nightmarish fantasy.
☛ Bellmer, Brauner, De Chirico, Dalí, Delvaux, Ernst, Gorky, Magritte, Matta, Miró, Nash, Tanguy, Wadsworth

Tachisme

A tendency in European painting in the 1950s and 1960s which formed part of the **Art Informel** movement. Taken from the French word 'tache', meaning 'blot', and first used by the French critic Charles Estienne in the early 1950s, Tachisme is close to **Abstract Expressionism**, and is characterized by abstract spots and stains of colour applied to the surface of the canvas.
☛ Michaux, Riopelle, Soulages, Wols

Vorticism

An English avant-garde movement founded by Wyndham Lewis in 1914. The name Vorticism came from the Italian **Futurist** Boccioni's remark that all creative art emanates from an emotional vortex. Like **Futurism**, Vorticism employed a harsh, angular and highly dynamic style in both painting and sculpture and aimed at capturing activity and movement. Although Vorticism did not survive the First World War, it was significant as the first movement towards abstraction in British art.
☛ Bomberg, Lewis

Further Reading

Also available from Phaidon Press:

Art Today by Edward Lucie-Smith.
A comprehensive guide to art internationally from 1960 to the present day.

The Story of Modern Art by Norbert Lynton.
An accessible and up-to-date account of the art of our century.

Directory of museums and galleries

Australia

Art Gallery of South Australia
North Terrace
Adelaide 5000
- ☞ Sickert, *Mornington Crescent Nude, Contre-jour*

Australian National Gallery
GPO Box 1150
Canberra 2600-2601
- ☞ Hesse, *Contingent*
 M Kelly, *Post-Partum Document: Documentation V*

Austria

Graphische Sammlung Albertina
Augustinerstrasse 1
Vienna 1010
- ☞ Schiele, *Recumbent Female Nude with Legs Apart*

Österreichische Galerie
Prinz-Eugen-Strasse 27
Vienna 1030
- ☞ Klimt, *Judith and Holofernes*

Belgium

Musées Royaux des Beaux-Arts de Belgique
9 rue du Musée
Brussels 1000
- ☞ Bonnard, *Nude against Daylight*

Museum van Hedendaagse Kunst
Hofbouwlaan
Ghent 9000
- ☞ Durham, *La Malinche*
 Tuymans, *Body*

Brazil

Museu d'Arte Contemporanea
Rua de Reitoria 160,
São Paulo 05508-900

- ☞ Modigliani, *Self-portrait*

Museu de Arte Moderna
Av. Infante Dom Henrique 85
CP 44, Rio de Janeiro 20000-20021
- ☞ Oiticica, *Bólide 18, B-331 (Homage to Cara de Cavalo)*

Canada

Montreal Museum of Fine Arts
1379 Sherbrooke Street West
Montreal
Québec H3G IK3
- ☞ Tansey, *Action Painting II*

National Gallery of Canada
380 Sussex Drive
Ottawa
Ontario K1N 9N4
- ☞ Oldenburg, *Bedroom Ensemble*

Ydessa Hendeles Art Foundation
778 King Street W
Toronto
Ontario M5V 1N6
- ☞ Bourgeois, *Cell III*
 Wall, *The Stumbling Block*

Denmark

Louisiana Museum of Modern Art
Gl Strandvej 13
Humlebaek 3050
- ☞ Bury, *Sphere on a Cylinder*
 Dine, *Wiring the Unfinished Bathroom*
 Fahlstrom, *Phase Four of Sitting, Five Panels*
 Francis, *Untitled*
 Jorn, *Dead Drunk Danes*
 Kirkeby, *Birds Buried in Snow*
 LeWitt, *Three Cubes with One Half – Off*

Morley, *Los Angeles Yellow Pages*
Tàpies, *Ochre*

France

Musée de Pontoise
4 rue Lemercier
Cergy-Pontoise 95300
- ☞ Freundlich, *Composition*

Musée Cantini
19 rue Grignan
Marseille 13000
- ☞ Artaud, *The Totem*

Musée des Beaux-Arts
10 rue Georges Clémenceau
Nantes 44000
- ☞ Cahun, *Self-portrait, 1927*

Fondation Le Corbusier
10 sq. Docteur-Blanche
Paris 75016
- ☞ Le Corbusier, *Still Life with Numerous Objects*

Musée Bourdelle
16 rue Antoine-Bourdelle
Paris 75015
- ☞ Bourdelle, *Crouching Bather*

Musée National d'Art Moderne
Centre Georges Pompidou
rue Beaubourg
Paris 75004
- ☞ Braque, *Composition with the Ace of Clubs*
 Hatoum, *Foreign Body*
 Hausmann, *The Spirit of our Times*
 Lam, *The Reunion*
 Laurens, *Head of a Woman with a Necklace*
 Messager, *Lances*

Musée d'Orsay
62 rue de Lille
Paris 75007
- ☞ Denis, *Homage to Cézanne*

Musée de Saint-Étienne
13 bis rue Gambetta
Hôtel de Villeneuve
Saint-Étienne 42000
- ☞ Bustamante, *Stationary I*

Germany

Akademie der Künste
Stiftung Archiv
Bildende Kunst
Hanseatenweg 10
Berlin 10557
- ☞ Heartfield, *Hurray, the Butter is All Gone!*
 Kollwitz, *Mother with Dead Child*

Kunsthalle Bremen
Am Wall 207
Bremen 28195
- ☞ Macke, *Russian Ballet I*

Museum Folkwang
Goethestrasse 41
Essen 45128
- ☞ Baumeister, *Eidos*
 Schlemmer, *Rear View of a Woman Sitting at the Table*

Karl Ernst Osthaus-Museum
Hochstrasse 73
Hagen 58042
- ☞ Kirchner, *Group of Artists*

Kaiser Wilhelm Museum
Karlsplatz 35
Krefeld 47798
- ☞ Beuys, *Barraque d'Dull Odde*

Goetz Collection
Oberföhringer Strasse 103

81925 Munich
- Halley, *CUSeeMe*

Westfälisches Landesmuseum
Domplatz 10
Münster 48143
- Heckel, *Sailing Ships in the Harbour*
 Wols, *The Windmill*

Staatsgalerie Stuttgart
Konrad-Adenauer-Strasse 30–32
Stuttgart 70173
- Grosz, *Dedication to Oskar Panizza*

Von der Heydt-Museum
Turmhof 8
Wuppertal 42103
- Modersohn-Becker, *Woman with Flowers*

India

Rabindra Bhavan Archive, Visva-Bharati University
Santini Ketan
West Bengal 731235
- Tagore, *Untitled*

Israel

Israel Museum
POB 71117
Jerusalem 91710
- Davis, *New York under Gaslight*

Italy

Galleria Nazionale d'Arte Moderna e Contemporanea
viale Belle Arti 131
Rome 00197
- Guttuso, *The Crucifixion*

Fondo Rivetti per l'Arte
via Botticelli 80
Turin

- Penone, *Helicoidal Tree*

Comitato Tina Modotti
via Mazzini 9
Udine 33100
- Modotti, *Hands of the Puppeteer*

Peggy Guggenheim Collection
Palazzo Venier dei Leoni
701 Dorsoduro
Venice 30123
- Metzinger, *At the Cycle Race-Track*

Japan

Naoshima Museum
Gotanji, Naoshima-cho
Kagawa-gun; Kagawa-ken 761-31
- Bartlett, *Yellow and Black Boats*

Museum Marugame Hirai
538 8 Cho-Me, Doki-Cho
Marugame-Shi
Kagawa 763
- Iglesias, *Untitled (Antwerp I)*

Paleis Huis Ten Bosch
Sasebo City
Nagasaki Prefecture
- Scholte, *After Us the Flood*

Contemporary Sculpture Centre
4.20.2 Ebisu Shibuya-Ku
Tokyo 150
- Gormley, *A Case for an Angel II*

Mexico

Ministry of Education
Republica de Argentina 28
Colonia Centro
06029 Mexico City

- Rivera, *Distribution of the Arms*

Museo de Arte Moderno
Paseo de la Reforma y Gandhi
Bosque de Chapultepec
Mexico City DF 11850
- Gironella, *Queen Riqui*
 Varo, *The Flight*

The Netherlands

Stedelijk Museum of Modern Art
Paulus Potterstr. 13
Amsterdam 1070 AB
- Dibbets, *Universe/Worlds Platform*

Museum Boymans-van Beuningen
Museumpark 18–20
Rotterdam 3015 CK
- Ader, *I'm too Sad to Tell You*
 Mondrian, *Composition with Blue and Yellow*

De Pont Foundation
Wilhelminapark 1
Tilburg 5041 EA
- Dumas, *The First People (I–IV) (The Four Seasons)*

New Zealand

Waikato Museum of Art and History
Grantham Street
Hamilton
Auckland
- Hotere, *Aramoana Nineteen Eighty-Four*
 McCahon, *Are There not Twelve Hours of Daylight*

Norway

Nasjonalgalleriet
Universitetsgaten 13

Box 8157 Dep.
Oslo 0033
- Munch, *The Dance of Life*

Poland

Muzeum Sztuki w Lodzi
ul Wieckowskiego 36
Lodz 90-734
- Kantor, *Edgar Warpol: The Man with Suitcases*

Russia

Hermitage Museum
Dworzowaja Nabereshnaja 34–36
St Petersburg 191065
- Matisse, *The Dance*

State Russian Museum
Michajlovskij Palace
Inzeneraja ul 4
St Petersburg 191011
- Mukhina, *Industrial Worker and Collective Farm Girl*

South Africa

Standard Bank Collection, Witwatersrand University Art Galleries
Private Bag 3
Witwatersrand 2050
Johannesburg
- Nhlengethwa, *It Left him Cold – The Death of Steve Biko*

Spain

Fundación Caja de Pensiones
Sala de Exposiciones
Calle Serrano 60
Madrid 28001
- Trockel, *Playboy Bunnies*
 Turrell, *Rayzor*

IFEMA Collection
Avenida Portugal s/n
Madrid 28011
- Boltanski, *Reliquary*

Sweden

Moderna Museet

Sparvagnshallarna

Box 16392

Stockholm 103 27

☛ Oppenheim, *My Nurse*

Tinguely, *Chariot MK IV*

Nordenhake

Fredsgatan 12

Stockholm 11152

☛ Klein, *FC–11 Anthropometry – Fire*

Switzerland

Adolf Wölfli Foundation, Museum of Fine Arts

Hodlerstrasse 12

Berne 3011 CH

☛ Wölfli, *St Adolf Diamond Ring*

Petit Palais

2 terrasse Saint-Victor

Geneva 1206

☛ De Lempicka, *The Two Friends*

Kunsthaus

Heimplatz 1

Zurich 8024

☛ Bill, *Rhythm in Four Squares*

United Kingdom

Peter Stuyvesant Foundation Limited

Oxford Road

Aylesbury, Bucks HP21 8SZ

☛ González, *Head of Screaming Montserrat*

Fitzwilliam Museum

Trumpington Street

Cambridge CB2 1RB

☛ Spencer, *Self-portrait with Patricia*

Scottish National Gallery of Modern Art

Belford Road

Edinburgh EH4 3DR

☛ Larionov, *Soldier in a Wood (The Smoker)*

Cotton's Atrium

Cotton's Centre

Hays Lane

London SE1 2QT

☛ Jones, *Dancers*

Courtauld Institute Galleries

Somerset House

Strand

London WC2R 0RN

☛ Renoir, *Portrait of Ambroise Vollard*

National Gallery

Trafalgar Square

London WC2N 5DN

☛ Cézanne, *Bathing Women*

Redon, *Ophelia among the Flowers*

Saatchi Collection

98A Boundary Road

London NW8 0RH

☛ Deacon, *Two Can Play*

Fischl, *Bad Boy*

Golub, *Mercenaries IV*

Hirst, *The Physical Impossibility of Death in the Mind of Someone Living*

Quinn, *Self*

Rae, *Untitled (yellow with circles)*

Rollins, *Amerika VI (South Bronx)*

Salle, *The Burning Bush*

Sherman, *Untitled (No.122)*

Wilson, *20:50*

Woodrow, *Cello Chicken*

Tate Gallery

Millbank

London SW1P 4RG

☛ Albers, *Study for Homage to the Square: Beaming*

Appel, *Hip Hip Hooray*

Bacon, *Triptych – August 1972*

Balla, *Abstract Speed – the Car Has Passed*

Balthus, *Sleeping Girl*

Boccioni, *Unique Forms of Continuity in Space*

Bomberg, *Vision of Ezekiel*

Burri, *Sacking and Red*

Chagall, *Bouquet with Flying Lovers*

Duchamp-Villon, *The Large Horse*

Epstein, *Torso in Metal from The Rock Drill*

Ernst, *Elephant of Celebes*

Gill, *Ecstasy*

Hepworth, *Three Forms*

Hiller, *An Entertainment*

Howson, *Plum Grove*

John, *Dorelia in a Black Dress*

Johns, *Zero Through Nine*

Kandinsky, *Swinging*

De Kooning, *The Visit*

Lewis, *The Surrender of Barcelona*

Nash, *Landscape from a Dream*

Nolan, *Glenrowan*

Paolozzi, *I Was a Rich Man's Plaything*

Picabia, *Catax*

J Piper, *Seaton Delaval*

Rego, *The Dance*

Rothko, *Red on Maroon*

Roy, *A Naturalist's Study*

Schütte, *United Enemies*

Sutherland, *Entrance to a Lane*

Viola, *Nantes Triptych*

Henry Moore Foundation

Dane Tree House

Perry Green

Much Hadham

Herts SG10 6EE

☛ Moore, *Family Group*

City Art Gallery

Nottingham Castle

Nottingham NG1 6EL

☛ Burra, *Storm in the Jungle*

Lady Lever Art Gallery

Port Sunlight Village

Bebington

Wirral L62 5EQ

☛ Waterhouse, *A Tale from the Decameron*

Salford Art Gallery and Museum

Peel Park

Salford M5 4WU

☛ Lowry, *Market Scene, Northern Town*

Southampton City Art Gallery

Civic Centre

Southampton SO9 4XF

☛ Ayres, *Hinba*

United States

IBM Corporation

Old Orchard Road

Armonk

New York, NY 10504

☛ Moses, *Checkered House*

Archer M Huntington Art Gallery, University of Texas at Austin

Art Building

23rd & San Jacinto Streets

Austin, TX 78712-1205

☛ Evergood, *Dance Marathon*

Indiana University Art Museum

Indiana University

Bloomington

Indiana, IN 47405

☛ Sage, *Lost Record*

Albright-Knox Art Gallery

1285 Elmwood Avenue

Buffalo, NY 14222

☛ Kokoschka, *London: Large Thames View*

Art Institute of Chicago

111 South Michigan Avenue

Chicago, IL 60603-6110

☛ Hopper, *Nighthawks*
 Maillol, *Reclining Nude*

J Paul Getty Museum

17985 Pacific Coast Highway

Malibu, CA 90265-5799

☛ Man Ray, *Violin of Ingres*

Walker Arts Center

Vineland Place

Minneapolis, MN 55403

☛ Kapoor, *Mother as a Mountain*

Yale University Art Gallery

1111 Chapel Street

New Haven, CT 06520

☛ J Stella, *Brooklyn Bridge*

Dia Center for the Arts

542 West 22nd Street

New York, NY 10011

☛ Fritsch, *Rat King*
 De Maria, *New York Earth Room*

Adolf and Esther Gottlieb Foundation, Inc.

380 West Broadway

New York, NY 10012

☛ Gottlieb, *The Enchanted Ones*

Soloman R Guggenheim Museum

1071 Fifth Avenue at 88th Street

New York, NY 10128

☛ Baselitz, *The Gleaner*
 Kosuth, *Titled (Art as Idea as Idea), [idea]*

Metropolitan Museum of Art

1000 Fifth Avenue

New York, NY 10028

☛ Schapiro, *Barcelona Fan*

Museum of Modern Art

11 West 53rd Street

New York, NY 10019

☛ Caro, *Midday*
 Carrà, *Funeral of the Anarchist Galli*
 De Chirico, *Song of Love*
 Dalí, *The Persistence of Memory*
 Kahlo, *Self-portrait with Cropped Hair*
 Kline, *Chief*
 Monet, *Waterlilies*
 Motherwell, *Pancho Villa, Dead and Alive*
 Newman, *Onement III*
 Picasso, *Les Demoiselles d'Avignon*
 Pollock, *Full Fathom Five*
 Weber, *Two Musicians*

New School for Social Research

66 West 12th Street

New York, NY 10011

☛ J C Orozco, *Table of Universal Brotherhood*

Whitney Museum of American Art

945 Madison Avenue

New York, NY 10021

☛ Demuth, *My Egypt*
 Nadelman, *Tango*

Smith College Museum of Art

Elm Street at Bedford Terrace

Northampton, MA 01063

☛ Sheeler, *Rolling Power*

Philadelphia Museum of Art

26th Street & Benjamin Franklin Parkway

Philadelphia, PA 19130

☛ Gris, *Still Life before an Open Window: The Place Ravignon*

San Antonio Museum of Art

200 W Jones Avenue

San Antonio, TX 78215

☛ Lawrence, *Bar 'n' Grill*

Hirshhorn Museum and Sculpture Garden

Smithsonian Institution

Seventh Street & Independence Avenue SW

Washington, DC 20560

☛ Scully, *Why and What (Yellow)*
 Siqueiros, *Zapata*

National Gallery of Art

4th Street & Constitution Avenue NW

Washington, DC 20565

☛ Bellows, *Club Night*
 Brancusi, *Bird in Space*
 Calder, *Obus*
 R Delaunay, *Political Drama*
 Diebenkorn, *Berkeley No.52*
 Van Doesburg, *Contra-Composition*
 Gauguin, *The Invocation*
 Gorky, *One Year the Milkweed*
 Krasner, *Cobalt Night*
 Kupka, *Organization of Graphic Motifs II*
 Lehmbruck, *Seated Youth*
 Magritte, *The Human Condition*
 Mangold, *$1/2$ x Series (Blue)*
 Marc, *Siberian Dogs in the Snow*
 Noguchi, *Cloud Mountain*
 K Noland, *Another Time*
 O'Keeffe, *Jack-in-the-Pulpit No.IV*
 Prendergast, *Salem Cove*
 Rauschenberg, *Doric Circus*
 Reinhardt, *Black Painting No.34*
 Rousseau, *Tropical Forest with Monkeys*
 Segal, *The Dancers*
 D Smith, *Voltri VII*
 F Stella, *Jarama II*
 Still, *Untitled*
 Warhol, *Soup Can*
 Wood, *Haying*
 Wyeth, *Field Hand*

Phillips Collection

1600 21st Street NW

Washington, DC 20009

☛ Dove, *Lake Afternoon*
 Marin, *Four-Master off the Cape-Maine Coast, No.1*
 Vuillard, *The Newspaper*

Uruguay

Museo Nacional de Artes Visuales

Av J Herrera YR s/n

Montevideo

☛ Torres-Garcia, *Universal Art*

Venezuela

Museo de Arte Contemporaneo

Parque Central Zona Cultura

Caracas

☛ Marisol, *Children Sitting on a Bench*

Acknowledgements

Contributors and Consultants

Rachel Barnes, Martin Coomer, Carl Freedman, Tony Godfrey, Simon Grant, Melissa Larner, Simon Morley, Gilda Williams

Photographic Acknowledgements

courtesy Foundation Marina Abramovic 471; Acquavella Contemporary Art, Inc., New York 148; courtesy George Adams Gallery, New York 300; Akademie der Künste, Berlin 194; American Fine Arts Co., New York 113; Galerie Paul Andriesse, Amsterdam 5, 126; Avigdor Arikha 13; Art & Language 16; Art Gallery of South Australia, Adelaide, A R Ragless Bequest Fund 1963 428; Art Institute of Chicago, Friends of American Art Collection, 1942.51 210; Ashiya City Museum of Art & History 329, 427; courtesy Paolo Baldacci Gallery, New York 423; Judith Barry, New York 30; Beaux Arts, London 150; photo Jean Bernard 17; Zarina Bhimji, London 43; courtesy Galerie Bischofberger, Zurich 33, 406, 414, 475; Marc Blondeau, Paris 403; courtesy Mary Boone Gallery, New York 18, 48, 139, 254, 320, 394, 419; Sonia Boyce, London 58; Guy Brett, London 114; Stuart Brisley, London 64; Galerie Jeanne-Bucher, Paris 118, 440, 476; Bundanon Trust, Nowra, New South Wales 59; Chris Burden, Topanga 67; Jean-Marc Bustamante, Paris 73; courtesy Camden Arts Centre/Henry Moore Sculpture Trust 257; Rodney Capstick-Dale, London 245; Leo Castelli, New York 95, 100, 332, 395, 402; © Helen Chadwick, London 85; Eduardo Chillida 89; Chisenhale Gallery, London 364; Christie's Images 6, 12, 14, 15, 20, 28, 37, 38, 63, 65, 78, 81, 83, 96, 105, 106, 115, 119, 120 123, 125, 129, 137, 138, 143, 153, 154, 155, 158, 162, 184, 189, 190, 21, 239, 255, 261, 262, 265, 271, 272, 288, 289, 295, 318, 343, 360, 370, 377, 393, 396, 399, 405, 421, 429, 434, 435, 438, 439, 456, 463, 472, 474, 478, 501; © Christo 1996/photo Wolfgang Volz 91; from the Contemporary Chinese Artists Archive edited by Hou Hanru for the Library and Archive of the Institute of International Visual Arts 214; courtesy Paula Cooper Gallery, New York 10, 31, 40, 54, 163; Jane Crawford 301; Galerie Chantal Crousel, Paris 305; Juan Davila 101; courtesy Dia Center for the Arts, New York 151, 229, 293, 491; Jan Dibbets, Amsterdam 110; courtesy Anthony d'Offay, London 93, 207, 249, 250, 252, 274, 310, 324, 371, 432, 467, 470, 477; Drouot, Paris 199, 355; courtesy André Emmerich Gallery, New York 8, 277, 363; Enghien, Enghien-Les-Bains 197; Collection, The Equitable Life Assurance Society of the United States/photo 1988 Dorothy Zeidman 41; Luciano Fabro, Milan 135; courtesy Ronald Feldman Fine Arts, New York 167, 224 (photo Erik Landsberg), 247, 488, 493 (photos D James Dee); Flowers East, London 213; Büro Günther Förg, Frankfurt 144; Galerie Jean Fournier, Paris 309; Frith Street Gallery, London 362; Galleria Nazionale d'Arte Moderna, Rome, with permission of Ministero per i Beni Culturali e Ambientali/photo Giuseppe Schiavinotto 181; Avital Geva, Kibbutz ein Shemer 157; Gimpel Fils, London 21; courtesy Barbara Gladstone Gallery, New York 4, 29, 209, 326, 375; Zvi Goldstein, Jerusalem 165; Foster Goldstrom, New York 334; courtesy Marian Goodman Gallery, New York 35, 175, 211, 344, 353, 387, 490; courtesy Jay Gorney Modern Art, New York 446; courtesy Jay Gorney Modern Art, New York and Sonnabend Gallery, New York 441; © 1979 Adolph & Esther Gottlieb Foundation, Inc., New York 174; © 1995, Grandma Moses Properties Co., New York 322; Solomon R Guggenheim Foundation/photo David Heald ©1995 306; Hans Haacke, New York 182; Peter Halley, New York 183; © The Estate of Keith Haring 188; Hayward Gallery, London 325; courtesy Pat Hearn Gallery, New York 176, 196; Patrick Heron, St Ives 200; courtesy Susan Hiller 203; Joan Hills, London 60; © David Hockney 206; Rebecca Hossack Gallery, London 462; Michael Hue-Williams Fine Art Limited, London 166; Archer M Huntington Art Gallery, gift of Mari and James A Michener, 1991/photo George Holmes 134; Leonard Hutton Galleries, New York 168; ICA, London 132; Christina Iglesias, Torrelodones 215; Ikon Gallery, Birmingham 177; Indiana University Art Museum, photo by Michael Cavanagh, Kevin Montague 404; Israel Museum, Jerusalem 102; courtesy Jablonka Fabri, Cologne/Anthony d'Offay, London 159; Allen Jones, London 221; courtesy Annely Juda Fine Art, London 152, 273, 285, 314, 373, 392, 418, 455 (reconstruction by Martyn Chalk); Donald Judd Estate 223; Kaiser Wilhelm Museum, Krefeld 42; courtesy Crane Kalman Gallery, London 208; courtesy Galerie Karsten Greve, Cologne, Paris, Milan 97; courtesy Karsten Schubert, London 388, 492; Kasmin, London 348; © Mary Kelly, New York 232; Sean Kelly, New York 408; Anselm Kiefer, Barjac 233; Büro Kippenberger, Cologne/courtesy Galerie Gisela Capitain, Cologne 235; Milan Knizak, Prague 243; courtesy Knoedler & Company, New York, © Helen Frankenthaler 1996 147; Joseph Kosuth, New York Studio 251; Kunsthalle Bremen 282; Kunsthaus Zurich 45; Yvon Lambert, Paris 281, 468; Margo Leavin Gallery, Los Angeles/photo Douglas M Parker Studio 87; Galerie Lelong, New York 11; Galerie Lelong, Paris/André Emmerich Gallery, New York 9; Lenono Photo